The Indispensable Guide to Lightroom CC
Managing, Editing, and Sharing Your Photos

Sean McCormack

The Indispensable Guide to Lightroom CC

Managing, Editing, and Sharing Your Photos

rockynook

Sean McCormack (seanmcfoto.com)

The Indispensable Guide to Lightroom CC:
Managing, Editing, and Sharing Your Photos

Editor: Maggie Yates
Layout: Hespenheide Design
Cover Design: Rebecca Cowlin
Printer: Versa Press, Inc. through Four Colour Print Group
Printed in the USA

ISBN: 978-1-937538-67-5

1st Edition 2015
© 2015 by Sean McCormack

Rocky Nook, Inc.
802 E. Cota Street, 3rd Floor
Santa Barbara, CA 93103

www.rockynook.com

Library of Congress Control Number: 2015939335

Table of Contents

Acknowledgments

I've written a few books and more than a few magazine articles on the subject of Lightroom, but *The Indispensable Guide to Lightroom CC* is by far the biggest and most life-consuming project I've done to date. While the writing is done in isolation in my studio, the book is not something that's created in isolation. For that reason, I've a few people to thank.

First and foremost, I'd like to thank Dave Clayton. Without him, I'd still be writing this for myself, and then shopping it around for Lightroom 7 (because I'd take that long to finish it). I work much better with deadlines, and it was Dave's suggestion to talk to Scott Cowlin from Rocky Nook that got the ball rolling. I'd like to thank Scott for taking me on board to write for Rocky Nook. I've always liked the books they've produced.

Maggie Yates deserves special mention. Maggie has the unenviable task of making me sound far more refined, a job she does spectacularly. Thanks to the rest of the Rocky Nook team for their involvement: Matthias, Joan, Jessica, Ted, and Gerhard.

Thanks to the team of Lightroom gurus and experts who I talk to and interact with on at least a weekly, if not daily, basis. These people are sounding boards, and people of character. I treasure speaking with them, even on things we disagree about. Victoria Bampton, Piet Van den Eynde, John Beardsworth, and Richard Earney: thank you.

I'd like to thank Chris Main at *Photoshop User* magazine for giving me articles that kept me writing between books. I'd also like to thank Mark Cleghorn and the team at ThePhotographerAcademy.com.

I've gone on a bit, but the most important people that deserve thanks are my wife, Cynthia, and my son, Matthew. I thank them for their tolerance of this project; sometimes I'm in the studio writing until well into the early hours of the morning. I thank them for accepting the times I couldn't be with them due to the intense nature of writing this book. Sunday drives are back on, now!

Sean McCormack
June 2015

Introduction

Adobe Lightroom is now in its sixth version, and it's been a great ride. Adobe's effort to consolidate workflow has gotten better over time. It now boasts an impressive array of tools to help the photographer's workflow run faster and more smoothly. There is also a wealth of plugins that provide additional features not available in Lightroom. With the availability of these options, Lightroom truly is the hub for digital photographers' management and processing needs.

Before we talk about Lightroom, let's talk about this book. The book introduces topics related to Lightroom, and describes how the tools and functions of the program work. There are also standalone Tech Talk articles that go into advanced detail about aspects of the program.

Beyond descriptions of Lightroom's features, this book also includes "how to" information that provides practical tips for using these tools. Finally, there'll be a dedicated section that offers solutions for everything from troubleshooting to more complex workflows.

For Mac users, any time you see the instruction to right-click the mouse, you can substitute this with holding the Control key and using the one-button mouse.

Enjoy!

Library Basics

Lightroom is a modular workflow application that uses a database (called the Catalog) to store information (both metadata and editing settings) about your images. During the image-ingestion process, Lightroom reads the information for each file and stores this information in the Catalog. The photos and videos are still on disk, located either where you originally had them or wherever you tell Lightroom to put them during ingestion. They don't reside in the Catalog; they're just referenced from it. Once an image is ingested into Lightroom, you have the option to work with your photos offline; that is, with the image drive disconnected. You only need to reconnect the drive once full resolution output is required. Lightroom can handle video editing, too, but not offline.

Tech Talk: File Formats

Speaking of images and video, Lightroom is limited in terms of the types of files it can import. For images, it supports JPEG, TIFF, PSD, DNG, PNG, CMYK, and RAW files. For video, it supports a large range of camera video types, including avi, mp4, mov, and avchd. File extensions for these are: MOV, M4V, MP4, MPE, MPEG, MPG4, MPG, AVI, MTS, 3GP, 3GPP, M2T, and M2TS. These are all the file types that Lightroom will work with.

JPEG, TIFF, PNG, and PSD are rendered files. This means that certain information, like White Balance, has been embedded in the file. JPEG is a lossy format, meaning that information has been thrown away to make the file smaller (compressed) while still retaining the original look. Editing and resaving a JPEG will lead to a loss in file quality. It only takes a few saves for this to become noticeable.

TIFF and PSD are lossless formats, meaning they keep all information available from the file. They are a high-quality format, and can contain layers and alpha channels—perfect for use with Photoshop. The main difference between them is that TIFF is now an open format, whereas PSD is an Adobe proprietary format. TIFF has better universal support than PSD, though a number of third-party apps also use PSD.

DNG is Adobe's generic RAW file format. The aim is to allow RAW files from any manufacturer to be readable at any time in the future. The specification does get updated, and even includes lossy versions for RAW control at JPEG file sizes (using JPEG compression).

PNG stands for Portable Network Graphics, an image format that can contain transparency. This format is good for logos, etc.

RAW files include sensor capture information. Each camera has a different RAW file format, even though they may have the same file extension. Canon has .CR2, Nikon has .NEF, Olympus has .OPF, etc. Lightroom supports files from hundreds of cameras; see http://helpx.adobe.com/creative-suite/kb/camera-raw-plug-supported-cameras.html for details. Lightroom adds support for new cameras (either full or provisional) in quarterly releases.

Lightroom does not support Adobe Illustrator® files, Nikon scanner NEF files, or files with dimensions greater than 65,000 pixels per side or larger than 512 megapixels.

You can access files from the Folders Panel. The Folders Panel looks like a file browser, but remember that it only has access to the files you've uploaded. There is a file browser in the Import Panel, though, so you can easily get to any files you'd like to add to Lightroom.

Installing Lightroom

Both Mac and PC require you to use a new version of the Lightroom installer. This brings Lightroom up-to-date with all other Adobe installers. If you have a Creative Cloud Bundle, the file is installed from there. Follow these instructions to install Lightroom:

1. Run the installer. Choose from either a purchased or trial version. The installer can install both the CC and Perpetual versions of Lightroom. Perpetual versions require a serial number to work after the trial runs out, whereas Creative Cloud versions require you to log in.

2. You must sign in to your account with your Adobe ID, whether or not you are using Creative Cloud. This will store your serial number, which will prevent you from losing it.

3. Accept the EULA (End User License Agreement) to continue installing.

4. Select your prefered language from the list. Choose your install location and select Install.

5. The install will run. When the process is finished, you'll be invited to manage your software and use Launch Now to start Lightroom.

Note: An uninstaller is installed with the application. In the past, Mac users could simply delete the application to remove it. It is now essential that Mac users use the uninstaller to remove the program. It'll save a lot of headaches if you do this. Windows users have always had to uninstall. Perpetual users will see Lightroom 6 branding in the application; Creative Cloud users will see Lightroom CC branding.

The Lightroom 6 Splash Screen

Getting Around in Lightroom

When you open Lightroom for the first time (or after creating a new Catalog), you're presented with a blank central area with panels around it. There's a prompt in the center: Click the "Import…" button to begin. Before you upload your photos and begin playing, let's first explore and get to know the interface. There's no point in making your photos look fancy if you don't know where to find them!

There are four panels around the main image: The Module Picker at the top (1), the Left (2) and Right (3) Panels, and the Filmstrip on the bottom (4).

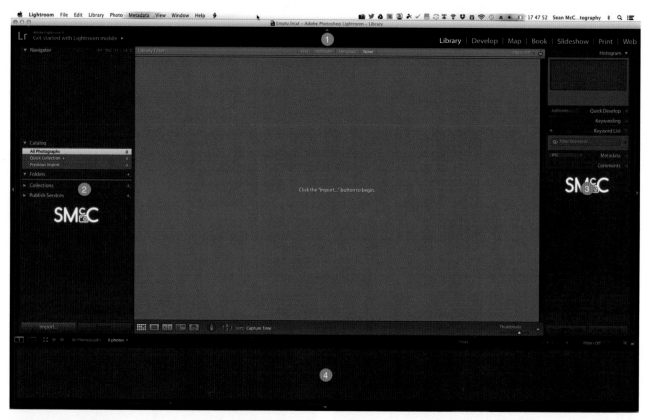

The Layout of Lightroom

The Module Picker

The Module Picker allows you to go directly to any of Lightroom's many modules. The first time you use Lightroom you'll be in the Library Module. Lightroom will remember the last module you were using and open it when you restart the program.

Module Picker

Lightroom has 7 modules, covering a range of tools a photographer might use. We'll take a more in-depth look at each later, but for now, here's a brief overview:

Library

The Library Module is Lightroom's asset management area. This is where files are added via import, sorted into folders and collections, have metadata (e.g., keywords) applied, and can be exported or published for use outside of Lightroom. Library allows various views of your images, from a thumbnail view in Grid to a double-image view in Compare, as well as a multi-image view in Survey. Loupe view is Library's standard single-image view. People view is a new option in which Lightroom runs its new face detection engine. This allows you to tag faces in your images. There will be more on this function in later sections.

Develop

This is the visually creative heart of Lightroom where your images are processed. Because Lightroom is designed for batch processing, settings can be applied to all selected images as you work, or by syncing settings afterward. For long-term applications, presets allow you to save settings for future use. Each setting is saved to the Catalog automatically as you work. There's no traditional Save in Lightroom—it all happens as you work. All the steps you make are recorded in the History, so it's easy to step back. If you reach a point where you want to keep those exact settings, you can save a Snapshot, making it easy to jump back to that point if you edit further.

Map

Map is effectively like having Google Maps inside Lightroom. You can search locations, view them via many views, including Satellite, Road Map, Hybrid Satellite/Map, and Terrain. There are also Light and Dark views. Location metadata, GPS, and tracklog information can be applied to photos. You can also use Saved Locations to jump to favorite places quickly.

Book

Making PDF books and printed Blurb Books is really easy through this template-based module. You can also view pricing as you work so you know roughly how much the book will cost. Books can be saved for future reprints.

Slideshow

Videos, photos, and music can be mixed to create an audio-visual treat. You have substantial control over backgrounds and text. Lightroom 6 allows you to use more music tracks than Lightroom 5 does, and both Automatic and Manual transition timing modes are available. There's also a Pan and Zoom option for Ken Burns-type effects. Slideshows can be exported as JPEG, PDF, or video files. You can also create Timelapse videos via a free template.

Print

The Print option allows you to create color-managed prints of anything from single photos to complex multi-image layouts, and even contact sheets. There are three layout options: Single image/contact sheet, Picture Package, and Custom Package. These packages offer enough options to cover most requirements for prints. You can also use the Print to JPEG function to save layouts for lab printing or online use.

Web

Web allows you to choose a range of individual galleries for use on the web. There is a major change from previous versions of Lightroom: Flash galleries are gone, and three new HTML galleries have been added instead. The Lightroom HTML Gallery is now the Classic Gallery, which includes the Grid, Square, and Track Galleries. Third-party plugins from Lightroom Blog, The Photographers Toolbox, and The Turning Gate expand the range of options to include creating whole websites from Lightroom.

> **Output Modules**
>
> Book, Slideshow, Print, and Web are often referred to as the Output Modules because you're creating some form of output for your images that is different from Export and Publish.

On the left side of the Module Picker is the Identity Plate, one of Lightroom's personal branding features. It contains the login panel for Lightroom mobile (Creative Cloud account required), Address Lookup, and Face Detection information.

Left Panel

Each module contains different panels in the Left Panel. These panels do have a common theme, though: they generally contain template- and management-related panels; e.g., the Folders Panel in Library, the Presets Panel in Develop, and the Template Browser Panel in the Output Modules. (The Collections Panel, however, is in every module.) It's slightly confusing to have panels inside panels, but this is the terminology Adobe uses.

Right Panel

The setting controls for each module are located in the Right Panel. For instance, in Library, the Right Panel holds Quick Develop, Keyword, and Metadata tools. In Develop, the Right Panel has all the tools to creatively interpret the look of your photos. In the Output Modules, the Right Panel contains layout settings. In Map, it contains the Location metadata for the selected images.

The Left Panel

The Right Panel

The Filmstrip

Located under the image, the Filmstrip shows a long strip of single images from the current folder or collection. This allows you to move between your

The Filmstrip

assets when in a single-image view mode like Loupe or Develop, and helps with managing your selection in Survey or Compare view.

You'll find navigation, view, screen, and filter tools located above the images in the Filmstrip. On the left-hand side, the number icons show the main and secondary screen options, followed by a shortcut to Grid View. The left and right arrows move you through recently used folders and collections, which are also available as a dropdown list. On the right are the basic filter options that allow you to filter by flag, rating, and label. Initially the view is collapsed, but clicking on the word Filter will open it up.

The Toolbar

There are two other parts to the workspace: The **Toolbar** and the **Filter Bar**. The shortcut "T" toggles the **Toolbar** on and off. This toggle only applies to the current module. You'll find module or current tool-related options on this Toolbar. On the right of the Toolbar is a disclosure triangle; clicking this will prompt a dropdown menu with available options. Checked tools appear in the bar; unchecked ones are hidden.

The **Filter Bar** allows you to choose criteria regarding what will be visible in the current view. Choose from Text, Attributes (flags, ratings, etc.), Metadata (EXIF or IPTC info, etc.), or any combintion of those three. This bar can be toggled from the View menu or with the shortcut "\".

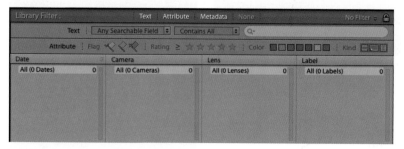

The Filter Bar

Personalizing Your Workspace

Lightroom has a myriad of options to control the UI Appearance. The overall color scheme can't be changed, but plenty of other stuff can.

Panels

In the center of each panel (Module Picker, etc.), there is a small disclosure triangle. Clicking this will alternately show and hide that panel. When the panel is closed, hovering the cursor over it will temporily show the panel. In

theory this is a great time saver, but often the panel will pop open at inopportune times. Fortunately, there are options. You can right-click on the panel's disclosure triangle. Choose from *Auto Hide & Show*, *Auto Hide,* and *Manual*. Auto Hide & Show is the default behavior—the panel will pop open when you hover your cursor over the triangle. Auto Hide means you have to click the triangle to open a panel, but moving away from that panel will hide it. Manual means you have to manually open and close the panel. I prefer Manual. *Sync with Opposite Side* will copy the setting to the opposite panel (e.g., select the Sync function to match what is on the Right Panel to the Left Panel).

Pressing the Tab key will hide/show the Left and Right Panels, while pressing Shift + Tab will hide/show all panels (or toggle through them). This doesn't affect the Toolbar or Filter Bar, which must be toggled separately.

The four main panels (Left, Right, Module Picker, and Filmstrip) also have dedicated open and close shortcuts.

The panel's Hide and Show options

- F5: Module Picker

- F6: Filmstrip

- F7: Left Panel

- F8: Right Panel

As well as the main panels, you can also change how the internal panels are viewed, including turning off individual panel headers. You can't move the panel headers, though.

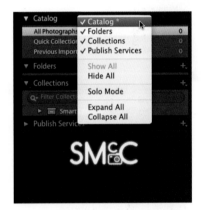

The panel contextual menu

Right-click on any panel header to see a menu with a list of the panels and viewing options. By default, there will be a check to the left of the name of each visible panel. Clicking the panel name will uncheck it, hiding it from view. This can happen by accident, which will cause you to lose view of a panel; simply right-click to reselect it. In our sample figure, there's an asterisk beside Catalog. This indicates that this is the currently selected panel in the Left Panel.

The viewing options are farther down this menu. *Hide All* will remove all panel headers except for the Navigator. Other panels will have all panel headers removed. If you hide all the panels, you'll need to bring at least one panel back via the Windows>Panels menu. Right-click and select *Show All* to bring the rest of the panels back.

The next option is *Solo Mode*. Solo Mode allows you to have only one panel open at at a time. When you click on a panel header, the panel will open, while similtaneously closing the previous panel. This saves a lot of scrolling down the panel, especially in modules with a lot of settings. You can also toggle Solo Mode via a shortcut. Option- or Alt-click on a header to open it in Solo Mode. Repeat to turn off Solo Mode.

The Left Panel of Library with Hide All active

The final pair of options consists of *Expand All* and *Collapse All*. These options open and close all panels. Command- or Control-click on a panel header to apply these as a shortcut.

You can open any panel from the Window>Panels menu. Shortcuts are listed in the menu.

Full Screen Modes

Occasionally it can be useful to see your photo as large as possible. For this, Lightroom provides a number of full screen modes. The main full screen mode, Full Screen Preview, is toggled using the shortcut "F". This overlay covers the controls, but remember that they're still active. For example, the B&W shortcut "V" will turn the full screen preview into a black and white photo.

Full Screen Preview was introduced in Lightroom 5. There are three older Full Screen modes that can be toggled using the shortcut "Shift + F". These are: *Normal, Full Screen with Menubar*, and *Full Screen*. Normal is the default—it shows Lightroom in an application window. Full Screen with Menubar expands to fill the screen, but maintains a visible menu. Full Screen hides the Menubar, which can be accessed by moving the mouse to the top of the screen.

These modes won't hide panels, but an additional option, *Full Screen and Hide Panels,* will. It doesn't hide the Toolbar/Filterbar; this must be done manually.

The Screen Modes menu in Window

Lights Out/Dim Mode

Preferences
Lightroom Preferences are located in the Lightroom menu on Mac, or the Edit menu on PC.

A great feature that works really well with those older screen modes to hide interface clutter is *Lights Dim/Out* mode. Use the shortcut "L" to toggle between the three views, or access the Lights Out menu in Window. Off is the normal

view. Lights Dim darkens everything around the image. By default it darkens everything to 80% of the original brightness. This means that while the interface outside the image is dark, you can still see it clearly enough to make changes to settings. Why is this viewing option useful? Sometimes it's simply easier to work without visual distractions.

Pressing "L" again toggles Lights Out, making the interface black. I use Lights Out to quickly hide clutter when clients are present. That way, their attention is drawn to the photo, not to Lightroom.

The Lights Out screen color and dim level can be set in the Interface tab of Lightroom Preferences. Screen Color can range from black to white, and Dim Level can run from 50% to 90%.

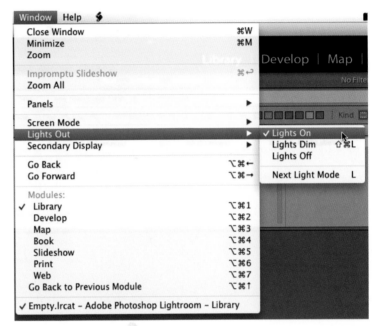

The Lights Out menu in Window

Lights Out active in Grid

The Lights Out Preferences showing available settings

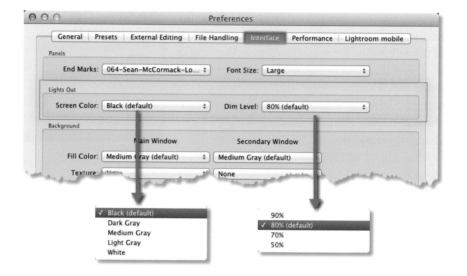

Panel End Marks

This decorative option is turned off by default. It provides the ability to add flourish to the end of the panels in the Left or Right Panel, and custom branding to Lightroom. People complained about these flourishes in earlier Lightroom versions, so they've been removed as a default option; however, they're still useful for branding purposes.

The End Mark dropdown menu

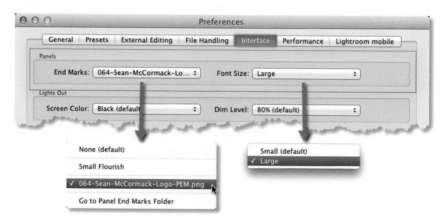

Past versions of Lightroom came with a large selection of flourishes, but currently only *Small Flourish* remains. To add your own Panel End Marker, go to the Interface tab in Lightroom Preferences. From the Panels section, click the

End Mark dropdown, and choose *Go to Panel End Marks Folder*. This opens the Lightroom Presets folder with the Panel End Marks folder selected. Drag the image you want to use as an end mark to this folder. You can use a JPEG, but images with transparency look better in this case. Restart Lightroom to have the image appear in the End Mark dropdown.

Custom Panel End Mark in the Left Panel, now visible in Preferences

Font Size

Font Size is another option in the Panels section. This option allows you to change the size of the font used throughout Lightroom's panels. You can choose between Small (default) and Large. A warning appears at the bottom of Preferences when you change this option, and a restart is required for the setting to take effect.

Background

While the dark gray of Lightroom's interface can't be changed, the background behind the photo can. Look further down the Interface Tab to find the Background section. There are two options: the main window and the secondary window. Both options have an identical dropdown menu: Fill Color. This controls the color of the background and has six options: White, Light Gray, Medium Gray, Dark Gray, Darker Gray, and Black. The default is Medium Gray, which lessens visual distractions. White or Black might unfairly influence your judgment of the brightness of a photo.

Keyword Entry

In the Keyword Entry preference section, you have the choice between using Commas or Spaces to separate keywords. With Commas, you can use spaces as you normally would; with Spaces, keyword phrases using spaces need to be inside quotes, e.g., "Nimmo's Pier".

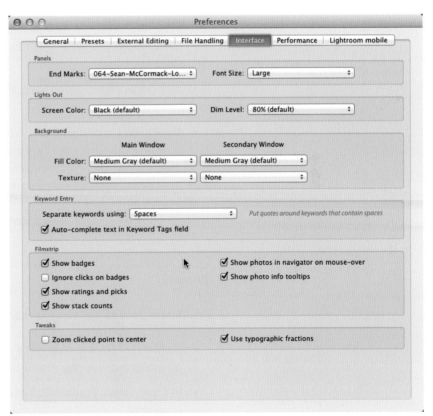

The remaining Interface preferences

Auto-complete text in the Keyword Tags field turns auto-completion on or off. This is where Lightroom remembers keywords that have already been entered and guesses what you're trying to enter as a keyword.

Filmstrip

There are six options in the Filmstrip Interface Preferences. Note that these options also depend on the filmstrip being tall enough to display the items.

- *Show badges*: Badges are the little icons in image cells that indicate the image has been edited, cropped, tagged, has GPS information, or is in a collection.

- *Ignore clicks on badges*: When this feature is turned off, badges are active links that will bring you to related areas of Lightroom when you click on them. When this option is turned on, the badge links are inactive, and clicking on the badges will not reroute you to another area of Lightroom.

- *Show ratings and picks*: This turns on the display of stars and flags under the image.

- *Show stack counts*: This shows the number of images in the stack in the Filmstrip.

- *Show photos in navigator on mouse-over*: With this function set to on, hovering the cursor over a thumbnail will show a larger version of the image in the Navigator window.

- *Show photo info tooltips*: When active, filename, exposure, and lens data will be shown when you hover the cursor on a photo for a few seconds.

Tweaks

The Tweaks section has two checkboxes:

- *Zoom clicked point to center*: The area of the photo you click will automatically move to the center of the screen.

- *Use typographic fractions*: Easy-to-read fractions are used instead of plain text.

Identity Plate

One of my favorite branding features is the Identity Plate. As well as placing your preferred text or logo into the Lightroom interface, it also makes it available for your Slideshows, Prints, and for Web Galleries. It's really easy to set up:

1. Right-click the default Identity Plate on the left side of the Module Picker.

2. Choose Edit Identity Plate (at the bottom of the menu). Alternatively, choose Edit>Identity Plate Setup on PC, or Lightroom>Identity Plate Setup on Mac.

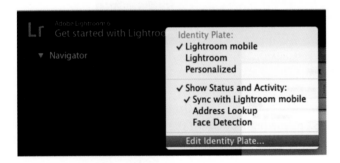

3. There are three sets of options for the Identity Plate: Lightroom mobile, Lightroom, and Personalized. Lightroom/Lightroom mobile only has a Status and Activity checkbox, so choose Personalized (or turn off Status and Activity messages by unchecking the box). The options can also be selected from the Context menu.

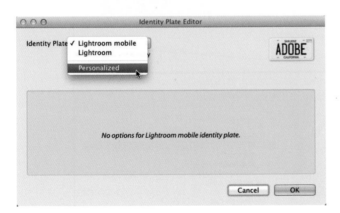

4. Initially, Lightroom creates a text Identity Plate based on your username. You can mix and match fonts, as well as colors. Simply select the text you want to modify, then choose a new font and color from the font dropdown menu and the color swatch. Only the selected text will change, meaning you can mix and match fonts and colors to create a logo.

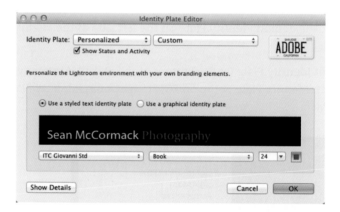

5. You can also use a graphical logo. Originally, this needed to be no more than 57 pixels high, but with the addition of Lightroom mobile

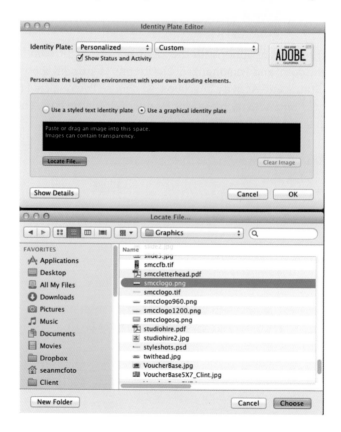

and with the availability of high-resolution display, this 57-pixel rule isn't hard-set. The default header is 41px high for normal screens, 62px for Windows machines in 150% scaling, and 82px for Retina displays. Essentially, that means you should start with those heights and see what works for your machine. The graphical file should use transparency for best effect. PNG files make for the best size/quality ratio. To load this logo, choose Use a Graphical Identity Plate. An advice box will tell you: Paste or drag an image into this space, Images can contain transparency. You can also double-click the text, or click the Locate File button to open the OS file browser. When you locate the file, click Choose to load it.

6. There's no limit to the number of Identity Plates you can make, but you must save them if you want easy access to them. Click the Custom dropdown menu beside the Personalized dropdown menu to

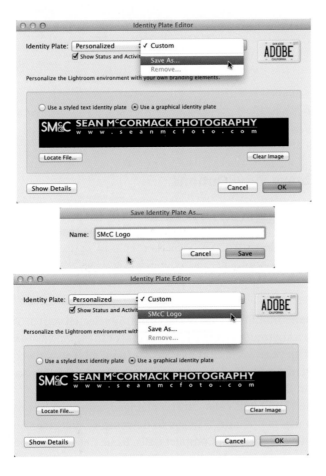

access the Identity Plate list. At the bottom of the menu are the Save As and Remove commands. Initially, the Identity Plate list will be empty; Remove will be grayed out until you create a saved Identity Plate. Choose Save As and then enter a suitable descriptive name in the box and click Save. The Preset menu will update to add the new preset.

7. Click the Show Details button to get options to change the font and color of the module names in the Module Picker.

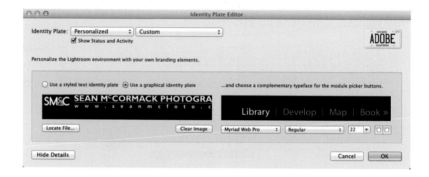

The Identity Plate can be used to create image borders for Slideshow, as well as branding for Web galleries. More on this in those sections.

Lightroom Library View Options

There are five view modes in the Module Picker: Grid, Loupe, Compare, Survey, and People. It's time for more detail!

Grid

Grid view is the main thumbnail view of the currently selected source. Even if you're not usually a shortcut person, the shortcuts for these views are worth knowing to speed up your work. Grid has the shortcut "G". You can access it from the first icon in the Toolbar "T", the small grid icon in the Filmstrip, or by selecting Grid in the View menu of Library.

The size of the thumbnail cells can be changed using the Thumbnail slider, or you can use the "-" and "=" keys to decrease or increase the size. There are also three cell settings: Compact Cells, Basic Cells, and Expanded

Cells. The "J" key toggles between them. Compact shows only the photo thumbnail with no information. Basic adds a small amount of information. Expanded adds file information such as filename, dimensions, file extension, etc. Choose what will be displayed in the View>View Options menu (shortcut: Cmd + J on Mac, Ctrl + J on PC).

Grid View Options

There are two tabs to the Library View Options dialog: Grid view and Loupe view. Here we'll just look at Grid view.

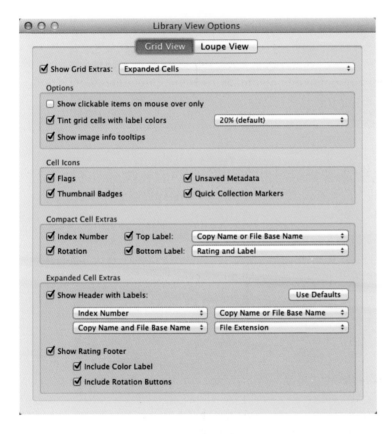

The Grid View options work for both Compact and Expanded Cells. The first checkbox toggles the Grid Extra options. I'd leave this on to get more information in the cells.

Options

The Options section is available no matter what position the Grid Extras toggle is in.

- Show Clickable items on mouseover only: this shows or hides things like image rotation and flags.

Note the flag and rotation arrows are on the right image where the cursor is, but not on the left

- Tint grid cells with label colors: This puts a tint in unselected cells, and a border on selected images that matches the applied label color. It can be tinted from 10-50% in 10% increments, with 20% as the default.

- Show image info tooltips: This shows more information on cell badges when you hover the cursor over them.

Cell Icons

There are four Cell Icon options.

- Flags (1): Shows the flag status (Pick, Unflagged, or Reject).

- Unsaved Metadata (2): Shows the Metadata status, indicating if metadata needs to be saved.

- Thumbnail Badges (3): Shows information relating to Crop, GPS, Tags, Settings, and Collections, along with Stack information.

- Quick Collection Markers (visible on mouseover) (4): Allows adding or removing images from the Quick (or Target) Collection.

All Cell Icons Visible

Compact Cell Extras

There are four Compact Cell Extras options.

- Index Number (1): This large number shows numerical grid position.

- Top Label (2): This information is about the image in the cell. In the dropdown menu to the right, you can see all available command options.

- Rotation (3): This shows the image-rotate arrows at the bottom of the cell.

- Bottom Label (4): This is the information under the image in the cell (it includes the same options as the Top Label).

Expanded Cell Extras

There are four header information sections from the same list options (arrows show related positions). It's almost the same as Compact Cell Extras, but with the addition of Index Number. A Use Default button (1) is available to reset these options. The footer can be added (2), with Ratings, Labels, and Rotation Arrow options. Applying settings with more than one image selected will apply those settings to all images.

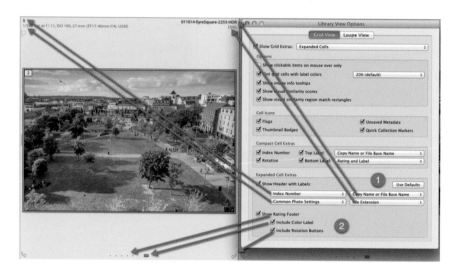

Loupe View

Loupe is the single-image view in Library. It enlarges the selected image (or current image, if several images are selected) to fill the image area. What you see depends on the zoom level in the Navigator window. Loupe view is enabled in a number of ways:

- Use the keyboard shortcut "E".

- From Grid, press the spacebar.

- Select the Loupe icon in the Toolbar.

- From another view, you can temporarily change to Loupe and back via the View menu>Toggle Loupe View command.

In Loupe, information about the image is displayed in a different manner than it is in Grid. Use the shortcut "I" to toggle through the two available Info Overlays (or from the View>Loupe Info menu). As mentioned in the Grid section, there are view options. Again, the shortcut is Cmd + J on Mac or Ctrl + J on PC.

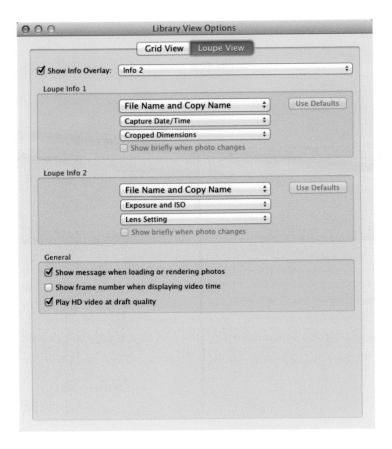

None

✓ File Name and Copy Name

File Name
File Base Name
File Extension
Copy Name
Folder

Copy Name or File Name
Copy Name or File Base Name
Copy Name and File Name
File Base Name and Copy Name
Copy Name and File Base Name

Common Attributes

Capture Date/Time
Cropped Dimensions
Megapixels

Caption
Copyright
Title
Sublocation
Creator

Common Photo Settings
Exposure and ISO
Exposure
Lens Setting

ISO Speed Rating
Focal Length
Exposure Time
F–Stop

Exposure Bias
Exposure Program
Metering Mode

Camera
Camera Model
Camera Serial Number

The two Info Overlays have three sets of information available from a drop-down menu with the options shown to the left.

Note that in Loupe mode, settings only apply to the current photo, even if other photos are selected in Library Grid mode.

Compare View

Compare is a two-image view. As with the other views, there are several ways to activate it.

- Use the keyboard shortcut "C".

- From the View menu, choose Compare.

- Select the Compare icon in the Toolbar.

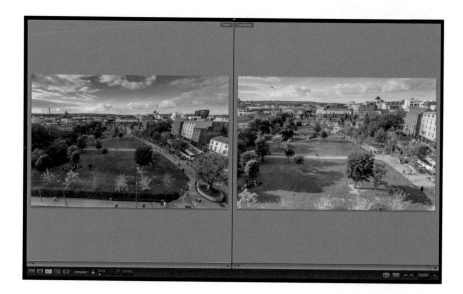

Once active, Compare view presents two photos, either two you've selected already, or the currently selected photo and the next one in order. The left-hand image is the Select, while the right-hand image is the Candidate. Use the left and right arrows to change the Candidate to the previous or next available image.

To check detail, zoom in on the photo using the standard zoom options in the Navigator, or use the Zoom slider in the Toolbar. To lock both photos to a zoom level, click the Link Focus lock icon in the Toolbar. Dragging around one image will also drag the other. To match the zoom position in the images, click the Sync button. This will force the Select to match the Candidate.

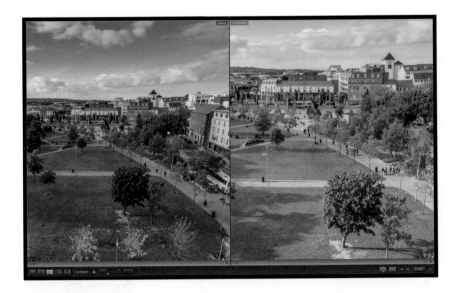

The aim is to check the two photos and choose the better one. If the Select is the better one, use the arrows to move to the next image. If the Candiate is better, you have two options: Swap or Make Select. These are the "X" and "Y" icons in the Toolbar. Swap will switch the positions of the Select and the Candidate. Make Select will change the Candidate into the Select and then go to the next available image. Alternatively, you can click the X at the bottom right of the Compare cells. Clicking on the X for the Select performs a Make Select operation. Clicking on the X for the Candidate navigates to the next available image.

When you've gone through the set of similar images, the Select is now the best image. It can be rated, flagged, or labeled to make it easy to find later. This can be done either via the options at the bottom of the cell, or via the shortcut discussed in the Choosing your best photos section. Click Done to exit to the Select showing in Loupe view.

Survey View

Survey is Lightroom's multi image view. The shortcut is "N", which is a little obscure—it's mathematician speak for a random number. A series of numbers is described as being from 1 to *n*—hence, Survey is referred to by the Lightroom engineers as the *n*-up view. You can also select Survey view from the View menu, or from the Toolbar in Library.

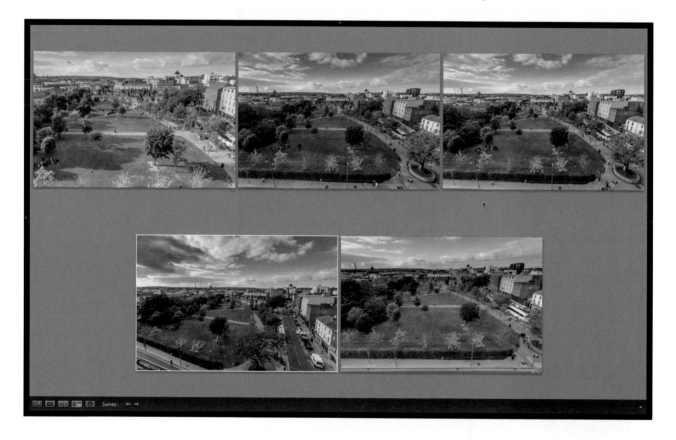

Survey displays the selection of images made previously in Grid, or via the Filmstrip. In Survey, the current image has a white border to help it stand out. Applying settings here will only apply to that image, unlike applying settings in Grid. As you hover the cursor over any photo in Grid, the ratings, flags, and labels become clickable for that photo. An X also appears in the bottom right of the photo. Clicking this X deselects the image in the Filmstrip and removes it from the main window.

Survey provides the heart of one of my selection methods; I'll cover it in detail in the Choosing your best photos section.

People View

People view is new to Lightroom 6. This is where you make use of the new Face Recognition engine. The engine is designed to be replaceable as better engines are designed, meaning Face Recognition will be improved in future Lightroom updates.

People view can be entered through the View>People menu, via the short-cut "O", or by clicking the face icon in the Toolbar. At first, you'll see the info box shown below, announcing that you need to index your photos to detect all the faces in them. This is a background process that will take a long time if you have a large catalog, and it will impact Lightroom performance.

Hovering the cursor over Start Finding Faces in Entire Catalog prompts a flyout dialog that alerts the user that Lightroom will begin background processing, making it faster to find people later. Alternatively, you can select Only Find Faces As-Needed, which won't index your files. This requires you to manually index a folder or collection when you want Face Recognition.

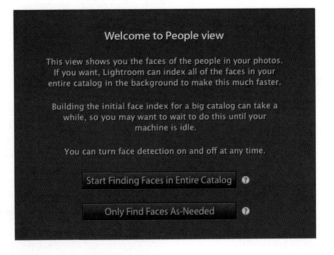

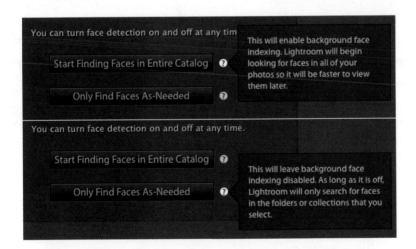

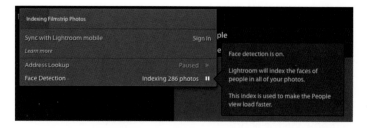

Clicking Start.. will trigger a flyout dialog and a little animation that goes to the Identity Plate menu and shows the process starting. I've watched this animation a few times, and the dialog doesn't stay long enough to be readable. Fortunately, it's just a matter of manually clicking on the Face Detection item in the Identity Plate menu.

This process can be paused from the dialog, and appears as a setting in the Metadata panel of Catalog Settings.

Once indexed, People view splits images into two categories: Named People and Unnamed People. The photos displayed here depend on where you are in Library. If you're in All Photographs in the Catalog Panel, you'll see all indexed photos here. If you're in a folder or collection, you'll see only photos located in that folder or collection.

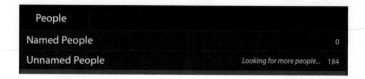

It might seem counter intuitive, but the next step is to go to Loupe view, where there will be a new icon in the Toolbar: 1 unnamed person (or unnamed people). Click on this icon to show the face regions that have been detected. Since this is the first name that is being entered for this face, Lightroom shows a "?" above the face region. Click on the "?" and enter the corresponding name.

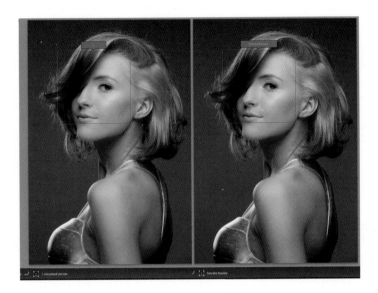

Going back to People view will now show the named faces in the Named People section, and the remaining faces in the Unnamed People section.

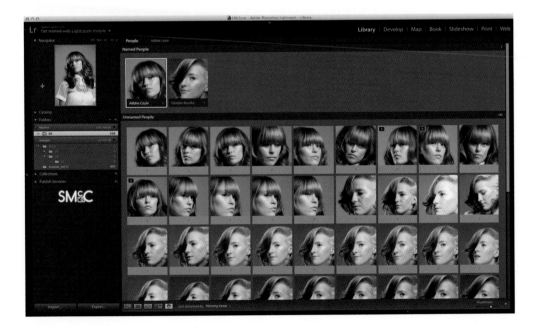

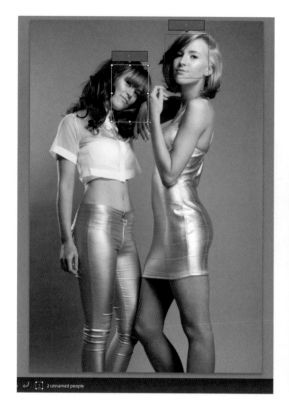

Lightroom will not get all the faces. It tends to miss faces at odd angles, and obviously it won't recognize the back of a person's head as a face. You can manually draw faces in these cases. Notice that in Loupe view the cursor is a crosshair; just click and draw it across a face to create a face region.

Once you've entered some names, Lightroom will start to suggest names based on the information already entered.

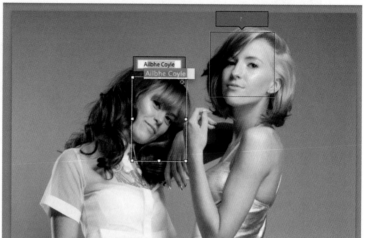

Back in People view, the Unnamed People will also have suggested names on them. Faces that Lightroom thinks are the same get put into stacks, and clicking the check that appears as you hover the cursor over the stack will apply that name to the entire stack. Clicking the cancel icon will tell Lightroom that it's not correct.

To speed things along, you can select a series of photos that have the same face and apply a name to one of them—this will apply to the entire sequence.

To check that all the faces are labeled correctly, double-click the face stack in Named People to bring up all the confirmed photos of a particular person. Change the name of any incorrectly labeled faces.

Lightroom will sometimes think it sees a face where none exists, which is why sometimes images of fabric or trees will be labeled as a face. Lightroom can also label faces with incorrect names. These problems will be less frequent as the underlying face recognition engine improves.

External Editing

While Lightroom is a versatile and functional program, there are things that it won't do. Fortunately, Lightroom allows external editors to integrate within its workflow. Images sent to photo-editing programs come back into Lightroom automatically when saved.

As a parametric editor (meaning one that records and applies settings to a preview), Lightroom doesn't edit pixels. It can remap using Lens Corrections, and fix blemishes and dust via Spot Removal, or even dodge and burn using the Adjustment Brush, but if you need to slim someone, flip color channels, or swap heads, you need an external editor. Because it is an Adobe product, Lightroom has special integration with Photoshop. In addition, there is an extensive collection of third-party editors that integrate with Lightroom, many of which have been covered in my Maximum Workflow articles for *Photoshop User* magazine. Examples include onOne Software's Perfect Photo Suite and MacPhun's Tonality Pro.

Control of the integration for Photoshop, and of Application Presets for third-party software, is done in the External Editing tab in Preferences.

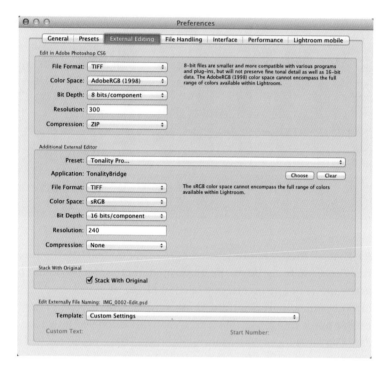

Photoshop

There are four sections in the External Editing preferences. The top section is for the currently installed version of Photoshop. As you can see, I have Photoshop CS6 (I have Creative Cloud on two other machines, so am using the perpetual version of CS6 on the machine you see in the screenshot). Lightroom automatically detects this version, and will update it when you update Photoshop.

The Photoshop options (invoked via the Edit in.. menu in the Photo menu) are based on files created by Photoshop. The first option is for file type, of which there are two options: TIFF and PSD. Both are layered files, but PSD is a file proprietary to Adobe, whereas TIFF is an open standard file format. This means TIFF is readable by more applications and is therefore the recommended option. Some third-party applications, like the Perfect Photo Suite, also create and use PSD files.

The second option is Color Space, which I'll cover in more detail in the Color Management section. The largest Color Space is ProPhoto RGB. sRGB covers the smallest range of colors. This doesn't necessarily make ProPhoto RGB the best, nor sRGB the worst. If you want the highest quality, set this option to ProPhoto RGB and convert the files to a more readily usable space like Adobe RGB or sRGB later on.

The third option is Bit Depth. This option decides the number of bits used to describe each color. 16 bit gives a larger range and is better for preserving graduation in a photo. It also prevent artifacts in the photo when doing extensive editing. Again, you can always export a copy of the final photo in 8 bit when all editing is complete. Note that not all Photoshop filters work with 16-bits files.

The fourth option, Resolution, maps the pixels to a physical dimension. By default, this is 300 pixels per inch (ppi), meaning that Photoshop will display 300 pixels in one inch of screen when viewed at 100%. The file size is dependent on the absolute pixel dimensions, not the Resolution, so a 72ppi file will still be the same size as a 300ppi file as long as the dimensions remain fixed. 300ppi is a good starting point, nevertheless. There's no point in arguing these semantics with a designer or printer, though. If they want 300ppi then set this option to 300ppi and forget about it!

The fifth option, Compression, reduces the space a file takes on disk. There are many types of compression, and they usually work by comparing a pixel with the surrounding pixels. For example, instead of reading a row of black pixels as "black, black, black, black," it might read it as "four blacks," thus taking less space to describe a file. LZW (Lempel–Ziv–Welch) is an older compression method. ZIP is more regularly used, and hence is the recommended option if you want to use compression. This compression is lossless so even though the file is smaller, no information has been thrown away in the process.

If you want the highest quality file to work with in Photoshop, use a16-bit ProPhoto RGB TIFF at 300ppi. An sRGB 8-bit TIFF will suffice for an image (with basic edits) that will be used on the web.

To open a file in Photoshop, go to the Photo menu. From the Edit in.. command, choose Open in Photoshop or one of the other Photoshop-related commands. You can also use the shortcut Command + E (Mac) or Control + E (PC).

Sometimes Lightroom can get out of step, in which case you need to reinstall Photoshop, then reinstall Lightroom. You can also edit the registry in Windows if the problem persists. For information, go to this Adobe Help page:
http://helpx.adobe.com/x-productkb/multi/edit-photoshop-command-missing-photoshop.html

Additional External Editor

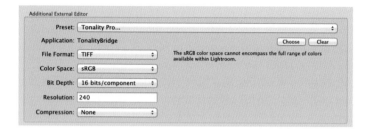

The next section covers other external editors besides Photoshop. The settings are similar to those in Photoshop, with the addition of JPEG. JPEG (or jpg) is the most common photo file format and provides great quality in a smaller files size than the TIFF format. It uses lossly compression though, so some file information is lost when JPEGS are created. These files also lose quality each time you save them. However, some external editors only read the JPEG file format.

To choose a new external editor for immediate use:

1. Go to the Application option, and press Choose.

2. Navigate to the editor's location (generally in Program Files or Applications).

3. Click Choose or press Return.

4. To remove the currently selected Application, press Clear.

5. To create a Preset that can be accessed from the Edit in.. Menu, open the Preset dropdown.

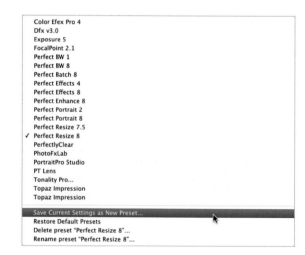

6. At the bottom of the menu, choose Save Current Settings as New Preset.

7. To activate any other preset, select it in this menu.

8. Additionally, you can Rename, Delete, or Restore Presets from here.

To open a file in the additional external editor, go to the Photo menu. From the Edit in.. command, choose either Open in Application or one of the Presets in the list. You can also use the shortcut for the currently selected editor: Command + Option + E (Mac) or Control + Alt + E (PC).

For the correct settings, please check the external editor's documentation for compatible file types. Newer editors will generally create their own Presets when they are installed.

> **Elemental**
>
> Elemental by Matt Dawson is a Lightroom plugin that gives Photoshop Elements the extra commands that Photoshop offers, such as Open as Smart Object, Merge to Panorama, Open as Layers, and the additional Remove Lens Distortion. It's available from: http://thephotogeek.com/lightroom/elemental

Stack With Original

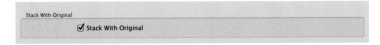

This option has one checkbox: Stack With Original. This forces the saved file to the top of a stack when it returns from the external editor. Stacking will be discussed later.

Edit External File Name

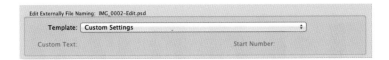

When a file returns from the external editor, you can add a suffix to differentiate it from the original file name. From the Template dropdown, you can create any file naming format for the edited file. Creating these Templates will be discussed shortly.

Selecting Files

Clicking a file will make it the active or selected file. Often you need to work on many files together, so it's important to know how to select them in a group, especially if they're scattered throughout the Grid or the Filmstrip.

To select multiple continuous images in Grid or Filmstrip, click the first photo you want selected, then Shift click the last one to include all photos in between. Note that the selected photos become highlighted. The first selected photo will be an even lighter shade to show that it's the active photo. If you selected too many or too few photos, holding down Shift again and clicking another photo will increase or decrease the selection.

You can change which photo is active in the selection by using the arrow keys, or by clicking on another photo in the selection. Be warned: you must click on the photo rather than the gray border. Clicking the border will force the selection from the multiple photos you chose to just that single photo.

Command + click (Mac) or Control + click (PC) on any photo to add it to the selection, or to remove a previously selected photo. Note that using the Shift key for a row of photos can only be done at the start of a selection. If you Command or Control click and then use Shift-click, the photo you last clicked will become the first photo in a new row selection, clearing the previous selection(s).

With many photos selected, using Shift + Command + D (Mac) or Shift + Control + D (PC) will reduce the selection down to the active photo. You can also click the gray border on that image to make it the active photo.

Clicking on any other photo will wipe the current selection and make that photo the active photo.

Command + A (Mac) or Control + A (PC) will select all images.

Command + D (Mac) or Control + D (PC) will deselect all images.

If you have multiple photos selected, the "/" key will deselect the active photo and make the next photo in the selection active instead. This can be useful to break a long selection into two while removing photos that are no longer required.

Managing Color in Lightroom

With so many different devices in our workflow, from cameras to printers, it's essential to keep the colors looking consistent no matter what device we use to view images. It's important to match what we print to what we see onscreen. The whole process is called Color Management, and it is an area that often inspires fear in the photographer. Lightroom takes the pain out of this process and manages it under the hood. There are still things that you need to do to have it work. It's critical to calibrate your screen and use correct profiles for the paper and inks you use in your printer.

Screens

How does Color Management work? It begins in the camera. By making the choice to shoot RAW, the camera creates a file that contains all the information captured by the sensor. This information can be interpreted many ways, and it's something that Lightroom works with natively. As you view the RAW file in Lightroom, you're looking at it through Lightroom's Working Space. This Working Space describes the range of color and tone that Lightroom can reproduce, called the color gamut. There are many common color spaces, including ProPhoto RGB, Adobe RGB 1998, and sRGB, which define particular ranges of color. The Lightroom Working Space is based on ProPhotoRGB, but with minor changes. It's affectionately known as "Melissa RGB." If you

want to know more about the origin of Lightroom's Working Space, you can check out one of the original Lightroom podcasts created during the development of Lightroom: https://itunes.apple.com/ie/podcast/podcast-8-tim-mark-hamburg/id116073210?i=8141122&mt=2.

Every computer monitor varies in the colors it can display, and even identical monitors from the same batch will have differences. What's visible onscreen depends on the monitor's color profile. Even if you've never made a profile, your computer will still have a default profile set as part of your operating system, or a profile provided by the screen manufacturer. Obviously it's generic, so it doesn't account for any variance in your screen. This is why it's necessary to calibrate your monitor.

Lightroom automatically maps the internal color of the image to your screen's color via this monitor profile. The better your monitor, the more colors it can display, and the more accurate it will be. It doesn't make sense to buy the best camera in the world and then edit your images on a poor-quality screen—as a photographer, you need to invest in a good monitor. Even good screens need calibration to get the most accurate view of your photo.

When you're done with your work in Lightroom, you can specify how you want your images to be displayed. The options Export, Publish, Print to JPEG, and Web all make you select a color space (or they choose it for you). The main three spaces mentioned already (ProPhoto RGB, Adobe RGB 1998, and sRGB) are the main options (Web uses sRGB only), but Lightroom will allow custom profiles to be attached to files.

As a general rule, ProPhoto RGB is an editing space. It encompasses most visible colors, and keeps your color intact as you edit. Adobe RGB 1998 holds less color, but is very popular for magazine work because it has more color than sRGB. High-end monitors can reproduce the entire gamut of Adobe RGB, meaning what you see onscreen is identical to the color in an Adobe RGB file. sRGB is a reduced color space and was created to match the color of the average computer screen. It's the same color gamut you see on the internet. Not all internet browsers are color managed, so using sRGB gives your photo the best chance of looking like it does on your screen once it's been uploaded to the web.

Printer

As well as digital output, you also need some way to make your prints look the way the images looked on your screen. Lightroom maps to the printer's colors using printer profiles. Like with monitors, you can make your own profiles; however, print and paper manufacturers provide very accurate profiles,

Color Space
A defined subset of all visible colors, usually created artificially.

which makes it much easier to get accurate prints. Lightroom does have dedicated panels to work with these profiles. We'll cover this in the section about the Print Module.

Calibrating your Monitor

Historically, monitor calibration was carried out by visual inspection. Photoshop shipped with Adobe Gamma, but this was phased out as screen calibrators became more affordable. You can still do visual inspection on both Mac and PC; while they can't beat a hardware calibrator, some management is better than none.

Apple has a software calibrator built into the Displays control in System Preferences. Click on Color, then Calibrate... Turn on Expert mode and follow the instructions.

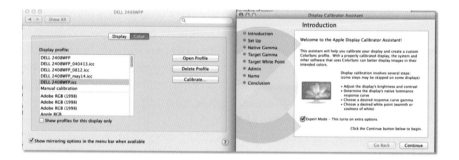

Visual calibration is no match for a hardware tool. Your ambient light, viewing angle, and even your alertness all factor in your results. Using a hardware calibrator is ultimately the best option for repeatable color. There are many on the market, such as the Color Munki, Spyder 4, and i1 Display Pro. For Windows, there is Quick Gamma, a German product. I've seen some videos on it, but haven't used it. You can check it out here: http://www.quickgamma.de/indexen.html

In the past, I used Monitor Calibrator Wizard (http://www.hex2bit.com/products/product_mcw.asp), but development on this product seems to have stalled, and I can't vouch for whether or not it will work with current Windows versions.

For explanation purposes, I'm using the X-Rite i1 Disply Pro, simply because I've found it reliable. I'm not specifically endorsing the product, just using it to show the calibration process. In previous books I've used Spyder as an example.

Using a Hardware Calibrator

The i1 Display Pro connects to an available USB port and is hung over the top of the screen. A weight is attached to the cable to provide a counterbalance, preventing it from moving during the calibration process. Let the monitor warm up for a bit before beginning—the color can vary in the moments just after starting up.

1. Install the software and do any updates necessary to get to the most current version of the software. Older versions often break when the operating system updates, so it is a necessary evil. With the calibrator plugged in, start the software. The calibrator acts as a dongle to make the software work.

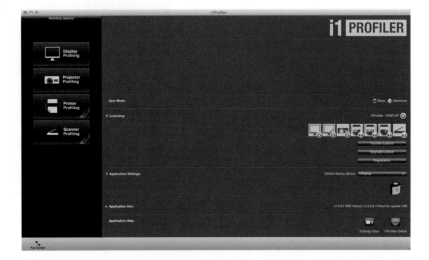

2. Click Display Settings to begin. Here you set the attributes for the display. Normal settings are D65 for white point and 120cd/m^2—though a lower brightness can be used, e.g., 100cd/m^2. 120cd/m^2 is probably the brightest setting you can use and still match prints accurately. Cd/m^2 is a measure of brightness level. D65 refers to 6500k color temperature. You can also use D50 (5000k), but it looks quite blue on most screens, which is why D65 is generally preferred. You can choose to monitor the ambient light levels, but mine don't change much, so I prefer not to use this feature. It also means I can store the calibrator device safely between uses. Click Next.

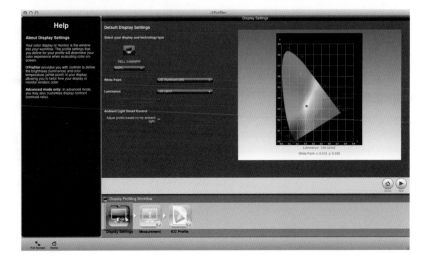

3. Click ADC to have the software automatically set up the display to a base level for measurement. The color tiles on the right show the colors that your screen will display during the measurement cycle. Click Start Measurement to begin.

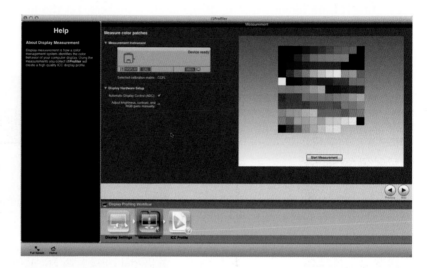

4. Place the device over the center of the screen. Let the software know what controls are provided in your on-screen display menu (OSD). Click the right arrow to proceed.

5. Use the Quality Indicator to set the correct brightness level via your OSD. You may need to refer to the manual that came with the screen. Click the right arrow to proceed.

6. The software will flash the colors on the screen from the Start Measurement page. This takes a few minutes, so be patient. Once this process finishes, click the Create Profile button to create and save the new profile. You can overwrite the old profile, or rename it to keep it.

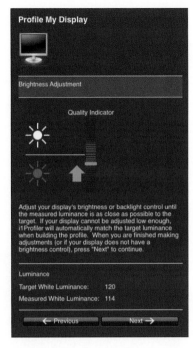

That's it. You're done. Welcome to better color! You can choose to set a reminder to do this at intervals. I wouldn't leave it longer than four weeks, since monitors do change as time passes.

Importing to Your Catalog

In Chapter 1, we mentioned that Lightroom is a database-driven application. The beauty of databases is that as the files are referenced, they can still be edited, even when offline. Previous version of Lightroom allowed all the metadata to be edited offline; but Smart Previews were added to Lightroom 5, which means you can now change Develop settings with the files offline. However, before this can happen, the files need to be ingested into the catalog via Import. Let's talk a little bit about catalogs and then delve into Import.

Catalog Basics

The Catalog stores all the information Lightroom reads from a file during Import. This includes all the camera information (referred to as the EXIF data), as well as user-added data like copyright and keywords (the IPTC metadata), and the edits made to photos.

> **IPTC & EXIF**
>
> International Press Telecommunications Council (IPTC) formulates a long list of information that can be added to a photo. Things like copyright owner, contact details, title, caption, location, rating, and license terms can be included in the IPTC information. The original list was called the IPTC Core, but in 2008, a second list with more information, dubbed IPTC Extension, was developed.
>
> Exchangeable image file format (EXIF) is the international standard for including information about a photo when it is taken. It includes things like date and time of capture, camera settings, a thumbnail of the image, and copyright information if included in the camera by the user.

Creating a New Catalog

When you open Lightroom, it creates a default catalog called Lightroom 6 Catalog.lrcat. You can make as many catalogs as you like, though it's best to use one main catalog to make searching for files easier. Sometimes, though, you might need to create a smaller catalog—to use on a laptop, for example.

Hold down the Option key on Mac, or the Control key on PC, when starting Lightroom. The Lightroom Catalog Dialog will appear.

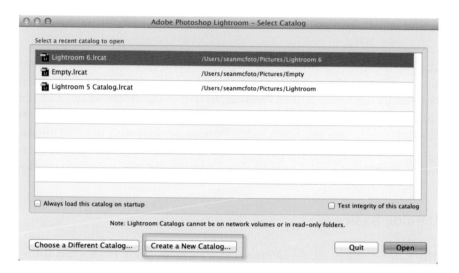

Press the Create a New Catalog... button at the bottom of the dialog. Choose a name for this catalog. Lightroom will create a folder of the same name and place the catalog and the corresponding preview files within it. Catalogs have a .lrcat extension, while the previews have a .lrdata extension. The names also match; i.e., Lightroom 6 Catalog.lrcat has a corresponding Lightroom 6 Previews.lrdata file.

With Lightroom already open, another way to make a new Catalog is to go to the File menu and choose New Catalog.

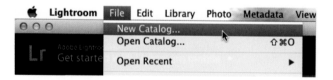

Open Other Catalogs

When Lightroom creates a new catalog, it closes down the current one. To get back to the previous catalog, or any other catalog, there are a few options.

1. In the Mac Finder or Windows Explorer, navigate to the catalog location and double-click the file to open it. Note that if the catalog is from a previous version of Lightroom, it will be updated.

2. In the File menu, choose Open Catalog. This opens the file browser. Navigate to the catalog, select it, and press Open.

3. Use the shortcut Shift + Command + O on Mac, or Shift + Control + O on PC to open the file browser as for #2.

4. An additional method is to use the File>Open Recent command to see a list of recently opened catalogs. Choose your preferred catalog from there.

5. With Lightroom closed, hold down the Option key on Mac, or the Control key on PC, when starting Lightroom. The Lightroom Catalog Dialog will appear. From there, choose a catalog. If the catalog is not in the list, use the Choose a Different Catalog... button to open a file browser window and find the one you want.

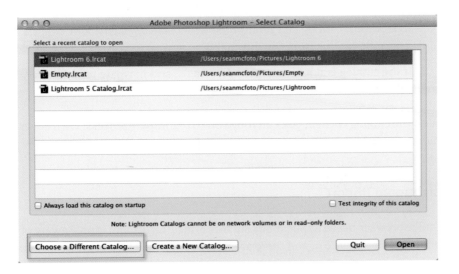

Set Default

By default, Lightroom loads the most recent catalog. You can change this behavior with the following steps:

1. Open Lightroom Preferences (Mac-Lightroom menu, PC-Edit menu), and click on the General tab.

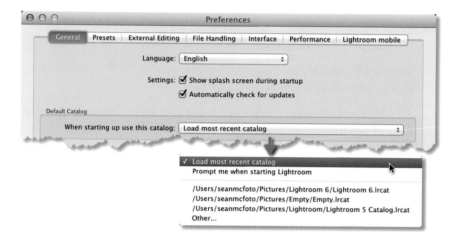

2. The 2nd section is Default Catalog. From here, choose between Load most recent catalog and Prompt me when starting Lightroom. Or, pick a specific catalog from the list.

3. If the catalog is not visible, choose Other… and navigate to it. Click the Choose button.

With the catalog chosen, you can move on to the Import process. We'll cover more advanced Catalog use later on.

Lightroom Import

Unlike browser-based applications such as Bridge, Lightroom is only aware of photos you bring into it, and there are many ways to get files into Lightroom.

Import Photos from Card

To trigger Import, do one of the following:

1. In Library, go to the Left Panel. At the bottom, press Import… to open the Import Dialog.

2. From the File menu, choose Import Photos and Video…

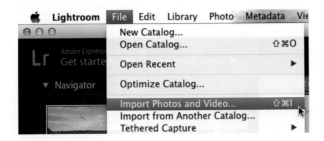

3. Use the shortcut Shift + Command + I on Mac, or Shift + Control + I on PC.

4. Insert a memory card (either via camera or via card reader). By default, Lightroom will open the Import dialog when it detects a card. You can change this in the Lightroom Preferences>General tab.

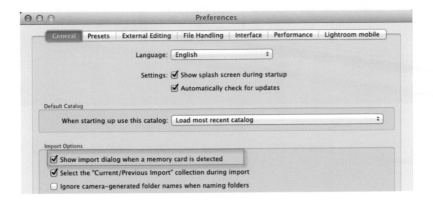

The Import Dialog

Lightroom has slightly different options for Import from a memory card and from a disk, so we'll look at an import from each. We'll start by inserting a memory card.

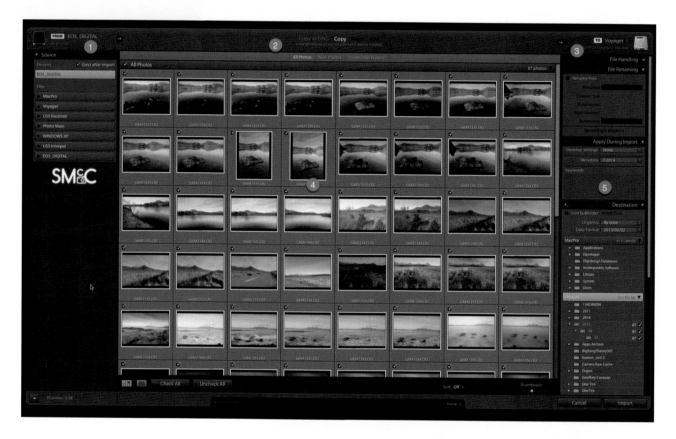

The Import Dialog opens, resembling a Module, albeit as a floating dialog. Five of the main areas are highlighted:

1. On the top left of the dialog are the Sources, both as the left panel, and the icon. Clicking the icon will open the Recent list, as well as some standard folders for pictures and movies.

2. The arrow next to the Source points to where we choose the type of Import. A memory card only has access to the first two options: Copy as DNG and Copy. The other types are Move and Add. We will discuss these options shortly.

3. This is the Destination for the files. New users are often confused about what Lightroom has done with their photos, so pay attention to what's happening here. Like Sources, you can choose a location by clicking on the drive icon located at the top right of the dialog.

4. The Grid View is the section where you choose what photos will be imported. You don't have to import everything here, so dud shots, such as when the lights didn't fire in the studio, can be ignored.

5. The right panel is where you rename files, back them up, add keywords, develop settings and metadata as you import, and create the folder hierarchy.

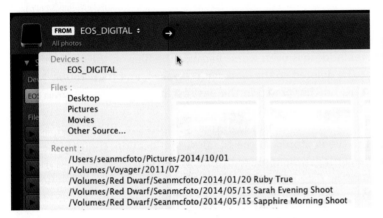 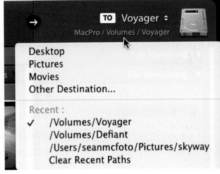

Sources can be Devices—memory cards or Files. You can only choose one Device at a time at Import.

Overcoming the Device Limit

While you can't select more than one device at a time, devices also appear in the Files section. From there you can select files from more than one card to import. Click each card icon to show the internal folders. With Include Subfolders turned on, just Command or Control + click the DCIM folder on each card you want to ingest in order to import them all together. Note that the Move and Add options are still not available, even in Files mode.

With our Source selected, let's look at the Import types:

- Copy as DNG: This copies the file from the card. After import completes, it converts the file to a DNG. The DNG is added to the catalog. In Lightroom 6, the DNG conversion is a background process.

- Copy: This creates a copy of the original file and adds it to the catalog.

- Move: This copies the file to the new destination and deletes the original, then adds the moved file to the catalog.

- Add: This leaves the file where it is, but also adds it to the catalog. Best used if the photos are already organized on the disk.

As mentioned previously, Move and Add are not available to memory cards. The reasoning is simple: any issue during Move could potentially delete your images forever. Adding is even worse because the files on the card are most likely going to be deleted so the card can be reused, and then you've lost all the photos. This has happened in the past because of confusion over what Lightroom does during import. Lightroom only ever references your files. The actual image data is not in Lightroom; it's on the disk. Only information about the file is stored in the Catalog: the location, the camera data, and whatever settings you apply to the file. When you use Add, Lightroom is merely reading the files from wherever they currently are on disk, and adding their information to the catalog. It's like telling Lightroom, "those files are here, and this is all you need to know about them."

Wiping the Card After Import

A big request from users is that Lightroom allow you to wipe the card after Import. One big aim of Lightroom is to protect users from accidental stupidity. Lightroom won't allow this action in case something goes wrong. It's far better to delete images or format your card in-camera, because the camera will do a better job than the OS. Mac OS tends to leave hidden files that relate to window positions on cards.

Pick and Reject

The central area is where we choose the photos to import. Initially we're presented with a Grid view, but there's also a Loupe view. The shortcuts you already know from Library views apply here too—you have learned these, I

hope! If you haven't, it's E for Loupe and G to go back to Grid. You can also use the Grid and Loupe icons in the toolbar under the photo(s). In Loupe view you can also zoom in to check for sharpness, etc.

One important thing to note is that what you are viewing is the embedded JPEG that's in the file. Obviously for JPEG, what you see is what you get, but for RAW files, you're viewing what the camera created as a preview for the back of the camera. This is important for a few reasons. One is that the file isn't color managed at this point, so the color you see isn't accurate—more on this when we discuss Profiles. The second reason is that the level of zoom depends on what size the camera maker has chosen for the preview. With Canon and Nikon, you generally get 100% of the original file as a JPEG, but brands like Fuji and Olympus provide much smaller previews.

I shoot video as well as stills. I shoot stills more frequently, and for this reason I tend to use a neutral Photo Style on camera. The files are quite flat-looking. You may prefer to use a more vivid look. The previews in Import show whichever look you've chosen in-camera. I go with the flat look because I know I'm going to process the files later. Moving through these photos is far quicker than doing it after Import, since Lightroom reverts to color-managed previews.

Speedy Import Selections

If you look under the photo in Loupe view, you'll notice the Include on Import checkbox. There are speedy ways to make selections here—perfect if you're looking for news or sports images quickly. Rather than using the checkbox, use shortcuts instead. Here's the workflow for the speedy selection of a handful of photos:

1. In the Import Grid, click the Uncheck All button in the toolbar under the thumbnails; no images will Import at this stage.

2. Go to Import Loupe (L).

3. Either engage the Caps Lock, or hold the Shift key to trigger Auto Advance mode. This applies your selection or rejection shortcut and moves to the next photo.

4. Either press "P" to pick an image, i.e., mark it to be included on Import, or press "X" to reject an image. Using the trick from #3, this will jump the selection to the next photo.

5. Repeat until you've found the best photos to Import.

WARNING! This process will only import these selected photos. The other photos on the card will not be imported, yet. What I would do here is import these selects, mark them with a star rating, color label, or flag, then run Import again and bring in the rest.

Back in the Grid there are visual clues as to what's happening. To aide demonstration, I've imported a few photos to show what happens when files are already in Lightroom. Notice that the first five photos are dimmed and have no checkbox available. Picked photos look normal, whereas Rejected photos are dimmed. To get a better view of the thumbnails, use the sliders in the toolbar. Unfortunately this doesn't have a shortcut like in Library.

The Import Toolbar

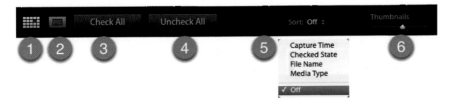

For clarity, the Import Toolbar in Grid contains the following tools:

1. Grid View: A thumbnail view of photos to Import

2. Loupe View: A single photo view

3. Check All: Selects all photos to Import

4. Uncheck All: Removes all photos from Import

5. Sort: Sorts by Capture Time, Checked State (pick or reject), File Name, Media Type (photo or video), or Off

6. Thumbnails: Changes the size of the thumbnails in Grid View

Loupe View has slightly different options. The Grid and Loupe View icons remain. The remaining options are an Include on Import checkbox and a Zoom slider. The Include on Import checkbox can be changed using the P and X keys as mentioned above. Zoom can go from Fit view (fit inside the central window) to 11:1 view (magnified to 1100%).

Above the main window in Grid is a filter bar offering three options: All Photos, New Photos, and Destination Folders. Destination Folders is not available when using Add.

All Photos shows everything; i.e., the current view in our figure. New Photos hides Suspected Duplicates. This is useful if you've a few shoots on a card and are importing each shoot one at a time. Each shoot that gets imported is hidden for the next import. This is useful if each shoot needs a different folder or different keywords. Destination Folders previews what folders the photos will go into. If you're using a dated Import, it will show the date folders and the photos that would be in

them. If you have a lot of folders, it will show pages of them—as per my example showing pages of dated iPhone photos. With all three options, the number of photos is shown on the right-hand side of the panel. Note that at the bottom left of the panel, you also see the total number of photos to Import, and their total size.

Final Destination

With the photos selected, it's time to decide where to put them and what to do with them as we Import.

File Handling

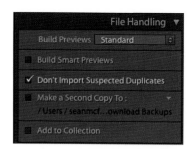

File Handling controls preview creation, backup, duplicates, and adding to a Collection.

- Build Previews: Lightroom depends on previews for viewing photos in non Develop modules like Library. Options are Minimal, Sidecar & Embedded, Standard, and 1:1. Minimal sets a thumbnail-size preview. Sidecar & Embedded use the internal camera-generated preview. Standard sets the screen-size preview (set in the Catalog Settings). 1:1 gives a 100% view of the file, perfect for zooming in to check focus.

- Build Smart Previews: Smart Previews are a smaller version of a file that can be used in Develop when the original file is offline.

- Don't Import Suspected Duplicates: This lets Lightroom compare photo date, name, and size to guess if a file may already be in the catalog. If turned off, you will import files Lightroom thinks are already there.

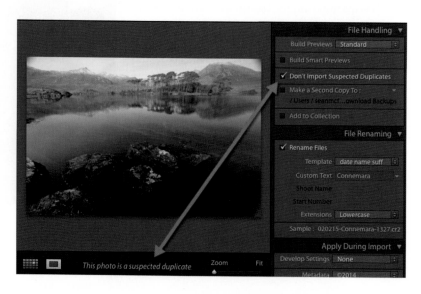

- Make a Second Copy to: As the photos get imported, this function creates a backup copy of the image to another folder wherever you choose. When active, clicking on the location will open a file browser to change it. After import, a dated folder will be in the location with the files matching the imported filenames.

- Add to Collection: Turning this option on adds the + icon, which allows you to create a new Collection. Alternatively it allows use of the Quick Collection. This feature is new in Lightroom 6.

Both Previews and Smart Previews will be covered in detail later.

File Renaming

This panel allows you to use File Naming templates to rename your files on Import.

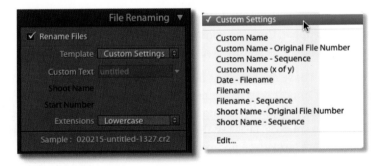

Check Rename Files to apply the template. From Template, pick one of the default template options. If you want to create your own, click Edit, and follow the instructions in the File Naming section.

If you've used either Custom Text or Shoot Name, fill in the text here—if you forget, Lightroom will use "untitled" instead. You can rename it later, so don't panic if this happens. If you've a sequence as part of the template, add the start number. This is 1 by default, but if you change it, Import will use your change as the starting number until you change it again. Finally, decide if the file extension should be uppercase or lowercase (i.e., .CR2 vs .cr2).

The setting is sticky, meaning Lightroom remembers it for the next Import session.

Apply During Import

These are items that get added to the file metadata in Import.

- Develop Settings: This option allows you to choose a Preset from Develop, which changes how the photo looks immediately on ingest. It can be any preset—the default Lightroom set, a user created set, or even a set bought or downloaded from the internet. The Preset is sticky, meaning Lightroom remembers it for the next Import session. Use with caution. Even recently I've had five or six imports processed by accident because I forgot to turn the Preset off.

- Metadata: These presets allow you to add information to the photo such as copyright, captions, and other IPTC metadata. Choose an option from the dropdown menu, or New to create a new template. After a Metadata template has been created, the choice to Edit Presets.. will appear. Creating your own preset will be covered after the Import section. The setting is also sticky.

- Keywords: These are tags that describe what's going on in a photo. In the case of Import, you're limited to keywords that describe all the photos being imported. Adding keywords is helpful for organizing and finding your photos. Because these images were all shot in Connemara and are landscape photos, I'll add those tags.

Destination

This is where Lightroom will put the photos it imports. It's critical that you have an active role in deciding this and that you have a uniform system so that you know where files are located. Some people argue that you could put everything in one folder, and use keywords and metadata to find your photos. This is completely true, but it's akin to dumping all your clothes into one huge drawer rather than sensibly organizing them. It's not that bad though, because you can use the Add to Collection feature from File Handling to use Collections to organize photos instead.

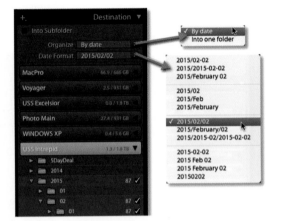

I prefer a system that works outside of Lightroom, so I used one of the date options, but I rename the bottom date to add descriptive text.

So what are the options? Ignore Into Subfolder for a moment—it probably should be down further in the dialog anyway. There are two main options in the Organize box: Into one folder and By date.

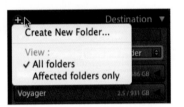

Into one folder: This places the photos into the selected folder. Click on any folder, and the images will be moved there. If you want to create a new folder, click the + in the panel header and choose Create New Folder... You can dock the folder using Affected Folders only, or by double-clicking on a folder. This hides all other parent folders and shows the folders below the current folder. Choosing All folders, or double-clicking again, will show all folders. This applies in the Files view in the Sources panel, too; double-clicking will dock a folder.

To have Lightroom create a subfolder in the selected folder (for example, if you've clicked on one of the Drive headers, like USS Intrepid in our example figure), tick Into Subfolder and give the folder a name.

By date: Here we get a series of date options. The main thing to remember with each of these options is that the "/" in the description means that a new folder is being created. So 2015/02/02 is three folders. The folder 02 is inside the folder 02, which is inside the folder 2015. 2015/February would have the folder February inside the folder 2015, and so on. The structure is shown in the panel, so fortunately there's no guesswork involved. You can use the Into Subfolder option here, but in my opinion, it's broken. The engineers say dif-

ferently, but when you tick the Into Subfolder box and enter a name, the dated folders are placed inside the subfolder. I'd expect the subfolder to be placed into the bottom level of the dated folder. I mean, that is what a sub-folder is, right? As you can imagine, I don't use this option.

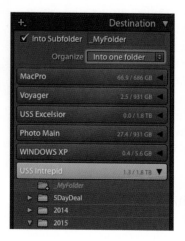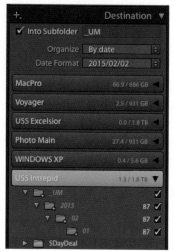

Import Presets

Before hitting the Import button to upload these photos, let's look at the last remaining part of the Import Dialog. Down at the bottom is a black area that houses the Import Presets and their controls.

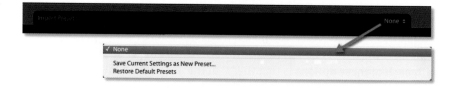

Initially there are no Import Presets, so click None to open the menu, and choose Save Current Settings as New Preset. This will take all the current set-tings and save them for later use. You can also use Restore Default Presets, though in this case there are none to restore.

When would you use an Import Preset? Well, after spending some time getting Import set up, it would be prudent to create a Standard Card Import preset to avoid going through this process again if something changes.

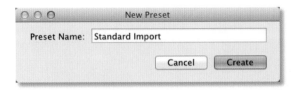

If you're shooting video, you may want the Import setup to show the video files first so you can bring them into a specific video project folder. An Import Preset would help there, as would having a Standard Import Preset for stills.

Another use for Import Presets would be if you shoot weddings with a second shooter. You could set up File Renaming to include the other photographer's initials and create an Import Preset for that photographer.

Once you create an Import Preset, you get additional menu options to manage them: Rename or Delete Preset.

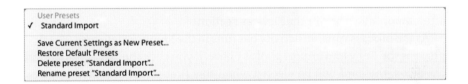

If you make a change while an Import Preset is active, the name of the file changes in the list and an edited suffix is added, and yet again, the menu changes with a new option available. You can now choose to Update Preset, or create a new preset via Save Current....

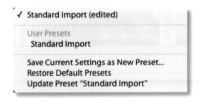

Import, Only Smaller

There's one final option in Import, which is the ability to use the smaller dialog. This is beneficial to those who always import everything, and those who use Import Presets to set up the dialog. Down at the bottom left of Import is a little triangle icon with a big name. This is the Show Fewer Options button. Click it to activate it.

The smaller Import Dialog appears. Cute, isn't it? It still has a lot of functionality—you can choose Metadata Preset, add Keywords, view naming template and File Handling options, and choose a Destination type.

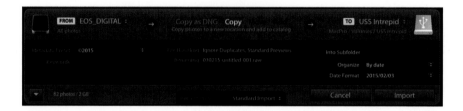

What you can't do is add Custom Text, Shoot Name, or a start sequence number. This makes this dialog less useful to me, but your mileage may vary. If you could at least change the Custom Name, I'd be delighted. The shortcut "\" toggles between the two views.

Push the Button

Now that Import is ready to go, press the Import button on the bottom right to start the process. If you want to automatically eject the card, click the Eject after import checkbox in the Devices section.

As the process runs, an activity bar runs in the Identity Plate area. The first phase is the Copy and import photos phase. If you click the Eject after import checkbox, the card will be ejected when this first phase completes. A new collection will appear in the Catalog panel called Current Import. The number of images in that catalog will increase as the images get imported. Upon completion, the collection will change name from the Current Import to the Previous Import collection. If you haven't unchecked the Select the Current/ Previous Import collection during import in Preferences>General, Lightroom will automatically display this folder. This option is a recent addition to Lightroom. Uncheck this option if you wish to remain working on a different set of photos while Import runs.

At this point you can start working on the freshly imported photos, but the second stage, Building Standard Previews, will run in the background. This does take up the computer's CPU time, so Lightroom may run more slowly than normal during this phase.

That's it. You've imported from your card!

Importing from Disk

Disk Import includes the Move and Add options. The destination options for Move and Copy are identical. Add has fewer options. Let's do a disk Import via Add.

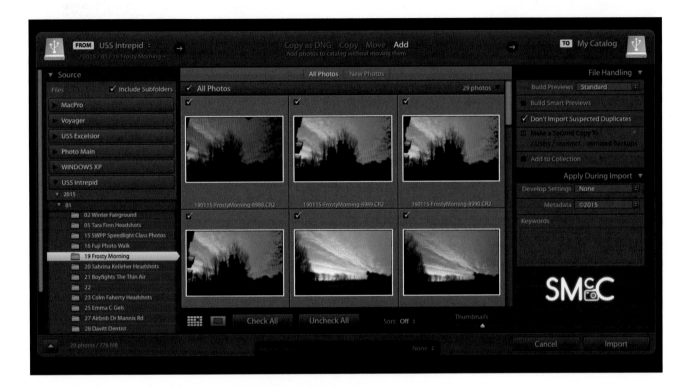

1. Start Import via the Import button, menu, or shortcut.

2. From Files in the Sources panel, navigate to the folder you wish to import from. If you want to add to more than one folder, Command or Control + click to add it. If you wish to dock a folder to hide others, double-click on the folder.

3. Click Add to import files at their current location.

4. Choose the files to Import using the instructions for cards in the previous section.

5. Note the lack of options for Add; only File Handling and Apply During Import are available. Set these options as required.

6. Click Import.

This process will run with an import and a preview stage, just like with the process of importing from a card. However, it's much faster because the photos are already on disk.

One final difference between card and disk import is in Destination for Copy. The additional option in Organize is By original folders. This keeps the original parent folder, and copies it into the selected folder.

> **Faster Import**
>
> A lot of Lightroom trainers will tell you that it's faster to copy the files off the card into a folder and then use Add to get them into Lightroom. In the past, this was definitely true for Mac users, but the improvements in Lightroom 6 make copying directly from the cards to the operating system equally fast.

Import Options

Two of the items in Import preferences have been mentioned, but for clarity, let's look at them all here:

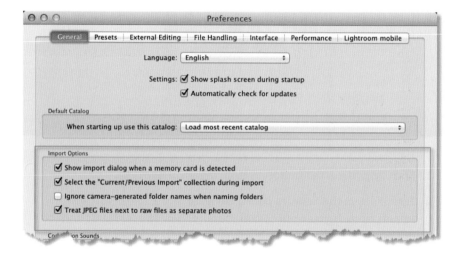

1. To get to Import Options, open Preferences (Lightroom menu on Mac, Edit menu on PC).

2. Go to the General tab. Import Options is the third section down.

3. The options are:

 a. Show import dialog when a memory card is detected: This opens Import when you insert a card via a camera or card reader.

b. Select the Current/Previous Import collection during import: This will jump you to the import collection when Import runs. This is great if you want to work on those photos right away, but not if you were working on other photos. If you have this on and need to jump back to the previous folder, use the arrow icons in the Filmstrip, or the recent folders list to go back to where you were.

c. Ignore camera-generated folder names when naming folders: This ignores the 100EOS5D style folder naming when using folder names. This is slightly odd because folder names aren't available in file naming on Import.

d. Treat JPEG files next to RAW files as separate photos: Some photographers shoot both RAW and JPEG files for various reasons. This option either hides or shows the JPEG files. Both RAW and JPEG files get imported, but the JPEGs may or may not be visible depending on how this option is set.

Tethered Shooting

Why Tether?

While getting your files off a card after shooting is probably the most common way of getting files into Lightroom, there are times when you need to see each photo as it's shot. Fashion and commercial photographers need to see in detail what's going on in the shot to refine each pose, the product, or the lighting. It's especially useful on larger fashion or commercial shoots where the entire team of hair, makeup, stylists, fashion designers, art directors, and digital techs need to see the photos to fix things that apply to their role.

To do this, Lightroom provides support for tethering Canon, Nikon, and Leica cameras. Fujifilm is currently developing its own Plugin for tethered shooting. Sony, Konica Minolta, Pentax, and Samsung can get third-party support from software like that from http://dslrsoftware.com/tethered_shot. php. Manufacturers that provide their own program to tether can also use Auto Import, which we'll cover after tether.

> **Supported Cameras**
> You can find a full list of supported cameras at: https://helpx.adobe.com/lightroom/kb/teth-ered-camera-support-lightroom-4.html. This is updated with each new version of Lightroom.

Tethering for Product Photography

To tether, connect your camera to the computer via the standard connection lead for the camera. Most will be via USB, but others will be Firewire. You can get cables that are 20 feet (6 meters), but beyond that the signal will fail, so USB repeater cables will be required. That's the physical work—Tether just means you're connected with a wire.

Activating Lightroom Tether

With the cable connected, go to the File menu and select Tethered Capture. From there, choose Start Tethered Capture. Note that you may need to cancel Import before doing this.

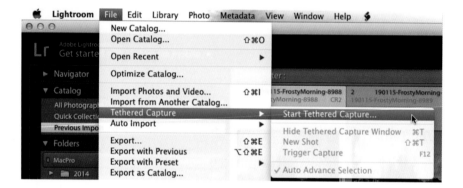

The Tethered Capture Settings dialog box will appear. You can create the settings required for the shoot in this dialog.

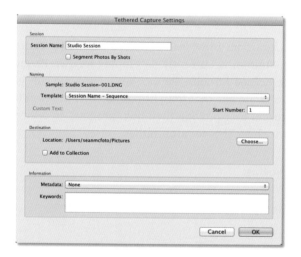

- In Session, choose the name of the Shoot. Use Segment Photos by Shots to create subfolders as you shoot. You can name these subfolders after hitting the OK button.

- Naming lets you pick any available Naming template to rename your files during Import.

- Destination lets you pick a folder to put the photos in.

- Add to Collection lets you create a Collection, as well. Note that if you want to put this collection in a Collection Set, you must create the set in advance.

- Information lets you apply Metadata Presets and Keywords. Note that you can apply Develop Settings to Tether, just not from this dialog.

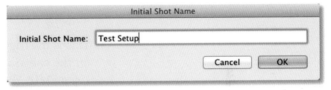

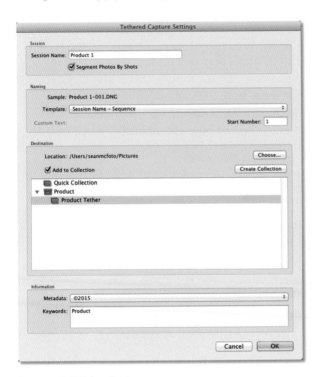

Some typical Tether Settings

Let's look at the parts to the dialog:

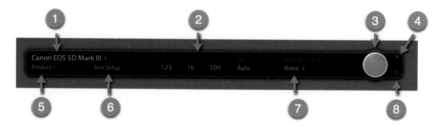

The modal dialog for Tether

1. When a compatible camera is attached, the camera name will appear in the dialog.

2. These are the settings on the camera. They can be viewed, but not changed.

3. This is the trigger button, which acts as a remote shutter button for the camera. F12 will fire a capture, though this is also a system key on Mac. You can still fire from the camera shutter. The image will transfer from the camera. Auto Advance is on by default in the Tether menu, so this image will display automatically when transfer completes.

4. This is the close tether icon.

5. This displays the Session folder.

6. This is the current shot for Segment by Shots. Clicking this lets you change it to create a new subfolder.

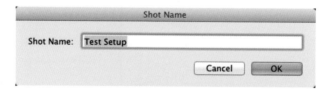

7. This lets you apply a Develop Setting. The 2nd option, Same as previous, is really useful. When you make the first shot, you can go to Develop and correct it, or give it a particular look. Selecting Same as previous will ensure that these settings are applied to all images that are uploaded.

8. Clicking the cog will bring up the Tether Capture Settings dialog.

It's best to test the tether option before shooting to make sure everything works before you're under pressure to achieve results. There's nothing worse that being in a room full of people waiting on you when something's gone wrong!

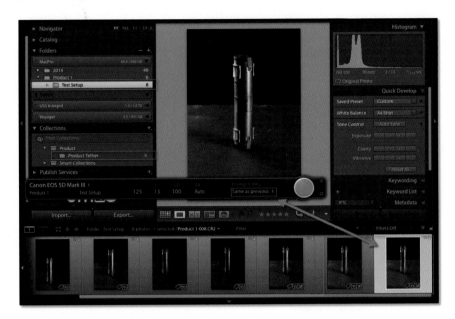

Some things to note in our active window:

1. The photos are in the folder Test Setup in Product 1.

2. The photos have been added to a collection called "Product Tether," as indicated by the Add to Collection settings.

3. Same as previous means the last two photos have the same settings. It's a subtle one here as all colors bar red have been desaturated. It's likely a sneaky spot color.

I recommend using quality cables, such as those from Tethertools. They're thicker than normal USB cables, and are long enough for most tethered situations. I really recommend a Jerkstop (again from Tethertools) for cable strain relief. I have broken the USB socket on a camera in the past by tripping on the cable. The Jerkstop would have prevented this.

Auto Import

Before Tether was introduced, the only automated way of getting photos into Lightroom was via the Auto Import option. This option works for far more than just tethering. The premise is simple: first you set up a Watched Folder; Lightroom waits until a file appears in the folder and then whisks it away to another location of your choosing.

Setting up Auto Import

Before you can enable Auto Import, you have to set it up.

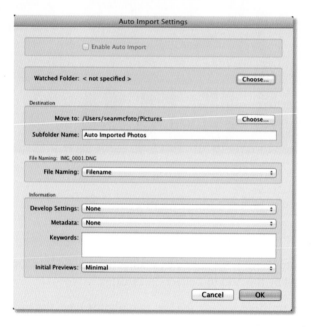

1. Go to the File menu, then Auto Import. Select Auto Import Settings.

2. First set up a Watched Folder. Click Choose to navigate to your preferred folder. You can make a new one from Finder/Explorer as you browse. Note that the folder you choose must be empty. Auto Import will fail if there is already even one file in the folder. As soon as you enter this folder information, the Enable Auto Import checkbox becomes available (as well as the corresponding *File>Auto Import>Enable Auto Import* command).

3. Choose a Destination folder and subfolder. This is where the file from the Watched Folder will get moved.

4. Decide how to name these files. We'll cover naming conventions shortly with File Naming, but the key is to give each file a unique name using a consistent naming scheme.

5. Apply a Develop Preset if you prefer. For Metadata, at least apply your copyright and contact information. Apply appropriate Keywords to make your photos easier to find. Finally, choose what size previews are generated on Import.

6. Check the Enable Auto Import checkbox to activate Auto Import.

How files get into the Watched Folder doesn't matter; it's just a matter of waiting for files to appear. Let's look at some case studies using Auto Import.

Case Study 1: Camera Software

If your camera isn't supported by Lightroom's tether option, it may come with software that allows you to use it. You may also prefer to remotely control the camera from the computer, something Lightroom doesn't allow you to do. For instance, you may have an assistant placing a product that you're working on while you shoot, so you need access to the camera without going to the camera room each time. Since Canon is supported by tether, I'm going to use Canon's EOS Utility to control my camera for this example. While slow to catch up, Olympus and Fuji now have remote software for their newer cameras.

1. Connect the camera to the computer.

2. Start the remote software and select the Remote Shooting option.

3. The remote panel will open. At the bottom, choose Preferences.

4. We need to change a lot of preferences over a lot of pages. Remote Shooting opens first. Leave the settings as is. Though it's tempting to tick Rotate Image, Lightroom will do this anyway.

5. Switch the dropdown to Destination Folder. Match this to your Watched Folder in Lightroom. Turn off the Create a subfolder option.

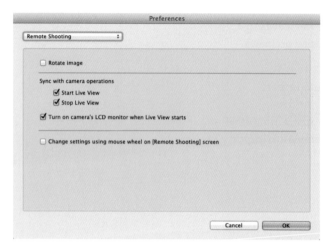
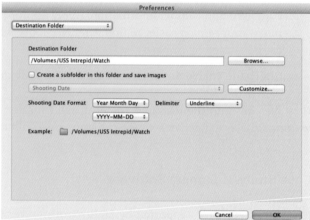

6. In Basic Settings, switch Automatically Display Preview window to Off.

7. In Linked Software, change the option to None.

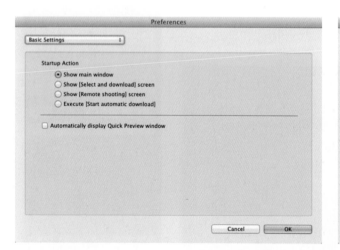

8. Click Ok to apply the settings.

9. Do a test fire to make sure everything works. EOS Utility will transfer the file into the Watched Folder, and Lightroom will move it to the Auto Imported Photos folder (unless you changed the destination).

There is a little bit of jumping through hoops to make this process work nicely. The Destination folder and subfolder are key and should be set to the Watched Folder location, while the Linked Software will prevent Digital Photo Professional from opening with every photo.

Case Study 2: Eye-Fi Cards

Eye-Fi cards are SD cards with a built in Wi-Fi transmitter. There is a range of different card options to suit all budgets. I have two: a Sandisk branded 8 GB version and a 4 GB Eye-Fi Mobi version. I've used them with Canon, Olympus, and Fuji cameras. Canon and Olympus have dedicated menus for these cards. Fuji doesn't, but it can still transmit files.

1. To set up an Eye-Fi card, connect it to the computer. A reader for the card may even be provided. Set up the software and activate the card. You need to log into an Eye-Fi account for the card to work.

2. Once the Software (Eye-Fi Center) is up and running, click on the Direct Mode tab in Networking. Eye-Fi can run on any network, but Direct Mode lets you connect directly to the card's own network. Note the network name and the password. Then click Start Direct Mode.

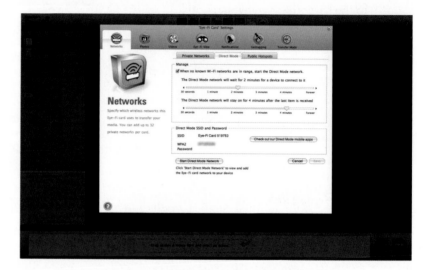

3. Go to the Photos tab. Enable Upload to This Computer. Set a destination folder. Unlike with EOS Utility, we will create Date-based folders, simply so we can have an empty folder to work with. Save your settings.

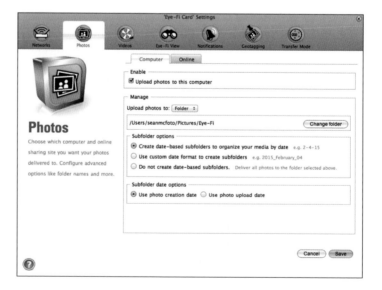

4. Eject the card and put it in your compatible camera. I use my 5D MkIII's SD slot, and set it to JPEG for quick previewing as I shoot. We're not going to connect to Lightroom just yet; but do a network test and create a folder. Fire a shot or two to activate the card.

5. Go to the computer's network settings. Join the Eye-Fi network.

6. The files will transfer automatically to the Eye-Fi dated folder. Go to it and delete the files. Remember the name of the folder.

7. In Lightroom, set the Watched Folder to that dated folder in Auto Import Settings.

8. Fire the camera and watch the file come in!

That's it!

Syncing the JPEG and RAW

If you edit those JPEGs, you can still get the settings across to the raw files by using Syncomatic from John Beardsworth (http://photographers-toolbox.com/products/jbeardsworth/syncomatic/), once you've imported them. John is a plugin developer on Photographer's Toolbox, and this plugin is great because it does the job well.

File Naming

We've seen three instances of places where you can rename files in Lightroom so far: Import, Tether, and Auto Import. In the Library you can also use F2 to trigger renaming for selected files. The Filename Template Editor can be used to set up sophisticated naming options for files, including drawing on the original filename for parts if needed.

Creating a Name

To be of most use, each file should have a unique name. Too many IMG_0001. CR2 files would be a mess to search through. Images should also have a consistent way of being named to make them easier to find. What makes a file unique? One thing is the time at which they were shot. Date is important. If you use continuous naming on your camera (and you should!), then most camera-generated names have at least 10,000 numbers before they cycle around. If you shoot 30,000 photos a year, then the number only

repeats three times. Not fully unique, but close. Combining the date and this camera-generated number will make for a unique file name. *DAM* book author Peter Krogh uses his initials (PK), the date, and the camera suffix for his naming style. This is a perfect example for a successful naming system for Import Presets.

Me? I'm more awkward. I like to have something of the content of the photo in the file name, too—just a clue as to where it was shot, or who I was shooting. For this I need to use the Custom name function. I start with the date, then the name, then the camera number suffix. Let me show you how to use this process.

Making a File Naming Template

1. Click the Library>Rename Photo.. (Shortcut F2) command in Library to begin. You can also start from the file renaming sections of Import, Auto Import, or Tether.

2. Click the File Naming dropdown menu. From the bottom, choose Edit….

3. The Filename Template Editor will open. At the top are the Presets, which contain the default set of presets seen in step 2. We'll come back to this when we've modified the filenaming.

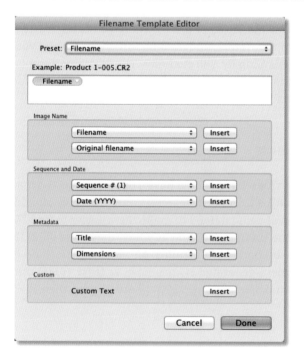

4. The window contains the tokens that make up the filename. You're not restricted to the tokens, though; you can write directly in the box to include text or a limited range of symbols like – or _. Writing directly is useful initially if you use a second shooter, or if you run a studio with several photographers in order to quickly keep track of who shot what.

5. Clear the window by deleting all that's in it.

6. In the Sequence and Date section, choose the 2nd option in the Date dropdown menu: Date (YYYYMMDD). If you prefer the date, month, and year, then choose Date (DD), then Date (MM), and then Date (YYYY) or Date (YY) for a 2-digit year. The separate dates will enter automatically on selection.

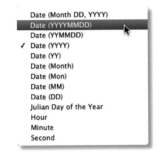

7. Back in the window, type in a separator. Dashes or underscores work, but Lightroom will change the dash to an underscore if you use the Web module. This can get confusing if you use a web gallery and someone sends you the filename with the underscore instead of a dash. For this reason, I try to use underscore when I can.

8. Next, insert the Custom Name token, so you can use different descriptions in the name.

9. Enter another separator.

10. From the Original Filename menu in Image Name, choose Original number suffix.

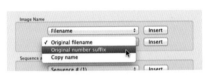

11. If you'd prefer to use a new sequence each time, use an option from the Sequence and Date menus Sequence dropdown. Note that for alphanumeric sorting, you need to use an option with leading zeros (like #001). The image increases with each shot, and it won't reset by itself. To reset the number, go to the File Handling tab in Catalog settings (covered in the Advanced Catalog section). Total refers to the total number of photos in that particular renaming session. In Import, there's an additional option—a counter for the number of import sessions you've had.

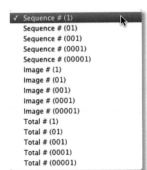

12. Another option is to use camera Metadata in the name. Choose from either of the Metadata dropdown options.

13. Here's our complete template. Note that an example of how the naming will look is above the window in the following figure:

14. Time to save it. Go back to the Preset dropdown menu and choose Save Current Settings as New Preset. The New Preset dialog will open. Choose an appropriate name that will be easy to remember. Click Create. The new Preset will be selected and active in the editor, and will be the default until you change it again.

15. Click Done to exit the Filename Template Editor.

Metadata Presets

Metadata Presets are used to add a whole range of IPTC information to your photos. At an absolute minimum, you should add copyright and contact information to your photos so that honest vendors can contact you to license your photos. Having the information in the file and proving it was removed can also aid in the prosecution of dishonest vendors.

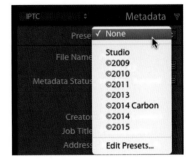

1. Open the Metadata Preset Editor by choosing the Edit option from the Preset dropdown menu in the Metadata panel on the right in Library, or from the Metadata section in Import, Auto Import, or Tether Capture Settings.

2. If you've only started with Lightroom, this will be blank. As you can see I've a few. I did have one for 2012, but I accidentally deleted it. We'll recreate it here.

3. Select Edit Presets.. from the bottom of the menu.

4. The Edit Metadata Presets dialog will open. Scroll down to the IPTC Copyright and Creator sections. I generally don't fill out photo content-related information because it's not relevant to all the photos. However, for sports photography, you could create a generic Preset before a game to have the basic caption information already available and even a list of Presets for individual players to apply quickly to appropriate shots after the game.

5. Enter the copyright symbol: Option + G on a Mac, or on PC, hold down Alt and type 0 1 6 9. Or just copy and paste the symbol from somewhere online.

6. Enter the year, and your name. While the Berne Convention (a major international copyright agreement) doesn't require the year, the US does, so it's safer to apply this information no matter where you are.

7. Change the Copyright Status to Copyrighted. With this on, a file will open with the Copyright symbol in the header in Photoshop.

8. Enter the Rights Usage.. e.g., All Rights Reserved. It could also be Public Domain, or one of the Creative Commons options.

9. Enter a URL for your copyright information. If you don't have a specific page, use your website.

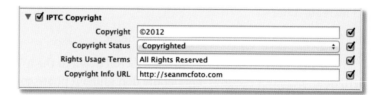

10. Enter your contact details in IPTC Creator.

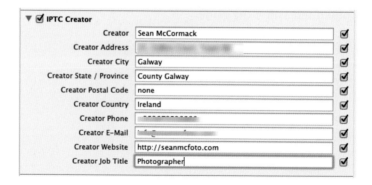

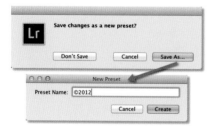

11. Click done to begin the save process. You'll be prompted to save the new settings as a Preset.

12. Choose the Preset from the Preset dropdown in the Metadata panel to apply it.

Previews

Browser-based applications load and display the embedded preview from a file. Lightroom reads the file, applies any settings you've made (or the default settings), and generates a preview. This preview is what you see when you view a file in Lightroom (except in Develop). This preview is color managed, so it is more useful than the embedded preview from the camera. These previews are used in Library, Print for draft mode, Slideshow, and Book, and they form the basis of Web preview.

The benefit of using previews is that settings get applied faster, and you can even edit metadata when the file is on a disconnected external drive. Another benefit is if something happens to the original files, via data corruption for example, it's possible to recover a version from the preview. Obviously it won't be the same quality as the original, but at least you'll have something.

Preview Generation

The first instance where we come across preview creation is in the File Handling panel in the Import Dialog. Let's expand on our options from there.

The four options are:

- Minimal: This creates a thumbnail-size image for use in Grid. This option means Import finishes quickly, but as soon as you go to Loupe view, Lightroom will create a preview to view. Lightroom will always create the largest preview it needs at the time.

- Embedded & Sidecar: Raw files have a JPEG thumbnail embedded in the file, the look of which depends on camera settings like Picture Styles or Modes. Lightroom will use this file initially, but generate a preview as required. Older Raw formats (like the Canon D60's .CRW file) put this thumbnail in a separate file, referred to as a sidecar file (A .THM file in the case of the D60). I find that this mode would be more useful if Lightroom let you use this preview in Library until you went to Develop. A lot of sports photographers use Photo Mechanic to select files, add metadata, and check focus very quickly. This depends on the program using the embedded previews. You don't need accurate color for those jobs, and the speed penalty from using Lightroom's preview system does not make it ideal to use at a sports game, when a deadline is pending.

- *Standard:* This creates a screen-size preview, the size of which depends on a setting in the Catalog Settings dialog. We'll look at these sizes next.

- 1:1: This creates a full-resolution preview of the original file. These are perfect if you plan on zooming in to see pixel-level detail and for checking focus. These are created automatically when you zoom in anyway, it's just a question of whether you want to create them before you view the image, or as you view the image.

If you start with Minimal previews, Lightroom will display a Loading.. bezel on the photo when you go to Loupe view. Zooming in again will bring up another Loading.. bezel while it creates a 1:1 preview.

Preview Settings

To set the Standard preview size, and to set how the 1:1 previews are handled, open Catalog Settings (Lightroom menu on Mac, Edit menu on PC). If you've opened Preferences by accident, there's a button to go to Catalog Settings at the bottom of the General tab.

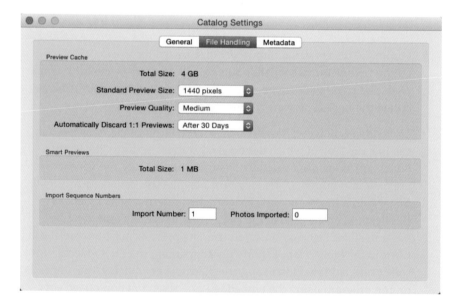

Preview Cache settings are located in the File Handling tab.

- At the top of the section, Total Size shows the physical size the previews take up on disk.

- Standard Preview Size: This gives a range of set sizes from 1024px to 2880px. A new option, Auto, detects the current display size and creates previews for that size, even if it's an intermediate size. I recommend this option over a set size.

- Preview Quality: Lightroom has three levels of preview quality: Low, Medium, and High. The trade off you're making is between the way the image looks onscreen and the space it takes up on the disk. If you've a powerful machine and loads of disk space, go with High. If space is a concern, go with Medium, but you may see banding in areas of gradations from time to time. Low is really for laptops, and doesn't look great, so avoid it unless space is really a problem.

- Automatically Discard 1:1 Previews: You can opt to have Lightroom remove previews to regain space on the drive. If you edit files immediately and don't come back to them for a while, choosing either the After One Day or After One Week options will be best. If you pop in and out of recent folders, the After One Month option would be best. If you always want 1:1 previews available, choose Never. Be warned that Lightroom will only delete previews that are more than twice the size of the current Standard preview size. If you use 2880px and your files are less than 5760px long, then Lightroom won't delete the 1:1 previews. Also, Lightroom doesn't delete the 1:1 previews immediately, so don't be surprised if it takes time for the Total Size to go down.

Advanced Previews

Previews are stored in the Catalog Previews.lrdata file (where Catalog is the catalog name) or folder, situated in the same folder as the catalog. While it is vital to allow Lightroom to display your photos, it isn't vital to back it up. If the previews were deleted, Lightroom would simply make them again as needed. In the meantime, you'd see gray thumbnails in Grid.

To create Previews at any stage, go to the Library>Previews menu. From there, choose to build Standard Sized or 1:1 Previews. You can also discard 1:1 previews manually from here.

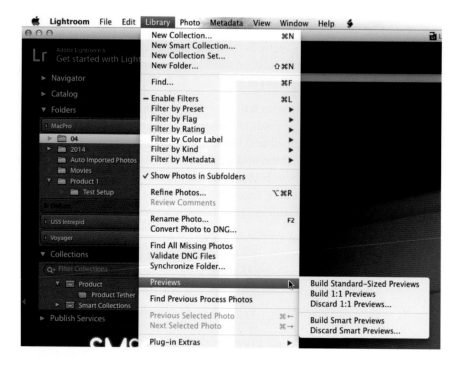

The Technical Details

You can view how Lightroom stores the preview files by opening the folder on PC. On Mac, you need to right click in the .lrdata file and choose Show Package Contents, and then open the Contents folder that is displayed. Going through the folders reveals .lrprev files. Clicking on them shows the thumbnails.

The .lrprev for a photo is based on a pyramid of highly compressed Adobe RGB JPEGs. The internal previews aren't directly viewable, though File Juicer for Mac (http://echoone.com/filejuicer/) can extract the JPEGs. You can, however, open the previews as a text file and see some of the headers.

It's important to note the Color Profile and the Levels. The Levels indicate what size previews are available within the file. Seven levels would be normal to include 1:1 previews for a 5DMkIII photo. Each preview size is half the previous and matches the zoom levels in the Navigator panel window, meaning Lightroom can easily get each preview without having to load a different file or render new previews. For that 5DMkIII the largest preview is 5760px on the longest image edge, then 2880px, 1440px, 720px, 360px, 180px, and finally 90px. Files with Face information have .lrfprev extensions.

Video files have sRGB previews based on the header. When you run a video, a new preview file type is created: a .lrmprev.

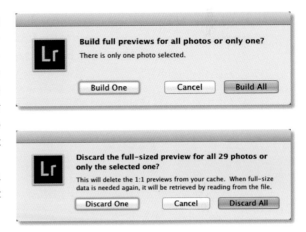

```
AgHg  Öheaderpyramid = {
          colorProfile = "AdobeRGB",
          croppedHeight = 3744,
          croppedWidth = 5616,
          digest = "077b070982fd42045ed5e932196fb988",
          fileTimeStamp = 332802872,
          formatVersion = 3,
          fromProxy = false,
          levels = {
              {
                      height = 60,
                      width = 90,
              },
              {
                      height = 120,
                      width = 180,
              },
              {
                      height = 240,
                      width = 360,
              },
              {
                      height = 480,
                      width = 720,
              },
              {
                      height = 960,
                      width = 1440,
              },
          },
          quality = "standard",
          uuid = "0ABF6F68-2EE4-49B5-8BE1-78BEEC75992B",
}
AgHg      Llevel_1´ÿ´€Ñ
```

A look at a typical Preview file

Managing Previews

When you delete a file from Lightroom, the preview will be deleted as well. If you use Remove, Lightroom will temporarily hold on to the preview, in case you undo the operation. As mentioned, you can create and discard 1:1 previews from the Library>Previews menu, assuming they're more than twice the size of the Standard preview. If you only have one photo selected, Lightroom will ask if you want to Build One, or Build All to include all photos in the current folder or collection.

The same is true for discarding 1:1 previews. Lightroom will offer to discard all the 1:1 previews from the current location, or just the selected photo.

Moving the Previews

We know the previews are in the same folder as the catalog. These folders can get large, and a full startup/system drive will slow you down. They make automatic backup more awkward, with loads of small files littering the drive (not quite, but you get the idea). Adobe hasn't provided a way to move the Previews folder/file. That said, there is an option:

Symbolic links are system-level links that act as though they were the real item. As part of its Unix heart, Mac OSX allows us to do a system-level redirect to another location. For all intents and purposes, the file system

sees this link as the actual folder. You can, of course, create a Symbolic Link in Terminal. If you're afraid of command lines, never fear, help is at hand.

Symbolic Linker (http://www.macupdate.com/app/mac/10433/symboliclinker) is a Contextual Menu Items plugin that lets you right-click on a file and create a symbolic link in the same folder.

To use this tool, simply install the plugin in Library/Contextual Menu Items and then Force Quit/Relaunch Finder. Next, move the Preview Folder to its new location (if it's an external drive, you'll need to delete the original Preview Folder). Then right-click (or Ctrl+click for one-button Mac mouses) on the folder and choose Make Symbolic Link. This creates a link with the same name, but with "symlink" appended to it. Finally, move the link to the original location of the Preview Folder and rename it to remove the "symlink" so the file will have the same name as the Preview Folder. If you've left Lightroom running while doing this, make sure you restart it, or you'll get a whole host of errors.

If you're more technical, you can use Terminal with this command: ln -s /source_path /destination_path. You can enter ln –s and then drag the source path (the new Preview folder) into Terminal. Then hit the spacebar and drag the Lightroom Catalog folder onto the Terminal window. This enters the path to the folder automatically, and in the correct Unix format. The symbolic link has the same name as the previews folder, and will fool Lightroom.

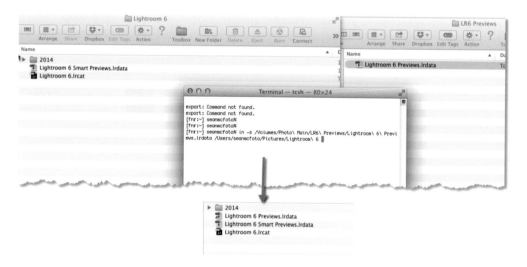

Start Lightroom again. If you can see your photos, it worked! Now remember, this works best with the new previews folder on a fast drive, preferably an internal drive. If the drive gets disconnected, Lightroom will have problems, so don't disconnect it if you're not sure. Warning: This is not an Adobe sanctioned workaround. You could break your previews. Adobe won't be held responsible if you do this and it doesn't work.

Lightroom will create new previews if it all goes wrong. Just delete the symbolic link and move the Previews folder back to the Lightroom Catalog folder.

Recovering Previews

Lightroom's internal previews can be used to generate JPEGS of the original files if something should happen to them. There are a few ways to do this:

1. Use the Adobe script found at:

 https://helpx.adobe.com/lightroom/kb/extract-previews-lightroom-4.html.

 Full detailed instructions are included with the script.

2. Use Jeffrey Friedl's "Extract Cached Image Previews" Lightroom Plugin. Jeffrey has 50 or so plugins for Lightroom. He's awesome. You can find it here:

 http://regex.info/blog/lightroom-goodies/preview-extraction

3. Use Rob Cole's "Preview Extractor." You can find it here:

 http://www.robcole.com/Rob/ProductsAndServices/PreviewExporterLrPlugin/

Smart Previews

While Previews have been part and parcel of Lightroom since its inception, Smart Previews have only been around since Lightroom 5. Smart Previews are designed to allow users to work with their photos in Develop when the original files aren't connected to the system, for instance, if they are on a disconnected external drive. Smart Previews have other purposes, but this is their main premise.

What are Smart Previews? Smart Previews are lossy DNG copies of the original file, 2560px long, and are stored in the Catalog Smart Previews.lrdata file/folder beside the catalog file. These DNG files are identical to an export of the original file with the Use Lossy Compression option ticked and the Long Edge set to 2560px. In fact, if you go to the Smart Previews folder, you can even import these files into Lightroom or edit them in Photoshop, independent of the original file. I wouldn't, though! Like Previews, Smart Previews can save the day if something happens your original

files and their backups. It gives you a higher quality, more editable version of your files than Previews.

Double-clicking a Smart Preview will open it in Camera Raw

Creating a Smart Preview

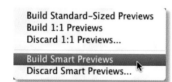

You may have noticed the Smart Preview option in the Previews menu already.

Clicking this option with one photo selected will open a dialog asking if you want to Build One or Build All, which will include all photos in the current folder or collection (similar to Previews). Discard will do the same—you can Discard One or Discard All. Keep in mind that Discard deletes the smart preview.

You can build Smart Previews automatically in Import, but not in Auto Import or Tether. The Histogram in either Library or Develop includes Smart Preview information, and also will trigger creation when you click it.

1. Here's the standard histogram for a file with no Smart Preview. Click Original Photo to open a Smart Preview Dialog.

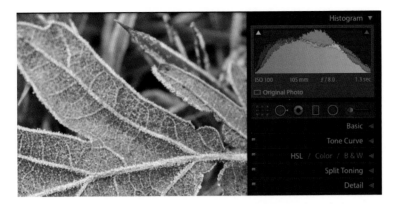

2. Along with the Build Smart Preview button, the Smart Preview dialog contains information on Smart Previews. Press Return.

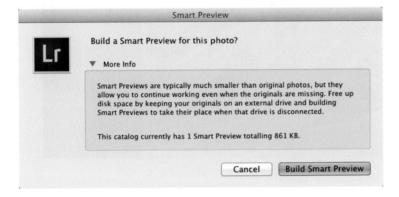

3. The Histogram will now show Original + Smart Preview.

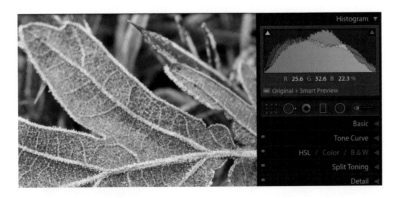

4. The current image is on an external drive. So, to test Smart Previews, eject the drive. The Histogram will now be labeled Smart Preview, indicating that the original image is offline.

5. Zooming in to 1:1 in the Smart Preview shows that the level of detail is lower than the Original file. To test the editing functions, press the V key to make the file black-and-white.

6. Finally, reconnect the external drive. The screen seems to zoom in; in reality, it's just that the original file is much larger than the Smart Preview. Notice the settings made to the Smart Preview have been automatically applied to the reconnected Original Photo.

7. If you have a series of photos selected in Grid, the display changes. Four items show what's happening in our selection of eight photos: 1) shows three Original Photos; 2) shows three Original + Smart Previews; 3) shows an offline file with a Smart Preview; and 4) shows a file that is missing without a Smart Preview.

Smart Preview Uses

With images on an external drive, Smart Previews allow you to fully edit files as if they were connected via a drive, even when they are not. Another benefit of Smart Previews is that they load faster than Original Raw files. If the Original file is available, Lightroom will read the Smart Preview first, then load the original file in the background. This means that files will load quicker with Smart Preview.

Smart Previews are the foundation of Lightroom mobile. When you create a collection and sync it to Lightroom mobile, the files that get uploaded to the cloud are Smart Preview copies of the originals. This makes the upload time more manageable and gives you full editing access to the file.

If something happens your original file, you still have the Smart Preview, which can print to A4, a common, international paper size.

The Library Module

Now that we can get photos into Lightroom, let's learn how to manage them and make the most of the Library module. Most of the direct file management features are based on operations in the Left Panel, so we'll start there.

The Left Panel

The Navigator

In terms of Lightroom's interface, the Navigator is a small window. It can also be found in Develop and Map, and has a brother, called the Preview window, in the remaining modules. The Navigator has many uses:

Image Preview

Move the mouse over the Filmstrip. Notice how the Navigator window updates to show the image under the cursor? Hovering over images in the filmstrip provides a quick preview of the image.

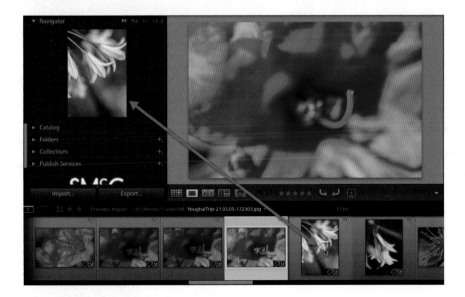

Zoom

The Navigator houses the different zoom levels available in Lightroom:

- Fit: This makes the entire current photo fit in the main image preview area.

- Fill: This expands the image exactly enough to fit the image preview area. Landscape photos get marginally bigger than with Fit, but portrait orientations zoom in a lot more.

- 1:1: This gives a 100% view, right down to a pixel-level view.

- Variable: This fly-out menu prompts a range of values from 1:16 to 11:1 (1100%). The reason for the unusual maximum zoom of 11:1 is a *Spinal Tap* gag—it goes to 11.

The white rectangle in the Navigator shows the area visible in the main image area. This rectangle can be dragged around; the zoomed portion of the photo you see in the image area will correspond with what you see in the white rectangle.

Zoom in on Zoom

As well as clicking on the visual icon for zoom, you can also zoom in on your image by clicking on a photo in Loupe view, or double-clicking on a photo in Grid to get to Loupe. Once zoomed in Loupe, the cursor becomes a hand tool—meaning you can drag the image around within the image area to view different parts of the photo at zoom view. You can also use the Spacebar and "Z" as a quick zoom shortcut. Pressing either of those keys will toggle you back to the previous Zoom level. Note that these two zoom levels are based on the previous two you've used in Navigator or via the shortcuts that jump between those four Navigator zoom levels. These shortcuts are Command + "=" and Command + "-" on Mac, or Control + "=" and Control + "-" on PC.

Folders and Collections

Hovering over a Folder or Collection will show the first image in that folder or collection. You can also right-click on any image in a Collection and choose Use as Cover Photo to make it the image shown when you hover the cursor over the Collection.

Presets/Snapshots/History

If you hover over the name of a Preset (for example from the Presets panel in Develop), a smaller version of the image with the applied presets loads in the Navigator window. This is also true for images viewed in the Snapshots and History panels.

The Catalog Panel

The Catalog panel brings together a set of virtual views of the Library. It has a mix of permanent and temporary collections that changes depending on what you're doing in Lightroom. The first three of these collections are always visible.

- All Photographs: This displays everything in the catalog: all photos and videos. Right-clicking on this will bring up two options: Import Photos and Videos, and Import from Another Catalog.

- Quick Collection: A fast way to gather photos together. I'll talk more about this in the Collections section.

- Previous/Current Import: Here you'll find what was last imported, or what has been imported so far in the current import session.

- All Synced Collections: This has all images currently uploaded to Lightroom mobile. This item will remain visible once you've started using Lightroom mobile.

- All Sync Errors: Thumbnails of images that have problems syncing to Lightroom mobile will appear here. A restart can sometimes clear this problem up, though often the issue is because a file is offline with no Smart Preview.

- Previous Export as Catalog: This shows images previously exported with a catalog.

- Added by Previous Export: These are images that were brought in automatically during an export using the Add to Catalog option in Export.

- Missing Photos: This is a virtual collection of missing photos that is created when the Library>Find All Missing Photos menu command is run. It includes photos and videos.

- Invalid DNG Files: Lightroom-created DNG files have an internal validation function that checks for corruption. This can be run with the

Library>Validate DNG Files menu command. Yes, I did have fun learning to deliberately corrupt a DNG file to make this work. When Lightroom files a corrupt DNG, the Show in Library Command will create this collection.

- Previous Process Photos: Lightroom's current processing engine is called Process Version 2012 (PV2012). There are two other versions: PV2010 and PV20303. Using the Library>Find Previous Process Photos menu command will create this collection.

- Save Metadata to Files Problems: If something happens to prevent Metadata from being written to a file or a sidecar file, you get an option to Show in Library from the error dialog. The files causing the error will be shown in this collection. Reasons for not writing Metadata include things like the file or sidecar file being locked, or the file missing.

The temporary collections with for example, Missing Photos and Invalid DNG Files, often overwrite each other. You can right-click on these Collections and choose Remove this Temporary Collection to clean up the panel. Because of the nature of these collections, there may be even more of them, but these are the most common ones.

Folders

While Lightroom isn't a browser, the file structure visible in the Folders panel does match what is on disk, assuming that the entire folder tree has been imported. If you imported your folders via Add, Lightroom will exactly match that structure in the Folders Panel. Take a look at the figure below. On the left, you can see my Folders panel. On the right you can see where the matching folder is. To see this in your own Lightroom interface, right-click on a folder and choose Show in Finder/Explorer.

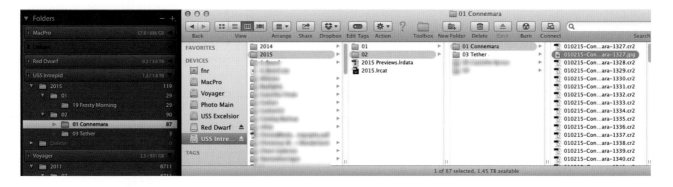

By looking at the right-hand side of the figure, you can see that the 2015 folder is the highest level of folder on the disk drive. Click on the folder name to view the contents of the folder. The folder name will become highlighted. To see the contents of the 2015 subfolder, check Show Photos in Subfolders in the Library menu. 2015 is the top-level folder for that drive in Lightroom, and is the parent folder for the 01 and 02 folders. If you right-click on 2015 and choose Hide This Parent, then 01 and 02 will become top-level folders. To bring 2015 back, right-click on either 01 or 02, and choose Show Parent Folder.

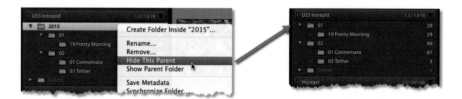

Speaking of drives, each connected drive has its own bar called the Volume Browser. These bars provide information relating to that drive. On the left of each bar is a colored rectangle relating to disk space. Green means plenty of space. Orange means you're starting to run low. Red means the disk is dangerously low on space. Black means the drive is not connected. The bar also dims when the drive is offline.

On the right of the Volume Browser is a disclosure triangle. Click this to open the drive and view the imported folders. Beside this is the Volume Info display. By default, this shows Size Remaining/Total Size for the drive. Right-click on it to get more options: Photo Count, Status (online/offline), and none. You can also view the drive via Show in Finder/Explorer, or get the drive properties in this menu via the Get Info option.

Because Folders represent what exists on the drive, moving a file from one folder to another will physically move the file on the drive. Typically (via the Don't Import Suspected Duplicates option in Import), Lightroom has only one copy of an original file. This file can therefore be in only one folder. We'll talk about Collections shortly, where you can have a file in as many collections as you like for organizational purposes. Folders match the location of a file on the corresponding drive, Collections let you organize them however you like: by genre, client, date, or any other category you need.

Creating a Folder

You can create a new folder by:

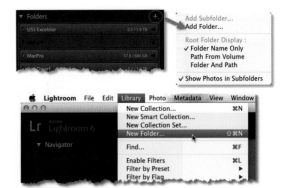

- Clicking the + on the right of the Folder's panel header

- Selecting the Library>New Folder menu command

- Using the shortcut Command + Shift + N on Mac, or Control + Shift + N on PC

Organizing Folders

You can organize folders however you like. You could easily dump all the photos you have into a new folder every year, if you use a good naming and metadata-labeling system. But really the best way to organize is by date. I use year/month/date with a custom name added after the date. Year and month might be enough for you depending on how much you shoot. Whatever you decide, the key is to stick to it. That way if you ever change from Lightroom to another program, your files will still be organized on the disk for the next program you use.

Renaming Folders

To rename a folder, right-click on it and select Rename from the list. A dialog will pop up with the current name selected. As part of my import process, I change the date and add something related to the contents of the folder, like the "19 Frosty Morning" folder, for example.

Updating a Folder

Because Lightroom can only handle imported files, it won't see files that get added to an existing folder outside Lightroom. These files may come from other editing programs, or when you're tidying up on disk. Fortunately it's easy to get these files into Lightroom without having to do a full import.

1. Right-click on the folder that has new images.

2. From the contextual menu, choose Synchronize Folder. If you need to choose specific photos, or want to see the images before committing to importing them, click Show Import before importing.

3. Lightroom will detect new and missing images, as well as updated metadata.

4. Check the boxes for the changes you want to make (e.g., remove missing photos).

5. Click Synchronize.

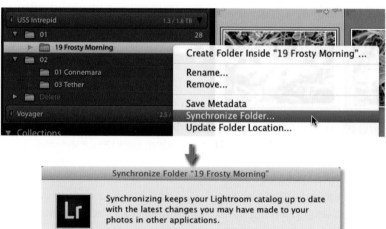

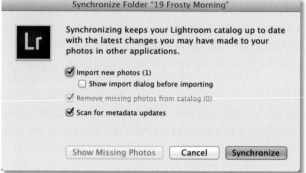

Adding a Drive

You can't add a drive directly in Lightroom. You have to import a photo that's on the drive to have Lightroom recognize it. The Volume Browser for that drive will then appear in the Folders panel. Alternatively, you can create a new folder on the drive you want to add to Lightroom.

Adding a Subfolder

To add a subfolder to the currently highlighted folder, right-click and choose Add Subfolder.. The current folder will be checked and grayed out, meaning the new folder will be placed into it. You can also opt to move the currently selected photos into the new subfolder. Alternatively, right-click on a folder and choose Create Folder Inside (*folder name*) to get the same dialog box.

Find Missing Folders

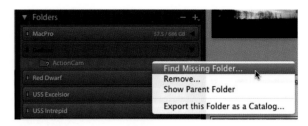

If a folder is showing a "?", it means Lightroom can't find the folder. You can help Lightroom find the folder's current location by right-clicking on Folder and choosing Find Missing Folder... Navigate to the second folder and click Choose. Do this if you moved a folder outside Lightroom and you want to reconnect it. Alternatively, you may choose to remove the folder via the Remove command in the menu.

Update Folder Location

If you have two copies of a folder in different locations, and want to swap from the current location to the other location outside of Lightroom, right-click on the folder and choose Update Folder Location. Navigate to the second folder and click Choose.

Remove Folders

Another of the right-click options is Remove. This only removes the reference to the folder from Lightroom, unless the folder is empty, in which case it deletes the folder.

Remaining Folder Options

The remaining options in the right-click menu are:

- Import to this folder: This sets the destination in Import to the current folder.

- Export this Folder as a Catalog: This creates a new Catalog file containing just the contents of the chosen folder.

Sorting in Folders

Last but not least, let's talk about sorting in Folders. All the sort options in the Toolbar are available to Folders as long as you are in the lowest-level folder.

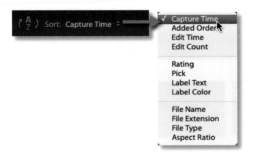

In the following example, this would be "19 Frosty Morning." You can't sort in the 01 folder, or in the 2015 folder, but you could sort in the "01 Connemara" folder. Click the cursor on the center of the image and drag; as you drag, a thick black line appears between cells, letting you know that you can drop it there.

If you try this on a higher-level folder (i.e., one with subfolders), you'll get the following dialog box:

Collections

Collections are the most versatile organizational tool in Lightroom. Folders keep track of the location of the original file, but Collections can have the file anywhere, as many times as you like. A photo could be in a Landscape, Portfolio, Prints, black-and-white, or Competition collection. Collections are an excellent way to organize your photos. They're so useable, especially since you can access them from every module in Lightroom. There are more than one type of collection, as well; you can use ordinary Collections, Smart Collections, the Quick Collection, the Target Collection, or module Collections. Collections only exist in the Catalog and are not saved with the XMP information.

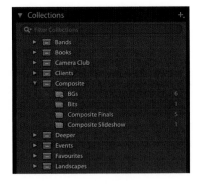

The Collection Set

Before we talk about Collections, let's talk about the principal tool in organizing the Collections themselves. Collections can't be stored inside other Collections like Folders can, so a different management tool is needed. This is the Collection Set. Collection Sets are like file boxes for Collections. You can have as many Collections as you like in a Collection Set (though there is a physical limit of about 1700—that holds true for Folders and Keywords, too). You can also store Collection Sets and Collections in a Collections Set. Why am I telling you this first? Because when you create a Collection, you get the option to put it into a Collection Set, but you have to create the Collection Set first. You can't make it when you're creating the Collection.

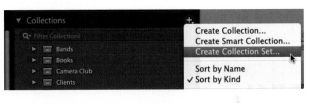

To make a Collection Set:

1. Click the + in the Collections panel header and choose Create Collection Set.

2. In the Library menu, choose New Collection Set.

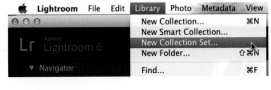

3. Choose to place this in another Collection Set—which you've already made, of course!

4. Click Create.

Don't worry if you forget to create your Collection Set in time—you can always make one later and drag your Collections into it.

The Collection

This is probably the most commonly used Collection type. It usually involves manually storing images that have a common connection or purpose. You could have Connemara scenery in a Collection stored inside a Landscapes Collection Set, for example. Let's make a Collection.

1. In Grid, select images you want to group together. Use the selection methods discussed earlier: Shift-click to add a row of images and Command-click (Mac) or Control-click (PC) to add single images. There are a few options for creating a Collection in Library:

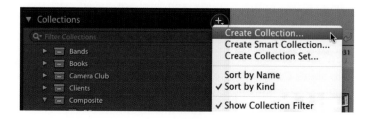

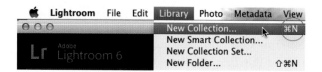

 - Click the + icon in the Collections panel header.

 - Go to the Library menu and choose New Collection.

 - Use the shortcut Command + N on Mac, or Control + N on PC.

2. When the Create Collection Dialog appears, enter an appropriate name for the Collection to make it easy to find.

3. Check the box for Include selected photos to add them to the Collection when it is created. You can create Virtual Copies too, so the photos in the Collection can be edited without changing the originals. An example of this is creating black-and-white versions of the photos while still keeping the originals in color.

4. If you want to add more photos to this Collection immediately, consider making this Collection the Target Collection. Check the applicable box to make this new Collection the Target Collection.

5. Finally, you can sync these photos to Lightroom mobile immediately via the Sync with Lightroom mobile option.

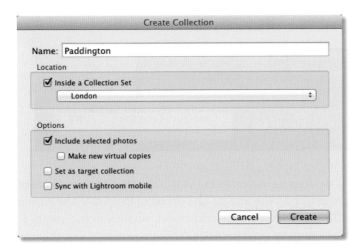

You can add to a Collection by dragging photos from the Grid or Filmstrip and dropping them on the Collection name in the panel. You can also make the Collection a Target Collection and use the shortcut "B" to add photos to the Collection. To remove them, just use the delete key. This will remove the images from the Collection, but leave the images on disk.

Organizing Collections

For a long time I had loads of single collections. This made the Collections panel quite cluttered. To find a Collection, I had to scan down the list to find what I needed, all because I was too lazy to be organized. Yet the effort involved in organizing the panel would have been much less than the effort wasted in searching for the Collection! When I realized this, I created a whole series of header Collection Sets. These covered all types of uses and genres for my photos—things like Tutorials, Landscape, Clients, and Projects got their own Collection Sets. Individual Projects got their own Collection Set inside the Project Collection Set. This made it easier to have all the images and the selects from a project in separate collections. The selects can even be a Smart Collection based on Flags, Stars ratings or Labels. Keeping Collections tidy saves time in the long run, a worthwhile endeavor.

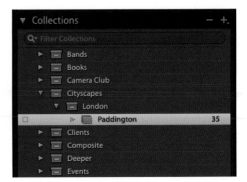

Quick Collection

The Quick Collection resides in the Catalog panel, and is active when there's a small + after the name (circled in red in the diagram). If there's no +, it means that there is a Target Collection active instead.

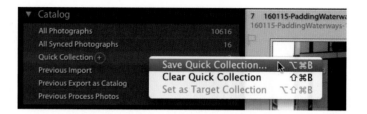

You can clear the images currently in the Quick Collection via the right-click menu, or by selecting all the images and pressing the delete key. Also in that menu is the Save Quick Collection command, where you can create a more permanent Collection for images in the Quick Collection. The last command, Set as Target Collection, is grayed out. This command becomes active when another collection is the Target Collection. You can then activate the Quick Collection again.

As you browse through various folders and collections, you can add (or remove) photos by pressing the "B" key. If you've got badges on your images, a circle badge appears in the upper-right corner of a Grid or Filmstrip thumbnail. Click this to add or remove the photo from the collection.

Target Collection

The Target Collection is identical in operation to the Quick Collection. Any normal Collection can be the Target Collection. Simply right-click on a Collection and choose Set as Target Collection. The + that was on Quick Collection will move to this Collection.

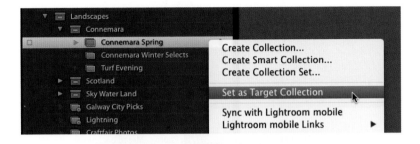

As with Quick Collection, the "B" key and the badge on the thumbnails will add or remove an image from the Target Collection.

Module Collections

In the Output Modules you can save books, slideshows, prints, and web galleries. These have an icon from the module they were created in, and double-clicking them loads the collection into the associated module with the saved settings from that module.

Notice the changed icons beside the highlighted Collections. There is a book icon for the Saved Book Collection, a play button for the Saved Slideshow Collection, a printer icon for the Saved Print Collection, and finally, a grid icon for the Saved Web Gallery.

Smart Collections

Smart Collections use a set of criteria to automatically gather matching images into a Collection. As with most Collections, they can be stored inside a Collection Set. Lightroom ships with some examples, like Five Stars, inside a Smart Collections Collection Set.

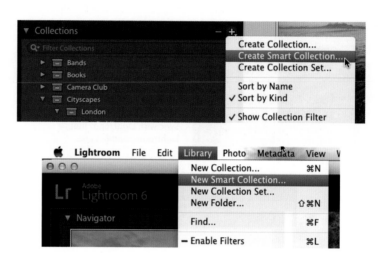

To create a Smart Collection, choose New Smart Collection from the Library menu, or click the + in the Collections panel header and choose Create Smart Collection. This opens the Create Smart Collection dialog box where you can search for specific items.

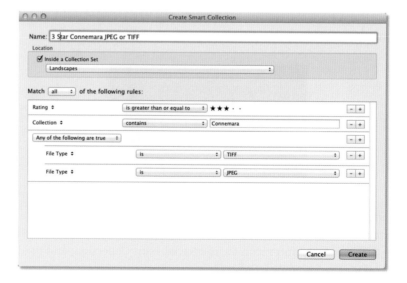

Let's talk about how to set this up. First, give the Smart Collection a usable name. Next, decide what Collection Set, if any, it will be going into. Decide if you're going to match all or match any of the criteria for the Smart Collection.

It's not obvious, but we can have mixed rules that allow more options. For our example, we start with a rating of 3 stars, with Is Greater Than or Equal To as the option. To add the Collection search, we click the + on the right of our Rating line. From the dropdown menu, we choose Collection, then Contains, then enter Connemara. So far we're searching for all files that are 3 Stars or more that are in a collection containing Connemara in the name. I'd like to have both JPEG and TIFF files, to get all my rendered files, but the current Match All option stops that, so what do we do? Well it's not too well known, but holding down the Option or Alt key will turn the +, which adds another criterion into a #, which allows us to make more extensive criteria choices, like choosing any additional critera, or excluding a criterion. Click the # on Collection, then choose File Type from the File name/Type menu, then choose TIFF. Click + on File Type and repeat for JPEG. Initially the choice between these is Any of the following are true, meaning either one, in our case. You can also have All of the following are true and None of the following are true, meaning you can force searches with negative options as well as a strict list of positive matches. That little Option/Alt trick actually makes Smart Collections far more powerful.

The criteria for Smart Collections aren't extensive, but you can see them in the list below:

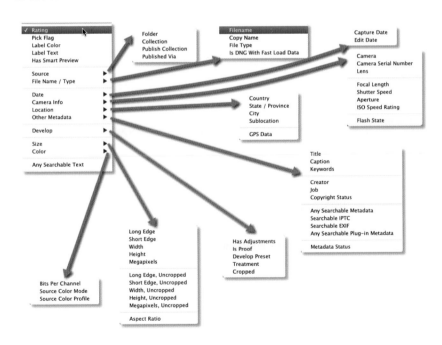

Smart Collections are created automatically, so you can't do a user sort on them. Because changing information in a file can remove it from a previously matching Smart Collection, any sort order would immediately break, making it useless.

As well as being great for finding sets of images in general, you can do very specific workflow tasks with Smart Collections. Here are a few examples:

- Adding Keywords: Create a Smart Collection with the criteria "Keywords," and use the option "are empty." You can now add keywords to the files in the Smart Collection. Be warned that as soon as you enter one keyword to a photo, it will drop out of this non-keyword Smart Collection, so create a new temporary collection and add all the files from the Smart Collection to this. The quickest way to do this is Select All from the Edit menu when in the Smart Collection, then choose New Collection from the Library menu and name it Files to be Keyworded. Delete this temporary collection when you finish however much work you want to do in a session. Recreate new ones as necessary from the Smart Collection later on.

- Adding Copyright: Create a Smart Collection with the criteria "Copyright Status," "is," and "unknown." Apply an appropriate metadata preset (e.g., the correct year and copyright information) to the images to update them with your Copyright information.

- Date: You could easily create a range of dated Smart Collections. For years, choose "Capture Date," "is in the range," then XXXX-01-01 to XXXX-12-31, where XXXX is the 4-digit year. Other useful date-related options include "last 30 days," and "last 7 days." To find recently edited images, use "Edit Date" with "is today" as your criterion.

- Flags, Ratings, and Stars: Use these to automatically mark your best images for collection. Mix these rating styles with dates to find images that need to be flagged from today, this week, and this month.

- File Type: Create a Collection that contains specific File Types to locate particular files easily, e.g., TIFF files or JPEG files.

- Adding Captions or Titles: Create a Smart Collection with "Caption" (or "Titles") and "are empty." You can now add captions or titles to these. Remember that as soon as you add a Caption or Title, the image will drop out of the Smart Collection. If your Caption requires more than one line, use the Large Caption field list in the Metadata panel to enter it.

These are just a few suggestions to help you get ideas on how to get better use out of Smart Collections.

Filter Collections

A new addition to Lightroom 6 is the Filter Collections bar at the top of the Collections panel. This lets you enter text, and hides Collections that don't contain that text. This tool is a great way to find a specific Collection quickly.

Publish Services

Publish Services are a way of exporting collections of photos out of Lightroom while still keeping a record of them inside Lightroom. You can publish to the hard drive, or to a Publish Services plugin. Lightroom ships with three such plugins, one for Behance, one for Facebook, and one for Flickr. It also offers a way to download more plugins for other services like SmugMug, Zenfolio, and Twitter.

Hard Drive

Let's creative a Hard Drive Publish Service with a twist. Rather than a normal drive folder, I'm going to export a set of images to a folder inside my Dropbox folder. This means the images will be available immediately online, for use on other computers, and on my phone or tablet.

I'll start by creating a parent folder, then put the publish folder inside it.

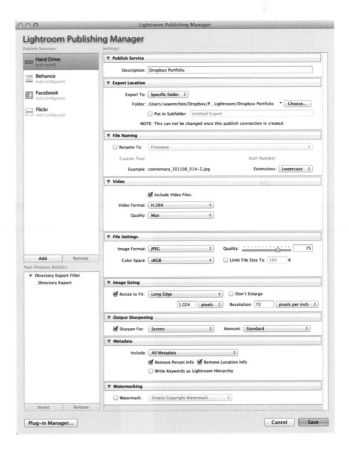

1. Click Set Up.. in the Hard Drive Publish Services.

2. Enter the settings in the following screenshot, choosing a folder in your Dropbox folder. We'll cover the nature of the settings in the next section: Export.

3. Click Create.

You now have an empty collection inside the Hard Drive: Dropbox Portfolio Publish Service.

Organizational tools for Publish Services are in the right-click menu.

You can make Publish Folders, Smart Folders, or Folder Sets. It's odd that they've chosen Folders here, because these folders work like Collections. Create a new Publish Folder called Landscapes from the right-click menu or the + icon in the panel header. Notice how the dialog looks like a Collections dialog.

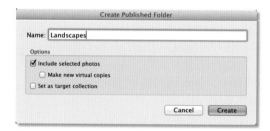

Add some photos to it. You now need to Publish. Notice that the photos are in a panel called New Photos To Publish. As usual, there are a few ways to accomplish this task. The Export button will have changed to a Publish button at the bottom of the Left Panel. On the top right of the image preview area is another Publish button. You can also right-click on the Publish Folder and select Publish Now.

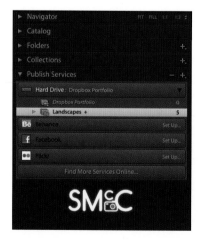

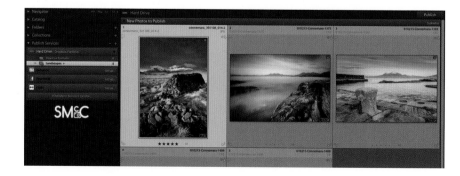

Once published, the panel in the main image area changes to Published Photos.

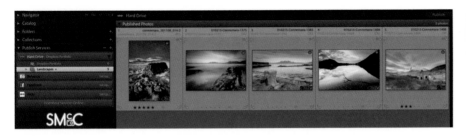

Right-click on the Folder and select Go to Published Folder. This will open the folder and show the images on the drive. Go to the folder on Dropbox to see them online.

If you make a change to a photo, a new panel will be created called Modified Photos to Re-Publish. If you delete a photo from the Publish Folder, that photo will go into a Deleted Photos to Remove panel. Both panels are cleared when you click Publish again. The deleted photo will be removed from the drive, and the modified photo will be added to the Published Photos panel.

Publish Services Plugins

To see one of the plugins in action, click Set Up.. in the Flickr option. If you don't have a Flickr account, you can set one up for free.

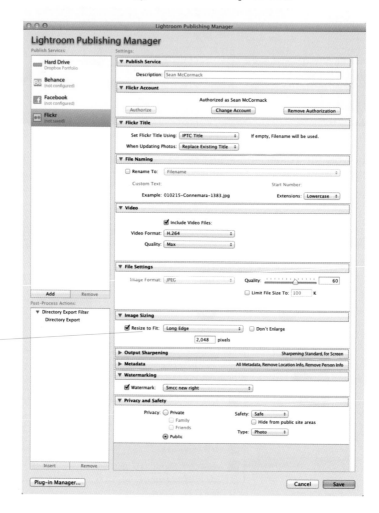

Drag some images into Photostream, and then click Publish. After the images are published, right-click on one of them and choose the Show in Flickr option.

The image will appear on Flickr. I've added a test comment to this photo to show an additional feature.

Go to the Comments panel at the bottom of the Right Panel. It will now say No Comments. Click the Refresh icon on the left of the panel header to load comments from online. The test comment will load here. You can add more comments from here, too, so you don't have to go online to get or make comments on Published Photos. A genuine comment came in after I posted this test, and I replied in Lightroom.

Services that provide commenting and liking/favoriting options (and access to them via software) will have them show up in the Comments panel. Facebook is a prime example, but many third-party plugins do it as well.

Export

Export is the primary way of getting photos out of Lightroom. Lightroom 6 has redesigned code so Export makes better use of multicore machines, making it faster than ever. To trigger an Export:

- Click the Export button at the bottom of the Left Panel of Library.

- Use the File>Export.. menu.

- Use the shortcut Shift + Command + E (Mac), or Shift + Control + E (PC).

The Export Dialog will open, showing the four main sections.

1. Export To: Location. The available locations are email (which we'll cover later), Hard Drive, or CD/DVD. The remaining options are presets for third-party applications.

2. The Presets section, where you create settings for particular tasks and then save them for later use

3. The Post Process Actions panel, where you can add plugins that work on the exported photos

4. The main export Settings panel

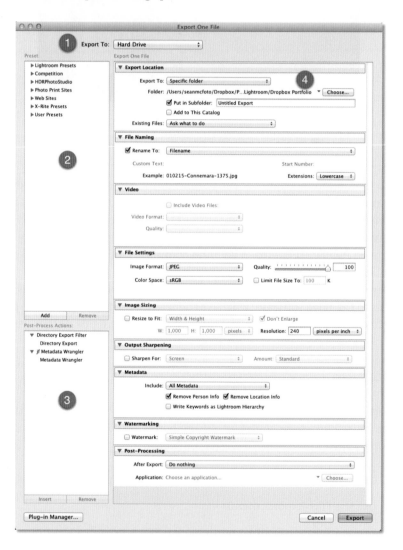

Export Amount

Take a look at the top of the Export Dialog. Here our example shows Export 1 File. If there were four files, it would say Export 4 Files, etc. Glance at this before you press the Export button so you're not accidentally working on a whole folder rather than the one file you wanted to Export.

Let's look at settings first.

Export Location

This is the location to which the file exports. Export To gives three options. The one you choose will affect the Folder option that follows:

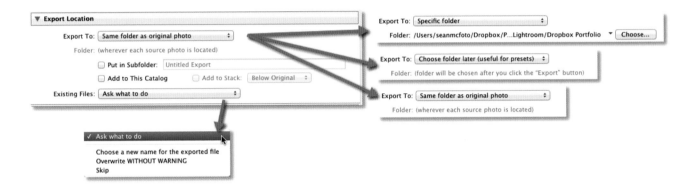

- Specific folder: This option lets you browse to a folder (or create a new one if required).

- Choose folder later (useful for presets): This leaves the Folder options blank. You'll see the message: Folder will be chosen after you click the "Export" button. As mentioned in the name, this is great for Presets, because you're not tied to a specific folder.

- Same folder as original photo: This leaves the Folder options blank. You'll see the message: wherever each source photo is located. This way, photos from different Folders on disk will have the export placed in the same folder as the source file.

Next in the Export Location dialog is the option: Put in Subfolder. This will be a new folder that is created and placed inside the Folder from Export To. If the Same Folder as original photo option is chosen, the subfolder will be created to include a source photo.

Add to This Catalog imports the selected photo to the Catalog via Add. When this option is selected, you also get the option to Add to Stack, which will group the exported file with the original file, either Below Original (hiding it in the stack), or Above Original (placing it higher in the stack or making it the top of the stack if a stack doesn't currently exist).

Existing Files decides what to do when files with the same name are in the same destination folder. You can Choose a new name for the exported file, Overwrite WITHOUT WARNING, or Skip. A fourth option at the top of the list (probably the best option) is Ask what to do. With this option, a dialog box will open to ask which of the other three options you'd liked to use.

You can see these options in the image of the dialog box below. Use Unique Names is an option that tags a number to the end of the file names to make them different than the existing file.

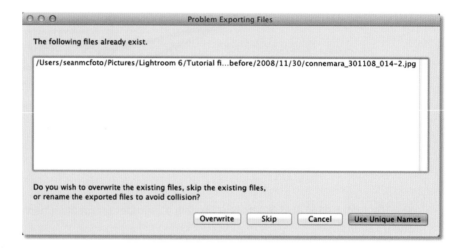

File Naming

This is identical to Import. Choose a File-naming Template to suit your file names. You can choose to use upper or lowercase file extensions.

Video

Video files can be exported. There are three options: DPX, H.264, and Original. DPX and H.264 include any edits made in Lightroom.

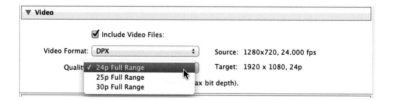

DPX (Digital Picture exchange) is a common format for visual effects work. It's good for use with Adobe Premiere Pro or After Effects. Files are always 1920×1080. You can choose from three Quality options: 24p, 25p, or 30p Full Range.

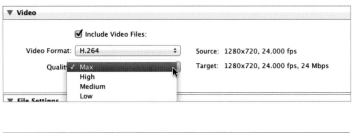

H.264 is a high-quality compressed format, perfect for mobile applications. There are four quality settings: Low (good for phones); Medium (good for web browsers); High (for better picture quality); and Max (matches the source file as closely as possible).

Copies the original file with no edits applied

File Settings

Here we choose the type of file that's exported, and the settings for how it's exported.

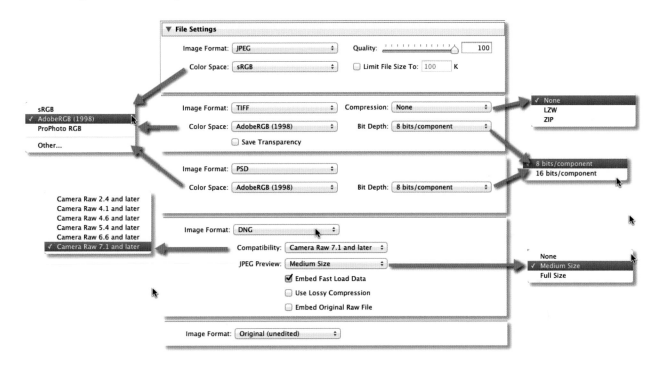

- JPEG: This is a compressed 8-bit file, perfect for sharing as a final file. The web is built for using JPEGs. Quality sets the amount of compression, with 100 being the least. 75-85 Quality is perfect for most exports, unless you absolutely want the Maximum. 100 is over twice the size an export as 90, without much visible increase in quality. For Color Space, use sRGB for general sharing, or Adobe RGB for magazines, if requested. ProPhoto RGB needs a 16-bit space to look best. If you need to export to a set size, then use the Limit File Size To option and enter that size.

- PSD: This is a Photoshop Document file with full quality and resolution that is readable by the Adobe Creative Suite. Choose 16-bit ProPhoto RGB for maximum editing ability, or 8-Bit Adobe RGB for smaller applications. It's better to convert to sRGB if needed from this file. PSD is a lossless compressed format, so it takes less space on disk than an uncompressed TIFF file.

- TIFF: This is best for sharing a full-quality file with others—as an editing format, and as a final archival file. I recommend using the same settings as with a PSD file, but use ZIP to make it smaller (LZW is less popular since the introduction of ZIP).

- DNG: This is a Digital Negative. Unless you're using really old versions of Photoshop, use Camera Raw 7.1 and later options to get the most out of DNG files. You can opt to Embed Fast Load Data with the newer options to create a Lossy DNG file. Using Lossy Compression also activates the Image Sizing options. Finally, you can Embed Original Raw files, which will more than double the file size, so I generally wouldn't recommend it.

- Original: This copies out the original file and adds any information from Lightroom into an XMP sidecar file.

DNG 1.4 Spec

Fast Load Data and Lossy Compression are part of the DNG Spec. So, what is the Fast Load Data? It's about a 200k preview of the file at 1024 pixels long that can be embedded in a DNG. This preview is read first by Camera Raw and Lightroom and allows the Develop sliders to activate much sooner than they would with the original file.

Lossy Compression reduces the size of the file by reading the tone curve of the file, and then applying high quality JPEG Compression based on that curve. This makes for a smoother file than normal JPEG compression. It also means that Lossy DNG files still have full white balance controls and close to the same highlight recovery as the original file. Because the file has been demosaiced from RAW, it also means you can reduce the size of the file. This Lossy Compression is how we can have Smart Previews, which are so beneficial in Develop. This forms the basis on which Lightroom mobile works.

A final benefit for DNG users is the change to using tiled images, where the data is in sections or "tiles" rather than one continuous compressed file. Because traditional files are continuous, the compressed nature of the file means each pixel has to be read in order—meaning only one processor at a time can read it. Tiled images, on the other hand, can be assigned over many processor cores, speeding up the whole process. It's more noticeable on fast drives (e.g., SSDs), because more time is spent reading than processing. It should be noted that DNGs created in-camera aren't tiled, but can be converted if you use Copy as DNG on Import.

Image Size

This is where we resize photos that are in file formats that allow resizing. First, check the Resize to Fit box to make the options active.

Next, choose the output size using the Fit options.

- Width & Height: This option restricts the photo to stay within the specified dimensions. For example, if you set it to 600×400, then files cropped to 2×3 (a normal DSLR file size) in landscape would be 600×400. Portrait images, however, cropped in the same way, would be

400 high, and only 267 wide. When restricted by the Width & Height option, the file must stay within these constraints. This is a useful tool for creating files for for web pages with a set height.

- Dimensions: This option will convert every file to the specified dimensions. In the case of using 600×400, both portrait-oriented and landscape-orientated image files will be rendered as 600×400 images. Portrait would be 400×600, and landscape 600×400.

- Long Edge: This is my preferred option. Enter one number for the size of the longest edge (either the vertical or horizontal edge), and the other side of the image automatically resizes accordingly.

- Short Edge: This is the reverse of Long Edge. Set the short edge length, and the long side resizes accordingly. The maximum size will still be restricted by the maximum length of the long edge (65,000px).

- Megapixels: This option will export the file as a Megapixel value up to 512MP.

- Percentage: This option uses a set percentage to define the export size.

Don't Enlarge will prevent photos from being exported in a larger size than the original.

Pixels is the most common dimension used, but you can choose inches or centimeters.

Finally, for Resolution, enter a preferred value in pixels per inch (ppi) or pixels per cm. 300ppi is a common resolution for high-resolution files, as is 72ppi for screen use. These denotations don't change the size of the file in terms of pixel values; they merely tell the software translating the file how to display it. If you use inches or centimeters, this value will affect the pixel dimensions of the exported file.

Output Sharpening

Set automatic sharpening on export. There are three media settings: Screen, Glossy Paper, and Matte Paper. Each setting is progressively stronger than the previous. Each also has three sharpening amounts available: Low, Standard, and High. You can't preview these once you've set them, but the settings are based on those from the tried and tested research of experts like the late Bruce Fraser and Jeff Schewe of the Pixel Genius group.

Metadata

This is the panel where you can set what metadata gets applied to the exported files. You have four main options:

- Copyright only: This removes all information except that in the Copyright fields.

- Copyright and Contact Info: This leaves the copyright and all the contact information intact, but removes all other information.

- All Except Camera & Camera Raw Info: This is to remove just the camera settings and whatever Develop settings were used to create the look of the file. An app exists that can read these settings from Flickr and create a Preset from them, so if you feel that your processing data and settings are none of anyone's business, this setting is for you.

- All Metadata: This setting includes all information.

When either of the two All.. options are selected, more options become available, including:

- Remove Person Info: This removes Face Recognition data so the people in the photos remain anonymous.

- Remove Locations Info: This hides Location data, e.g., via Map or GPS, to protect the location of the photo.

- Write Keywords as Lightroom Hierarchy: This matches the keyword structure, so the keywords aren't a flat list.

Watermarking

This is where you can apply a logo or any copyright information to the exported file. There's a dedicated section on making Watermarks coming later in the text.

Post-Processing

The Post-Processing section lets you send the photos to another application for further processing. Normally this option is set to Do Nothing, so the export completes directly, as though no other applications exist.

You can choose from the list of installed apps that automatically populate the list, or choose from two other methods to get to other applications:

- Choose Open in Other Application.. from the After Export dropdown menu. The Application section will become active and you'll be able to use Choose to navigate to the application you want to use. Compatible applications usually are ones that support drag and drop responses (for instance, how dragging a file onto the Photoshop icon will open that file in Photoshop). Choose the application.

- Choose Go to Export Actions Folder Now from the After Export dropdown menu. This opens the Export Actions folder located inside the Lightroom Presets folder. This folder is empty initially. Drag Photoshop droplet files (these are Photoshop Action Files that have been converted into executable programs), or shortcut/aliases to the programs you want to use—Mail, for example, or Photomatix. For Mac, Command + Option will let you drag an application into the folder to automatically create an alias. Some FTP programs create droplets, making them useful for getting files online automatically after export. Restart Lightroom for these files to become visible in the After Export menu.

Presets

The Presets are on the top left of the Export Dialog. To save the settings for use again, click Add and give the Preset a name. You can also create a Preset Folder to help organize your Presets.

Once you've made the Preset Folder and named your Preset, click the Create button. The new folder and Preset will appear in the panel.

Our example shows a good web preset: 960px sRGB JPEG at 75% quality, sharpened for screen, with a simple watermark. Let's say we update the watermark to our logo instead. Simply right-click on the Preset and choose Update with Current Settings to have the preset updated to reflect the new watermark.

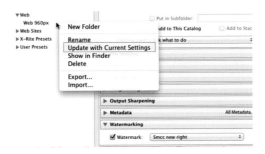

Export Presets Menu
The presets you create here also appear in the File>Export with Preset.. menu, and can be used without having to run Export again. Handy!

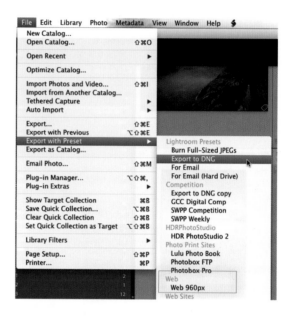

Post-Process Actions

Post-Process Actions are third-party plugins that offer additional functions over what Lightroom offers. Here are two examples:

- Directory Export: This creates a folder structure to match that of the original files.

- Metadata Wrangler: This option, from Jeffrey Friedl, lets you specify what metadata is added to the file, including none—something Lightroom doesn't do.

Click Insert to add these to the Export (before the Post-Processing) or Remove to Take them out. When you're ready to Export, click the Export button or press return. A Progress bar in the Identity Plate will let you know how the export is going.

Export to CD/DVD

This option is identical to Hard Drive, except you don't get a choice of location—it'll be the CD or DVD you insert into your machine. You also don't get to use post-processing from external applications. When you click Export, the files will export, with a Preparing files for disc burning progress bar. After this process is complete, a new dialog will open, prompting you to insert a disk. Insert a disc and click Burn. When the files have been burned, the disc will eject and the temporary files will be deleted. If the files are too big for the disc, Lightroom will request more discs as required.

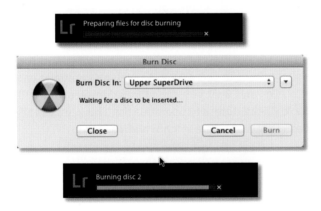

Email Photos

When you select the Email option at the top of the Export panel, you'll be able to choose options for the photos you're exporting. Clicking Export runs Lightroom's internal Mail Dialog with Custom settings defined in the Export Options dialog for the Size. So, let's take a look at email in Lightroom.

Like with Export, there's a dedicated menu for email: File>Email Photo, with the shortcut Shift + Command + M (this is available on Mac only—the PC shortcut was taken for headless Merge, and hasn't been assigned a new one).

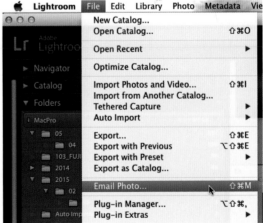

Once the Dialog loads, it resembles an email application.

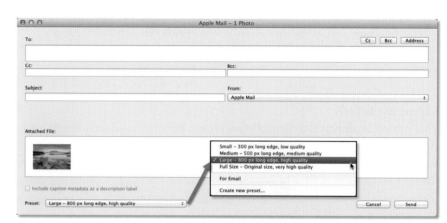

The main thing to decide is what size the image will be. Choose from the Preset list or create your own from the Create Preset.. option in the list. This opens Export in Email mode, where you can build a new preset for inclusion in the list, or just change settings to get back to the Custom settings defined in Export Options dialog in Email Export.

In the diagram above, I've clicked Cc (Carbon copy) and Bcc (Blind carbon copy) to show them in the dialog. As well as manually entering email addresses in To:, Cc:, and Bcc:, you can store addresses and pull them from an Address Book. Click Address to open this list. This only has addresses you enter, and doesn't read from the system address book.

Enter the Subject. By default, Lightroom will email via your default mail application—in this case Apple Mail. If you know the SMTP details of your email server, you can click Go to Email Account Manager and enter the information to send the photos directly from Lightroom.

You can automatically generate body text by checking the box for Include caption metadata as a description label.

Click Send. The benefit of going through Mail is that you have a copy of the message in your Sent mail, whereas you won't when you use an SMTP server to send mail.

Watermarking

The argument over whether or not to watermark your photos reigns supreme on the interwebs. The fact is, images are stolen every day, watermark or not. The benefits of watermarks are the same as the downsides; a logo or message displaying the owner might ruin the aesthetic of your photo, but it makes sure people know you took it. Some say having a watermark is a sign of ego or insecurity.

As someone who's had quite a few photos stolen, and even had them used to build fake accounts on modeling sites, I know what side of the argument I'm on. Watermark it and ignore the whiners. From a work perspective, I have to watermark particular photos, anyway. The nightclub I shoot for wants their logo visible in the image to promote the club.

To create a Watermark, go to Lightroom>Edit Watermarks on Mac, or Edit>Edit Watermarks on PC.

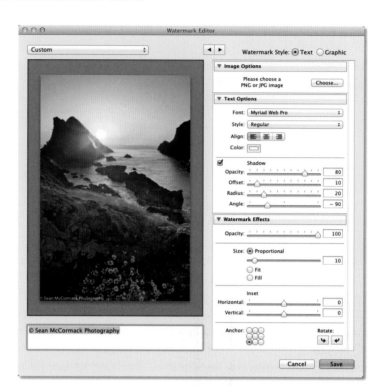

You have two watermark types: Text or Graphic.

Text

Unlike the Identity Plate, text settings for watermarks affect the entire text, so it's not possible to create a logo using the text options. By default, Lightroom reads your username and applies that as the watermark text. It can be anything, though—simply edit the text under the sample image. For our example, we'll make a large copyright symbol in the center. Remove or edit the text (but leave the ©).

In Text Options, choose whatever Font, Style, Align, and Color values you prefer. Note that OpenType fonts are not supported, but the default settings are fine for our desired use. A shadow will work well to lift the text off the photo and also as a background to white text on a lighter-toned photo. Opacity controls the strength of the shadow. Offset controls how deep the shadow will be, simulating distance from between the text and the photo. Radius controls the softness of the shadow. Lastly, Angle controls the angle of the shadow's virtual light source.

For Watermark Effects, start by reducing the Opacity to 10%. You want it visible, but not obnoxious. For size, there are three options: Proportional (with a scale of 1-150), Fit (which will make the watermark fit inside the width of the photo), and Fill (which expands the watermark to fit the width and height of the photo). Fill is the best option for us here, though we will tweak it a little.

To make the watermark smaller, we'll use the Horizontal and Vertical Inset. In this case, only the Horizontal Inset does anything, so we'll set it to 4. Finally, for Anchor, we'll choose the center. Fill has it centered anyway, but this is just making sure.

Click Save to name the Watermark, and then Create to save it. It now appears in the top-left dropdown menu.

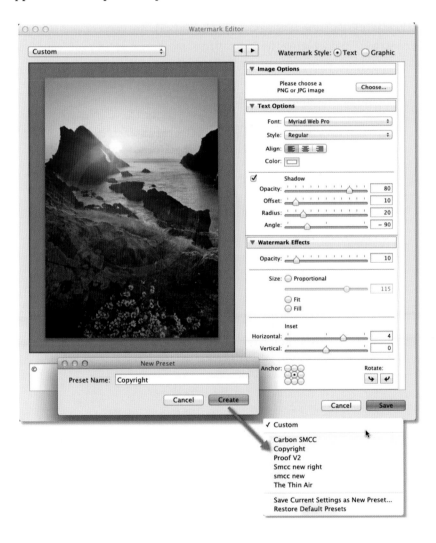

Graphic

For the Graphic option, click the Choose button in Image Options. As per the text, use a JPG or PNG. If you want transparency, PNG is the option. I keep my logos and general graphics files in a folder on Dropbox called Graphics. Before I organized them this way I would often end up looking for files for ages, finding them on older external drives or even other computers. Organizing them in one folder made it all so much easier.

With the file loaded, Text Options get turned off and the text box is grayed out. Watermark Effects are still available, though. I want this graphic on the right side of the photo, so I choose the bottom right bubble in the Anchor section of options. Rather than have it across the bottom, I want it sideways, so I click the left Rotate button.

It needs to be smaller, so I click Proportional and reduce the slider to 13. The logo is a little close to the edge, so I bring both the Vertical and Horizontal Inset to 1. Finally, I bring the Opacity to 80, so it's not as "in your face." Save and Create again to have it appear in the menu.

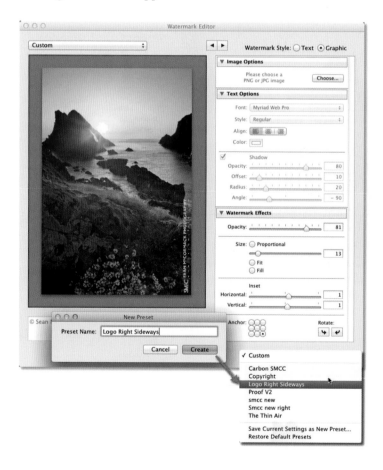

The Right Panel

The Right Panel is where the nitty gritty gets done, from making Smart Previews, to Quick Developing our photos, to managing Keywords and Metadata.

The Histogram

At the top of the Right Panel is the Histogram. This graph represents the range of colors in the image, from blacks to whites. The height at any point of the graph represents the intensity of color at that point. Directly below the histogram are the camera settings for the photo, if available: ISO, Focal Length, Aperture, and Shutter Speed.

 With many images selected in Grid, the currently selected image is used to generate the Histogram and camera information. Below this is the Smart Preview information, which we've already covered in the Smart Previews section. Finally, if a photo has been rendered with a previous Process Version, a little lightning bolt will appear on the bottom left of the Histogram. Click to change it.

Quick Develop

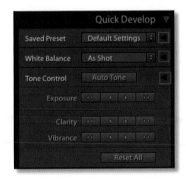

Quick Develop gives access to the controls from Develop's Basic panel in button form. These controls are relative controls in that they add or subtract from the current setting. In Develop, where sliders are used, the settings are absolute—they become identical in all affected images (via sync, auto sync, etc.). Normally, if two images were selected and one image had 1 stop of exposure added already, clicking the rightmost button in Exposure would take that to 2 stops of Exposure; the second image would now be at one stop of exposure. However, if done in Develop, both images would be at +1 stop of Exposure. Quick Develop's key use is in batch processing large quantities of images in Grid.

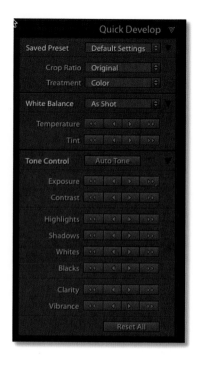

By default, Quick Develop is quite a small panel. Click the disclosure triangles highlighted to get the full panel.

Let's look at the three sections.

Saved Preset

This section houses the full list of Develop Presets currently available in Lightroom. Fortunately it's not a flat list these days, and has one folder level. Go to a preset folder and choose a Preset to apply it.

Next is Crop Ratio. Here you can select from the list of factory and custom crop ratios. If you need a different ratio, click Enter Custom.. at the bottom of the list to save a new ratio. You can have five custom ratios, and the newest one created will replace the oldest in the list. Here I'm entering 851×315, a Facebook cover photo crop size. You can enter any number from 0.001 to 10,000 to create a ratio. Lightroom will automatically work out the final ratio from the numbers.

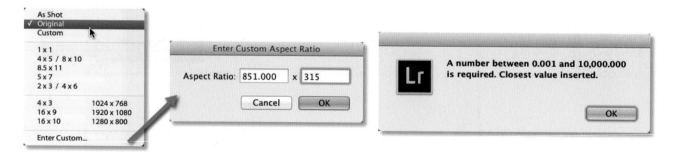

The crop is applied centrally to ensure that an even amount of image space is taken from each side of the photo. It's useful to know this, because you can shoot to suit the crop. For example when shooting headshots, the print is normally 8×10 inches. On a normal DSLR, you'd allow space above and below, knowing the 8×12 size of the DSLR would have an inch taken off at the top and bottom for the print. Below is what the custom crop of 851×315 has done to a batch of images. If you have badges turned on, the Crop badge will be visible in your cropped images.

Treatment changes the selected images between color and black–and–white.

✓ As Shot
Auto
Daylight
Cloudy
Shade
Tungsten
Fluorescent
Flash
Custom

White Balance

White Balance is the next section. Choose from the Presets in the list (JPEG, TIFF, or PSD will only have As Shot, Auto, and Custom) or use the Temperature and Tint buttons. The single arrow applies a small change (about 315K in temperature, 4 for Tint), while the double arrow applies a larger change (about 1500K in Temperature, 17 in Tint).

One thing to be aware of is selecting As Shot to try and sync a White Balance across a series of images. All it does is return photos to the original color, not match to the current image.

Tone Control

Tone Control gives access to the main global Develop tools from Library. Auto Tone is the first button and attempts to do a global fix for the image. It's hit or miss—usually miss. Auto Tone usually works with the Exposure, and Blacks and Whites adjustments (visible in the panel below Auto Tone).

We'll go into more detail about the settings themselves in Develop, but for now, let's process an image in Quick Develop.

For the sake of it, we'll start with Auto Tone. If it works, great!

Auto Tone has done a good job this time. The brightness and contrast of the image have increased and it looks much better already. The sky is a little bright, though. I hit the down double arrow in Highlights to bring back some highlight detail. Next I click the up double arrow in Shadows to open up the darker parts of the image.

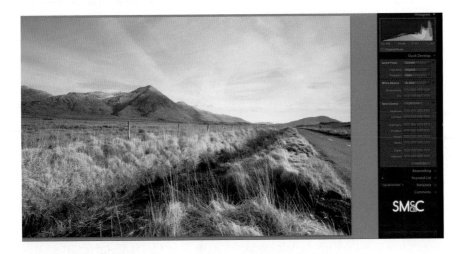

While I like the more open shadows, I think the very darkest parts of the image need to be darker to help make the image more punchy, so I click the down single arrow in Blacks twice—the double arrow was too much. Next I hit the up double arrow in Clarity to improve the midtone contrast. I liked it so much that I did it again.

Next I boost Vibrance—two clicks on the double arrow. Because Vibrance protects skin tones, the yellow in the grass is not getting as much color as I'd like. Saturation would be much better. But there's no Saturation control. Or is there? Hold down the Option (Mac)/Alt (PC) key and the Clarity and Vibrance controls turn into Sharpening and Saturation controls. Two clicks of the up single arrow in Saturation is enough. Finally, add a little Sharpening. Be warned that Sharpening is only properly visible at 1:1.

A few quick clicks and our photo has dramatically improved.

Had we done all this post-processing using the largest thumbnail in Grid, with all similar photos selected, they'd all be finished now. The Sync Settings button at the bottom will copy settings to other photos, so use Command (Mac) or Control (PC) and click other photos to change in suit. Click Sync Settings. Click Check All to sync everything, or uncheck the options you don't want to copy to other photos, and then press Synchronize. The other photos will update to match your input settings.

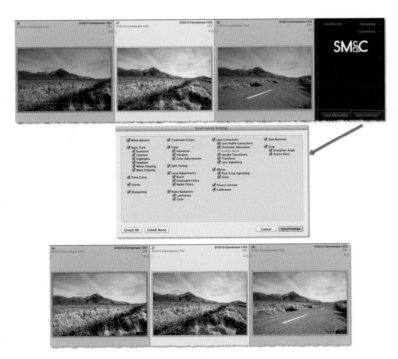

If you want to start again with new settings, click the Reset All button. If you want to reset individual controls, double-click on the name of the control, e.g., double-click Exposure to reset it.

> **Hidden Panel, Crouching Presets**
> When the Quick Develop panel is closed down, the Presets menu becomes part of the panel header, so it can still be accessed quickly.

Keywords

Keywords are critical to finding a photo as soon as you need it. As well as words that describe the contents of a photo (waves, sea, sky), using words to describe the emotion associated with the photo will help finding photos within a certain theme (calm, turbulent, love), especially for stock photography. Even the overall color of the photo makes for a useful keyword.

Lightroom has two panels dedicated to Keywords: Keywording and Keyword List. We've seen that Lightroom also offers keyword entry in the various import methods provided.

Keywording

The Keywording Panel has three sections: Keyword Tags, Keyword Suggestions, and Keyword Sets.

Keyword Tags

Keyword Tags is the manual keyword entry area in Library. You can enter text in the main window, or the Click here to add keywords box. This box can also be activated from the Photo>Add Keywords.. menu. You have three options of visibility here:

- Enter Keywords: Allows Keyword entry.

- Keywords & Containing Keywords: Shows parent keywords from keyword hierarchies.

- Will Export: Shows keywords that will export with the image. You can create keywords that are visible in Lightroom, but not in exported versions.

If you have more than one image selected, and they have different keywords, all keywords from all images will show. The keywords that are not shared by all images will have an asterisk (*) after them. Re-enter the keyword to apply it to all images.

You can enter keyword hierarchies using the greater than sign (>). Put the highest level first, then subkeywords next, e.g., 1>2>3, Flora>Fruit>Pear, or Automobile>V6> McLaren MP4/4.

The keywords visible here are the generic keywords applied to the whole import. Some of the photos were long exposures with a 10-stop filter, so I want to apply this information as keywords. I could use shutter speed to search for long exposures, but this wouldn't indicate use of the 10 stop filter—nighttime shots could be just as long without a filter, for example. So I enter "10X" and "Long Exposure" separated by commas into the entry field.

Keyword Suggestions

Below Keyword Tags is Keyword Suggestions. Lightroom remembers recently added keywords, keywords from surrounding photos, and other photos that have shared keywords with the current photo. It adds them to the Keyword Suggestions, giving you a quick way to locate and add these potentially related keywords to the image.

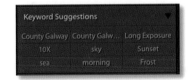

Keyword Sets

The basic Keyword Set visible by default is Recent Keywords—the nine most recently used Keywords. While you can just click on them in the list, there is a keyboard shortcut. Hold down the Option (Mac)/Alt (PC) key. Each Keyword gets a number. Press this number to apply the keyword.

There are three other default Keyword Sets in the panel to provide examples of a Keyword Set. These are Outdoor Photography, Portrait Photography, and Wedding Photography.

Option/Alt + 1-9 also applies the keywords in these sets. Option/Alt 0 is available too, but not for a keyword. This shortcut swaps between Keywords Sets. This helps overcome the nine-keyword limit per set. Keywords Sets also have a dedicated menu section in the Metadata menu where they can be selected and edited.

To create a new Keyword Set, Choose Edit Set.. from the dropdown menu, or Edit.. from the Metadata>Keyword Set menu. Edit the entries, and then choose Save Current Settings as New Preset from the menu. Name the Preset and click Create. The new preset name will appear on the list. Click Change to make this the selected Keyword Set.

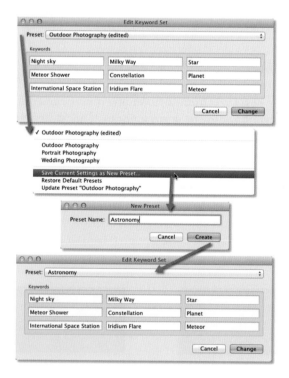

Keywords from this set can be added from the Photo>Set Keyword menu.

Keyword List

After Keywording is the Keyword List. While initially it just looks like a list of keywords, it's from here that you create, edit, and manage your keywords and their hierarchies.

At the top of the list is the Filter Keywords bar. Enter text here to reduce the list to show matching keywords. Click the "X" at the right of the bar to reset to the full list.

Looking at the full list, some things are noticeable. The check beside some of the items indicates that the current image contains those Keywords. There's a number beside each Keyword too; this indicates the number of photos that have this keyword.

If we hover over a Keyword, an arrow appears to the right. Clicking on this arrow will show us all the photos with that keyword.

You can drag a keyword from the list onto a set of selected images to apply it to them all, or drag images onto the keyword to accomplish the same purpose.

Double-click a Keyword to Edit it. The name at the top is the Keyword. The Synonym section is where you add words with similar meanings. All the synonyms get added on export if you set that option. This is just a way of increasing the chance of a photo being found in a search.

The Keyword Tag options let you set specifics for this keyword:

- Include on Export: This adds this keyword and its synonyms to the image on export. Unchecking this option means the keyword is a private keyword, visible and searchable in Lightroom, but not to the external world. Unchecking this option also unchecks the next two options (Export Containing Keywords and Export Synonyms). You could use this to create the parent of a hierarchy that you don't want outside Lightroom.

- Export Containing Keywords: If the keyword is in a hierarchy, this allows the parent keywords to be exported, as well.

- Export Synonyms: This allows the tags entered in the Synonyms box to export.

- Person: This converts the keyword to a person keyword (i.e., the name of a person), allowing it to be used in People view. This means that where you've used keywords in the past to find people, you now have a way to tie them to face regions for People view.

Let's say you want to apply names to people in People view. You can set up the names before you apply them by clicking the + icon in the Keyword List to create a keyword. In this dialog, you can set the person's name, and choose to uncheck the Include on Export option. If the person is better known by a nickname, you can include it in Synonyms. The Creation Options section appears under the Keyword Tag Options, because we have both an image and a keyword selected. We can add this under the currently selected keyword, or add it to the current image. This will now be a suggested name in People view.

Create Keyword Tag

Keyword Name: David Rice

Synonyms: Ricey

Keyword Tag Options
- ☐ Include on Export
- ☐ Export Containing Keywords
- ☐ Export Synonyms
- ☑ Person

Creation Options
- ☐ Put inside "Ailbhe Coyle"
- ☐ Add to selected photos

Cancel Create

Hierarchies are useful for a number of reasons. They help by preventing Lightroom from having long, flat lists. They organize similar things together; this allows the shared parent keywords to be applied on export. The hierarchy can travel with the image on export and is readable by other programs.

We've mentioned using the greater than symbol (>) as way of making hierarchies, but you can also drag and drop keywords into other keywords. Take our "10X" and "Long Exposure" keywords from earlier. Long Exposure photography is a wider field than 10X, so 10X could fit inside Long Exposure. Simply drag 10X onto Long Exposure and release it. Now when I enter 10X as a Keyword, Long Exposure gets entered automatically as well.

Your full keyword list can be exported and imported into another catalog. While the single catalog workflow is optimal, you may prefer a different system, like a catalog per job, or yearly system. Exporting the list means that you've got all the special edits for Include on Export and Person ready for a new catalog. Both Import and Export Keywords are in the Metadata menu. There are companies that make predefined lists specifically for stock photographers; for example David Riecks' *Controlled Vocabulary* at http://www.controlledvocabulary.com/ or Shangarah Singh's Keyword Catalog at http://www.keyword-catalog.com/

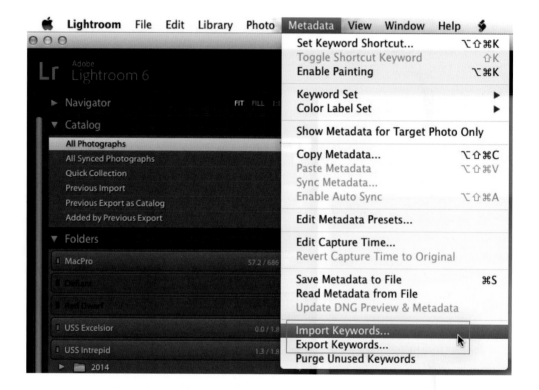

Painter Tool

While applying keywords is just one of the uses for the Painter Tool (aka the spray can), this is a good place to introduce it. The Painter Tool is located in the Library Toolbar. If the Toolbar isn't visible, press T to toggle it on. If the Painter Tool isn't visible in the Toolbar (again, it's the spray can icon), go to the triangle on the right of the toolbar and select it from the list.

To activate the painter, click on the spray can icon. The cursor will turn into a spray can, and the Painter Tool options will become visible. The first option is Keywords. Enter a series of keywords to apply them via the Painter Tool. If you hold the Shift Key with the text box active, it loads a modal version of the Keyword Sets panel to allow a quick choice of keywords. Essentially this means the Keywords Sets panel floats out from the Painter Tools options, so you don't need to go to the panel to make use of these sets.

To add the keywords to a photo, click on the photo cell. To add these keywords to a series of photos, just click and drag over them. Photos that have the keywords (or other Painter Tool settings) get highlighted with a white border.

To remove the Painter Tool settings, hold down the Option(Mac)/Alt(PC) key. The cursor changes to an eraser. Click or Click and drag to remove the settings. A bezel will appear to show what you've done.

Let's have a look at the other options.

- Label: Choose a color label to apply to the images.

- Flag: Choose from Pick, Unflagged, or Reject flags.

- Rating: Choose from 0-5 stars to apply a star rating to the images.

- Metadata: Choose a Metadata Preset to apply to the images.

- Settings: Choose a Develop Preset to apply.

- Rotation: Choose from Rotate Left, Rotate Right, Flip Vertical, or Flip Horizontal.

- Target Collection: Use this to add or remove an image from the Target Collection.

Metadata

The Metadata Panel allows you to add Metadata Presets to your photos, as well as control how you view and edit Metadata on individual photos or groups of photos. To apply changes to groups of photos you must have the Show Metadata for Target Photo Only box, in the Metadata menu, unchecked changes will only apply to the current photo. Catalog Metadata will be covered in the next section

At the top of the panel is the Preset Dropdown. Select or Edit a Metadata Preset from here.

Metadata Field List

There is a menu in the Panel header that lets you select a Metadata Field List. These lists restrict the entire range of available metadata into usable chunks. The list includes:

- Default: This option displays the filename, copy name, folder, rating, text label, and a subset of IPTC and EXIF metadata (like camera settings and camera data).

- All Plugin Metadata: This option displays custom metadata created by third-party plugins. If no plugins are installed, this option will display filename, copy name, and folder.

- EXIF: This option displays the filename, file path, dimensions, and EXIF camera metadata such as Exposure, Focal Length, ISO Speed Rat-

ing, and Flash. If your camera records GPS metadata, that information will be embedded in the EXIF metadata.

- EXIF and IPTC: This option displays the filename, file size, file type, file location, metadata status, and all EXIF and Core IPTC metadata.

- IPTC: This option displays the filename and the following IPTC metadata: Contact, Content, Image, Status, and Copyright metadata.

- IPTC Extension: This option displays the filename and IPTC Extension metadata, e.g., model releases and other types of licensing information.

- Large Caption: This option displays a large caption edit box and the copyright box. This is useful for entering multiline captions because hitting the return key will create a new line, not enter the information and exit out of the caption box.

- Location: This option displays the filename, copy name, folder, title, caption, and location fields, including GPS data.

- Minimal: This option displays the filename, rating, Caption, and Copyright metadata.

- Quick Describe: This option displays the filename, copy name, file path, rating, and the following EXIF and IPTC metadata: Dimensions, Date Time, Camera, Title, Caption, Copyright, Creator, and Location.

- Video: Displays video-related information.

Third-party plugins can have their own Field Lists defined and added here, as well. An example is the free Fashion Team plugin I've created for recording the participants in the editorial and advertising fashion shoot. The plugin is available on the Adobe Add-ons site:
https://creative.adobe.com/addons/products/2315

Helper Icons

Notice that some of the fields in the list have little icons, like an arrow or a series of lines. Clicking these icons will run an action relating to the field. For example, clicking on the arrow beside an IPTC or EXIF field will bring up all photos with that setting. Clicking the arrow beside the Folder name will open that folder, and clicking the lines icon on the Filename will allow you to rename the file.

Metadata Menu

As well as the Metadata Panel, there's a dedicated Metadata menu. We've seen some of the commands already, but let's review the others.

Copy Metadata

There are four commands in this section: Copy, Paste, Sync, and Enable Auto Sync. The latter two are available when more than one photo is selected. Copy Metadata brings up a dialog similar to the Metadata Preset dialog. Select the fields you want to copy. Having fields that are left blank or are unchecked won't affect the images. Pasting will place the previously copied metadata to any selected photos.

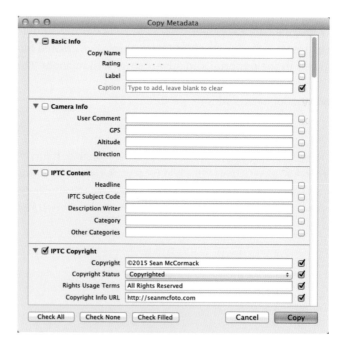

Sync lets you copy metadata from one photo to the other selected photos. The dialog is identical to Copy Metadata except for the name in the title bar. Using Enable Auto Sync means that as you make changes to the current photo, those settings also update immediately in the other selected photos.

Edit Capture Time

Before editing the capture time in Lightroom, you need to decide if you want to change the time in the original file, or just the Catalog. Nothing Lightroom does affects the original file, but for incorrect capture time, Lightroom can write back to the file if needed.

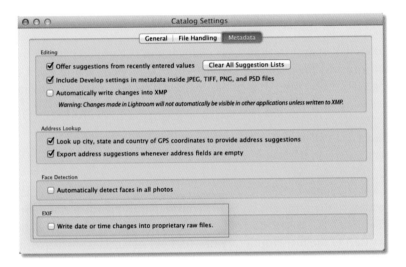

Go to the Metadata tab of the Catalog Settings (Lightroom>Catalog Settings on Mac, Edit>Catalog Settings on PC). At the bottom is EXIF, which has one option: Write date or time changes into proprietary raw files. Checking this box turns on Writing into the file, and displays a warning that you will alter the contents of the file you edit. Go to the Metadata menu and select Edit Capture Time.

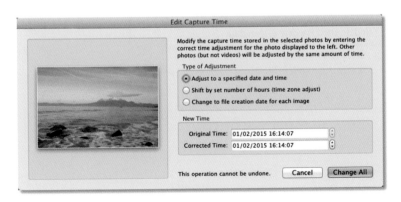

You have three options for the change:

- Adjust to a specified time and date: Enter the correct time and date. Lightroom will incrementally change the time or date of all other selected photos by the difference between the new and old information.

- Shift by a set number of hours (time zone adjust): Selecting this will cause a menu to pop up that allows you to choose a number of hours by which to adjust the currect information.

- Change to file creation date for each image: This changes the time of each image to match the date the file was made.

Lightroom will warn you that these changes can't be undone, but there is a menu command called Revert Capture Time to Original. If you use a date-naming system and then change the creation date, you may want to rename the files to make use of the new date.

Save, Read, and Update Metadata
The last options in the Metadata menu are:

- Save Metadata to Files (Command + S on Mac, Control + S on PC): This writes all the information from Lightroom into the file for rendered files like JPEG, TIFF, PNG, or PSD. DNG files also have the information written to the file. Proprietary raw files get a sidecar XMP file with the Metadata written to it. These XMP files are readable by Lightroom, Bridge, and Camera Raw.

- Read Metadata from Files: This overwrites the current metadata in Lightroom with the information from the files.

- Update DNG Preview & Metadata: This updates the information and embeds a new preview into the DNG.

Save Metadata to File	⌘S
Read Metadata from File	
Update DNG Preview & Metadata	

Metadata Preferences

Because we're going on to Advanced Catalog Workflow next, let's look at the final items in the Catalog Settings Metadata tab.

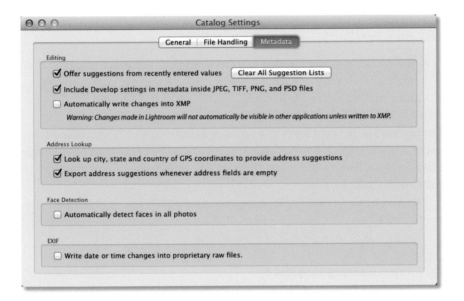

Editing

There are three options here:

- Offer suggestions from recently entered values: This turns on the auto fill, which completes text as you write to speed the data-entry process.

- Include Develop settings in metadata inside JPEG, TIFF, PNG, and PSD: You can opt to include Develop settings in rendered files. This function has limited use because while Lightroom and Photoshop can read and render these file correctly, other apps can't, which means your edits aren't visible. It's better to export a new version of the file with the settings applied.

- Automatically write changes into XMP: Choosing this option will elicit a warning that changes made are not visible to other apps unless they've been saved. It doesn't warn you that constantly writing Develop updates as you post process your images will slow your machine down. This option is not recommended unless you have a super fast machine. Manually selecting all images and using Command + S on Mac or Control + S on PC will save metadata in the same way and will only slow you down as it runs.

Address Lookup
There are two options here:

- Look up city, state, and country of GPS coordinates to provide address suggestions: This is the reverse lookup in which Lightroom will fill in the address information in the Location IPTC.

- Export address suggestions whenever address fields are empty: If the address fields are unused, Lightroom will fill them in based on GPS information as the file exports.

I'm not sure why you'd want the address fields empty in Lightroom before exporting your files. If you're using Maps and GPS, better to have those fields filled for your own records, and then choose to include or exclude them in the Export Dialog.

The last two sections are Face Detection and EXIF, which have been covered elsewhere.

Advanced Catalog Workflow

We've covered making and selecting catalogs, but now we're going to take a much deeper look at them.

Catalog Anatomy

From a technical viewpoint, the Catalog is a database file. In fact, it's an SQLite database (http://www.sqlite.org). This is the same database type as Apple's Aperture, and a host of applications you use daily rely on it, as well. It's well supported, which means there are loads of external tools that can be used with it.

Because SQLite is an open source database, it helps keep Lightroom's price down; but there are limits to the database's abilities. Possibly the most annoying one for studios, or even partner photographers, is that SQLite databases are single user only. In plain English, only one person can access a catalog at a time. Normally this isn't a problem, but for multiple photographers using a single large catalog, it means only one person at a time can be using the database. What's the worst that can happen from multi user access, I hear you ask? Well you could corrupt the catalog and lose everything! So yes—there are downsides to the database.

Now that doom and gloom is done, let's look at the advantages of a database. We've mentioned this already, but if you've imported files from an external drive into Lightroom and generated previews, you can still access the file to add keywords, metadata, ratings, etc., even when the drive is no longer attached. One other benefit is that if you accidentally delete your original files, there are applications that allow you to retrieve the existing previews and convert them into usable picture files. If you use Smart Previews, you can also develop those files even when they're offline.

In physical terms, there are three key files, along with another two temporary files, that exist when Lightroom is running. The first, the Catalog file that contains all the information, ends with a .lrcat extension. The second file, for the Previews, is the same name as the main catalog file, but with a .lrdata extension and the word Previews added to the name. For example, Lightroom.lrcat would have a corresponding Lightroom Previews.lrdata for its previews. If you've created even one Smart Preview, there will also be a Lightroom Smart Previews.lrdata file.

When Lightroom is running, two more files are created. The first one ends with the .lock extension. This is the file that prevents a catalog from being opened by a second person, thus preventing catalog corruption. The last file is the journal file. This file contains the changes and metadata from the current session in Lightroom. When you close Lightroom, this information gets added to the main catalog, and the lock file gets deleted.

One problem that happens when Lightroom is closed unexpectedly (like a power outage, for example) is that the lock file doesn't get deleted. When you try to open Lightroom, it tells you it can't access the catalog because someone else is using it. For most people, they're the only user, so this is a little confusing. The solution is to find the lock file and delete it. It's in the same folder as the Catalog file, with the same name, with the .lock file extension.

Import and Export Catalog

As well as creating new catalogs, you can make subsets of the current catalog to use while traveling, or to send to others for editing. You can also use them as temporary holders of information when you use a catalog for each shoot or job, apart from your main catalog that holds all your photos.

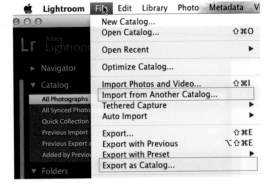

Export as Catalog

We'll look at Exporting first. To Export as Catalog, select the images you require. They can be in Folders, Collections, Collection Sets, or a variety of these options. Go to the File menu and select Export as Catalog.

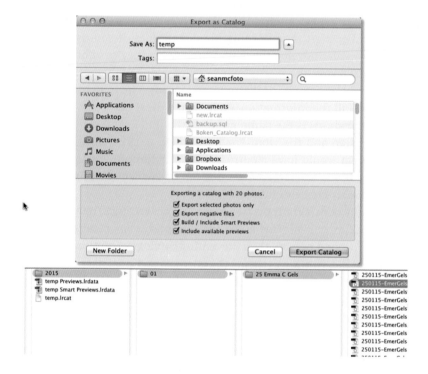

A browser window will load where you can create the new Catalog. The name you enter will be the folder name and a catalog file will be created inside that. You can use the following settings to specify what else is in the folder.

- Export selected files only: With this option, only the selected photos are exported. If this is off, all the photos will be exported.

- Export negative files: This option exports copies of the files and places them in a matching folder hierarchy in the new Catalog folder.

- Build/Include Smart Previews: The option adds or creates Smart Previews.

- Include available previews: This option copies available previews to the new folder.

The Export as Catalog screenshot shows that the selected photos have been exported, along with Previews and Smart Previews, and are ready for use.

Import from Another Catalog
In the File menu, select Import from Another Catalog. Browse to the catalog and press return to import. For this example, I've added metadata, made edits, and added another file to the catalog we just exported.

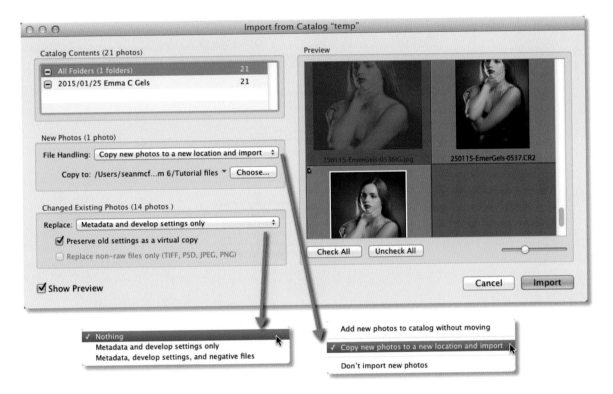

The Import from Catalog dialog opens. Click Show Preview to see the images. We can see that there is one new photo to be imported. We can Add, Copy, or not import this photo. For the 14 changed photos, we can opt to ignore the changes, replace the Metadata and Develop Settings, or change the file and the settings. If you choose either option with settings, we can create a virtual copy with the old settings. Finally, we can choose to only replace non-RAW files. Using the Metadata and Develop Settings is a quick way to transfer changes. When you've selected your options, press Import.

The new information and file(s) will be added to the current catalog.

Catalog Backup

Let's talk about catalog corruption for a minute. Because all that work is stored in the Catalog, it would be upsetting to lose it all due to corrupted files. There is a catalog backup option in Lightroom that allows you to create backups at regular intervals. In Catalog Settings (Lightroom menu on Mac, Edit menu on PC) go to the General tab. At the bottom of this tab is the menu for selecting the backup frequency. Choose a frequency that suits you. The default is once a week.

The backup location is set when the backups run. Click Choose in the Back Up Folder Location. I recommend using the next two options: Test Integrity and Optimize Catalog. These make sure the catalog doesn't have errors, and cleans up orphaned metadata from deleted files.

The backup routine runs when you click Back up. With Test Integrity and Optimize Catalog selected, you can see the running order of the backup in the figure below.

Some things to note: After the backup, Lightroom zips the backup file. This reduces the footprint by almost 90%, saving a lot of disk space. Lightroom also optimizes the previews, removing orphaned previews, and making the process more efficient.

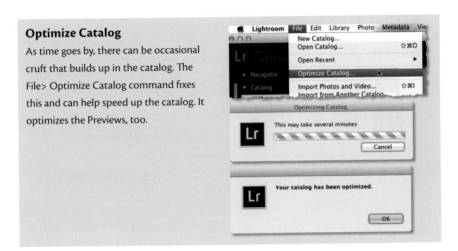

Optimize Catalog

As time goes by, there can be occasional cruft that builds up in the catalog. The File> Optimize Catalog command fixes this and can help speed up the catalog. It optimizes the Previews, too.

Catalog Repair

Lightroom does have corruption detection, and can run a routine to fix broken catalogs when you restart the program. I've had it happen, and the catalog has successfully repaired itself. The following screenshot shows the standard process that happens. First a dialog appears to warn you that Lightroom has encountered an error and needs to quit. Click OK to restart.

Upon restart, Lightroom alerts you that it shut down due to a problem reading the catalog, and must check the catalog

An integrity check will run.

If the Catalog fails the check—which it will, if there is corruption—you'll see the following dialog:

You can view the Technote here, without dealing with a corrupt catalog: https://helpx.adobe.com/lightroom/kb/catalog-corruption-error-photoshop-lightroom.html.

Click Repair Catalog to get the repair started. The Repair Catalog dialog will look like the following screenshot:

If you're lucky, you'll see an Optimize message, followed by this great news:

If you're unlucky, you'll see the following message:

You might be able to repair the problem yourself using SQLite tools in extreme situations where Lightroom fails.

Mac

1. SQLite is built into Mac, so open Terminal to begin.

2. Type cd, then space, then drag your catalog folder onto Terminal to give the correct location. Then press return.

3. Zip up your catalog file as a backup.

4. Where your catalog file is called Broken_Catalog.lrcat, enter the following two lines, pressing return after each:

 echo '.dump' | sqlite3 Broken_Catalog.lrcat >backup.sql

 sqlite3 new.lrcat <backup.sql

5. You'll see error messages, but at the end you'll have a new catalog file called new.lrcat. Delete the old catalog file, and rename the new.lrcat file to the match the old catalog.

6. Restart Lightroom with the renamed catalog.

7. You may need to use the Try Again option a few times.

Windows

1. Download precompiled binaries for Windows from http://www.sqlite.org/download.html

2. Put a COPY of your catalog in the same folder as sqlite3.exe

3. Open a command prompt window in this folder and type:
 sqlite3 Broken_Catalog.lrcat .dump >backup.sql

4. After sqlite3 finishes creating the dump file, type:
 sqlite3 new.lrcat <backup.sql

5. You may see error messages, but at the end you'll have a new catalog file called new.lrcat. Delete the old catalog file, and rename the new .lrcat file to the match the old catalog.

6. Restart Lightroom with the renamed catalog.

Hopefully this will have worked for you.

Catalog Settings

We've covered most of the Catalog Settings (Lightroom>Catalog Settings on Mac, Edit>Catalog Settings on PC) already in relevant sections, but here are the remaining items:

We've looked at Backup. The other part of General is the Information section, which gives us details about the Catalog, including the location (which can also be shown in Finder/Explorer), the name, the date created, the last Optimize and Backup, and finally, the physical size of the catalog.

We've covered Previews in the File Handling tab. The final section here is Import Sequence Numbers. Import sets the first number in a series of import operations; Photos Imported resets the number of how many photos have been imported. Both are used as a token in file naming. Import reflects the total number of imports, while Photos reflects the total amount of photos imported.

Catalog Upgrade

That nerve-wracking moment when getting a new version of Lightroom: the Catalog upgrade. The process with Lightroom 6 is no different than with previous versions of Lightroom. Lightroom 6 will open with the last catalog used in Lightroom 5 and begin the upgrade process. There are two things to note: Lightroom 6 will take the previews folder from Lightroom 5, so if you still want both to run smoothly, you may want to backup the Lightroom 5

previews folder and reinstate them after upgrade. Also Lightroom 6 will copy the Preferences from Lightroom 5. If there's a problem with the upgrade, you still have your Lightroom 5 Catalog to try again.

You can see where the new Catalog will go when you press Upgrade, choose to load a different Catalog, or choose to Quit.

The Preferences File

Lightroom 6 has two different Preference files. The startup information is now stored separately from the rest of your preferences. This means that should you need to delete the Preferences, Lightroom will still load with the last-used Catalog; this is unlike previous versions, where Lightroom would attempt to create a new Catalog.

The process will follow the steps of updating the Catalog file, and optimizing it and related data before opening the new catalog file.

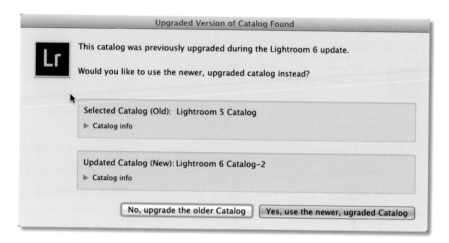

As a bonus, if you try to upgrade a file that has previously been upgraded, Lightroom will let you open that catalog instead of upgrading again.

If you're importing from a catalog and it needs to be upgraded, Lightroom will run this as a background task. Unfortunately the Import from the Catalog process itself still puts a dialog front and center, locking out the app.

Video in Lightroom

Lightroom provides basic support for videos and is generally restricted to managing video formats from cameras and videos that Lightroom makes, like Slideshow exports. It's not designed to be a full-blown editor. You can place clips in Slideshow, but you have no timeline to work with.

Video imports along with photos and resides with them. For easy access to video, you could create a Smart Collection with the criterion "File Type," "is," and "Video."

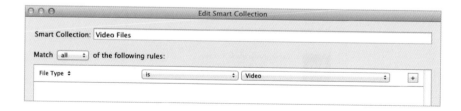

I'm using some clips from a behind-the-scenes shoot I did for photographer Julia Dunin called "Moodance." You can view the shoot and video at: https://juliadunin.wordpress.com/2013/12/10/oondance-fashion-photography-with-sirona-butique-galway/

With Grid open, you can hover the mouse over the thumbnail of a video file. As you move from left to right and back over the thumbnail, Lightroom will scrub through the video. Note that the length of clip is displayed in the bottom left of the thumbnail. In the Metadata Panel, there's also a dedicated field list for video, which lets you add data related to the clip.

Click into the file to open it in Loupe view. Video controls appear at the bottom of the screen. The transport bar shows the play button, the scrubby slider, the current time position in the video, the Frame menu, and the Trim cog icon.

To move to any point in the video, use the scrubby slider. From there you can use Capture Frame on the frame menu to save a single frame, or set the thumbnail for the video using Set Poster Frame. The captured frame is a JPEG, and it's stacked with the video.

To edit the video by changing the start and end points, click the Trim Icon. The controls shuffle about, and the scrubby slider becomes a mini timeline. Grab the two endpoints to shorten the clip.

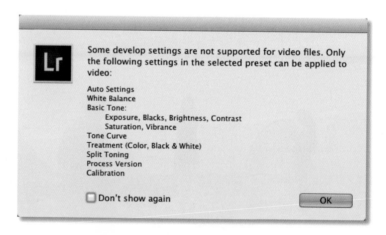

Video is not supported in Develop.

Lightroom's Develop module doesn't support video. But that doesn't mean you can't make changes to a video.

You have two options. One is to apply a Preset in Loupe or Grid. When you do, a warning dialog will appear letting you know the limitations of the settings you can use.

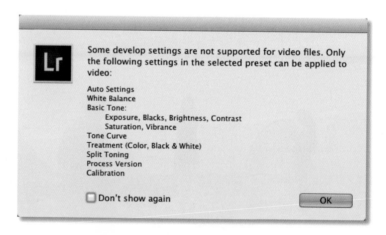

Some develop settings are not supported for video files. Only the following settings in the selected preset can be applied to video:

Auto Settings
White Balance
Basic Tone:
 Exposure, Blacks, Brightness, Contrast
 Saturation, Vibrance
Tone Curve
Treatment (Color, Black & White)
Split Toning
Process Version
Calibration

☐ Don't show again OK

The second option is to cheat a little. Use the Capture Frame option to create a JPEG from the clip. Open this clip in Develop. Edit the clip using the allowed video settings in the screenshot above. Either save these settings as a new Preset, or use Copy Settings in the Develop Settings command (in the Photo menu in Library). Move to the video in Library, then either apply the Preset, or use the Paste Settings command (also from the Develop Settings menu).

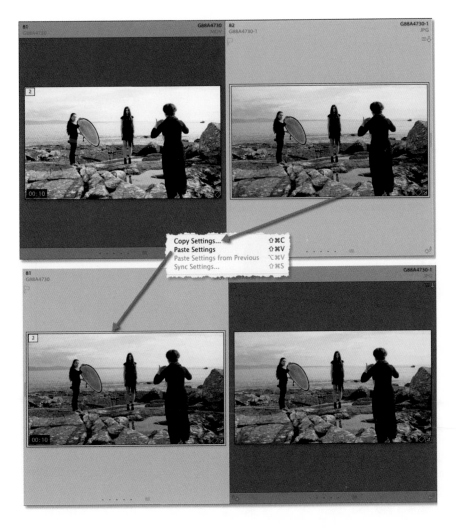

Camera Settings for Video

In order to give Lightroom, or any other video editor, a chance to get the best from a clip, you need to have low contrast, unsharpened video. For an excellent look at the hows and whys of this concept, check out Stu Maschwitz's blog at: http://prolost.com/flat

We'll talk about using video in Slideshow when we discuss the Slideshow module.

Multiple Monitors

Lightroom can make use of two monitors.

To activate the second monitor, click on the "2" icon at the top left of the Film-strip. If you only have one monitor, a second window will open instead. You can also use Command + F11 (Mac) or Control + F11 (PC). Any of the Library

views can be accessed (except People) on the second monitor (or window) by modifying their main-monitor shortcuts with the Shift key. For example, use G for Grid on the main monitor, and Shift + G for Grid on the second monitor (window). I regularly open the second window by accident by pressing Shift + N when I mean to just press N. There are also additional Loupe views—Live and Locked, in addition to the Normal view. Loupe-Normal has the shortcut Shift + E.

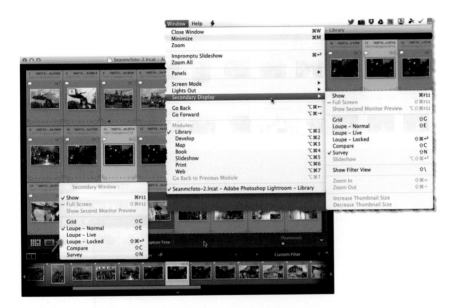

To access the menus for the Secondary Display, either go to: Window>Secondary Display or right click in the "2" icon in Filmstrip.

- Grid View is identical to the primary window.

- Loupe-Normal is identical to the primary window.

- Loupe-Live gives a live view of what's under the cursor. If you're zoomed to 1:1 in this view, it lets you view images in the Filmstrip or Grid, or main screen Loupe view at 100% in the Secondary Display.

- Loupe-Locked is when the view remains locked to the image and zoom level at the time of locking.

- Compare is identical to the primary window.

- Survey is identical to the primary window.

You can open a photo into Locked Loupe from any of the main window views by right-clicking and choosing Lock to Second Window.

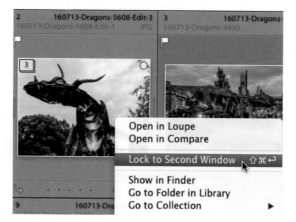

You can open a Filter Bar in the Secondary Display using Shift + \. The Filter Bar acts the same as on the main window.

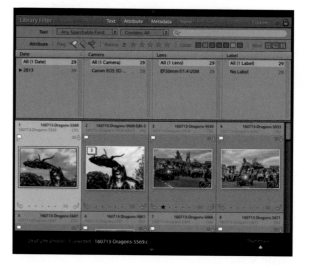

The second monitor can also be a projector, and the Slideshow module can be set to play back to the second monitor for presentations.

One Grid

You can only have one view of Grid open at a time. If Grid is open in the primary window and you try to open Grid in the secondary window, Lightroom will switch the primary window to whichever view was used before Grid. If Grid was open in the main window and Compare in the second window, pressing Shift + G opens Grid in the second window and swaps Compare to the main window.

Virtual Copies

Rather than having to waste space duplicating a file to create an alternate look, Lightroom lets you create new versions using Virtual Copies. The Virtual Copy will have its own preview, and can have entirely different Develop settings and Metadata associated with it.

How does it work? Lightroom makes a copy of the original image's preview (including the current settings), adds a little page flip icon (highlighted in the screenshot below), and displays it as a new image. The only space used on disk is the preview, so you've saved 30MB+ on disk with the average raw file. The Virtual Copy acts like an original file in every way, but independent of it. The original file is referred to as the Master. Deleting the Master will also delete all Virtual Copies.

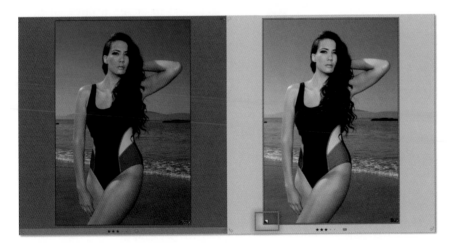

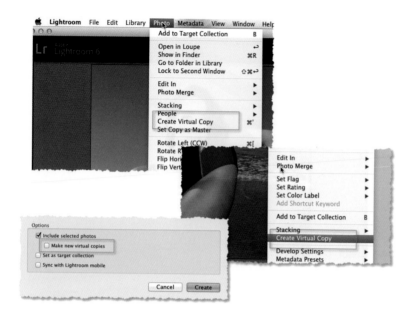

Creating and Using Virtual Copies

There are many ways to create a Virtual Copy.

- From the Photo menu, choose Create Virtual Copy.

- Right-click on a photo and choose Create Virtual Copy.

- Use the shortcut Command + ' (apostrophe) on Mac or Control + ' on PC.

- When creating a Collection, check the option for Make new virtual copies.

Virtual Copies get stacked with the original file. When editing a Virtual Copy, you may get to a point where you prefer it to the Master. To turn the Virtual Copy into the Master, go to the Photo menu and choose Set Copy as Master. The Virtual Copy will become the Master, and the Master will become a Virtual Copy.

If you need to create a physical copy, you can use Export. To make it a duplicate, select Original as the file type. That way Lightroom will copy the original file and place the settings in an XMP file. Alternatively, you can use DNG. Virtual Copies are not stored in XMP, so you'll need to create Snapshots to save the different looks you've created.

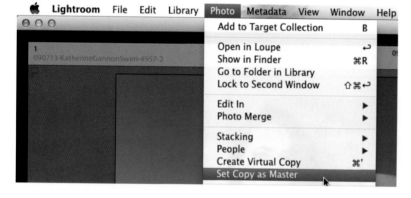

Crops

Virtual Copies are a great way to try out different crops on a photo. Simply create a range of crops to find one that looks best, then Set Copy as Master and delete the rest. Alternatively, use the copies to have different crops available for printing at any time.

Stacking

We've mentioned Stacks as part of Virtual Copies. Stacking is the process of grouping images together. They can be versions of a pose, a panorama or HDR sequence, even a time-lapse photo set.

Stacks have a top photo that represents the contents. For similar photos, you want this to be the best photo in the stack. For panorama or HDR sets, this might be the completed merge from these files. With Virtual Copies, it might be your favorite copy.

You can only stack photos that are in the same Folder, or Collection. You can't stack across Folders, Collection Sets, or even Keywords.

Creating and Using Stacks

There are many ways to create a Stack. First, select the photos to group together. Then, choose one of the following options:

- From the Photo menu, choose Stacking, then Group into Stack.

- Right-click on a photo and choose Stacking, then Group into Stack.

- Use the shortcut Command + G on Mac or Control + G on PC.

- Creating a Virtual Copy automatically creates a Stack.

- From the Photo or right-click menu, choose Auto-Stack by Capture Time.

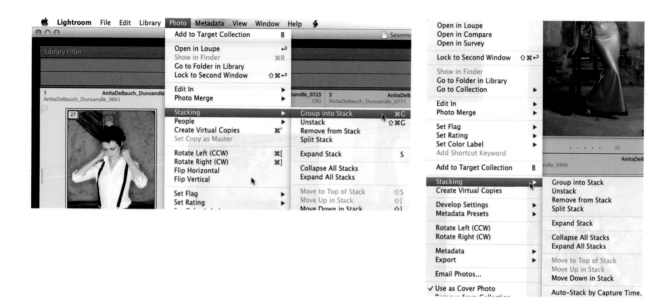

Once grouped, Stacks display a number badge indicating the number of photos within. Opened stacks show the badge in the from "1 of …". Stacks can be opened or closed using the S key, or via the Expand All Stacks and Collapse All Stacks commands. Alternatively, click on the number badge to open the stack.

To move a photo to the top of a Stack, use the shortcut Shift + S, or choose Move to Top of Stack in the Stacking Menu. To move a photo up or down the Stack, use Shift +] or Shift + [.

You can select the photo for the top of the stack in many ways:

- Select all the images in the Stack. Go to Survey (N). Use the X on an image to drop it out of view. Drop images until you are left with one. Press Shift + S to move this to the top of the Stack.

- Select all the images in the Stack. Go to Compare (C). Cycle through Candidates images until you are left with one Select. Press Shift + S to move this to the top of the Stack.

- Use large thumbnails in the Grid and browse through them until you see your favorite. Press Shift + S to move this to the top of the Stack.

To break the grouping, use the shortcut Shift + Command + G on Mac or Shift + Control + G on PC. Stacks can also be separated into two stacks from the menu using the Split Stack command. Individual images can be removed from a Stack using Remove from Stack.

Auto Stack By Capture Time

The last method for creating Stacks deserves a more detailed explanation. Selecting Auto-Stack by Capture Time will bring up a dialog box with a slider that represents the time between photos. To the left, you get more stacks; to the right, you get fewer. If you shoot a series of photos, then have a gap of time before the next series, the photos will be gathered into stacks automatically.

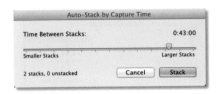

Selection Methods in Lightroom

It's vitally important to organize your photos, but the most important task in Lightroom is choosing your best images. Lightroom provides many ways of doing this. We've already seen how the Quick Collection and Target Collection can be used to gather images together. We've also seen that the Import dialog can be used to bring in only the best photos (which can be added to a Collection as they import). We've seen how Stacks can be used to put the best image at the top, and collapsed so only the best images are visible.

> **The Edit**
>
> I'm referring to the process of picking the best images as *making selects*. You'll also see this referred to as *editing*. I've deliberately gone with selecting rather than editing because editing also refers to the post processing of images to improve how they look.

These are great tools, but we still haven't looked at the three main tools for making selections in Lightroom: Star Ratings, Flags, and Labels.

> **Auto Advance**
>
> A great speed trick for making selections is Auto Advance. Located in the Photo menu, Auto Advance jumps to the next image when any of the selection methods are used. It halves the number of key presses required to go through a folder, when working one image at a time. The Caps Lock key also engages Auto Advance. The Shift key will engage it while held down with the relevant rating, flagging, or labeling shortcut.

Star Ratings

Star Ratings use a scale of 0-5 to indicate the quality of the image. Using stars makes it easy to group images by different levels of quality. You can get through most selections sessions with 3 stars, leaving 4 and 5 stars available for your portfolio- and competition-worthy images. By default, images have

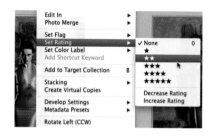

a 0-star rating on Import (unless they've had one applied prior to Import). You can change this via a Metadata Preset. Star Ratings are included in XMP, so they will travel with the images.

To apply a Star Rating:

- Use the numbers 0-5 to apply that value of rating to the image.

- In the Toolbar, click on the star that represents the rating you want to give the image.

- In Expanded Cells (in Grid), click on the appropriate number of stars under the image in the cell.

- In the Photo> Set Rating menu, click the star number you want to give the image.

- Right-click on an image and choose the star rating you want to give the image from the Set Rating menu.

- Use the square bracket keys [or] to decrease or increase the rating of an image.

- In the Painter Tool, choose Rating and select the rating you want to apply to the image.

To reset a Star Rating, either press 0 or pick an alternate Star Rating.

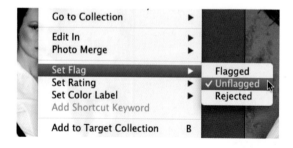

Flags

Flags are the simplest of the three options. They only offer three choices: Pick (or Flagged), Unflagged, or Reject. The Import default is Unflagged. Unlike Ratings and Labels, Flags are not part of the XMP specification, so are not saved with the file.

Flags give a Yes, Maybe, or No style of selection. With Refine Photos, they give a two-pass system for making selections.

To apply a Flag:

- In the Photo > Set Flag menu, choose from Flagged, Unflagged, or Reject.

- Right-click on an image and choose Flagged, Unflagged, or Reject from the Set Flag menu.

- Use the shortcut keys P for Pick (aka Flagged), U for Unflagged, or X for Reject.

- In the Toolbar, click on the Flag icon you want to apply.

- In Expanded Cells, click on the Flag icon you want to apply.

- Use the Command + Up/Down Arrows (Mac) or Control + Up/Down Arrows (PC) to increase or decrease the Flag status.

- In the Painter Tool, choose Flag and select the flagging you want to apply to the image.

When you've completed Flagging, you can delete the Rejects using Command + Delete (Mac) or Control + Delete (PC). The Rejects will appear in the image preview area, giving you a chance to review them before final deletion.

Using Refine Photos (either via the Library Menu or the shortcut Command + Option + R on Mac, Control + Alt + R on PC), all the current Unflagged images become Rejects, while the Flagged images become Unflagged. This means you can go back through the images to confirm your choices for flagging images.

To reset a Flag, press U.

Labels

Labels are the third option. As well as providing a six-step selection system (five colors and none), you can also customize the meaning of each Label. Labels are saved in XMP, but are only visible when they match what's already in the application. For example there are Lightroom Default and Bridge Default sets. If you use Bridge, then select Bridge Default from the Metadata > Color Label Set menu. Changing Color Label Sets will hide current labels until the matching set is selected.

You can create your own Color Label Set. Click the Edit.. button in the Metadata > Color Label Set menu. Enter your preferred names for the labels. From the menu, choose to Save Current Settings as New Preset or Update Preset. This Set will now appear in the Color Label Set menu.

To apply a Label:

- In the Photo > Set Color Label menu, choose from the colors listed.

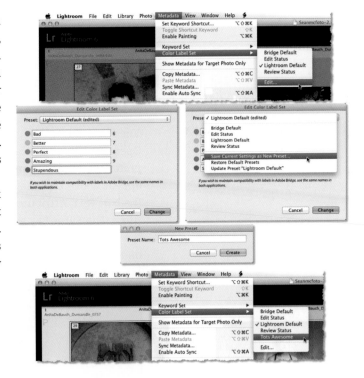

- Right-click on an image and choose a label from the Set Color Label menu.

- Use the shortcut keys: 6 for red; 7 for yellow; 8 for green; and 9 for blue. There is no shortcut for purple.

- In the Toolbar, click on the color label you want to apply.

- In Expanded Cells, click on the color label icon you want to apply.

- In the Painter Tool choose Label and select the color you want to apply.

To reset a Color Label, choose the same label again. Shortcuts act as a toggle, so applying 6 for red will set the color label. Pressing 6 again will remove it.

I'll cover my own workflow for how I make speedy selections when we discuss Filtering methods in Lightroom.

Filter Methods in Lightroom

Being able to get down to an exact match of images is the key point in Digital Asset management. Being able to find the right photo at the right time for the client (even if you are the client) is why we go to the effort of managing our photos. We've seen how powerful Smart Collections are, but we don't need a saved search every time. Sometimes we just want to access a photo right now. This is where the Filter Bar is useful.

The Filter Bar

Open the Filter Bar from the View menu, or by using the shortcut "\". If you'd prefer the Filter Bar in a second window, use Shift + "\". The Filter Bar will appear above the image preview area. There are three main components in the bar: Text, Attribute, and Metadata. There's also a None option to reset all three. The Filter Bar acts on the current source, so go to All Photographs in the Catalog Panel if you want to filter everything. To have all three options on at once, Shift + click on the closed options to add them.

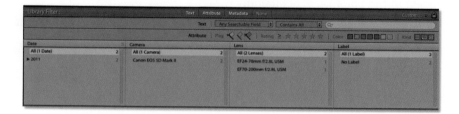

Text

Text allows you to search through any text or specific types of text. The catch-all is Any Searchable Field, but you can restrict the search to Filename, Copy Name, Title, Caption, Keywords, Searchable Metadata, Searchable IPTC, Searchable EXIF, or Any Searchable Plugin Field.

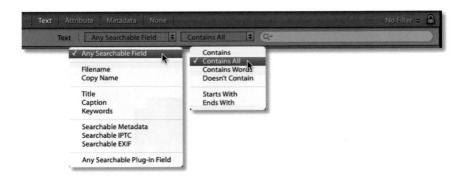

You can also set criteria for how the text is handled.

- Contains: As long as a file contains any of the text entered in the text box (separated by commas), the file will appear in the main image area. Great for finding lists of files.

- Contains All: All the text must match with the entered text. This is great for homing in on very specific files.

- Contains Words: Matches an exact word.

- Doesn't Contain: The reverse of Contains.

- Starts With: If the beginning of the text matches, the images are displayed.

- Ends With: If the end of the text matches, the images are displayed.

Add an exclamation mark (!) before any word to exclude that word from the results. A plus sign (+) before any word will apply the Starts With rule to that word. A plus sign (+) after any word will apply the Ends With rule to that word.

Attribute

Attribute covers Star Rating, Flag status, Color Label, and Kind. Kind refers to Master file, Virtual Copy, or Video file.

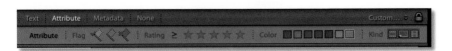

Metadata

Metadata is a column-based search of specific criteria. Each column filters from the previous one. You can choose all as an option for a column, or just one or two matching items (e.g., All Date or 2009 and 2010). To narrow down the selection use Command (Mac) or Control (PC) to click on items you want to include. Initially there are four columns, but you can add or remove columns from a popout menu that appears when you hover over the end of the last column.

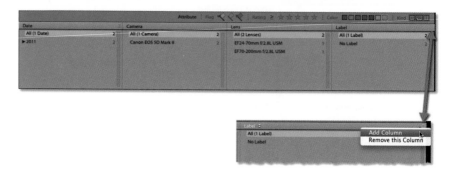

The data in each column is chosen from the list in the screenshot to the left. Click on a column header to make the list active and choose the data you want in that column.

Presets

On the right-hand side of the Filter Bar is the Presets. Anything you create as a filter can be saved to make it available to be applied again. From this menu you can select a Preset. If you make a change you can save a new preset, update or delete the current Preset, and Restore Default Presets if they're missing.

Filter Lock

At the very end of the Filter Bar is the lock. This locks the Filter on so all views have the filter applied. You can set a different filter for each source, though. Go to the File>Library Filters menu and check the Remember Each Source's Filter Separately option. You can apply the lock from this menu, too.

Show Me the Filter

Let's look at a practical example. Say I want to find all the rendered photos from Connemara in the past five years except the ones from 2010, those that have a red label, and the ones taken with a 17-40 or 11-16mm lens. We'll need all three options for this. First we set text to "Connemara," and then Attribute gets set to the red label. In the Metadata Dates field, select 2009, 2011, 2012, 2013, and 2014 by Command/Control-clicking on each date. Then change column two to File Type and select JPEG, TIFF, and PSD. Lastly, select the two lenses. From this, you'll end up with three photos out of 245,000.

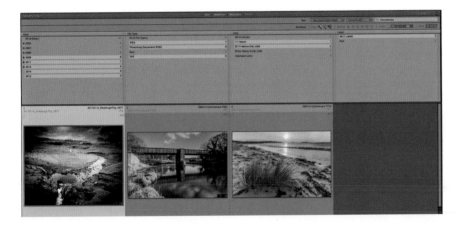

Filmstrip Filter

The Attribute filter also appears at the top right of the Filmstrip. If only the word Filter is visible, click on it to expand the options. From there, click the Star Rating, Flag, Label, or a mix thereof to filter the visible images. This is easier than using the Filter Bar if you need to filter by Attributes. There's also a Filters Off button on the far right.

Filter Menu

As well as the Filter Bar and the Filmstrip Filter, there's also a Filter menu. We've seen the source options, but there are also dedicated options. From the File>Library Filters menu you can Filter By:

- Preset: Use any of the previously created Filter Presets.

- Flag: Choose a Flag status.

- Rating: Choose a Star Rating.

- Color Label: Choose a color.

- Kind: Choose from All, Master, Virtual Copy, or Video.

Survey and Stars for Speedy Selections

In this final section of the Library module, I'm going to talk about how I get to the heart of my shoots to find my favourite shots. I use this method with headshot and models clients when we do a post-shoot selection. It gets us through the photos quickly, and the client knows they've seen everything, and they're taking away the best photos from the shoot after editing.

We start by setting up Grid so that it's six thumbnails wide. The main problem people have with deciding if they like a photo is not having another photo to compare it to. By choosing six, I have enough photos to make a comparison, but not too many as to cause analysis paralysis.

I select the first image, then Shift-click on the sixth image so the top row is selected. Even if there's an obvious dud in the set, I like to keep to one row of six at a time. Then I press "N" to go to Survey. Shortcuts are an essential part of the process. If the Toolbar is preventing me from seeing the photos as a 3×2 view, I turn it off by pressing "T".

With the six images visible, I click the one-star rating under the photo, or I use the arrow keys to move around the photos and press the "1" key to apply a one-star rating. The active photo is white, and I pay attention to this so I don't accidentally star the wrong photo. From here I go back to Grid by pressing the "G" key. I move to the beginning of the next row and select those six images. From there, it's back to Survey again to star images. You can star as many as you like, or even none from each six. It doesn't matter. I repeat this process until all the photos have been seen. This is the first pass. Then I go back to the Grid.

For the second pass, I need to Filter the images. In the Filmstrip, I click on the Greater than or Equal one-star options. A bezel appears showing One Star and Higher.

Looking on the left of the Flimstrip, I can see that I've gone from 67 to 27 photos quickly. To finish the second pass I go back to the beginning and select the first six photos in the Grid, and go back to Survey. This time I'm looking for the best of the new selections, except I'm going to give them two stars. I rate the images, then go back to Grid. I Select the next six images and then go back to Survey to rate the two-star photos. I repeat this process for all images, and go back to the Grid.

For the third pass, click the two stars icon in the Filmstrip. Now there are only 16 images.

Again, go back to the start of Grid. At this stage I might opt to only show four images at a time. In Survey, I look for three-star images within the first four images and rate them using the "3" key. I repeat the process: Grid, Survey, Star. When all the remaining images have been viewed and starred, I can filter the three-star images. You can opt to do another pass if needed, or drop out images that don't appear as strong as the rest of the set.

You might also apply a Color Label at this point, like red to indicate that the file needs to be processed. Then you can set up a Smart Collection to show recent files with a red label. The next time you process, you can go to the Smart Collection and get to work immediately. You can update the label to yellow after editing, which will remove the image from the Smart Collection. When the Smart Collection is empty, you're up-to-date with processing.

The Develop Module

Working with the Library for file management is akin to doing accounts for most photographers. Processing photos into works of art is far more fun, much like the act of capturing a moment. Develop is the heart and soul of Lightroom—it's where you create your masterpiece. Library finds your best photos; Develop makes them perfect.

One of the key benefits of Lightroom's Develop module is that you get to work directly on your RAW files without needing to render them to a JPG, TIFF, or PSD. All the settings can be reset without affecting the original file. Settings can easily be saved, or copied to other images instantly. Add to that the ever-improving process versions, and you can see why Lightroom is so popular.

GPU Acceleration

Lightroom 6 has a big first. For the first time in Lightroom, the GPU (Graphics Processing Unit) is used to speed up Develop. This means that Slider adjustments update the image in real time (or almost real time). This is especially beneficial to newer 4K and 5K screens now being used. GPU acceleration is on by default, and can be turned on and off in the new Performance tab in Preferences. The tab will display the name of your video card (or an error if there's an issue with your card). Minimum system requirements: 64 bit only, OpenGL 3.3 and up, Mac 10.9 and higher, or Windows 7 and higher. It's essential to have up-to-date drivers for GPU Acceleration to work properly. GPU Activity is shown on the right of the Toolbar in Develop.

To get to the Develop Module:

- Press the shortcut key "D".

- Click Develop in the Module Picker.

- Use the menu shortcut Command + Option + 2 (Mac), Control + Alt + 2 (PC).

- Jump to specific tools in Develop: R for Crop, W for White Balance, M for Grad Filter, Shift + M for Radial Filter, K for Adjustment Brush, and Q for Spot Removal.

Like most Modules, the Left Panel is about management of Presets, Snapshots, and History, as well as the ubiquitous Collections panel. These functions heavily depend on what goes on the Right Panel, so for this reason, we'll dedicate this chapter to the panels within the Right Panel.

The Right Panel

Processing With the Histogram

We've seen the basic Histogram in Library. The Develop Histogram is far more powerful; it allows you to process photos directly in the panel. You can also see where clipping occurs in the photo, the status of your Smart Preview, and you can update the Process Version from previous versions. You may want a wider version of the panel, so simply click and drag the panel edge to the left to make it bigger.

A Good Histogram

Before we talk about processing, let's talk about what makes a good Histogram. Generally speaking, a well-exposed shot will have most of the tones in the middle range of the histogram. Tones at either end won't be bunched up, and the rest will be well distributed.

That's not to say that a photo is wrong if its histogram doesn't look like this. A scene with tones bunched to the left would normally be considered under-exposed. But a night scene could have tones bunched up to the left and a spike on the right, and still be correctly exposed.

If the tones are bunched to the right, normally we would consider the image to be overexposed, but a high key scene could have a lot of tones on the right of the Histogram and still be correctly exposed.

Clipping Indicators

The clipping indicators are at either side of the top of the Histogram. Hovering over either triangle will display a clipping overlay on the image. On the left is Shadow Clipping; on the right is Highlight Clipping. The color of the triangle shows the colors that are clipped. White means all three color channels (red, green, and blue) are clipped. Black means nothing is clipped. Red, Green, or Blue means the corresponding color channel is clipped. Magenta means that the red and blue channels are clipped, and so on. Click on either clipping indicator to turn on the overlay for that area. Shadow Clipping appears as a blue overlay on the image; Highlight Clipping appears as a red overlay. Click the triangle again to turn the overlay off. Both indicators can be turned on or off using the "J" key. Generally speaking, a little clipping in the darkest areas of a photo is ok. Clipping the highlights is generally bad,

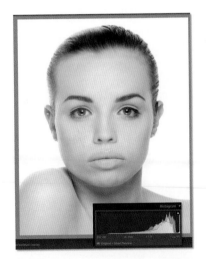

though it's fine in the case of a high key photo, or in images where you've exposed for the face and the sky detail has been blown out (as it tends to do on a dull day).

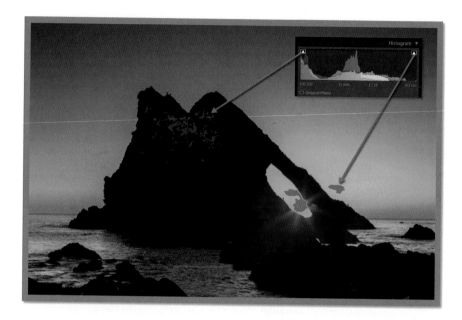

Tone Controls

Hovering over the main part of the Histogram highlights five different sections: Blacks, Shadows, Exposure, Highlights, and Whites. Each section becomes slightly lighter than the rest of the Histogram, indicating what area of the tones they affect. Clicking and dragging on the Histogram will change the values visible on the bottom right and the corresponding sliders in the Basic panel. We'll explain the sliders in more detail next.

Smart Previews and Process Versions

The final part of the Histogram shows the current state of Smart Previews, which we've already seen. If the file is an older file that's been imported in a version of Lightroom prior to 2012, there will be a lightning bolt icon on the bottom right of the Histogram. This indicates that an older Process Version is being applied to the file. Other clues include only four (rather than five) areas available in the Histogram: Blacks, Fill Light, Exposure, and Recovery. Hovering over the icon will let you see the Process Version (either 2010 or 2003), and a tool tip will appear to let you know that you can update to Process Version 2012. Simply click the icon to update.

Below the Histogram is the Tool Strip. We'll look at this in the next chapter.

Basic

The Basic panel houses the main global adjustments for your photo. There are four parts to the panel: Treatment, White Balance, Tone, and Presence. Before we get on to the controls, we're going to talk about two very important tools that probably should be in the Basic Panel, but are not. These are the Process Version and the Camera Profile.

Process Version

We've mentioned the Process Version briefly before. We've seen that there are three versions of it: 2003, 2010, and 2012, marked for the year of introduction. There are a few places it can be changed, like the Histogram, but the main location is in the Camera Calibration Panel.

Process Version 2003 represents the first method Lightroom (and its older sibling, Camera Raw) used to render a RAW file into something that could be edited, and the tools used to make that edit. This was the Process Version used by Lightroom 1 and 2. The sliders used in the Basic panel were Blacks, Fill Light, Exposure, and Recovery.

Process Version 2010 was an update of 2003, and used the same sliders. The main differences were better noise reduction and sharpening.

Process Version 2012 was a complete change of the processing engine. Five new Tone Controls replaced the four previous: Blacks, Shadows, Exposure, Highlights, and Whites. In addition, you could also apply local corrections for White Balance (Temp and Tint), Highlights, Shadows, Noise, and Moiré.

Demosaicing and Process Version

Most current cameras use a system called a Bayer Array to capture light on the sensor. These arrays consist of a mosaic pattern of alternating red-green and green-blue photo sensors. This means there are twice as many green sensors as red or blue, which matches the sensitivity of the human eye to green light. The process of changing these alternating colors into something that matches what we see is called Demosaicing. The Process Version refers to how Lightroom and Camera Raw perform this Desmosaicing. Each new Process Version gets a little more quality out of the RAW files, so older RAW files have just as much benefit from the changing technology as new ones; another great reason to shoot RAW rather than JPEG.

Camera Profiles

The ability to change Camera Profiles is something that I feel should be part of the Basic panel. Instead, it's buried all the way down in the bottom panel, in the Camera Calibration panel, below Process. Why would I like to see these Profiles in Basic? Well, Profiles change how Lightroom processes RAW files to emulate the Picture Styles/Modes in cameras. Changing the Profile might give you exactly the look you want without needing further adjustment. The Profile tells Lightroom how to interpret the color from your RAW file. You can also create your own profiles with tools like the X-Rite ColorChecker Passport, Adobe's DNG Profile Editor, or get third-party ones, like the Film Emulation profiles from VSCO.

Profiles for Canon, Nikon, Olympus, and Fuji-X are available, and more camera makers are developing profiles as time passes.

Three different Camera Profiles: Adobe Standard, Camera Landscape, and a Custom Profile

Treatment

At the top of the Basic Panel is Treatment. Here, you can choose between a Color and a Black-and-White rendition of your image. The shortcut "V" will toggle this setting also, and as a result the HSL Panel down further becomes the Black & White Panel.

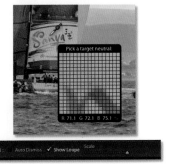

White Balance

Next is the White Balance section (shortcut "W"). This is where you can set the base color of the photo. Usually, clicking the eyedropper on an area of neutral tone (anywhere from black to almost white) will do. Mid gray is best, but as long as the tone is neutral, it will work. Be warned that paper contains brightening agents that make gray seem slightly blue.

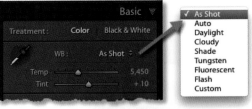

To prevent the eyedropper from turning off when you click a test area, deselect the Auto Dismiss box in the Toolbar. Show Loupe gives a magnified view of the area under the cursor. Scale is another option in the Toolbar. This sets the zoom level for the Loupe to allow you to click on specific areas of the image more accurately. As you hover, the Navigator will preview the White Balance based on the current pixels under the cursor.

You can also opt for the White Balance Presets, or use the Temperature and Tint sliders to play with it manually. While accurate color is a good thing for commercial work, setting white balance for pleasing color is quite common for a more artistic interpretation of an image. Photos of people tend to look more natural when rendered slightly warmer than neutral.

Use the Show Loupe slider to increase sample area

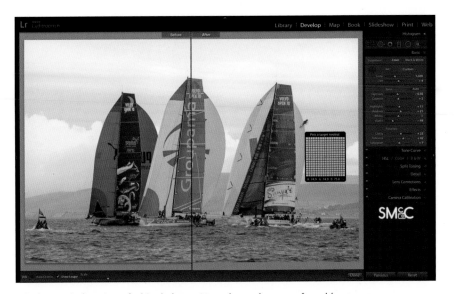

The Navigator allows you to preview the White Balance setting

A before and after view of white balance. Note the sea has gone from blue to gray.

ColorChecker or Gray Card

You can use test shots with a gray card or a ColorChecker card to get a correct white balance and copy it to other photos. Here's a typical workflow for this:

1. Take a test shot with a ColorChecker or Gray Card. This can be in any situation—the example here just happens to be in a studio. The light source needs to fall on the card, and the shot shouldn't overexpose the white tile on the ColorChecker. I'm using an X-Rite ColorChecker Passport here. It uses painted tiles to get exact colors, so make sure not to touch them (finger grease will change the color). If you plan on running the X-Rite software (or even Adobe's DNG Profile Editor), make sure it's facing the right way up.

2. Click the mid gray tiles with the White Balance eyedropper.

3. Go to the Settings menu in Develop and choose Copy Settings, or use the shortcut Command + Shift + C (Mac), or Control + Shift + C (PC).

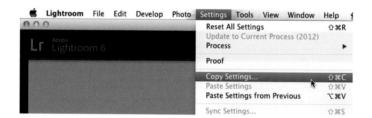

4. From the Copy Settings dialog, choose Check None, then select White Balance.

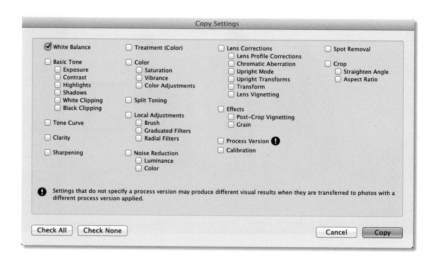

5. Go to Grid and select the images to paste the new White Balance setting to. From the Photo menu, go to Develop Settings and choose Paste Settings or use the shortcut Command + Shift + V (Mac), or Control + Shift + V (PC).

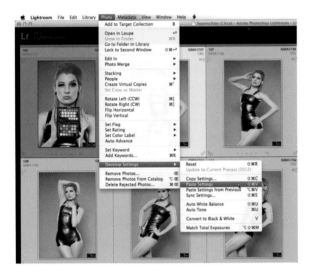

6. The images will all now have the same, correct white balance.

Alternatively, you could preselect images in Grid and use the Sync button in Grid instead of the Copy and Paste Settings. The Sync dialog is identical to the Copy Settings dialog in function.

Tone

The Tone section houses the five controls from the Histogram, along with a Contrast slider. While there are distinct areas in the Histogram, in reality the sliders are interactive, so moving one changes the work of another. This makes the controls in Lightroom 4 onwards more powerful and smoother than older Process Versions. It also takes more computing power, but it's more than worth it for the final look.

Exposure matches the camera exposure concept in that it works in f-stops. Unlike digital cameras, where increasing the exposure will lead to hard clipping of the highlights, Lightroom's Exposure is more film-like and will prevent highlight clipping. This means you can brighten an image significantly in Lightroom and not lose highlight detail.

Contrast splits the image into two ranges: Darks to midtones, and midtones to lights. Increasing Contrast darkens the tones below the midtone, and lightens those above. Reducing Contrast has the opposite effect and can make an image gray and muddy. Increasing Contrast has a side effect of increasing Saturation—it makes the color richer.

Highlights covers from above the midtone to the brightest parts of the image. There is overlap with Whites, so often you need to balance these sliders.

Shadows cover from below the midtone to the darker parts of the image. As with the relationship between Highlights and Whites, Shadows overlap with Black.

Whites control the very brightest parts of an image. If you shoot high key shots with a lit white background, you'll become intimate with this slider. Why? Because Exposure does such a great job of protecting highlights, it pulls back the level of white to very light gray. The Whites slider lets you get it white again. We'll do a practical look at this when we look at the Adjustment Brush.

Blacks control the darkest parts of the image.

The last four sliders are really two pairs and should be set together as pairs. Use a top-down approach to correct a photo, but don't be afraid to go back to tweak it later because the sliders overlap.

Presence

The Presence controls are Clarity, Vibrance, and Saturation. We'll look at them in reverse order since the relationship between Saturation and Vibrance is based on how Saturation works.

Saturation controls the depth or richness of a color. As you move the slider to the right, colors become more intense. As you move it to the left, they become more muted until the image is eventually monochrome.

Vibrance is a specialized version of Saturation. It's designed to add saturation to less saturated colors, while also protecting the reds, yellows, and oranges from becoming saturated. This helps protect skin tones from becoming too orange, like the Saturation slider would at a similar value. It's great for adding "pop" to photos of people, but can be a little underwhelming on landscape photos where it favors saturating the blues.

Clarity was originally called Punch, an apt name when moving the slider to the right (not so much when moving it to the left, though). Clarity adds midtone contrast that looks great in landscape photos, and is just gorgeous in character-driven portraits. Reducing Clarity softens skin, but it also softens facial features. Fortunately it can be applied as an Adjustment Brush, which makes Lightroom useful for quick retouching. Clarity emulates a special type of Unsharp Mask from Photoshop. Most sharpening has a high amount and a low radius, but if you use a large radius and low amount, it increases the midtone contrast.

Practical Basic Panel

We've seen a practical look at the use of these settings in Quick Develop, but here's another example of usage:

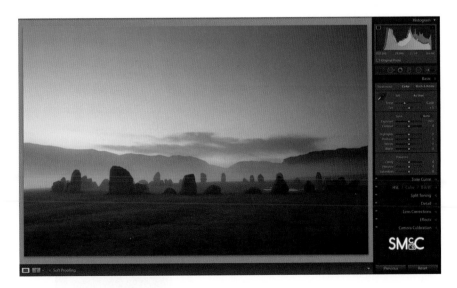

We start this section with a completely unprocessed photo—dust spots, and all. For landscape photos, I fix the overall exposure first. I'm not referring to the Exposure control, but to the black and white points of the photo. This can be done manually, but Lightroom 6 has a new trick: Auto sliders. We've looked at Auto Tone—in both Quick Develop and Develop, you can hold the

Shift key and double-click on the Exposure, Highlights, Shadows, Blacks, and Whites to set them automatically. Setting them individually can produce a different result than clicking the Auto button. Shift + double-click on both the Blacks and the Whites sliders.

With the Shadow Clipping indicator on, we can see that Auto has clipped the shadows in the bottom part of the image. Looking at the Histogram, we can see that we've also expanded the whole range of tones to fit. To fix the clipping, hold down the Option (Mac)/Alt (PC) key and start to drag the Blacks slider. The image will turn white, with a little color in the corner where the clipping occurs. Drag the slider towards 0 until the color is almost gone. This Option/Alt trick works for Exposure, Highlights, Shadows, Blacks, and Whites, though the lighter options go black rather than white.

We now have a full range of tones to work with. The image is still a little dark, so we Shift + double-click on Exposure. The image brightens, but now we see the Highlights are starting to clip. Hold down the Option (Mac)/Alt (PC) key and start to drag the Highlights slider (remember, we've already set the Whites). Stop when the clipping is gone.

There's still a load to do. I know we've just set Highlights, but as the Shadows and Highlights are the tone mapping tools in Basic, I often increase the Shadows to +100, and then decrease the Highlights to -100.

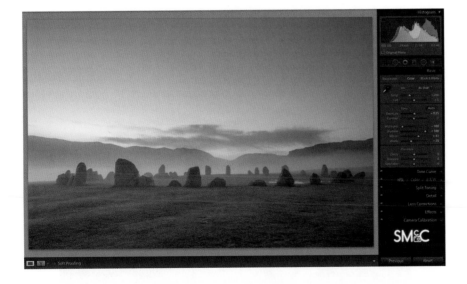

As we get towards the end, we're going to combine some steps. First we increase the Contrast and Clarity to add punch. Next we add Vibrance, which increases the blue content of the photo. Due to the reds and yellows in the sky, we increase Saturation, and then subtract Vibrance to control the blues in the image.

The increase in color has brought out the blues in the grass area. It's being lit by the open sky before sunrise, and we should probably warm the tones. We push the Temperature to the right to warm up the image colors. This will also counteract the blues in the sky. Finally we nudge the Tint a little hint to the right to add some magenta into the image, just enough to make the skies richer.

We've come a long way from the start of the image. There's still Spot Removal and Cropping to be done. Below is a version with the crop and spot removal applied.

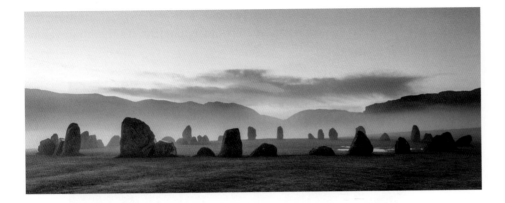

Tone Curve

The Contrast slider offers a fast remedy for needed contrast changes in a photo. That's fine if you need something quick and dirty, but when you need finesse, you need the Tone Curve. The Tone Curve comes in two varieties: the Parametric Curve and the Point Curve. Both interact, so settings in either carry over to the other.

Parametric Curve

The Parametric Curve is the original implementation of Photoshop's Curves adjustment. It was designed to give a lot of power to control contrast, but at the same time, it prevented the user from doing any damage to an image. This is the default view the first time you use it.

Let's look at the five main parts to the Parametric Curve.

(1) shows the Targeted Adjustment Tool (TAT). Clicking on this target icon changes the cursor into a crosshair with a target flanked by up and down arrows. It's a rather complicated icon for a simple task. The arrows give the hint to move the cursor up and down, but first you must click on the image.

Hover around the photo with the TAT active, and pay attention to the curve window. Notice that a circle moves up and down the line as you hover. The area name appears under the curve window and the matching slider

becomes highlighted. Click on the image and drag up or down. The lightly shaded areas around the line show the boundaries of that section's curve. Notice that as you drag, the circle goes black and the corresponding slider moves. The top left of the curve window indicates the change in percentage in the form: 56/60%. The first number indicates the original position; the second indicates the new position. In Photoshop terms, it's the Input versus the Output.

(2) indicates the curve window. As well as using the TAT, you can click and drag up or down in this window. The action will still target similar areas. The corresponding slider will also move along with the update in the input/output percentages. Click and drag in all four control areas (Shadows, Darks, Lights, and Highlights), to make changes. The steeper you make the curve, the more contrast in the image. The Shadows are the darkest parts and the Highlights are the lightest (unlike in Basic, where it's Blacks and Whites). Dragging the Shadows down and Highlights up creates a basic S-Curve, the quintessential shape for increased contrast in the Tone Curve.

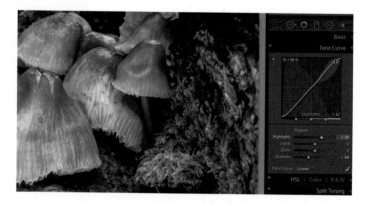

(3) is the Range Sliders. This maps the quarter-tone points—named so because they split the image into four tone areas. They work from the whitest point down (which is slightly confusing). The three triangles correspond with the three-quarter tone point, the midtone point, and the quarter-tone point. Moving the quarter-tone to the right means the Highlights slider affects only the extreme topmost tones in the image. Moving the midtone point left would expand the range of the Lights, while reducing the range of the Darks.

(4) shows the Curve Sliders. We've seen them remotely controlled from the TAT and the curve window, but they can be moved on their own. The sliders control four areas: Shadows, Darks, Lights, and Highlights.

(5) shows the Point Curve Preset box, where you can choose a preset created in the Point Curve. The Parametric Curve will remap to this preset, with the boundaries changing to match the new curve start points. To the right of the Presets is an innocuous icon, but it hides one of the more powerful color controls in Lightroom. Click on it to switch to the Point Curve.

Point Curve

I have a confession to make. I always have to switch back to show the Parametric Curve. In fact, I'm often tempted to ignore it. Why? I never use it. The Point Curve does everything the Parametric Curve does and far more. It's not unlike an adjustable wrench versus a spanner set, or a knife when you need a scissors. One will do the job, albeit with some swearing; the other means you can have a tool that is a perfect fit for your job. The Point Curve always lets you pick the perfect point to work with. It also doesn't try to protect you. You can do wonderfully destructive things to your photo with it (and we will!).

The Point Curve reduces down to the curve window, the TAT, and a Channel menu. The Preset menu remains—but with a major differences; changes made in the Point Curve can be saved to the menu.

The Targeted Adjustment Tool is similar to the Parametric Curve. Hover over the image to see what part of it corresponds to the curve. Click and drag to change that point. The whole curve will change, with no limit to how much it can be changed. As soon as you release the mouse button, your point becomes fixed on the curve. Clicking again will create another point. The range of this point depends on the previous point. Dragging the second point has a large effect in the area up to first point, and a smaller effect past it. If you start with a central point, then dragging the curve towards the middle of the curve window will start to make the image look gray and muddy. Dragging away will increase the contrast. As with the Parametric Curve, the steeper the curve, the more contrast in the image.

To delete a point, double-click on it. To move a point, simply click on it and drag it. Without adding a point, you can still make radical changes to an image.

Negative

The standard linear curve has two end points. These can be dragged to the opposite corner to create a negative of the image.

Solarization/Smoke

You can also create solarization effects by dragging the black point to 100% and pulling the center point down to 0%. Tweaking the curve will create different variations in this look.

This look was made famous by Man Ray. One of my personal uses for this look is with abstract photos of smoke. Made by lighting an incense stick, then using off-camera flash, these shots are an interesting way of creating a huge variety of arty images. There's luck in getting the smoke to take on familiar shapes, so I'm just using a random one to demo the changes.

The Matte Look

One look that's hugely popular is the Matte look. In the past I've referred to it in videos as a faded and toned look. It's the same thing, just with a fancy name. Essentially you lift the black point up to about 15%. Add a second point about a quarter to halfway along the curve, and drag it down so the main part of the curve is linear again. It gives a faded vintage feel to the image. Looking at the Histogram, you can see a large gap between the left edge and the start of the blacks. If you plan on using this again, it might be worth saving as a Point Curve Preset (or even a Develop Preset).

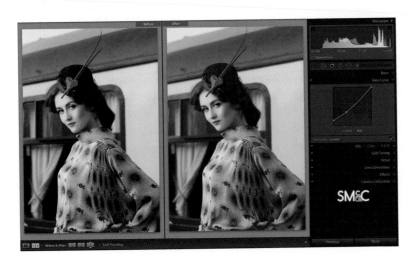

Saving a Point Curve Preset

Saving a preset is easy. Click on the Point Curve selection menu. Assuming you've made an edit, the Save option will appear at the bottom of the dialog. Select this to open a browser window to save to the Camera Raw Curves folder. This isn't in the normal Lightroom folder and it is shared with Camera Raw. As you've noticed, it's not a typical save Preset dialog box. The saved curve will now be selected in the menu.

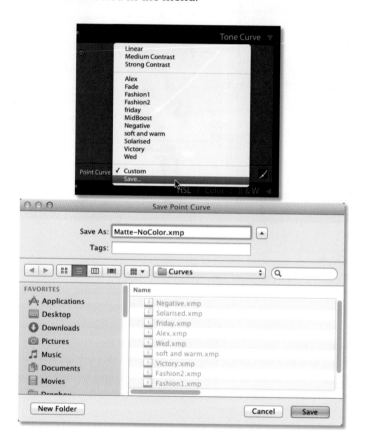

RGB Curves

Everything up until now has been on the RGB Curve, working on the luminosity of the photo. We're not limited to just those, though. By clicking the Channel menu, you get the option to choose between Red, Green, and Blue channels, as well as the default RGB channel. If you don't see the Channel menu after moving to a new image, you're probably not in Process Version 2012.

By pushing a point up on the Red Channel, you increase the redness at that point. Less obviously, when you decrease Red, it effectively adds Cyan to the image at that point. Cyan is the opposite color to red on the color wheel.

For the Green channel, pushing the curve up increases green, while decreasing it adds magenta. Finally for the Blue Channel, increasing adds blue, and decreasing adds yellow. Again, these are all based on the color wheel. Our example image has the Matte preset from above applied, then a very minor adjustment showing how powerful these channels are for changing color.

The Targeted Adjustment Tool now applies to the currently selected channel curve. This means you can go to any part of the image, click, and drag up and down to change the color at that point.

These new controls are useful for removing awkward color casts, or even for creative effects like more accurate Cross Processing effects. This has been done quite well using Split Toning up until now, but there is much more control with RGB curves.

Digital Cross Processing With Curves

Cross Processing is a technique from the film days when film was developed in the wrong chemicals. Generally it was slide film (E6) processed in color negative (C41) chemicals. The colors would be wacky and the contrast really strange. You'd have to overexpose the shot and do loads of random things to get a great look. Of course you'd have to make extensive notes so you knew what had happened so it was repeatable. Fortunately we don't need to go through that to get repeatable results now.

We've seen how effective minor changes in the RGB channels are, so combining them will help emulate the film Cross Processing look. With Instagram more popular than ever, as well as film emulation presets like those from VSCO, let's go create some of our own looks. As a general rule, images with cooler tones in the Shadows, and warmer tones in the Highlights look great, but that's not a hard and fast rule.

When creating Curves, you're not just limited to the points on the curve in each channel—you can also bring the end points in. Begin with the Matte look in the RGB Channel (you did save that as a Point Curve Preset, didn't you?). Now go to the Red channel and move the bottom point to the right

about 9-10%. This will add a cyan tone to the image. Next go to the Blue channel and move the bottom point up about 7%, adding blue to the cyan in the shadows. Move the top point down to about 95%, or to taste. This adds warmth to the highlights of the image. As you can see, small amounts are all that are needed for large changes of color.

Let's create a cross process with more contrast. Start with the Point Curve set to Linear. In the Red Channel, create a little S-curve by pulling the shadows down (about ¼ in from the left), and the highlights up (about ¾ from the left).

In the Green Channel, pull the shadows down, making them more magenta. Add a second point in the center and bring the highlights towards neutral. In the Blue Channel, lift the middle of the curve up, and then use a second point to bring the highlights back to the middle. If you feel this has too much contrast, use the Contrast slider to reduce it.

HSL/Color/B&W

This is the three-in-one panel. To get to each section, click its name in the panel header.

HSL

Hue Saturation Luminance (HSL) is a set of color-targeted sliders that can be viewed as Hue, Saturation, or Luminance, or all three, with 24 sliders. The job each does is displayed in the slider, so it's not really a guessing game. Hue sets the base color, Saturation the richness of that color, and Luminance controls the lightness of the color.

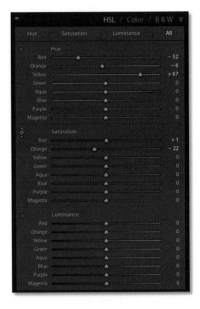

Each set revolves around eight colors: Red, Orange, Yellow, Green, Aqua, Blue, Purple, and Magenta. The color centers are chosen to make them as useful as possible, which is why we have Aqua rather than Cyan, for example. We're more likely to be dealing with aqua sea color than with something directly cyan.

As with the Tone Curve, there's also a Targeted Adjustment Tool for each set. Simply select the one you require and then click and drag it onto the image to change the properties of the selected color in the photo. Things might surprise you as you work. Grass, which in our eyes is green, is actually controlled more from the yellow slider, as is foliage. Because the TAT is visual in nature, it's beneficial to watch the image rather than the sliders. Just be warned that the extreme settings can produce visible edges between different colors. Also, the blue sliders can increase the noise visible in the image. Your aim is to blend colors to make them sit better together.

How do I use HSL? I have the All option on, and then switch between the TAT for hue, saturation, and luminance. This can be done by clicking on each TAT, or from the Toolbar. Once the TAT is active, the Toolbar switches to show Target Group. From the list, choose from Hue, Saturation, or Luminance, or go back to Tone Curve. Alternatively, selecting Grays will switch to the B&W panel.

Color

If you prefer to work on individual colors by using the hue, saturation, and luminance sliders visible for just that color, click Color in the panel header to activate this option. Each of the eight colors can be selected by clicking on the color tile. The eight colors can be worked on together by clicking All.

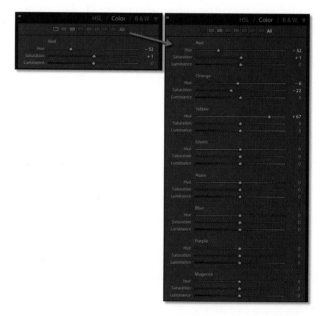

B&W

Photography started in black-and-white, and despite the progression to color film and then digital, we're still enamored with the look of black-and-white images. We've already seen some quick ways to make a black-and-white image in Lightroom:

- In Quick Develop, choose Black & White from the Treatment menu.

- In the Basic Panel, click the Black & White option.

- Press the "V" key.

And now we see that pressing the B&W name in the HSL/Color/B&W panel will create a monochrome image.

Let's back-pedal slightly, though, because although the process of changing to a black-and-white image this way might seem like the quickest option, there is an alternative (read that as: quick-and-dirty) way to do it.

Back in the Basic Panel, drag the Saturation slider all the way to the left. Now, push the Contrast slider to the right until you like the way the image looks. I can hear the purists screaming now, but for a quick look, it's great. In fact, some of the original B&W Presets in Develop were made this way, so while it may not be the purest way, it still works. Personally I've used it in a lot of my own Presets.

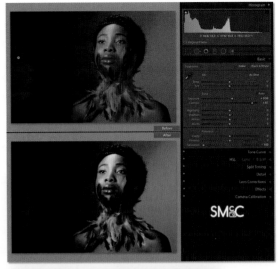

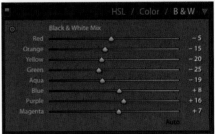

Let's get back to the B&W panel, though, where we've far more options for tweaking our image post conversion. When you go to B&W for the first time, it creates an auto version for you, trying to create a nice default black-and-white photo. You can choose to turn the default auto off by going to Lightroom Preferences, and in the Presets tab, turn off Apply auto mix when first converting to black-and-white.

Now we have a black-and-white image. So why are there still eight sliders? Well that's the beauty of this panel. Each slider represents a color in the original image, so we can darken or lighten any of the underlying colors. First let's look at a flat conversion.

You can use the Targeted Adjustment Tool to work on the image or just work via the sliders. Bringing the Reds up lightens the skin, making it glow—useful if you want to create infrared photo effects. The Orange slider lifts the hair and fills in the face shadow a little. Yellow works on the rocks and on the top of the dress. I've used Green to darken the dress. Aqua affects a small bit of the sea and the bottom of the sky—but only just. Blue darkens the entire sky. Too much and it causes unnatural glowing edges on the hair and noise begins to appear. Purple works on the edge of the hair. Bringing it down blends it into the sky better. Magenta does nothing in this image.

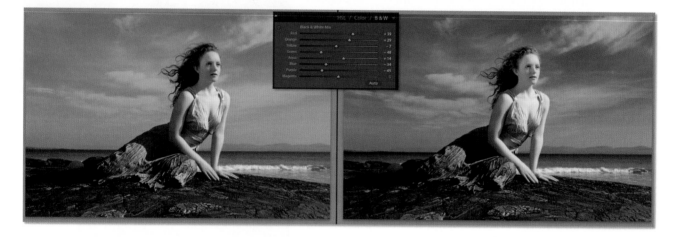

The aim here is to show the amount of control you have in the sliders. Here's a more refined version with added Contrast:

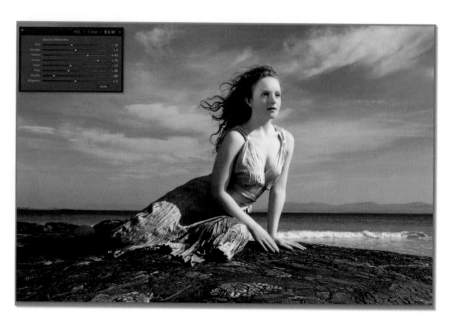

To make a black-and-white photo a little more authentic, we need to add grain. Grain is in the Effects panel, which we'll cover shortly.

Split Toning

Historically Split Toning was done to black-and-white prints to create a range of tones in the print. Initially, toning (like Sepia toning) was done to give a print greater longevity. Part of the process involves bleaching the print to remove the silver. By partially bleaching, a second toner could be added to make a Split Tone print.

The Split Toning panel allows us to emulate these processes, and much more. Split Toning works by applying one tone to the Highlights and another to the Shadows. The Balance slider skews the color towards one or the other. Each tone is created using Hue and Saturation sliders; Hue for the base color, and Saturation for the intensity of color. Fortunately, Lightroom has a little trick to help: hold down the Option (Mac)/Alt (PC) key and start to drag the Hue slider. We're now previewing Hue as if the Saturation slider were set to 100. With the historical view in mind, we'll look at black-and-white tonal processes first, and then look at color applications.

Black-and-White Toning

Basic toning processes are monotoned (the silver is replaced by another color). To emulate these, we generally use the Shadows to replace our blacks with a different color.

Sepia Toning

Sepia toning is recognizable from the brown tone to the shadows of the image. You see it in a huge range of older prints. I find that somewhere in the range between 25 and 45 in Hue provides an excellent base for this tone. Hold down the Option/Alt key and drag the Hue slider into this range. With the Hue selected, release the slider. Now drag the Saturation slider up until you are happy with the look. It doesn't need to be a lot. In fact, more subtle tones look really good and help create a more personal and unique look.

Cyanotypes

Cyanotypes were based on the chemistry used for making blueprints. I can remember my schoolteacher using this paper, which was used to make our quiz papers. Anna Atkins, considered the first female photographer, used this to document ferns and seaweed, creating the first cyanotypes. The color is in the cyan to blue range, so from about 190–220 on the Hue slider. Again, use the Option/Alt key and drag the Hue slider in this range. Set Saturation to taste.

Sepia Toning

Cyanotype

Selenium Toning

Selenium toning gives a red-brown or purple-brown color to the blacks in a print. Originally the process was designed to counteract the brown-green look of certain papers, making the black richer and longer lasting.

For this, keep the Hue from 0-15, or 355-360. Saturation should always be set to taste.

Duotone

Duotones have toning in both the Highlights and Shadows. We can use the monotone settings we've seen already and apply them to create an interesting duotone.

Start with a Sepia tone for the Shadows. For this we'll go with a Hue of 27 and a Saturation of 22. This sets our darker tones. For the Highlights, we'll go for a bluer tone. Set Hue to 22, with a Saturation of 29.

Finally, move the Balance slider to change how the tones affect the shot. For this, -25 looks great, bringing out more of the Shadows.

You can, of course, use any tone combinations you like.

Selenium Toning Duotone

Color Split Toning

Just because the concept of toning comes from black-and-white photos, it doesn't prevent us from using it on color images. Before the Tone Curve had individual channels to play with color, Split Toning was the only way to emulate Cross Processing.

A good start here is to aim for cooler tones for the shadows and warmer tones for the highlights. These complimentary colors help enhance an image. Remember, we're not going for subtle here. A little wildness won't hurt.

For the shadows, look anywhere from yellow to deep blue. For highlights, red to yellow will look good. Velvia, a saturated slide film from Fuji, tends to go quite green in the shadows and yellow in the highlights, so we'll emulate this look first. Our first image is slightly cool in tone, so the settings will reflect this.

First set the Shadows Hue to 110. We want a strong green, so set the Saturation to 59. For the warm Highlights, set Hue to 55. Since the tone is strong, we don't need as much Saturation, so set this to 27. The Balance looks fine in the center.

Tweak away to your heart's content. Here's another sample toning:

Shadows: Hue 177, Saturation 38
Highlights: Hue 42, Saturation 59
Balance: 0

Split Toning isn't as versatile as the Tone Curve, but for quick and easy toning, it's perfect.

Detail Sharpening and Noise Reduction

While Ansel Adams may have believed that there was nothing worse than a sharp image of a fuzzy concept, it's still nice to have sharp images of sharp concepts! Not to mention clean views of that concept. That's where the Detail panel comes in. Detail is home to the Sharpening and Noise Reduction tools, allowing you to increase edge details, and remove both color and luminance noise.

When you view the Detail panel initially, there's a warning icon. Below 100%, you don't get an accurate view of what's happening in either Sharpening or Noise reduction. When the detail window is closed via the disclosure triangle on the right, the warning icon is still visible. Clicking this icon zooms the main image area to 100%, allowing you to see the process accurately.

With the Detail window open (by opening the disclosure triangle), clicking on the crosshair icon will allow you to select the location visible in the box. This way the main image zoom isn't as critical because you can see the effects correctly in this preview.

Sharpening

Lightroom has three types of sharpening: capture sharpening, output sharpening, and local sharpening. We've seen output sharpening used in Export, and will see it later in the Output modules. Local sharpening is done with the Brush tool, which we'll see in the next chapter. Capture sharpening is done to correct the blurring that happens in-camera to prevent aliasing—a defect that occurs due to the digitization of the photo. This blurring is due to the anti-aliasing filter on most modern cameras. The tool is more powerful than to be used for just fixing capture artifacts, and can be used creatively.

There are four sliders that control various aspects of Sharpening: Amount, Radius, Detail, and Masking. As well as the direct control sliding, each slider has a preview mode, activated by holding the Option (Mac)/Alt (PC) key. Sharpening works by creating more contrast along edges, and each of the sliders gives control over specific aspects of this process.

Amount: This controls the strength of the Sharpening. Originally designed to go to 100, this feature was extended to 150 for those requiring even more sharpening. Below 100, the sharpening algorithm has safeguards to prevent the image from breaking up. These are removed above 100, so you can really crunch up an image—which can give a great creative look for certain images (character portraits, for example). The default value for RAW files is 25, and

is a pretty good set-and-forget point, unless you actively want more sharpening. Rendered files (e.g., JPEG or TIFF) have a default of 0, based on the assumption that JPEGs from cameras would already have camera sharpening applied.

Holding down the Alt/Option key and clicking on the slider shows a grayscale preview of the photo. Lightroom sharpens on this luminance channel view, avoiding any potential artifacts from color sharpening—the previews allows you to see exactly what's being sharpened.

Radius: Radius controls how far from the pixel edges in the image the sharpening will affect, varying from 0.5 to 3.0 pixels, with a default of 1.0. The result is best seen with the Alt/Option key held down while dragging. The darker areas show where the Radius slider is affecting.

Detail: Detail controls the sharpening in high frequency detail in the image. Examples of high frequency detail include things like leaves in a forest scene or pores on a face. Detail can also be used to suppress halos that can appear with sharpening along areas of contrast (like a mountrain ridge against a clear sky). As with the other sliders, holding the Alt/Option key shows a preview of the what Detail is affecting. As you move the slider to the right, those areas of high frequency detail become sharper.

Masking: The masking slider creates an edge-based mask. At 0, the whole image is selected for sharpening. As you move the slider to the right, less and less of the image is selected, until only the most prominent edges are selected. This is great because it allows you to sharpen faces without sharpening the skin itself, or sharpen landscape elements without making the sky look crunchy. The caveat is that areas outside the mask receive no sharpening whatsoever—sometimes leaving them a little soft.

The Option/Alt preview is vital to this slider, because it lets you see exactly what's being masked. Anything that's white is being sharpened (everything with Masking at 0) while the black is not. As you move the slider to the right, the amount of black visible in the preview will increase, meaning less of the image is sharpened.

Using the "\" key, I can toggle the before and after view to preview the changes, or get a before/after view using the "Y" key.

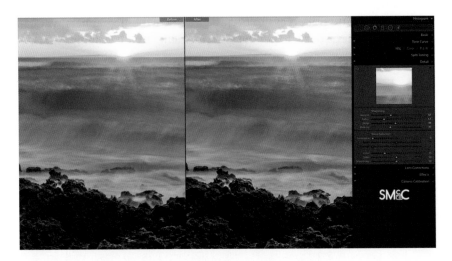

With the example photo, and for most landscapes, around 60 is a good amount of sharpening. Here I've used 57. A slight tweak for Radius to 1.1 is enough. For Detail, I want to bring out some of the splashes, so I bring it up to 48. Finally, I use Masking to hide all but the edge details that I want to sharpen—in this case I set it to 37.

Bring the Noise

The second part of Detail is Noise Reduction. In some ways it goes hand in hand with Sharpening, because applying noise reduction often leads to a softer image, which requires sharpening to correct it.

So where does the noise come from? The most common cause is shooting with high ISO—forcing the sensor to amplify the light signal also amplifies the sensor noise. It's always there, but at low ISO, the noise is less noticeable relative to the light signal. Long exposures cause the sensor to heat up. We see this as hot pixels (pixels that are the wrong color compared to the surrounding ones). Post processing can create noise in the same way as high ISO photos—pushing up Exposure, etc., also increases noise. Finally, there can also be pattern noise from the camera. This is often visible as lines in the shadow areas, made worse with post processing (Lightroom doesn't fix this type of noise yet—increasing the Blacks level in Basic does help, though).

Lightroom deals with two types of noise: Color (also called Chroma) and Luminance (or Grayscale). Color noise displays in two ways: one is the speckles you see in areas that should be a continous tone; the other is in color

variation over larger areas. Luminance noise is visible as uneven brightness across pixels that should be the same, which gives the images a grainy look.

With the advent of better sensor technology, the need for noise reduction has lessened, but with access to even higher ISO's, photographers will use the tools at their disposal to get the shot, including that ISO bump.

We'll look at Color first, because the default is a non-zero value. Lightroom uses 25 as the Color default setting. This setting doesn't do the same thing at every ISO. It's tied to the ISO and is designed to give the best balance of removing noise while retaining the integrity of the photo.

To see the noise in the photo, we'll have to take Color back to 0. There's some difference in the files. Bringing the slider back up to 25, we see the reason is the default setting. That icky-colored speckling is gone, and the uneven blue/purple areas are mostly blue now, and the photo still looks natural.

Both Detail and Smoothness are at 50 (the default setting). Detail works to protect the high-frequency elements in the shot. Effectively it acts as a threshold. If we put it to 100 here, some of the speckled pixels start to reappear. Smoothness works for low-frequency elements. In our image, you'll see this as the purple blotches mixed in the blue sky.

By setting Smoothness to 0, we can see these areas properly in the shot. At 100, they're removed completely. At 50, they're still gone, hence it being a good default. On this image, I'd err on the side of more, though.

Luminance achieves the goal of even brightness via blurring. A quick look with it set to 100 shows you just how blurred it can get. Detail retains high frequency elements in the same way Color does. Setting it to 100 here shows these elements.

Not pretty in this case, but these are extreme values. Contrast brings back lost contrast locally in the image. Higher values look a little mottled, though. With a default of 0, it's best used on really noisy images to bring back the contrast. If the image is still a little soft, Sharpening may be used to bring back edge detail.

The amount of Noise Reduction you use is a personal choice. It's better to err on the side of too little, and be content with the noise in order to retain actual detail. For this photo, I've added 49 Luminance and increased the Smoothness. Changing the Detail from the default 50 brings back too much noise, and increasing contrast makes the image mottled. Increasing the Sharpening to 35 brings back some lost detail, but adds a little noise.

The Detail panel is the one panel where 95% of the time the default settings just work. The other 5% of the time they provide enough control to correct the issues in Lightroom. If you find you'd rather apply Noise Reduction or Sharpening locally, it is possible via the Adjustment Brush, though in both cases it's a single-slider application.

Creative Detail
By playing with both Noise Reduction and Sharpening, you can make great creative effects. Luminance blurs features, and combined with sharpening, you can make a great painterly effect.

Lens Corrections

The Lens Corrections panel is where you fix lens-related issues, including pincushion/barrel distortion, chromatic aberration, vignetting, and perspective.

Pincushion or Barrel distortion is a common lens problem. Wide-angle zooms are especially prone to it. Pincushion looks like someone has pushed the middle of the image inward, so straight lines curve toward the center. Barrel distortion is the opposite, where the image looks bloated, with straight lines curving outward. Other complex forms of distortion, like mustache distortion, can also ruin a photo.

Chromatic Aberration sounds like a rare and painful tropical disease. It's simply a name for the color fringing you see on the edges in an image. It happens because light bends as it passes though a lens. Each color doesn't focus at exactly the same point, meaning the color can appear around the edge of the object. Additional lens elements are used to correct this in most lenses, with varying degrees of efficiency. There are two types of fringing: Axial and Transverse (also called Longitudinal and Lateral). The first refers

to the purple/green fringing you see in many photos, especially fast prime lenses. The second refers to the blue/yellow or red/cyan fringes you see on highlight edges. This second type can be fixed automatically.

Vignetting is the darkening of the corners in the image. Again, this can be corrected automatically based on the lens.

Perspective distortion happens when the camera is aimed up or aimed down. Vertical lines move from the outside in, so rectangular objects like buildings start to appear more triangular. It's especially critical to fix these issues for architectural or real estate photography.

The Lens Correction panel has four parts to correct these issues: Basic, Profile, Color, and Manual.

Basic

The Basic tab pulls together three checkboxes from the other tabs: Enable Profile Corrections, Remove Chromatic Aberration, and Constrain Crop. We'll look at these in the related tabs.

The Basic tab also houses the Upright section, where Lightroom deals with fixing perspective issues.

Upright

While not a tab in itself, the Upright section deserves special mention. Upright has four types of correction: Auto, Level, Vertical, and Full. Before beginning, it's a good idea to apply a lens profile by clicking the Enable Profile Corrections, because this gives better results for the image analysis.

Auto: This will straighten the photo, fix the aspect ratio, and correct perspective issues.

Level: This will straighten the photo while fixing perspective issues weighted in the horizontal direction, e.g., ceiling lines.

Vertical: Vertical perspective is more important in this fix, but it still levels the photo.

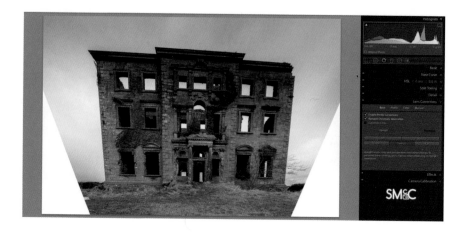

Full: This option applies all three corrections.

I find that Full works for single-point perspective compositions, where you're aiming at the front of a building or one wall of a room. When aiming into a corner (two-point perspective composition), Full tends to try and make it into a single-point perspective composition.

No one option here is perfect for every image, though Auto is a good start. Cycle through the options to see which fits your image. Occasionally something can trigger a failed response, in which case you can use the manual controls.

Shooting for Easy Upright

If you're shooting real estate, and you want an easier time post processing, you've two real options. One is to shoot at mid-room height and have the camera completely level, both horizontally and vertically. Newer cameras have built-in digital levels to aid this. The second option is to use Tilt Shift lenses. Again, you'll need a level camera, but you can shoot higher than mid room.

Loupe Overlay

It can be hard to trust your eyes to see how straight something is without a reference. Fortunately, Lightroom gives us two options for this. In the View menu is the Loupe Overlay menu. To show the overlay, use the shortcut Command + Option + O (Mac) or Control + Alt + O (PC). As well as the two options that can aide straightening, there is a third option for shooting images for layouts. Whichever of the three options are turned on in the menu will appear. The Guides are shown in the figures below.

To change the position of the Guides, hold down Command (Mac), or Control (PC). The icon at the center of the Guides will change and they can be dragged to another location (as seen in the figure on the above right).

Additionally, you can opt for a Grid. Again, hold down Command (Mac), or Control (PC), and then click and drag the Size and Opacity name icons to change the relevant property of the grid squares.

The final option in Loupe Overlay is the Layout Image. It's not really useful for perspective, but can be used for seeing how a photo fits in a composite, or how it looks for a magazine cover. To choose an image for the layout, use the shortcut Shift + Command + Option + O (Mac) or Shift + Control + Alt + O (PC), or Choose Layout Image in the Loupe Overlay menu in View. Again, hold down Command (Mac), or Control (PC), to change the Opacity

(which fades the Layout Image) or the Matte (which darkens the outside of the Layout Image).

This menu is also available in the View menu in Library.

Profile

The distortions and vignetting in a lens can be measured. These measurements can be taken from one lens and used for all copies of images made with that lens. If the lens is measured using a full frame camera, those settings can also be applied to a crop body camera.

Adobe engineers have taken these measurements and created Lens Profiles with them. Lightroom (and Camera Raw) uses these profiles to automatically fix the distortion in a lens. Generally these profiles are created for RAW files, but there are some that also work on JPEG.

Supported Lens List

For a full list of supported lenses, go to:

https://helpx.adobe.com/x-productkb/multi/lens-profile-support-lightroom-4.html

This list expands with each new Camera Raw and Lightroom dot release (a dot release is one that's not a whole number, like 6.0 to 6.1).

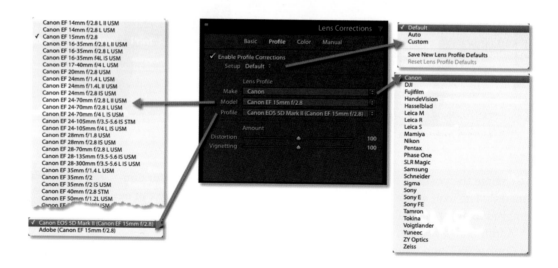

To use the profiles, check the Enable Profile Corrections option. This reads the lens metadata from the EXIF file and matches it to an available profile. Be warned that older cameras didn't always write useable metadata (for example, a Canon 24-70 might appear as 24-70 or EF24-70 even though it's the same lens). In this case, select the Make—often this will find the correct Model from there. If not, select the Model and Profile from there. Next, in the Setup menu, choose Save New Lens Profile Defaults. Each time Lightroom encounters this lens, it will apply your new settings automatically.

One lens type where the corrections are strikingly different is with a fish-eye lens. Lightroom de-fishes the lens, removing the characteristic bowed lines from around the edges.

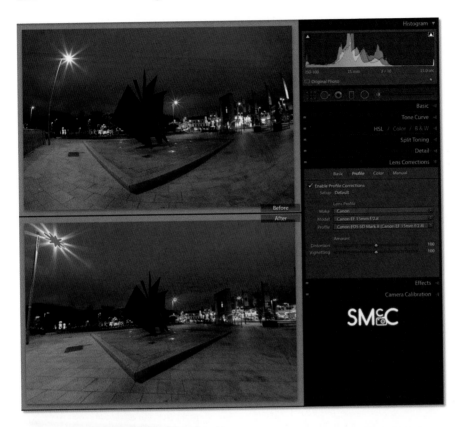

If you use mirrorless cameras, you'll be glad to hear that Lightroom automatically applies the built-in Lens Profile from the camera. The figure on the right shows what a file from a Fujifilm X-Pro1 looks like.

Clicking on the little *i* will open the information dialog explaining that the RAW file contains a built-in profile, and that profile has been applied.

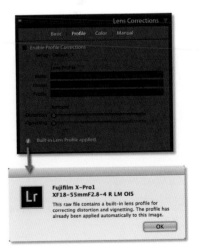

Roll Your Own

If you wish to create your own Lens Profiles, or even download ones created by other users, go to https://helpx.adobe.com/photoshop/digital-negative.html#resources and get the Adobe Lens Profile Creator, or the Adobe Lens Profile Downloader.

At the bottom of Profile are the Distortion and Vignette sliders. When a Profile is applied, these are set to 100, representing 100% of the settings in the Profile. You can reduce or increase the strength of either, if you need to. I often reduce the Vignette amount on my astrophotography with the Canon 17-40 because I find the edges are too light. The image below shows the difference that bringing Vignette back to 69 makes. The top-left edge has darkened, and looks similar to the middle of the top area in this shot of the International Space Station and the Milky Way.

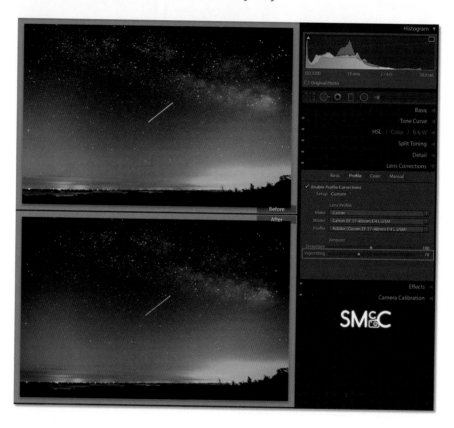

Color

Color is where both Axial and Transverse chromatic aberration can be corrected. For the blue/yellow and red/cyan fringing in Transverse chromatic aberration, the fix is easy. Click the Remove Chromatic Aberration option.

Axial chromatic aberration is slightly more difficult to correct. For this you need to take the Defringe eyedropper and click on an edge with purple or green fringing (or both). Make sure the Remove Chromatic Aberration option has been checked, ensuring you're working on the right type of fringing.

You'll notice that the Defringe eyedropper has similarities to the White Balance eyedropper. As well as the visual and operational similarity, both also have Auto Dismiss, Show Loupe, and the Scale slider in the Toolbar. They work in the same way as with White Balance. Auto Dismiss should be off for this tool. You may need to hunt to find a good sample. If you click and there's not enough information, a bezel will appear letting you know to try again.

Manual

When all else fails, or when you want to tweak what a Profile has done, the Manual tab is there to help. Manual gives full control over Lens Corrections and is applied in addition to the Profile, if it has been enabled.

Distortion: Moving this slider to the left fixes pincushion distortion. Moving it to the right fixes barrel distortion.

Vertical: This corrects perspective issues resulting from aiming the camera up or down. Move the slider until vertical lines appear parallel. New areas created in the process are transparent.

Horizontal: This corrects skewed perspective that results from the camera sensor plane not being parallel to the scene. Even aiming an inch or two to the left or right can make horizontal lines skew. Move the slider until horizontal lines in the image are parallel. I love this slider because it's often hard to gauge if the film plane is parallel to the room I'm shooting on the back of the camera. Again, new areas created in the process are transparent.

Rotate: Rotate corrects any tilt of the camera. The center of rotation is always the center of the original uncropped version of the scene. It's sensitive to the Vertical and Horizontal settings, so it can appear to move the image in an unexpected way, unlike the Straighten tool in Crop.

Scale: This zooms the image area in or out. When you get below 100, new areas created in the process are transparent. This slider is useful when you to need to regain space to crop into the available image area.

Aspect: Sometime the Profile and other tools can distort the aspect ratio of the image. This slider lets you slim or expand the image. You can cheat and use it to slim people, of course!

Constrain Crop: This crops to exclude any transparent areas created in the process of correcting lens issues.

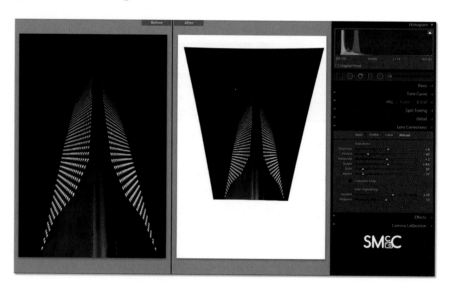

Below these sliders are the Lens Vignetting settings. These give a manual control for fixing lens vignette. It works on the whole, uncropped image. Amount darkens when the slider is moved to the left, and lightens when moved to the right. Midpoint becomes active when Amount is changed. Moving the Midpoint slider to the right brings the vignette closer to the center. Moving it to the left pushes the vignette out to the corners.

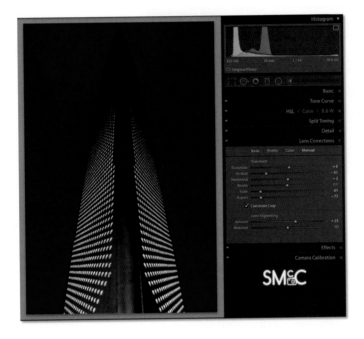

By way of example, here's the Auto version of the ruined house image from earlier, tweaked in Manual.

Effects—Vignette and Grain

We've seen Vignette in the form of lens corrections, and touched on Grain before. In both sections, most of the sliders are unavailable until the Amount slider is changed.

Post-Crop Vignetting

Vignette in Lens Corrections is applied to the whole, uncropped image. It can be used creatively, by darkening the corners to draw attention to the center of the photo. If you crop the image, the vignette won't move with the crop, because it's designed to work on the entire photo. Fortunately, Lightroom has a tool that does work with the crop, and has far more options than exist in Lens Vignette: Post-Crop Vignetting.

There are three types of Post-Crop Vignetting: Highlight Priority, Color Priority, and Paint Overlay.

Highlight Priority allows highlights to be retained in the vignette. This allows important areas to remain visible even when they're within the vignette. It can lead to color shifts in darker parts of a photo.

Color Priority prevents color shifts in darker areas of the photos at the expense of the highlights. Use this when color is an issue.

Paint Overlay is a legacy from Lightroom's first attempt at Post-Crop Vignette. It paints white or black pixels over the image with no thought to underlying color or highlights. Feel free to try it to see how truly horrible it is and why we now have Highlight and Color Priority instead. The Highlights slider is not available with Paint Overlay.

Normally I just use Highlight Priority for my vignettes. While I usually darken, we'll examine the entire range of options for each slider. To make the operation of the slider easier to see, we'll set the Feather slider to 0 first. This means the vignette will have a hard edge.

Amount

Moving the Amount slider to the left darkens the corners. Moving it to the right will lighten them. Moving the slider all the way to the left will make the corners completely black; all the way to the right, the corners will be completely white. Unfortunately the slider shading doesn't accurately reflect the color change.

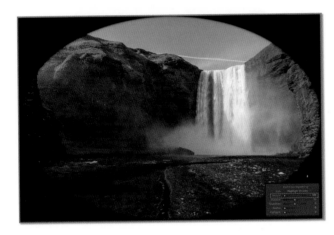

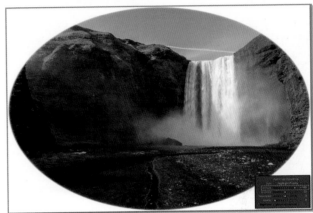

Midpoint

Midpoint controls how close the vignette will come to the center of the image. Move the slider to the left, and the vignette comes right into the middle of the image; move the slider to the right and it barely cover the corners.

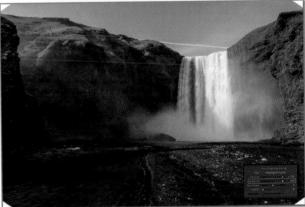

Roundness

Roundness controls the shape of the vignette. With the slider to the left, the image becomes more rectangular (with rounded corners). With the sliders to the right, it becomes circular.

Feather

Feather controls the softness of the edge of the vignette. We've been using it at 0 to show the effects of the other sliders—you can see that the lines of the vignette are quite hard when the slider is moved to the left, though not a solid line. If you move the slider to the right, the edges become really soft.

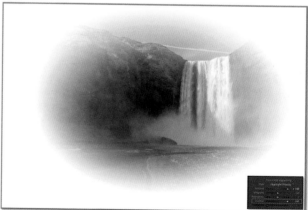

Highlights

Highlights will only be available in Highlight and Color Priority. Even then, the Amount slider must be to the left (darkening the image). I've cropped in to make sure we have a highlight in the vignette area. The highlight recovery is most noticeable in the top right of the waterfall. Notice that the right side of the vignette is not as dark as the left, since the Highlight Priority lets the midsection of the water remain visible.

Seeing the full effect of each slider will give you an idea of what can be done, but let's have a look at some practical settings. Here we have a vignette that darkens the corners subtly, and pulls attention to the waterfall. The settings are: Amount -35, Midpoint 34, Roundness 0, Feather 44, and Highlights 0. The Roundness was perfect in the center, and there were no highlights in the corners to worry about.

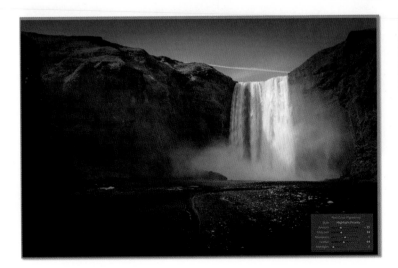

The next example uses Post-Crop Vignette to create a border for the image. The settings are: Amount 100, Midpoint 27, Roundness -100, and Feather 0. Highlights are off because the Amount is greater than 0.

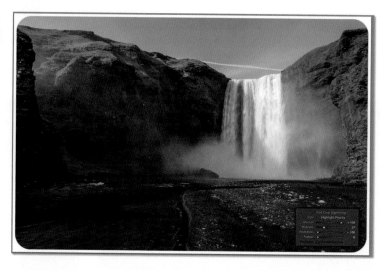

The final example is a variation on the last one. Here we're creating a slightly darkened edge. The settings are: Amount -10, Midpoint 28, Roundness -100, Feather 0, and Highlights 0.

Grain

Grain makes black-and-white and color photos look more like they were shot with film. This is the primary reason the Grain effect was added, but it does more than that. It can also help with banding and disguise bad noise in a photo. There are three controls: Amount, Size, and Roughness.

Amount increases the grain in the photo. Viewing the image at 100% makes it far easier to see what's happening. Zoomed out, the effect is less obvious. Adding grain changes the contrast in the image. With the Clipping Indicators on, you'll probably start to see tiny red dots where the grain is adding high-lights. For the final look, you'll need to zoom out to see the effect on the whole image.

Size increases the apparent size of each grain. At high levels it tends to blur the photo. This can be useful for removing blemishes, but not at the expense of other detail.

Roughness changes the nature of the grain. Different films and developers produce very different characters of grain. Roughness emulates these differences.

The three settings work quite interactively, making for a huge range of Grain effects.

Camera Calibration

We've already looked at the two most important parts of Camera Calibration: Process Version and Profiles (back in the Basic panel section). One other thing worth mentioning is that Camera Profiles only apply to RAW files. Rendered files show the word Embedded in the Profiles section instead of a dedicated camera profile.

Before the current Profiles existed, the only options were previous renderings from Camera Raw, which became the Adobe Standard profile. To change how Lightroom rendered color, you had to use the sliders below the Profile menu.

There are three pairs of color controls and a Shadows Tint slider. This latter slider allows you to fix white balance issues where the shadows vary in tint to the main white balance of the photo.

The three pairs of sliders allow you to change the Red, Green, and Blue Hue and Saturation values.

In the past you could use the FORS script (http://www.fors.net/chromoholics/), or manually match a photo of a colorchecker to the real one to set these sliders. Now, with the DNG Profile Editor or the X-Rite ColorChecker Passport system, you can create your own profiles to match your lighting and camera automatically.

Moving on

The remaining item in the Right Panel is the Tool Strip. We'll cover this, along with the Left Panel, in the next chapter.

The Tool Strip

The Tool Strip is located under the Histogram in Develop. Despite the small size, it houses some of the most useful and powerful tools available for changing your image. There are six tools here: Crop, Spot Removal, Red Eye, Graduated Filter, Radial Filter, and Adjustment Brush. When any of the tools are open, you can switch their effect on and off temporarily from the bottom of the panel using the light switch icon. You can also reset the work done so far or close the tool from there.

Crop

Cropping is a really powerful creative tool. The camera we choose to shoot with generally dictates our relationship with cropping. A digital SLR user or 35mm film user will be familiar with the 3:2 ratio crop. Medium Format users might be used to the 6×4.5 crop, or as it is with some mirrorless cameras, the 4:3 crop. Other Medium Format users might prefer the square of the 6×6 format. You might even love the look of images made with a panoramic camera like the X-Pan or the Fuji 6×17. Moving with current trends, you might prefer the widescreen 16:9 crop. Sometimes you need to crop for traditional printing—like needing a 10×8 print made from a 3:2 camera.

The Art of the Crop

The shape of the image will influence the composition within. Turning a landscape photo with a bland sky into a panorama can often increase its impact, turning it from a miss to a hit. Lightroom has the tools to do this. First, let's talk about the art of the crop. When learning the art of photography, we're often told to fill the frame, or use the rule of thirds. Sometimes, even when using these rules, we still don't get what we want. Sometimes a change in crop is all that's needed to alter the photograph to fit your vision.

In this first example, altering a vertically oriented image to a horizontally oriented image improves the composition. It removes the bland sky and the immediate foreground with nothing of interest. The rock is now the foreground, leading the eyes to the house and the mountains in the background.

For our second example, we've cropped into a face. This is a pretty extreme crop, but since the original file is quite large, we can still safely print an a4 shot from the crop. The removal of the hair simplifies the photo, giving it more impact.

Our final example shows that cropping into an image can draw more attention to the subject. In the first version of this image, the arch is a major part of the composition. By cropping, we draw more attention to the model.

Freehand Cropping

To access Crop, click on the icon in the Tool Strip, or press "R".

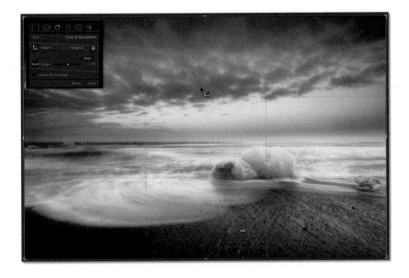

Notice that the crop tool has changed to a set square. This is the freehand crop tool. With the lock set to open, the tool allows a free aspect ratio. That means you can draw any crop you like on the image immediately. If the lock icon is closed, you can draw a crop, but you're limited to the selected ratios in the Aspect list. Initially this is the Original crop. To change the Aspect lock, either click the icon or use the shortcut "A" to toggle it.

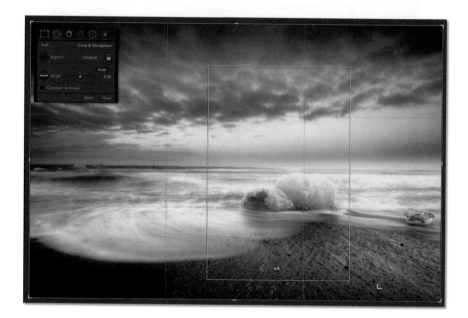

Setting the Aspect Ratio

To change to another ratio, click on the Aspect dropdown menu. There are five main ratios, with three additional screen-based crops: 1×1(Square), 4×5 (8×10), 8.5×11, 5×7, and 2×3 (4×6). These coincide with common print sizes. The screen ratios are 4×3 for 1024×768 crops on iPad, 16×9 for 1920×1080 HD size, and 16×10 for 1280×800, which is a common widescreen computer monitor size.

In addition to the default Aspect ratios, you can also have up to five custom ratios. To enter a custom ratio, select Enter Custom.. from the list. Simply enter the numbers (including screen dimensions) and Lightroom will work out the ratio for you. Some common ratios include 851×315 for a Facebook cover photo, or 20×8 for a panorama.

When you reach five custom ratios, entering an additional set will delete the oldest available set. We've mentioned 20×8 (or 2.5×1) as a ratio for panoramas. Others include 2×1, 3×1, 4×1 and 6×17.

Crop Overlays

When you select the Crop tool, the Crop Overlay is introduced. Initially this appears according to the "Rule of Thirds," but there are others sizes available. Change the appearance of the Crop Overlay by pressing the "O" key, or with the Cycle Grid Overlay command in Crop Guide Overlay from the Tools menu.

The Rule of Thirds Crop Overlay

The Diagonals Crop Overlay

The Triangles Crop Overlay

The Golden Ratio Crop Overlay

The Golden Spiral Crop Overlay

The Aspect Ratio Crop Overlay

The Grid Crop Overlay

Each individual Crop Overlay can also be selected from the Tools > Crop Guide Overlays menu.

The Crop Guide Overlay Menu

You can also change which of the overlays appear when you cycle through them by clicking Choose Overlays to Cycle from the Crop Guide Overlay menu, and then unchecking the ones you want to remove.

The Triangles, Golden Spiral, and Aspect Crop Overlays can be rotated to match the preferred composition for the image using Shift + O, or with the Cycle Grid Overlay Orientation command in Crop Guide Overlay from the Tools menu.

Cropping into an Image

As well as freehand drawing, you can also drag from any corner or edge center to reduce the size of the image. With the Aspect lock off, you can drag to any position. If you want to retain the current aspect ratio with the lock off, you can hold the Shift key to constrain the crop. Lightroom keeps the crop in the center of the screen while moving the image behind it. If you're used to the traditional methods of dragging the crop over the image, this can take a little getting used to.

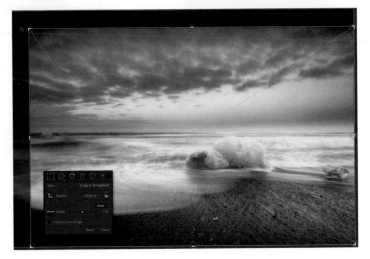

Drag the crop from any of the eight circled points (see the figure on the previous page). Hold the Shift key to constrain the crop with the Aspect Lock off. Again, with the Aspect Lock off, you can hold the Option (Mac) or Alt (PC) key and drag any of the four edge center points to have the crop move in or out evenly with both the selected edge and the opposite edge.

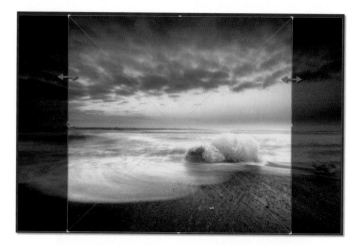

You can combine the Shift and Option/Alt keys together to drag in evenly from each corner. This means the center of the image remains the same after the crop is complete.

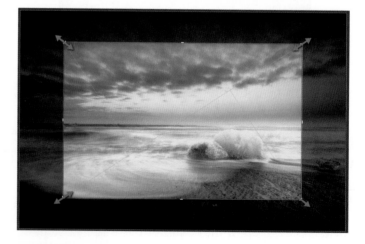

You can apply the crop Aspect to another image by selecting it in the Filmstrip and pressing "S". The image Aspect will copy over from the previous image. Note that the position of the crop won't copy, only the crop Aspect.

Rotating and Straightening an Image

All this cropping is useless if we can't straighten the photo, or even rotate it for a better position. We've seen that we can rotate in Lens Correction, but there's nothing to help you straighten quickly here in Crop. The next part of Crop will help though: Angle.

New in Lightroom 6 is the Auto button. Click this to apply an automatic correction based on the Levels button in Lens Correction (note that Levels does not get selected when this happens). You can also achieve this effect by holding the Shift key and double-clicking on Angle in the panel.

You can also drag the Angle Slider. Once you click on the slider, the overlay automatically switches to the Grid Overlay until you release it. Drag until you're satisfied. You can also double-click the number and enter an angle directly. Alternatively, hover over the number until the cursor turns into a pointed finger with double-headed arrow, and then click and drag left or right to change the angle. This works for all numbers throughout Lightroom, not just the ones in Angle.

Accurate Straightening

Because Lightroom doesn't allow a cropped-in view while working in Crop, you may want to turn on the Loupe Overlay (discussed in the last chapter) and zoom to 1:1. Lay the overlay guide over the horizon line, and then change the angle. As you work, press "R" to toggle in and out of Crop to check how level the horizon is. The view will return to 100% (or whatever the previous size was) when you move out of Crop.

The Angle slider with Loupe Overlay inset

The final option, which has two steps, is to click on the Angle icon. This straightens the image using a two-click process. Click one point on the horizon on one side of the image, and then click a second point on the other side. Lightroom will calculate the correct angle using these two input points. Even quicker than clicking on the Angle icon is simply holding down the Command (Mac) or Control (PC) key. This temporarily activates Angle and lets you draw a line between the two points to fix the horizon.

Flipping Orientation

Sometimes we want to change from a vertical to a horizontal composition, or vice versa. In the past you've have to drag a corner out at a forty five-degree angle and hope the flip would work. Fortunately, after much pleading, Adobe gave us a shortcut key. When Crop is active, press "X" to flip the orientation of your image. Remember that outside Crop, "X" is the Reject shortcut, so Crop must be active for this to work.

Spot Removal

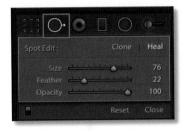

Spot Removal was originally designed to eliminate spots created by sensor dust during post-production. Originally a circular tool, Spot Removal was enhanced in Lightroom 5 to include a brush-like tool, allowing you to eliminate spots with a tool of any shape. To start Spot Removal, click the second icon in the Tool Strip, or use the shortcut key "Q".

Spotting Controls

Using Spot Removal is really easy. Click on a spot and Lightroom will auto hunt to find a replacement area. There are two types of Spot Removal available:

- Clone: This copies the sampled or source area over the selected or destination area.

- Heal: Similar to Clone, but Lightroom will match the sampled area to the surroundings of the selected area to make it blend better.

Clone vs. Heal

Personally I have a preference for calling the sampled area the *source*, and the selected area the *destination*. With a spot selected (the pin for the spot will have a black dot when selected, or the circle will have a visible source area), you can swap between Clone and Heal. There are three options with each spotting brush: Size, Feather, and Opacity.

- Size: This controls the width or diameter of the brush. For spotting, you generally want the brush slightly larger than the spot. Use the shortcuts "[" and "]" (square bracket keys) to change the Size.

- Feather: This controls the softness of the source edge. This really needs to be outside the selection. Note that feather works inwards from the Size, not adding to the Size. Increasing Feather may mean that you need to increase Size to compensate for the decreasing source area. Use the Shift key with the square bracket keys "[" and "]" to change the Feather.

The first image has Feather of zero, the second 100. The Size in both cases is 80.

- Opacity: This sets the transparency of the tool. At 100, the source covers the destination area. Below this, the underlying spot will start to show through. At 1, the spot removal will be almost invisible.

Opacity of 1 vs. Opacity of 100

Hide and Seek

To hide the pins and the spot outline, use the "H" key. This hiding action applies to everything across the Tool Strip. Anytime you feel you should be seeing a pin (or evidence of another tool applied), try the "H" key to see if it's been hidden.

Manual Source Selection

Lightroom generally does a good job of finding a replacement spot. If the results are not satisfactory, simply drag the source to a new location. For

non-circular spots, drag the pin. If the destination point is not exactly where you meant it to be, you can drag this, also.

There's also a shortcut key to tell Lightroom to try another source: the "/" (forward slash) key. Press this until you find a suitable spot.

As you find spots, you can manually choose the source point for their removal. Hold the Command (Mac) or Control (PC) key when you click on the point, then drag to your preferred source.

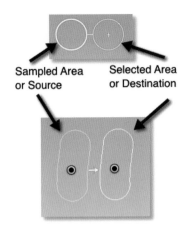

Sampled Area or Source

Selected Area or Destination

Sizing on the Fly

When you're working with an image with varying spot sizes, there is a way to change the circular spot tool as you work. Hold down the Command + Option (Mac) or Control + Alt (PC) keys before creating a new spot. Click on the center of the spot and then drag outward until the spot is covered. Lightroom will choose a source point.

Deleting a Spot

With a spot active, press the delete key. Alternatively, right-click on any spot, and choose Delete from the flyout menu. Lastly, you can hold the Option (Mac) or Alt (PC) key to turn the cursor into a scissors, which will delete any spot you click. On Mac, deleting a spot will show a cloud of smoke with a reassuring "poof" sound to let you know it's vanished from the image.

Visualize Spots

It's easy to see the big spots, but the smaller ones can be hard to see. There was a trick in Photoshop where you inverted the layer to make the spots stand out, and then you'd invert it back after spotting was finished. Lightroom now has a more sophisticated version of this called Visualize Spots.

The image on the previous page is a landscape photo with processing done in the Basic and Lens Corrections panels. The image still needs to have spots from sensor dust removed. A quick look reveals a few faint ones. Zooming in will reveal more, but you still may miss some, so it's time to use the Visualize Spots feature.

The Visualize Spots checkbox is in the Toolbar. Click this to activate it, or use the shortcut "A" to toggle it on and off. The image will become black and white, similar to the mask from Masking in the Detail Panel. Move the slider to the right to increase the contrast, which allows you to see even more spots.

Remove the spots by clicking on the circular or semicircular areas that look out of place. In the figure below, I've highlighted some examples in red circles. The image below shows the final set of spots revealed through Visualize Spots.

Just like with normal spotting, make sure the source points Lightroom has chosen work for each spot, and correct them if needed.

Moving Through the Image

To get a better view of the spots, zoom in to 1:1 view. Start at the top left of the image and use Page Down to move through the image. When you reach the bottom, press Page Down again to move back to the next unseen section of the top. Page Up works the same in reverse.

Advanced Healing Brush

This is the name given to the new version of Spot Removal. Instead of a single circle, you can use the Advanced Healing Brush to draw and create a shape instead. Lightroom will select the source and show a gray pin. A black dot on the pin means the spot is active.

Using a brush for spotting means you can do things like remove poles or fence posts. In fact, you can even use this tool for object removal if the image suits it.

For this figure, I've removed some fence posts from the image

Blemish Removal

Spot removal is not just for landscapes or dust removal, it can also be used to retouch facial blemishes. Let's do some spot work on a face. For this image, I'm just doing light work to demo the process. There's been some negative Clarity brushed on the skin, and a little red removed from the skin. All blemishes were left intact for the initial shot.

For the circles under the eyes, I draw over the area to be retouched with Feather and Opacity at 100. The Size is set so only one stroke is required. Next, I reduce the Opacity to blend the fix with the original area. This helps it look more natural. The aim is not to remove, but to improve. Lightroom won't select the best area, so move the source to the cheek directly below the eye. When retouching, you need to match areas because skin texture is different all over the face. Skin from the upper cheek is different from cheek skin near the chin. The side of the forehead is different than the center, or even the area just above the nose. It's critical that you match skin as you spot.

With one eye done, repeat the process for the second eye. The settings you've changed for the first eye will be set for the second. Now tackle the blemishes. After the first blemish is removed, reset the Opacity to 100. You want to completely remove these. Set the size to match the blemish. Use the shortcut Command + Option + click and drag (Mac) or Control + Alt + click and drag to size the spot as you go.

The difference between the Before and After views is subtle. That's the point. If a retouch is noticeable, you've done a bad job. There are more tools in the Tool Strip that can be used in Beauty retouching, and I'll show examples as we get to them.

Red Eye

Red Eye occurs when flash is reflected from your subject's retina. It's prone to happen with compact cameras and in-camera flashes from digital SLRs. It can still happen with external in-camera flashes if you're far enough away from your subject and using a telephotos lens. In fashion circles, it's common when using a ringflash.

Red Eye is the third tool in the Tool Strip. It has no shortcut and can't be synced to other photos. Lightroom 6 has a new addition to Red Eye; the Pet Eye tool. Let's look at both.

Red Eye Removal

For humans (and possibly some aliens), the retina reflects red. This tool will detect the redness and apply a black mask to hide it. In order for the redness to be detected, you must draw an oval over the eye area.

As per the panel instructions, click the center of the eye and drag outward to include the whole eye. If it works, you'll see a little animation as Lightroom zooms into the pupil and darkens it.

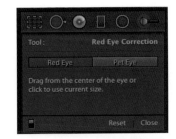

Our example photo has red eye from using a ring flash.

If you've not included enough of the eye, or the currently selected size hasn't worked, you'll see an error message.

Once the eye has been fixed, the panel changes to Edit mode. In this mode, you can change the pupil size, as well as darken the pupil further if necessary. In addtion, you can drag the red eye position around.

Click the other eye(s). If you want to avoid the error dialog, drag over each eye individually.

Pet Eye Glow Removal

Animals have a layer of cells behind their retinas called the tapetum lucidum. This aspect of the eye acts like a mirror and helps them see better at night. It also causes that demonic glow in images when flash hits them. Again, it's the angle of the flash that causes that pet eye glow to become visible.

I'm not allowed to have pets in my apartment complex, so I called on some friends to photograph their pugs. Rocco here was the only one that would pose. I promise I took some nice shots of him as well!

Rocco's been possessed by a face-licking entity—not really, it's just my ring-flash. It's time to go to the Pet Eye tool.

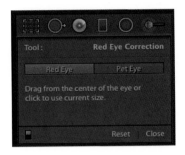

Exactly as with Red Eye, drag from the center of the eye outward to include the whole eye. Lightroom will darken the eye and add a compensational catchlight now that the eye has been darkened.

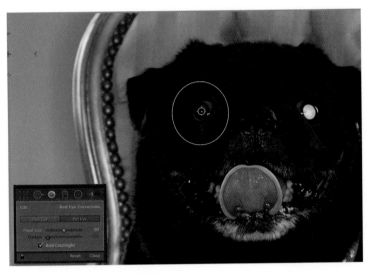

The Edit tool now contains the Add Catchlight checkbox, and the Darken slider has been grayed out. On the eye itself, you can move the catchlight about or change the pupil size.

I have to increase the size of the pupil to hide all of the green glow. I compared these images to images of dogs that didn't need the Pet Eye treatment. I found that the eyes that didn't need post-processing looked darker naturally, so expanding the Pupil Size slider for the images that did need the Pet Eye treatment made these images look more natural.

And here's the face-licker in better light!

Graduated Filter

Landscape photographers often use graduated filters, which have a dark section and a clear section. The dark part usually blocks a fixed amount of light:

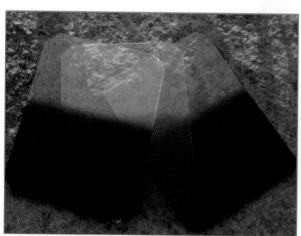

Real life Graduated Filters

1 stop, 2 stops, etc. These filters evolved during the film era to help balance the light from the sky with that reflecting off the ground. Normally an exposure set to give a good look in the sky would have the land too dark. Exposing for the land would often lead to blown highlights in the sky. Landscape photographers would often use slide film, so they needed to reduce the dynamic range of the scene. These graduated filters were the solution. The graduated part refers to the transition between the clear and dark sections. A rapid transition is called a hard-line graduated neutral density (GND) filter, while a more gradual transition is called a soft-line GND filter. Neutral density refers to the dark part, which adds no color, but offers a specific amount of light reduction. A 0.3 GND reduces by 1 stop, 0.6 GND reduces by 2 stops, and so on.

Lightroom can emulate the work of these GND filters, but with a whole range of other effects. This option, called Graduated Filter, is the fourth option in the Tool Strip. It takes its name from the original filter. Click the rectangular icon or press M to open the Graduated Filter. You can also choose Graduated Filter from the View menu.

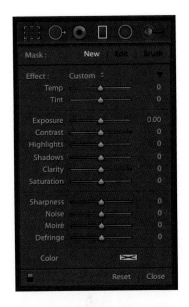

Applying the Graduated Filter

To operate this tool, simply click and drag a line on the image. The effect starts where you click and ends where you finish dragging. For a hard transition, drag a very short line. For a softer transition, drag a long line. Hard transitions are good for flat horizons, like a view out to sea. Soft transitions work best for almost everything else. To keep the filter level as you drag, hold down the Shift key.

You'll notice that a filter has three lines. The outer two show the transition around the filter edge, which is the central line with the gray pin. A selected filter will have a black dot on the pin. To move the filter, drag the pin. To change the transition, drag one of the outer lines. The opposite line will remain in place and you can drag towards it or away from it to change the transition strength. If you're happy with the position of the central line of the filter, then hold the Option (Mac) or Alt (PC) key as you drag. This moves both of the outer lines in and out as you drag. If you want to rotate the filter, hover the mouse over the central line of the filter, away from the pin. It should change to a curved arrows icon. Click and drag the line up or down to rotate the filter around the pin. As with Spot Removal, "H" (for Hide) will toggle the visibility of the pins. You don't need to have any settings active in the panel while creating a filter. Right-click on a pin and you'll get more options: choose Duplicate to make a copy of the filter, or choose Delete to remove it. You can also reset the filter, and any brushes from the panel. Let's take a closer look at the panel. The Graduated Filter panel has three parts: Mask, Effect, and Color.

Mask

Mask allows you to add new filters, edit the currently selected graduated filter, or, new in Lightroom 6, add to or remove from the current filter. You won't see the filter directly as a

The red arrow shows the direction the filter was dragged

Mask because the function works in the background of Lightroom. In essence, Lightroom is applying the settings to the whole image, then removing it where there's no mask. You can see this mask by pressing the "O" key or by hovering the mouse cursor over the pin. It's also a checkbox in the Toolbar called Show Selected Mask Overlay. The ruby areas are where the settings will apply. There is also a menu in the Toolbar that toggles Pin visibility. Auto or Always are probably the best options.

When entering Graduated Filter for the first time, you're automatically starting with the tool active, so you don't need to press New. Each time you need a new filter, press New, and then drag out the new filter.

Edit becomes active when your filter has been created. A word of warning here: The settings that are active at the start of filter creation are the ones that will apply to the next filter you create. If you make a filter, and then edit your settings, clicking New for a new filter will apply the previous filter settings. It's a little annoying, but you get used to it. This also applies to the Radial Filter and Adjustment Brush settings. You don't need to press Edit to start, just move the sliders and you'll be in Edit mode automatically.

Brush, new in Lightroom 6, lets you add or remove sections of the filter. It takes the Adjustment Brush and adds it to the Graduated Filter. Very few natural regions have a straight horizon, so being able to change the edge of the filter to suit is a great feature. You could just use the Adjustment Brush tool, but it's often quicker to use a filter and remove the bits you don't want affected.

I've created a filter with no settings to start. It covers the entire sky so the whole sky will be affected by the settings. As seen in the next two figures, I bring Exposure down:

The sky looks great, but the hill is a little dark. To fix this, select the Brush option. At the bottom of the panel, set the brush to Erase. Use Size and Feather to taste. Leave Flow at 100. We'll look at the tools in detail in the Adjustment Brush section. To make it easier to see what's going on, I've turned on the overlay ("O").

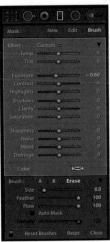

Once the red is gone from the hill, and the overlay has been turned off, we see the sky is darker without affecting the hill.

Effect

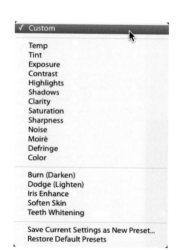

Effect contains the sliders that create the changes the Graduates and Radial Filters can make, as well as the Adjustment Brush. As you change between the three tools, the sliders settings will remain the same. At the top is a drop-down menu of Presets that contain particular looks and are shared between the three tools.

The first section in the menu contains single slider functions. Usually these set the slider to 25, bar Clarity (which sets to 50), and Exposure (which sets to +1.00). The second section contains settings for specific tasks such as Dodge, Burn, and Skin Softening. Sometimes these Presets can go missing. Simply choose Restore Default Presets from the menu to retrieve them. If you select a Preset and make a change, you can save this as a new Preset with Save Current Settings as New Preset. You don't need to start with a Preset, though; editing the default settings will allow you to save a Preset.

We've seen most of these settings before in the Basic Panel, and they function in exactly the same way here, only they don't need to be applied to the whole image. The last four sliders do require some explanation, though:

- Sharpness acts similarly to the Amount slider from the Detail panel (above zero settings). Below zero, it removes sharpness until negative fifty. Below this it acts as a lens blur, which is a useful effect.

- Noise is actually Noise Reduction, but there isn't room for the full term to fit. Specifically, it's luminance noise reduction, which is great for reducing noise in the shadows when they've been brightened.

- Moiré, also called color aliasing, is a wavy pattern that can appear in digital images where the actual detail can't be resolved. It's often seen where the existing pattern contains lots of lines or dots. This slider helps remove it.

- Defringe removes color fringing from edges in the image.

Double-clicking the word Effect in the panel will reset all the sliders to zero. Double-clicking the name on each slider will reset that slider to zero.

Color

Color allows you to add a color to the filter. Again, this applies to all three of the localized filters: Gradual, Radial, and Brush. Simply click the gray tile to start. From the swatch panel that appears, click to select a color to use.

Selecting a Color From the Photo

As well as selecting a color from the swatch panel, you can choose one from your photo by holding down the left mouse button while in the panel and moving to the location in the image you desire.

To remove a color, simply put the "S" (Saturation) slider at zero. Note that this color is in addition to the underlying color. To get closer to the actual swatch color, bring the Saturation slider in the Effects section down to reduce the underlying color.

For Graduated Filters specifically, you can get that Top Gear/CSI Miami sky to match the use of a Graduated Tobacco Filter by using a yellow-to-brown swatch (H 36, S 70, for example). You can select the numbers and type directly into the boxes.

At the top of the swatch panel are five swatch presets. Click on these to choose the color, or Option (Mac)/Alt (PC) + click on one to store the current color as a swatch preset.

Faking a Tilt Shift Lens

Not as popular as it once was, emulating the blurred look from a Tilt Shift lens in a reverse tilt form draws attention to the sharpest parts of an image. Normally Tilt is used to increase the depth of field in a photo, but by going in the opposite direction you can reduce the depth, creating an interesting look. For portraits the focus would be on the eyes. In landscapes and cityscapes, it can give a miniature effect, especially if the view is looking down on a subject.

To make this effect, I normally use four filters. I reset the Effects panel, then bring Sharpness to –100. From the top down, I create a filter with a slightly hard edge, then a second one with a soft edge. For a portrait, this bottom line will be above the eyes. I then repeat the two filters from the bottom up. Why two pairs? Well, with a real Tilt Shift lens, the blur increases more rapidly than with a normal lens, so I'm emulating this. I also find that even a medium soft blur edge can look abrupt, so this helps correct that.

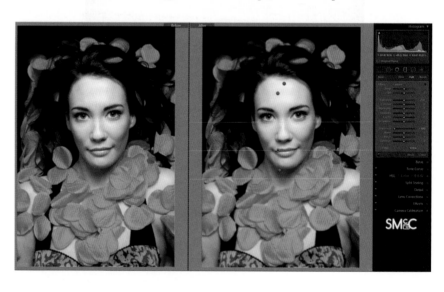

Radial Filter

Imagine bending a Graduated Filter into an oval, and you'll understand the basic premise for a Radial Filter. The original intention for the Radial Filter was for creating an off-center vignette. Vignette, in the Effects Panel, always uses the center of the current crop; so another option was created for better effect. And because they matched it to the Graduated Filter Effects slider, it's far more versatile that Vignette is. In fact, it's one of my favorite tools in Lightroom. It's hard not to refer to the Graduated Filter when you talk about Radial, because essentially the settings are the same except that instead of using two lines to set the transition, Radial has a Feather Slider. You can also choose to swap which side of the oval the settings apply to.

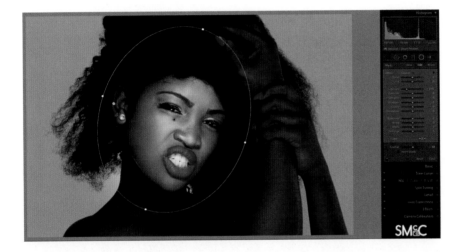

Getting Started With Radial Filters

To start, click the fifth icon in the Tool Strip, use the shortcut Shift + M, or choose Radial Filter from the Tools menu. Like Graduated Filter, just click and drag to create the filter. Because of the original premise, the effects of a Radial Filter appear outside the oval you create. You can change this with the Invert Mask checkbox at the bottom of the panel. The oval has four points and a pin in the center. If you drag any point, the opposing point will move to match, leaving the pin in the center—the reverse of what the lines do in Graduated Filter. If you move one pin in, the opposite one moves into the center, also. If you the keep the opposite pin fixed in position, hold down the Option (Mac) or Alt (PC) key and then drag the pin. The pin will move to remain in the center. If you hover your cursor near a pin, it will change to a

curly arrow cursor, and you can click and drag to rotate the filter. Holding the Shift key and dragging a pin will make all four pins move in or out together. To change the rate of fade, use the Feather slider.

Besides the obvious use with vignette, the Radial Filter is great for dropping patches of light or color into an image. Let's look at some example uses for the Radial Filter.

Radial Landscapes

For this I'm using a shot of Jökulsárlón, the Ice Lagoon in Iceland, after sunset. Landscape photographers are always hoping for that post-sunset glow, but to no avail this time. Given that it's a long way away, I'll just add in my own color.

With the Radial Filter on, and with Invert Mask on, and with Feather set to zero, we choose a color to add to the horizon.

Next, set the zoom to 1:16 to zoom really far back. This way, when you draw the oval, the top and bottom will be nearly parallel. We're effectively creating a Coral Filter, a physical filter you can buy to bring color to a poorly colored sunset. Draw a long oval on the horizon. Stretch it out as far as you can.

Zoom back in. Because Feather has a hard edge, we can easily see the transition line. Move the center of the filter to get it exactly where you want it on the horizon. Now increase Feather until you like the blend. I'm at 83 in the example. To increase the saturation of the color, you can go back to the swatch and increase it there.

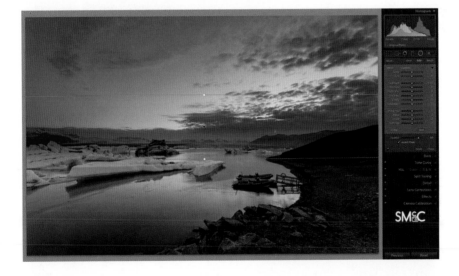

What's in the sky gets reflected in the water, so we need to make a fake reflection to match the color adjustments we made to the sky. To get a filter with the same settings quickly, you can right-click on the filter pin and choose Duplicate.

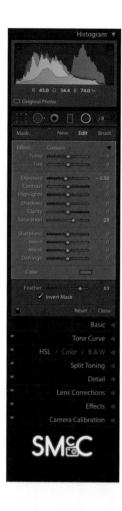

Move the duplicated filter over the water. You may need to zoom out again to resize the filter down. You only want it over the water here.

Finally for this image, I'm going to lighten the hill on the right. Click New, then double-click Effect to reset the filter. Next, add 1 stop to Exposure and draw over the hill. Next rotate the filter to match the angle of the hill. For final tweaks, add exposure to the colored filters, and try other colors until you're happy.

Radial Portraits

Here are three short examples of using Radial Filter on Portraits:

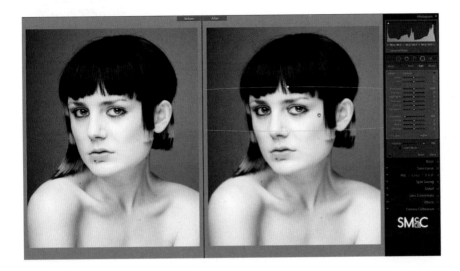

1. Set the Sharpness too –100 (all other effects at 0) with Invert Mask off. Set Feather to 100. Draw a long oval over the eyes. Right-click on the pin and select Duplicate. This gives a really quick Tilt Shift effect that brings focus to the eyes.

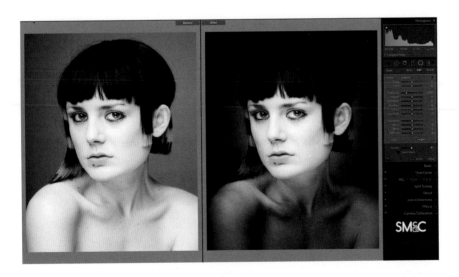

2. Set Exposure to taste, starting with –2 stops. Turn Invert Mask and set Feather to somewhere in the middle (45-55). Draw the Radial filter over the face. The area around the face will darken, drawing attention to the face.

3. With Invert Mask on, and Exposure set to around 0.5 stops, draw two Radial Filters that exactly cover each eye socket. Add Clarity and Contrast to taste.

Adjustment Brush

The Adjustment Brush lets you add any combination of the Effects sliders, in any amount, to any part of any image. It's the prime freehand drawing tool for adding local corrections and creative color to the photo. Between the Basic Panel and the Graduated Filter, the properties of each of the Effects sliders have been covered already. Here we'll be taking a more practical look at using the brush for different tasks; but first, let's look at the properties of the Brush section itself. To open the Adjustment Brush, click on the last icon in the Tool Strip, use the shortcut "K" or choose Adjustment Brush in the Tools menu.

Brush is the last section in the panel. You have two different brush settings, A or B, and an Erase brush to remove part or all of a sequence of previous brush strokes. All three can have different properties and are set using Size, Feather, and Flow. Size controls how large the brush is. Feather controls how soft the edge of the brush is. Flow controls how much of the effect is

added with each brush stroke. With a low Flow, you can paint over an area to build up the effect without pressing the New button for a new brush session.

Size can be changed using the square bracket keys, "[" and "]". Hold Shift when using those keys to change Feather.

There are two other options for each brush: Auto Mask and Density. Auto Mask attempts to keep the effect in areas of similar color to where you paint. Density sets the maximum amount of effect to a stroke. If you've set a low Density (let's say 30), and you've set Flow to 100, then no matter how many times you brush, the effect never goes above 30%. It's like the opacity control for a brush stroke. Once you've set the A brush, click B or use the "/" key to swap brushes. Generally I'll use a large, soft brush on A and a small, hard brush on B. Click Erase to set the size and softness of the eraser. When brushing with the A or B brush, you can hold down the Option (Mac)/Alt (PC) key to temporarily swap to the Erase brush.

Generally speaking, I always have Density at 100. The only time I would have it lower is when I absolutely don't want an effect to be overpowering. Normally, I just use lower settings in the Effects section, instead. Flow is also usually at 100, unless I want to build up an effect. Low Flow can sometimes have weird overlaps as you paint, so pay attention as you paint. Lastly, I only have Auto Mask on when I'm working on a difficult edge. It's very processor intensive and doesn't always work as you expect. When it does work, it's great; when it doesn't work, it's really messy. Try using it on an image with a mix of blue and clouds to see how it looks.

Bogged Down in History

Each stroke is recorded in History, so when using low Flow to build up an effect, you end up with a huge History. This can slow Lightroom down, so you may want to clear the History. This just removes the record of the steps you've taken, not the steps themselves.

You're not stuck with only seeing the effects; Lightroom has an overlay to help you see exactly where you're painting. With the pins visible, hover over a pin (Press H if the pins aren't visible). The brushed area will go red. You can also view this as an overlay by pressing "O". There's also a range of colors to choose from: red, green, white, and black. Press Shift + O to cycle through them. Press "O" again to turn the overlay off.

Finally, you can right-click on a brush pin to duplicate it, delete it, or reset the brushing.

Retouching Portraits

Let's do a portrait retouch using the brush and some Spot Removal.

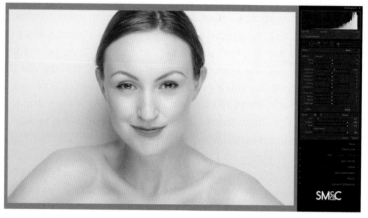

The original image

First press "Q", and then zoom in to remove spots and blemishes around the face. Use Page Up and Page Down to move quickly through the image. These keys move past the image boundary to the next part of the image, making it quicker than scrolling around.

Next press "K" to go to the Adjustment Brush. From the Effects drop down menu, choose Soften Skin. This sets Clarity to –100 and Sharpness to 25. Paint on the skin. Avoid the ears, eyes, eyebrows, nostrils, and lips—anywhere on the face with detail. You want to keep detail in these areas. You could cheat and use a large brush on the whole face, then use a smaller, harder Erase brush to bring these back. I generally press "O" here so I can see the mask properly.

Turn off the mask by pressing "O". In Lightroom 5, you could click on a pin and drag it to change the settings, but because you can now move brush strokes in Lightroom 6, you need to hold down Option (Mac) or Alt (PC) before dragging on a pin to change settings. Option (Mac) or Alt (PC) drags the pin. Notice that both the Clarity and Sharpness values change in proportion. As Clarity increases from –100, Sharpness decreases from 25 at ¼ of the rate. We're making this change because –100 Clarity makes the skin too soft. About –50 Clarity is fine for most portrait retouching.

Click New for a new adjustment. With Auto Mask on, paint the lips. Use the Overlay to check your progress. You may need to switch overlay color here if the lip shade is too close to the red overlay.

Turn the Overlay off. Open the color swatch and choose a different lip color. The color will mix with the lip color, so use the Saturation slider to reduce the original lip color.

Next we'll do some contouring. This works by lightening and darkening the skin. Lighter areas appear to protrude more, while darker areas recede. This lightening and darkening is often called Dodge and Burn. There are Presets for Dodge and Burn in the Effects Dropdown. For faces, you generally darken around the edge of the face, the sides of the nose, under the brow by the nose (the part near the eye socket) and the middle of the cheek (from the bottom of the ear to the lip). Lightening is done anywhere that normally protrudes most: the forehead, the chin, the top of the cheeks, the centre of the nose line, and the outer part of the under brow. I generally use 0.15 Exposure to Lighten/Dodge and -0.15 to Darken/Burn. Click New as you go to make new brushes for each adjustment.

Click New again (I know you know this by now, but we all forget!). From the Effect drop down menu, choose Iris Enhance. Paint the iris.

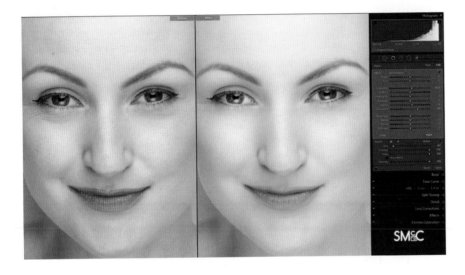

Finally, we're going to add some makeup. Normally makeup is applied and blended out, but for digital makeup, I find it's easier to add too much and then use a big soft Erase brush to clean it up. Let's put a color on the eyelids, crease, and brow in a similar way to the Lips, but without Auto Mask on. Use Exposure to lighten or darken the effect of the color. You could use a -4 stop Exposure brush to create fake eyeliner, or even another color brush for blush on the apple of the cheek.

The makeup is just to show you that you can do this in Lightroom, but I wouldn't normally use it on a portrait like this one. Here's the final Before/After view:

Spot Color

Spot Color is totally out of vogue right now. That doesn't prevent people from requesting it, especially if they've just seen the movie Sin City. I apologize in advance for showing you this. First, use a large brush set to -100 Saturation and paint the whole image to remove all color.

Then use the Erase brush to bring back some color. Auto Mask can help here since you're limiting the brush to a small color range. Refine the edges if needed. And yes, that is Ulorin Vex's hair color.

Milky Way

The following screenshot shows an unprocessed shot of the International Space Station and the Milky Way.

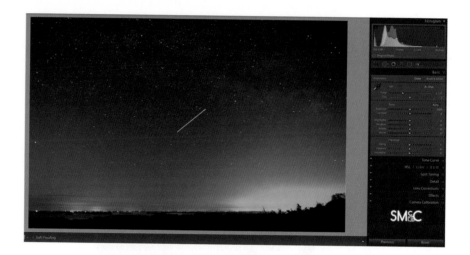

The Milky Way is quite faint, so adding Clarity in the Basic Panel will help make it more visible.

The problem is that getting enough Clarity to enhance the Milky Way makes the rest of the image look crunchy. The solution? Bring the Clarity slider back down a little (from 56 to 36 on this image). Open the Adjustment Brush and set it to +100 Clarity, then paint over the Milky Way with a large feathered brush.

Much better!

Fixing a White Background

We've mentioned that the Process Version 2012 Exposure control likes to preserve highlights. In general this is fantastic, except when you're trying to overexpose a white background. It will look white until you compare it to a white page, where you see that it actually looks very light gray—like you didn't know how to light a high key image! Notice that the highlight clipping warning is on in the figure below, but we're not seeing any red in the background. Because the background should be pure white, we should see it with a full red overlay.

To fix this issue, the first thing to try is using the Whites slider in the Basic panel. Moving this to the right will start to clip the highlights. It also starts to lighten skin colors. As much as I love bright skin, the amount of Whites needed to clip the background lightens the skin too much.

Pull back the Whites level until the skin looks natural. Open the Adjustment Brush and set it to +2.00 Exposure. Turn on Auto Mask—this helps keep the adjustments to the background only. Again, use a large feathered brush. Paint on the background until it all shows red from the highlight clipping warning.

High key images can suffer from lower contrast, so as a final touch, pull down the Blacks until you see a color appear in the shadow-clipping indicator.

Other Uses

There are plenty of other jobs the Adjustment Brush can do:

- Mixed White Balance: When you have light coming from outside mixing with tungsten and fluorescent lighting inside, the result is a horrible mix of blue, yellow, and green lighting. Use Temperature and Tint in the brush to correct these. Add yellow to the blue light, blue to the yellow, and magenta to the fluorescent areas.

- Landscape Dodge & Burn: Just like highlighting the skin, use the Exposure brush to create interest in the photo.

- Moiré: Remove this pattern-based artifact with a Moiré brush.

That concludes our look at the Tool Strip. Next we look at the Left Panel in Develop.

Left Panel

As with the Library, the Left Panel is where you manage things that are file-related in Develop. Here we have the Navigator, Presets, Snapshots, History, and Collections panels.

Navigator

The Develop Navigator is identical to that of Library, and included here for completeness. It previews any of the items you hover over in the other panels, such as Presets, Snapshots, or History.

Presets

Creating Presets

Presets are essentially saved Develop Settings in file form. You can hover over an existing Preset to see a preview of the settings in the Navigator window. To create a new Preset, click the + icon in the panel header, choose New Preset from the Develop menu, or use the shortcut Shift + Command + N (Mac) or Shift + Control + N (PC). When a Preset is selected, a "-" icon also appears in the panel header. Use this to delete the selected Preset.

A view of the Presets panel. Use the "+" icon to create a new Preset (highlighted in red).

When you create a new Preset, the New Develop Preset menu appears. At the top is where you name the new preset. By default it will be untitled, so give it a meaningful name that reminds you what it does. Elegance, Grace, Serendipity might all be great marketing names for Preset sellers, but really what you need is "Black-and-White High Contrast." Or even "B&W Contrast 70."

You can store Presets in folders to make them more manageable. Lightroom allows a single folder hierarchy. Even if you were to manually create a deeper folder structure in the Lightroom Presets Folder, Lightroom would only show one folder level. From the Folder drop-down menu, choose an existing Folder (User Presets is chosen by default), or create a new one using the New Folder... command at the top of the menu.

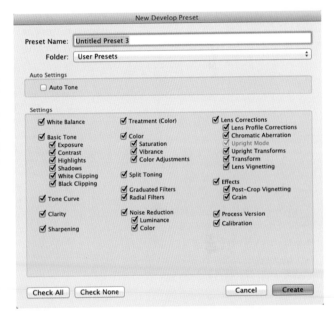

The New Folder dialog will appear. Enter a suitable name and click Create. The new folder will be selected in the Folder menu.

The next section lets you decide what settings are included in the Preset. By default, this includes everything. For the majority of Presets, this is actually a bad idea. Why? Well, every setting you include in a Preset will overwrite anything you've already done to the file. Like in my example above, to create a B&W High Contrast Preset, you only need the Treatment (or Saturation if

you've used that instead) and the Contrast (or Tone Curve, if you used that) options checked to actually have the Preset work.

For Presets that create particular looks, only select the options that are needed for it to work. Even if you consider leaving out Exposure, you've already done yourself a little favor. The main reason a lot of Presets only look good on images that are similar to how they were created is because all the settings were saved.

Think of these as building blocks. Having your Tone Curves, Split Tones, and other panel Presets separate means you can build up a range of looks by hovering over the Preset and seeing the result in advance in the Navigator. From there, build more full-look Presets and save them—minus Basic settings (unless they're essential to the look).

To remove all options, click Check None. To select all options, click Check All.

For the example Preset, I've selected Saturation and Contrast. Treatment selected automatically, as did Process Version. Because Process Version 2012 uses a different Contrast control than the older versions, it's essential this is checked for the Preset to work.

Click Create to create and add the new Preset. Your new Preset (and folder) will appear in the Presets dialog.

Too Many Presets

When Adobe created the Presets idea, the thought of people selling Presets wasn't on their mind. A Preset Pack might contain hundreds of presets. After buying, collecting and creating Presets, you might end up with thousands. Each Preset is like a little program that gets loaded in Lightroom. For this reason, Lightroom 6 has removed the option to right-click on a file and choose a Preset from the menu. It simply took too long to load and list the thousands of Presets some people have. You can still select them from the Develop Preset menu, or from Quick Develop, so it's not a massive inconvenience.

The Right-Click Menu

The Preset panel has a contextual right-click menu with additional options. The contents of the menu depend on whether you right-click on a folder or on a Preset.

```
                                    New Folder

                                    Apply on Import

                                    Rename
          New Folder                Update with Current Settings
          Rename                    Show in Finder
          Delete Folder             Delete

          Import...                 Export...
                                    Import...
```

The right-click menu The right-click menu from
from a folder in Presets a Preset

The options from Presets are also in the right-click folder, except for Delete Folder, which deletes the selected folder. Below are the remaining options:

- New Folder creates a new Presets folder.

- Apply on Import sets the Preset in the Import Develop Settings dialog.

- Rename does just what you think: it renames the Preset or Folder.

- Update with Current Settings changes the Preset to match the current settings.

- Show in Finder/Explorer shows the physical Preset file on disk.

- Delete will delete the file both on disk and in the Presets Panel.

- Export.. allows you to copy the file to a location outside Lightroom for sharing or backup. This opens a file browser to allow you to choose a location for the copy.

- Import.. allows you to add a shared Preset to Lightroom.

Preset Files

The Preset file is actually just a text file, though it can also contain code. Using Show in Finder/Explorer, you can open the file in a text editor. Below shows the contents of the Preset file we just created. As you can see, it's just text. There are four lines in the settings section matching what was selected in the New Preset dialog: Contrast2012 for Contrast, ConvertToGrayscale for Treatment, ProcessVersion for the Process Version (note that the number

reflects whichever version of Camera Raw the Process Version was introduced in), and Saturation for Saturation. Other settings do take more than one line: e.g., Tone Curve—this one just happens to have a setting per line.

```
◀  ▶       Black and White High Contrast.lrtemplate  ⬍
s = {
    id = "5389A754-2D28-4FE1-B22E-AD25C3F7132C",
    internalName = "Black and White High Contrast",
    title = "Black and White High Contrast",
    type = "Develop",
    value = {
        settings = {
            Contrast2012 = 70,
            ConvertToGrayscale = false,
            ProcessVersion = "6.7",
            Saturation = -100,
        },
        uuid = "55933A37-72C2-47B8-9A2B-5D9F198E1979",
    },
    version = 0,
}
```

Batch Processing in Lightroom

Presets are the best way of applying settings to many files at once in Lightroom, especially settings that you want to match with other sets of images. They're not the only way, though. We've seen some of the options before, but we'll look at them all together here.

Copy/Paste Settings

We've seen these options in an example before. Basically, choose Copy Settings, or via the shortcut Shift + Command + C (Mac) Shift + Control + C from the Settings Menu, or you can copy settings from a file in Lightroom. It looks similar to the New Preset Dialog in that you choose which of the settings you want to copy over to other images.

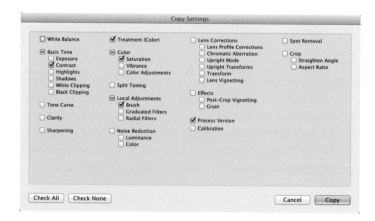

Once you click Copy, the settings are ready for pasting to other images. Select these images in Grid and choose the Paste Settings from the Settings Menu, or via the shortcut Shift + Command + V (Mac) Shift + Control + V to paste the settings.

Sync Settings

Sync Settings is in the Right Panel of Library, but Develop has the Sync button in its Right Panel. This is available when more than one image is selected in the Filmstrip (or from Grid before going to Develop). Clicking this will bring up an almost identical dialog to Copy Settings. Again, just check the settings you want included, and these will be applied to the other selected images when you press Sync.

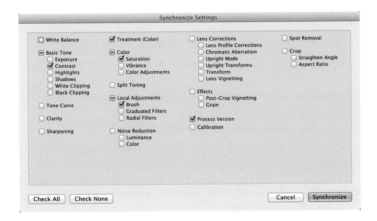

Auto Sync

To the left of the Sync button is a switch. Click this to turn Sync into Auto Sync. Command or Control + clicking on Sync will also make this change. In this mode, each change you make in Develop will apply to all selected files in real time. Do be warned that if you try to do this with hundreds of files, your machine will probably freeze as Lightroom takes over applying the changes. Use Sync or Copy/Paste after all your settings are finished instead. This process is usually fine to apply for a small numbers of images.

The switch highlighted in red converts Sync to Auto Sync and back

Previous

With just one image selected, the left button in Develop is Previous rather than Sync. Pressing this will copy all of the settings from the last viewed image. It's like the manual version of Same as Previous from the Tethered Capture dialog. It also appears in the Settings menu as Paste Settings from Previous.

Snapshots

A Snapshot is a record of the settings of an image at the moment the Snapshot is created. It's like a Virtual Copy inside the file—in fact, when you make a Virtual Copy, the copy has a Snapshot called Create Virtual Copy created automatically. Snapshots are saved in XMP, whereas Virtual Copies are not.

Snapshots can be used to make many different versions of an image—any amount of different color or crops. To make a Snapshot, click the + icon in the panel header, use the shortcut Command + N (Mac) or Control + N (PC), or choose New Snapshot from the Develop Menu. Give the Snapshot a suitable name and click Create.

The new Snapshot will appear at the top of the panel. With more than one Snapshot created, you can hover over them with the cursor to preview their settings in the Navigator. As you'll see in the following screen capture, I've hovered over the underlying Flat Snapshot, which is color. It shows in the Navigator.

To change the image to another Snapshot, simply click on it. Right-click on a Snapshot to bring up more options.

Copy Snapshot Settings to Before

Rename
Update with Current Settings
Delete

- Copy Snapshot Settings to Before: This takes the Snapshot you right-clicked on and makes it the Before view in Before/After view.

- Rename: This allows you to give the Snapshot a new name. Useful if you forgot when creating it.

- Update with Current Settings: Snapshots aren't stuck in time—you can change them. If you're not sure about updating, just create a new Snapshot.

- Delete: This lets you remove the Snapshot. You can also do this from the panel header; with a Snapshot selected, the "-" icon will appear, allowing you a simple click-to-delete function.

History

History is a chronological list of settings applied to the file. You can't remove an individual step in History; you can only go back to a particular step. Every setting you make is recorded. Lightroom adds up the steps to give the results you see, so it doesn't matter how many times you move a slider—the final combination of actions leads to the current setting. To undo the last step,

click on the previous step. To undo a particular step that's not the most recent, look at the value of the setting you'd like to change and apply the opposite amount on the named control.

History is stored in the Catalog and in XMP. If you do a lot of work on files, the History can make the Catalog file unnecessarily large and slow. To counteract this, you can delete the history. Click the "X" in the panel header to remove all the recorded steps. Your settings won't change; you're merely removing the record of how you got to that point. If you need to record particular steps, use Snapshots to save them instead.

To delete the History from a selection of images, go to the Develop menu and choose Clear History... .

Undo

You can use the standard OS undo command; Command + Z on Mac, or Control + Z on PC. Just note that this applies to Module Changes and UI changes as well as actual settings.

A Dialog will pop up with three options: Selected Photos, Cancel, and Active Photo. By default it's the Active Photo. The dialog will display the number of photos affected if you choose Selected Photos. Do this if you want to clean out the catalog, but be sure you want to do it. There's no progress bar for this, so you just have to trust that Lightroom is doing it. You can still use Lightroom during this process.

Collections

The Collections panel is identical to that in Library, and all other modules, and is just included here for completeness.

Photo Merge

Photo Merge is a new tool in Lightroom 6. It compliments the Merge to HDR Pro in Photoshop and the Merge to Panorama in Photoshop commands from the Edit In.. menu.

The difference is that the files created by Lightroom have full Develop controls, including temperature-based White Balance (rather than simply "cooler" or "warmer" like with a TIFF file).

The files created are 16-bit floating point files, which allows them to contain enough information to create HDR images as 24- or 32-bit files in a much smaller space. The process for both HDR and Panorama is straightforward, as you will see.

HDR

High Dynamic Range images are based on creating a sequence of bracketed exposures that increase the dynamic range of a photo when combined. Lightroom aims for a natural result, creating a merged file that is saved as a DNG. Essentially it's a raw image. The merge reads the raw data from the selected files and then merges them into a new raw file.

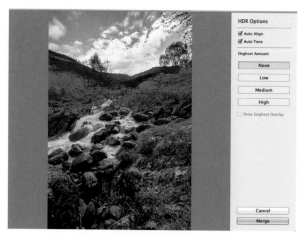

The Preview shows the current Merge. There's some issue with the Preview.

To begin, select two or more bracket exposures. From the Photo menu in Library or Develop, go to Photo Merge and choose HDR. You can also use the shortcut Control + H (both Mac and PC). The HDR Merge Preview dialog will open and Lightroom will generate a preview of the HDR Merge. Note that the actual Merge will happen in the background after you click the Merge button, and the process takes some time. The preview window can be expanded, but the maximum preview size is 1024px long for normal monitors and 2048px for Retina and HiDPI monitors.

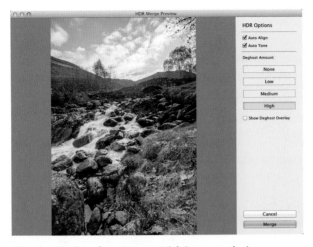

Changing Deghost from None to High improves the image

You can view where the Deghost algorithm is working by turning on the Show Deghost Overlay Option. The shortcut "O" will toggle this on and off (Mac only).

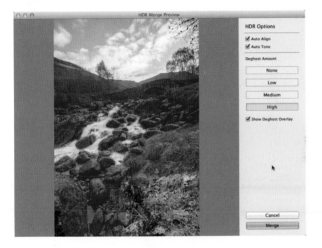

The resulting file is added to the catalog and takes its name from the active file with an -HDR suffix on the end. It can be processed just like any other RAW file, just with increased dynamic range.

Panorama

To begin a Panorama Merge, select two or more Photos. From the Photo menu in Library or Develop, go to Photo Merge and choose Panorama. You can also use the shortcut Control + M (both Mac and PC). Note that the images don't need to be in a line—you can do vertical and horizontal panoramas, or even combinations of both.

The Panorama Merge Preview will open.

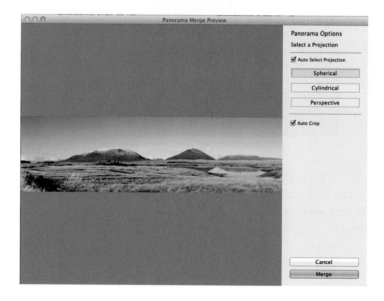

There are three options for how the resulting panorama will be projected. There is an Auto checkbox that will automatically choose one of the three to give the best projection. These are:

- Spherical: Treats the panorama as a 360° mapping. Essentially acts as though the panorama is projected onto a sphere. Perfect for 360° panoramas, but works on other image sets also. This is also known as an equirectangular projection.

- Cylindrical: Images are treated as though they were mapped onto a cylinder. The reference image is placed in the middle and the other files are overlapped to match.

- Perspective: The middle image is the reference image and the other images are mapped and overlapped to this. It can have a "Bow-Tie" effect where the side images are stretched into a bow-tie shape. Cylindrical solves this. Perspective is also known as rectilinear projection.

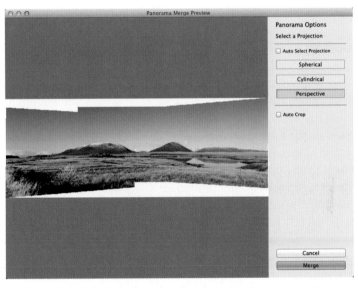

A Perspective projection with Auto Crop off, showing the Bow-Tie effect

Auto Crop is the final option. This crops into the final panorama to remove all transparent areas resulting from the merge. This crop can be changed after Merge, so it isn't critical if it's on or off when processing your image. Being on means you can access the maximum crop without doing it manually.

Press Merge to create the Panorama. Like HDR, this will be created in the background and added to the catalog on completion. The file will take the name of the selected image from the original files and add a -Pano suffix. Lens Profiles are used as part of the merge process to get the best blend. If Lightroom can't find a profile, a warning will be displayed. Manually apply a profile before continuing. The final Panorama still has the Lens Profiles options active, but these are left active for creative effect rather than for making corrections.

Headless Mode

You can trigger both HDR and Panorama in Headless Mode. This means you run the command and the Merge will be done in the background without any dialog boxes appearing. Simply hold the Shift key when clicking in the Photo Merge menu, or add the Shift key to the normal shortcuts (Shift + Control + H for HDR, Shift + Control + M for Panorama).

Soft Proofing

If you've ever wanted to see how a print might look without actually printing it, or how an image might look on another device, then you've had a need for Soft Proofing. Soft Proof is the process of applying a profile to an image to see how it might look. Lightroom takes it a few steps further than other programs, and allows you to see the colors the monitor can't reproduce correctly, as well as the profile you've chosen. There has been a change under the hood from Lightroom 5 here: Lightroom 6 uses the same underlying soft-proofing engine implementation as in Camera Raw 9.0.

A print would be a hard proof. There's an obvious cost, and it might take a few prints to get the image to match the way you see it onscreen. Obviously having a calibrated workflow can help this, but often this is limited by the paper stock you print with. Fine Art papers have a notoriously high tendency to absorb ink, so they don't appear as saturated as the image on the screen, even on glossy paper.

Using Soft Proof

In Develop, use the shortcut "S", the View>Soft Proofing>Show Proof menu, or check the Soft Proofing box in the Toolbar. If the box isn't visible in the

Toolbar, click the triangle at the right of the Toolbar and select Soft Proofing in the menu that appears.

The first thing you'll notice is that the background changes to white. Proof Preview appears in the top right of the image preview area, and the Histogram panel changes into the Soft Proofing panel.

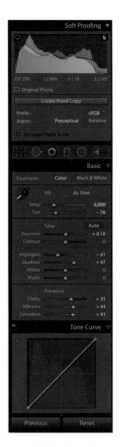

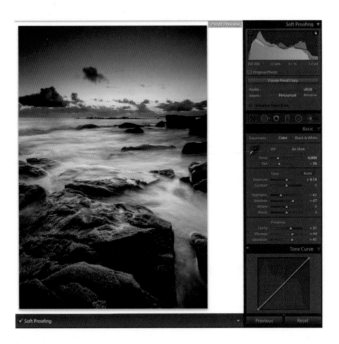

The default white that is displayed is called Paper White (to simulate paper). You have a range of choices from black to 100% white. Simply right-click on the white for this option to appear.

Looking at the Soft Proofing panel. There is a display similar to the Histogram, but with important differences. First, the numbers under the display are now in a 0-255 range instead of the normal percentage. This happens because the percentages are now mapped to a profile. Normally the preview that you see comes from your monitor profile. In this case, we have sRGB selected in the Profile section, so we can see the full sRGB color under the cursor. To see this scale in Lightroom, start Soft Proofing with a profile to activate it.

The clipping indicators have changed as well. The Show/Hide Monitor Gamut Warning is on the left. Clicking this will show a blue overlay on areas of the image that exceed the monitor colors and are therefore not displayed properly. The Show/Hide Destination Gamut Warning is on the right. When on, a red overlay will display areas of the image that are outside the profile's ability to produce.

Profiles

By default, Soft Proof has two selectable Profiles: sRGB and Adobe RGB (1998). You can easily add more by clicking the Other.. option at the bottom of the Profiles flyout menu.

A large list of paper profiles will appear. These are installed when you add a new printer. You can also download paper profiles for specialist papers from the maker's website. Check the boxes to add these profiles to the menu. If you want to preview displays, check the Include Display Profiles option at the bottom of the dialog.

Click Ok to add the Profiles to the list. Going to Profiles again will now show the extended list. We'll select a paper profile to see how to make use of Soft Proofing.

When you select a paper profile, the Simulate Paper & Ink option becomes available and will be turned on. This emulates what will happen to the image when we print to the paper that matches our selected profile. White in paper is not true white, and black ink tends to be dark gray. It's not available in all profiles. Here it's Epson's Archival Matter Paper (now called Ultra Premium Presentation Paper Matte) with the Pro38 ARMP profile. I've chosen this because it shows the radical difference you get between a paper profile and the screen view of the image.

Intent

Below Profile is the Intent option, which allows you to choose between Perceptual and Relative rendering intents.

- Perceptual will map colors into the smaller space evenly. All colors are changed, but the balance between them remains. The aim is to create a visually pleasing result. It's like reducing the size of an image. All of the image is there, but the pixels are no longer at the same place. We've squeezed it all down to fit in the smaller space.

- Relative maps the out-of-gamut colors to the nearest in gamut colors and leaves all other colors unchanged. We've squeezed into the edges of the file, but left the middle unchanged.

Perceptual is the more common choice because it preserves the relationship of the colors.

Proof Copies

Proof Copies allows us to create a new version of the image based on changes made to get the best results for the profile we're proofing for. Before we create our Proof Copy, we need to see what work needs to be done. Turning on the Destination Gamut Warning will show colors that will not produce correctly.

We can fix the issues in a number of ways:

- Reduce overall Saturation or Vibrance.

- Use Saturation in HSL to reduce the specific colors that are out of gamut.

- Use Hue in HSL to change the colors to ones that are in the gamut.

- Use a negative Saturation Adjustment Brush to remove saturation from specific areas of the image.

All of these options require making changes to the image for printing. Fortunately we don't need to change the original image. We can make a Proof Copy for the selected profile. Why do this? You may have a range of papers to print on, or are proofing for a range of devices. Having a Proof Copy leaves the original untouched and allows you to proof for any device.

To make a Proof Copy, click the Create Proof Copy button, or simply start editing the image with Develop.

The Create Proof Copy button will vanish and the Profile and Intent sections will become highlighted, drawing attention to the profile being used for the proof. In the Metadata Panel, the profile name and the rendering intent will have been added to the Copy Name field.

Using a combination of the four methods mentioned above, work to bring the image back in-gamut. The paper I've chosen as an example is particularly bad, so it takes a lot to make it work. Even after all that work, some parts are still out of gamut.

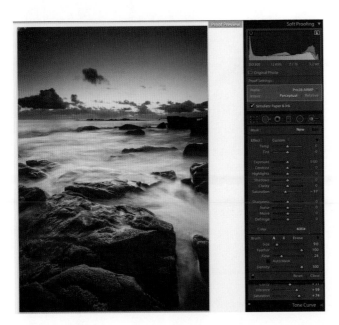

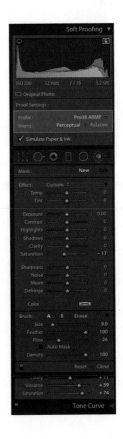

Some feel that Soft Proofing should be part of the Print Module; after all, it is for showing how your prints will look. The reason it's in Develop is that a proof is little good if you can't make changes to improve it, and for that you need to be in Develop.

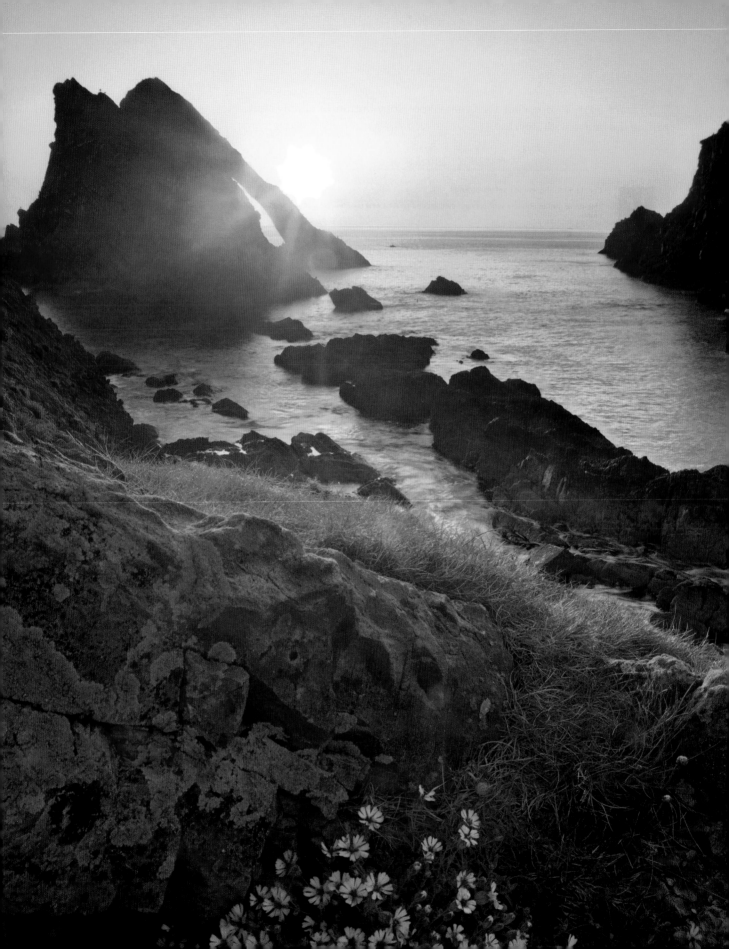

Map and Book

6

When maps were added to Apple's Aperture, all of the sudden people wanted them in Lightroom. Using maps to organize your photos is another tool in your file-management arsenal, especially for travel and landscape photographers.

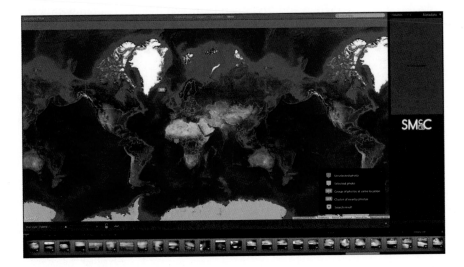

Map

Getting Started With Map

Location-based organization is one of many methods to manage your photos and videos. The Map Module makes it easy to work with locations because it provides great tools to place your photos physically on a world map.

The Map module will automatically detect any photos that include GPS information (most newer compact cameras and smart phones do). Usually there is an option to turn on these location services in the device. If you don't have embedded GPS data in your files, you can get them from Tracklogs, or simply use the map search tool in the filter bar to find places you know you've been and drag and drop your images to the map.

In the Left Panel, Saved Locations lets you specify places where you've shot images. You can manage photo locations by controlling the radius around these areas. Photos within this radius will be included in the saved location.

There are also controls for Reverse Geocoding in the Address Lookup section of Metadata in Catalog Settings. There are two options: Look up city, state and country of GPS coordinates to provide address suggestions; and Export address suggestions whenever address fields are empty. These basically fill in the Location metadata automatically. When you start to use Map, Lightroom will open a dialog asking if you want to activate this feature. It uses the GPS information from the pins on the map to add the location information to the photo's metadata.

When you first open Map, you'll be presented with a set of tips letting you know about features. You can turn these off in the dialog. They can be viewed in the Window>Map Modules Tips menu at any time.

Map Styles

Before we get started on Maps, let's take a look at the layout, beginning with the Map Styles. The default, and my preferred style, is Hybrid, which is a mix of Road Map and Satellite.

To select between them, use the Map Style menu in the Toolbar ("T" to toggle). Also in the Toolbar is the Zoom Slider, which allows you to zoom in and out of

the Map. The Lock icon lets you lock a pin in place to prevent moving it by accident. Finally, the squished "N" icon is the Tracklog tool, which we'll discuss later.

The next style is Road Map. This is like any printed Road Map, and it works well if you're looking for a clean view.

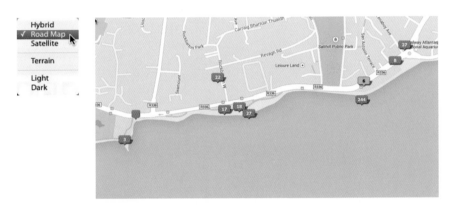

After Road Map, we have the Satellite view. This is a photo-only version of the map, with no street names or other identifying features.

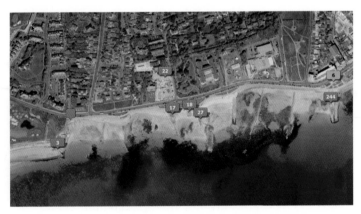

After these three main styles, there are three alternative styles. The first of these is Terrain, which shows the map in relief. The following example shows a more mountainous view to give you a better idea of what this option looks like.

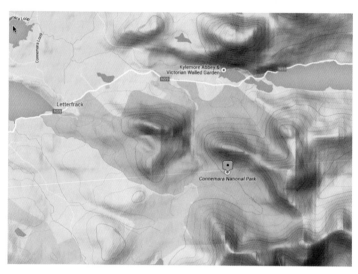

Next up is the Light view—this option gives a mostly white view with very little color.

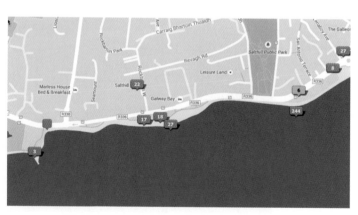

The final Style is Dark view, which is the reverse of Light view. Water appears dark blue rather than gray. Also, railroads and airports appear lighter.

Auto GPS

If this is your first time using Map, you may be surprised to find that some of your photos are already on the map. To me, this is one of the best things about Map. I wish the rest of Map were this easy. Not that any of it is hard; there's just nothing better than doing nothing and still having the work done!

On your device, make sure you've turned GPS on. For the iPhone, go to Settings, and then Privacy, and finally into Location Services.

If it isn't on already, turn Location Services on at the top. Next turn on the Camera Location Services. In fact, do this for all the camera apps that allow it.

With Location Services turned on, all photos taken will have GPS data embedded. Now when you import photos into Lightroom, the GPS information from the photos will be read and the photos will be automatically placed on the map.

The photos in the screenshot above were shot as a recce for a future shoot. Having a map to go with your images is a great help to remember how to get to the location. Two of the three photos were taken in one spot. Clicking on

the orange marker with the "2" inside it will bring up thumbnail views of the photos at the location. Using the arrows, you can view all the photos taken at that point. The arrow keys or scroll wheel can also be used. Pins with one photo show only that thumbnail.

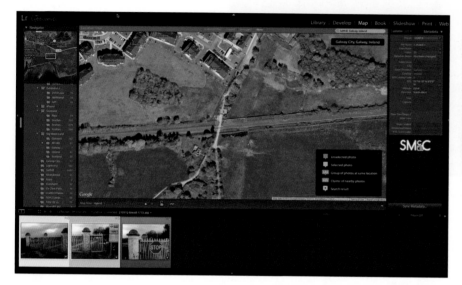

If you zoom out using the zoom slider in the Toolbar (press "T" to toggle it on and off), or use Cmd/Ctrl "-", the photos will cluster together. You can view the thumbnails in the new cluster by clicking on the pin.

One caveat to all this is that once placed, it isn't possible to move a pin cluster (i.e., one with multiple photos). You need to drag the same images to a new point. It's a limitation based on the way Map is accessed from Google. Single-image pins can be moved, though.

Another difference is that single-image pins will bounce on the map when you hover over the photo in the Filmstrip, but clusters will not.

Location Drag and Drop

Another way to get photos onto the map is by searching for the location and dragging the photos onto that location on the map.

In the Location Bar at the top of the screen (use "\" to toggle it on and off), enter the location in the Search Map section. The search location will display in a bezel under the Search Map bar. This bezel can be toggled on and off using the shortcut "I".

In the past, I know I've tagged photos from the location in Keywords so I could jump to Library and use the Keyword list to filter for that location. This time I'll create a Smart Collection for photos containing the keyword "Salthill."

With the photos collected together, it's simply a matter of selecting sets of photos and dragging them onto the map. Make sure you're reasonably accurate, though, since we'll be exploring this further in the section on Saved Locations.

Within my Smart Collection, there's a large block of images used to create a time-lapse, so I'm going to drag these onto the map first. Due to the sheer number, it's easier to select these in the Grid in Library. With the selection made, I go back to Map and drag from the center of the first image in the selection and drop it onto the point where the shots were taken. Like I've mentioned, you can't move this pin cluster after dropping it—you have to drag from the Filmstrip again.

Now would be a good time to look at the other options in the Location Bar. Clicking Visible On Map will hide all the images that are not on the map in the Filmstrip. Tagged dims the photos that are not tagged.

Untagged does the reverse and hides tagged images. All the options will be turned off when you choose None.

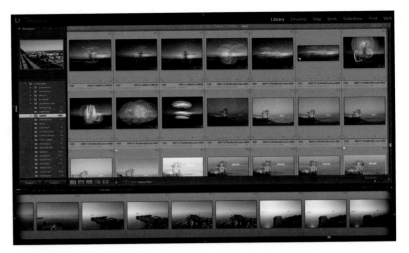

The Salthill Smart Collection

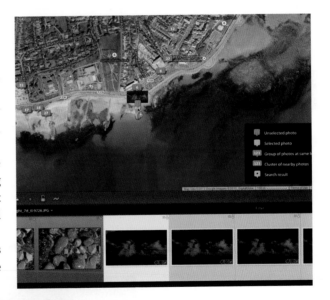

Map Clicking

As well as dragging and dropping, you can get photos to the map in two other ways:

- Select the photos in the Filmstrip and Command + click (Mac) or Control + click the desired location on the map.

- Select the photos in the Filmstrip, right-click on the desired map location, and choose Add GPS Location To Selected Photos from the menu.

Next we'll move on to using Saved Locations.

Saved Locations

Using Saved Locations is a cool way to jump to places where you shoot regularly, or perhaps vacation and travel destinations where you've been.

Using Salthill as our backdrop, we'll look at creating Saved Locations that cover smaller areas, overlapping our main Salthill Saved Location, before moving further afield. Click the "+" symbol beside Saved Locations. There doesn't appear to be a shortcut or a menu item for it.

Enter the location's name. The suggested name is taken from the map location. You can also create a New Folder here.

If you want to always prevent this location from being exported, click the checkbox for Private. The most likely use for this is to prevent people from knowing your home location, or to protect the location of a particular view.

Use the Radius slider to determine the area to include in the location. Don't worry if you get it wrong: once created, you can drag the center point to a different location on the map and change the radius from that location.

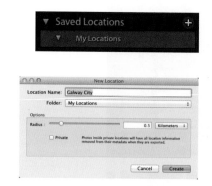

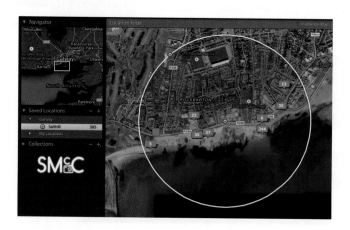

You can create smaller locations within this larger location, too. It's not like the Spot Tool! Here I've created one for Blackrock Diving Board.

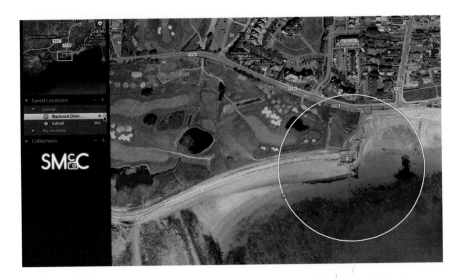

To move the location, click and drag the pin at the center. To change the radius, select the pin on the radius circle and drag.

You can jump to any Saved Location by selecting it in the Saved Locations panel and clicking on the arrow to the right of the name. Here I've selected "Camus," a location I made previously. Nothing appears on the map, because I'm still in the "Salthill" Smart Collection I made earlier.

To make the photos from here visible, I need to either go to a Collection containing these photos, or out to All Photographs. Rather than jump to Library, I simply created a Smart Collection for photos with Rating of 0 or greater (i.e., every photo). The photos now appear in the Saved Location.

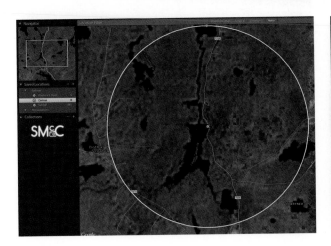
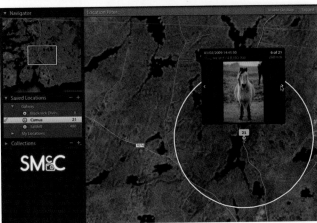

Tracklogs

Tracklogs are files generated by GPS devices. You can set waypoints as you go, to mark where you've been. If you have an iPhone, apps like Trails or Geotagr can be used to generate tracklogs as you take pictures. Lightroom reads .GPX files, so if your device uses other formats (e.g., NMEA), you'll need to convert it with GPSBabel, which you can find here: http://www.gpsbabel.org/. Note that Lightroom doesn't import the tracklog from your device—you need to do that yourself. Geotagr will export to Dropbox, as will a host of other phone-based apps.

Tracklogs are all in UTC by default, but as you travel, you'll probably be changing time zones as you go. Even if you're in the UK on GMT, you'll still be adding an hour with British Summer Time. This means that the tracklog time and your photo times may not match up. We'll look at how to fix these issues as we go.

Let's import a tracklog. I was in Scotland a while ago with fellow Lightroom author and blogger, Richard Earney. He was kind enough to email me tracklogs from the trip.

Click to the squished N icon in the Toolbar and choose Load Tracklog from the menu. Browse to the file and press Choose. The tracklog will appear on the map. From here we can match our photos to the tracklog.

On the map window, I've clicked to see the time of the first waypoint. As it happens, it's slightly after I started shooting. To get the photos onto the map, I'm going to use the first of Lightroom's tools for dealing with tracklogs.

In Library, I've selected all the files I shot in the tracklog timeframe on the beach. From there, I drag all the photos onto the start point of the tracklog.

A dialog box opens asking if we want all photos, or just the active photo on the map. In this case, we want the entire selection.

Because I shot with more than one camera, another dialog appears asking if we want to use all the cameras. Of course we do! Both of these dialogs can be checked so you never see them again, but the truth is, you may want to only select one camera in the future, or have only one photo placed on the tracklog, so I say leave them on.

With the dialog dismissed, Lightroom will attempt to place the photos along the tracklog, matching offsets from your first photo to make it all fit. In this case the tracklog isn't actually accurate for the photos, since I stayed on the beach, rather than wandering out further. However, in this instance, it's close enough for me. Sometimes you may need to drag smaller photo amounts onto the tracklog to make it work.

As you load tracklogs, they add to the Recent Tracklogs list. As well as being able to select from the list, you can also go back and forward from the Tracklog flyout, or using the shortcuts Command + Option + T (Mac), or Control + Alt + T (PC) to choose the Next Tracklog, or use Shift + Command + Option + T (Mac), or Shift + Control + Alt + T (PC) for Previous Track. If you need to select all the Photos on the current tracklog, simply choose Select Photos on Tracklog. (Yes, obvious, I know.)

For my next tracklog, I load a previously unused tracklog. I know the location, so I select photos shot in that location. From the Tracklog Flyout, I choose Auto Tag Selected Photos. Lightroom makes these fit the tracklog. Am I allowed to be impressed?

If you need to offset the time to get photos to match the tracklog, use the Set Time Zone Offset option to get the photos to the correct setting. When the time is wrong, it appears in red. Move the slider until it goes black, then use the Auto Tag to get the photos to the map.

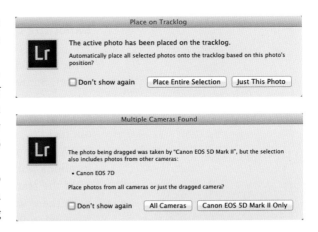

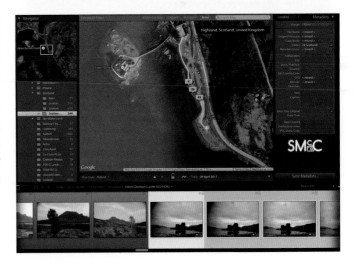

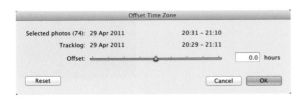

Exporting Location Data

With the addition of GPS, there's a lot more information to be gained on export. Sometimes location information can be sensitive, like your home address, or even a spot you love shooting that you don't want your friends to know about. Fortunately we can control what information goes out with our files.

We've already mentioned one: Private Saved Locations. Photos in these locations won't have the location revealed on export.

In the standard Export dialog, the Metadata section has changed. Originally there was a choice between Copyright and All Metadata, but this has been extended.

The first two options, Copyright Only and Copyright & Contact Info only, automatically have Removed Location Info checked.

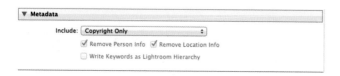
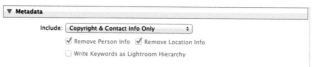

The other two options, All Except Camera & Camera Raw Info and All Metadata, allow you to choose if location information is exported with the new file. It's good to know we have full control over this.

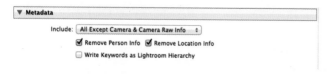
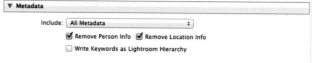

Final Destination

We've covered the bulk of Map in this chapter, but there are a few more small things worth mentioning. When you create a Saved Location, that information is saved into the catalog as searchable Metadata. Open the Filter Bar in Library ("\" to toggle on and off), and click on Metadata. Click date in the Date column, and select Map Location from the list.

The column will now show all of your Saved Locations.

Other little tips include holding the Alt/Option key down to drag a rectangle on the map. The map will zoom into this rectangle. Also, any photo that appears on the map will have a little pin badge. Click the badge to go to that location on the map.

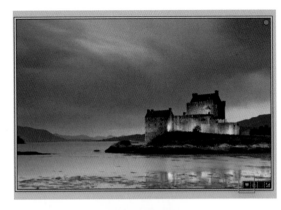

In the Metadata Panel, if the GPS field is filled, clicking on the arrow will bring you to that point on the map. Alt/Option clicking it will open it in Google Maps.

This might seem obvious, but you need to be online to see the maps. Google only allows use of the map when connected online.

Again, because Google is licensing the maps, there's a time limit on the mapping function in each Lightroom version. Currently each version is licensed for five years. This does mean you have to upgrade Lightroom every five years or lose access to Maps. If you have Lightroom CC, then Maps will deactivate when your account payment pauses or stops.

Well, that's it for Maps.

Book

In response to requests for a way to create photo albums, Adobe added the Book Module to Lightroom. It's a template-driven module, and while there is a large amount of customization available, you're still limited to set book sizes. These sizes are based on book sizes from Blurb.com, which is the only current printing partner with Lightroom. There was going to be a tool kit released to create your own sizes (this information is based on an interview I did with Adobe engineer Kevin Tieskoetter), but it hasn't been released yet. Someone did post a method of editing the existing book sizes, though, which we'll look at later.

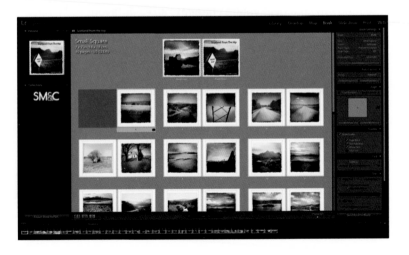

In the Left Panel Book only has Collections and Preview, which will show the currently selected book page or two-page spread. Preview has three zoom levels:

- Fit: This shows the page with a yellow border around it. This border has an arrow at the bottom where you can select a page template.

- 1:1: This is a full-size view where the screen matches the book size.

- 4:1: This is a zoomed-in view of the page.

Getting Started With Book

To get started with Book, create a collection of images that you'd like to have as a photo book. With this method, it's a good idea to start with the images in roughly the order you want them to appear in the book. We're going to use the Auto Layout function to make a book quickly. This will create a book based on the presets we choose in the Auto Layout panel, which is the second panel from the top in the Right Panel.

Auto Layout a book

For your first book, we'll take a step-by-step approach to the process. The collection we are going to use for this book is a set of images shot with the Hipstamatic app. The app produces a square photo, so we'll create a square book to match.

1. Choose either Blurb or PDF from the Book: dropdown menu in the Book Settings panel. You may want to create an actual book, or just do a test run with a PDF.

2. Choose a size. We're using Small Square for this example. You will see the following dialog if you're changing sizes or layout.

3. Next go to the Auto Layout panel. I usually press Clear Layout at this stage to get a fresh start. For this book, choose One Photo Per Page to start. Don't worry if this isn't exactly what you want, we can change it later.

4. Finally, click Auto Layout to make a full book. If you're printing to Blurb, books are limited to 240 pages. PDF publishing has no page limit. Click the Multi Page view icon ▦ in the Toolbar. This will show a preview of the whole book. In this view you can easily swap images around. By Shift + Clicking on a series of pages, you can drag the selected pages to a different part of the book. Just drag from the yellow border of one of the pages.

By default the first image is placed onto the front cover, with the last image placed on the back cover. If you look at the thumbnails, you'll notice numbers over each image showing how many times they've been used. Auto Layout puts all images in the book once, except for the two cover images, which will have a "2", indicating they've been used twice (on the cover and in the book). The information panel showing the book details can be toggled on and off using the shortcut "I". We can start to refine our book with the cover.

Refine the Cover

1. Select the cover in Multi Page view. The border around the cover will become yellow to indicate it has been selected. Click on the Single Page view icon ▣ to fill the image preview area with the cover. You can also double-click on a page to open it in this view.

2. At the bottom right of the border is a disclosure triangle. Click this to see the cover options.

3. In the right column we can see most of the cover options. We're going to use the thumbnails, highlighted in red.

4. Drag photos from the Filmstrip to fill the photo cells in whatever order you like. To select a range of images, click the first, and then shift + click the last. Drag these to the cover to fill the cells automatically.

5. Next, make the background black in the Background Panel (at the bottom of the Right Panel) by clicking the Background Color swatch and choosing the black swatch. To make all pages black, you could also check the Apply Background Globally option. You can always turn it off again and change individual pages later.

6. From there, add your title and author text, along with back cover text and the spine information. The available text frames become visible when you hover the cursor over the cover. The default text is black so we need to change the text color since the background is also black. To change the look of the text and its position inside the text frame, go to the Type Panel.

7. In the Type Panel you can choose whatever font family, weight, size, color, and opacity you like. You can save these settings, for easy reuse, by clicking the Text Style Preset dropdown menu and choosing Save Current Settings as New Preset.

That covers the basics of changing the cover in the Book Module. Now that we're this far, I recommend saving the book.

Saving Your Book

There are a few ways to save your book. The most obvious is the bar at the top of the main window, below the Module Picker. It indicates you have an unsaved book and gives you the option to Clear Book or Create Saved Book.

Once you press Create Saved Book, you'll be presented with the following Dialog box.

Name the book and click Create. You may opt to create a Collection Set for your books, rather than saving them beside the original Collection.

Alternatively, go to the Collections panel and click the "+" beside the title. Choose Create Book from the flyout menu to see the Create Book dialog shown above.

The saved book will appear in the Collections panel with an icon resembling an open book next to it.

Page Handling

Now that we've seen how to lay out a basic book, customize the cover, insert cover text, and save the book, let's move on to customizing single pages.

Like with the cover, go to a page in Single Page View by double-clicking on any page to zoom into it. Use the left and right arrow keys to move between pages.

Like with the cover, click the disclosure triangle at the bottom right to choose a new page layout. In this case, we'll stick with one photo, but add a larger border.

You can also access this same set of options in the Page Panel.

If you choose a template with a different shape, you can either move the image inside that shape to get a better composition or you can use the Zoom to resize the image to fill the frame.

Working With Text

Go to a different page and choose a different layout from either the disclosure triangle or the Page Panel. This time, we're going to choose a page template that contains text so we can look at the available text options. Text is shown as a series of lines in the template thumbnail. Type some text into the box.

If you already have a caption written in metadata, this can be used instead. If you want the text to be reusable, you're better off entering it in the metadata panel rather than in this text panel. Right-click on the text area and choose Caption from the Auto Text

command from the contextual menu. Other options include Title and File-name. Let's go with normal text first, though, shown as Custom in the Auto Text menu.

Go back to the Type Panel to select suitable text options. For this image, I think the current text size is too big, so that's the first thing to change. Change the Size slider in the Character section of Type. The alignment options are at the bottom; Left, Center, Right, and Justified. You can also place text in the top, middle, or bottom of the text box. Here we'll choose gray, centered text.

Open the disclosure triangle to see more Character options.

- Tracking: This controls the spacing between characters. Increasing the tracking widens the gap, while decreasing it will force the characters to overlap more and more.

- Baseline: This controls how far above or below the normal typing line (the baseline) the characters will appear. Baseline should be called Baseline Shift, but there isn't enough room for that full name.

- Leading: This increases the space between lines of characters, giving more space for the type.

- Kerning: This is the process of setting the space between the individual characters of a proportional font to make them sit better together. (Tracking sets it for all characters equally; Kerning refines it for single characters.)

- Auto Leading and Auto Kerning: these set these properties automatically.

You can also split the text into Columns. Once you go past one column, the Gutter slider becomes available, letting you set the gap between the columns.

Using the Cell Panel, I'll use Padding to make the text box smaller. Initially, Padding shows as a single slider. Click the disclosure triangle to view it as four sliders. Uncheck the Link All checkbox to have individual control over the left, right, top, and bottom padding.

Below the Cell Panel is the Text Panel. There are two options here: Photo Text and Page Text.

Click on a photo to make Photo Text active, or click the Add Photo Text button. Photo Text can be custom text (useful for pages with no other text options), or from a Text Template. These Text Templates can be selected and edited from the Photo Text menu. Click Edit… to edit or create a template for yourself.

The Text Template Editor will open. In a similar fashion to the File Naming Editor, choose from the available tokens to build up automatic information for the Photo Text. Use Option(Mac)/Alt(PC) + Enter to create a new line. These Text Templates are also available in other Modules.

If you want to use either Title or Caption (or any metadata-based template), these must first be entered in the Metadata Panel in Library. On pages with more than one photo, the Photo Text appears on each photo where the option has been checked. Each Photo Text is independently controlled from the Text Panel.

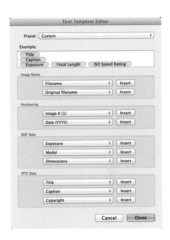

The Offset moves the text away from the text's base position. That base position can be set to Above, Over, or Below the photo. Above is grayed out because the page template has the photo at the top of the page.

The Page Text appears only once on a page, either at the top or bottom, depending on which button is pressed. Again this is useful for pages where there is no text box already available. You can also use the Auto Text option.

Favorites

Before we move on to pages with more than one photo, we should look at Page options. You can choose to add Page options to Favorites. That way, when you want to choose a new page layout, you can select from your preferred layouts in Favorites. You can also click the circle badge in the top left of the template thumbnail. The icon looks similar to that of the Quick Collection icon.

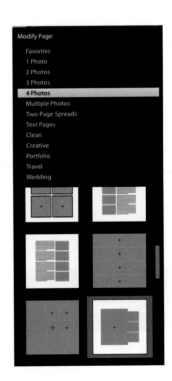

Multiple Photo Options

Now let's try a layout that features more than one photo per page. It's very similar to creating a single-image layout. Use the Page panel and select four photos. Use a template with one large photo and three small photos.

Drag photos from the filmstrip and place them in the empty cells.

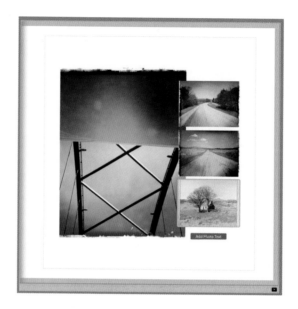

Because all the images were already used in the layout, we'll need to find pages to delete to free up some photos. On the pages you want to delete, right-click on the page and choose Remove Page from the menu. This can be done in Multi Page view.

Other options in that menu include:

- Zoom Photo to Fill Cell: This increases the zoom so all the area available for a photo is filled. This is faster than doing it manually. You can drag the photo in the image area to get better layout composition after zooming.

- Remove Photo: This deletes the photo from the current page, leaving the page otherwise intact.

- Add Page: This creates a new page after the current page, with the same formatting and layout.

- Add Blank Page: This adds a new blank page with no layout.

- Copy/Paste Layout: This copies or pastes the layout to other pages.

- Save as Custom Page: This saves the current page as a new page Template and saves it to Custom Pages, which is below Favorites.

Backgrounds and Guides

Beginning With Background

When we learned how to modify the cover, we changed the background color to black in the Background panel. Here we'll look at modifying the background in detail.

Backgrounds can be applied globally, or on a page-by-page basis. Let's say you wanted the whole book to have a black background. Click Apply Background Globally. Then click Background Color and choose the black swatch. All the white pages will become black.

It's probably more versatile to leave Apply Background Globally off to allow for more variety. With Apply Background Globally off, you can use multiple colors and add page graphics and photo backgrounds.

Photo Backgrounds

To add an image background, simply drag a photo from the filmstrip to the preview box in the Background Panel. Make sure Graphic is turned on. Use the Opacity slider to set the transparency of the background photo. To remove a photo, right-click on the photo in the Backgrounds panel and choose Remove Photo.

Graphic Backgrounds

You can find other options besides the default Photos by clicking the disclosure triangle to the right of the preview window in Background. There's also a collection of Travel and Wedding graphics. These are gray by default, but using both the Opacity slider and the swatch, you can make them any color and transparency you like.

Jump back to the Page panel and click the Add Blank button. Then in the Background panel, select a Graphic. By default the graphic will be at 20% opacity, but bringing this value higher will make the graphic look more solid. By clicking the swatch, you can select a color for the graphic that suits the book. I've randomly chosen a blue for this example. By default, this swatch shows HSL and RGB percentages. Click HEX to show the 6-digit web color values instead.

You can turn off the Graphic. To remove a Graphic, go to Photos in the Graphic dropdown and choose the blank photo.

Guides

To use Guides, first check the Show Guides box.

The first option is Page Bleed. This shows the edges of the book that are likely to be cut off when a book is published. These are shown in the Book Module as a thick gray border. Keep the important part of photos inside these borders.

Next is the Text Safe Area. This shows the maximum space where text can be shown and look good. It is shown as a thin black stroke slightly in from the edge of the page.

The next guide is for Photo Cells—it shows as a gray rectangle where the outside photo will go. A Cell border will turn yellow when you hover over it, whether or not it is selected.

Finally we have Filler Text, which just puts random text in boxes to show where the text area is.

Book Settings

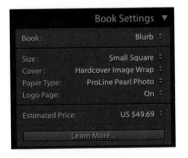

When we started making our book, we went with a Small Square 7×7 book. Let's look at the other available options. To see these options, open Book Settings.

Book

The first section, Book, is where we decide the type of output product. There are three options:

- Blurb: Send the final design to Blurb.com for printing.

- PDF: Create a PDF version of the design. This can be for a saleable ebook, proof, or a file to send to an alternate book publisher

- JPEG: Create JPEG versions for alternate book publishers. Unfortunately these are single page output, and a lot of publishers seek double-page spreads.

Changing between these three options makes changes to the rest of the panel options.

Sizes

Next is the Sizes section. All three of the output options are tied to these sizes, which are dictated from the Blurb book size options. There are five size options:

- Small Landscape 7"×7"

✓ Small Square	7 x 7 in (18 x 18 cm)
Standard Portrait	8 x 10 in (20 x 25 cm)
Standard Landscape	10 x 8 in (25 x 20 cm)
Large Landscape	13 x 11 in (33 x 28 cm)
Large Square	12 x 12 in (30 x 30 cm)

- Standard Portrait 8"×10"

- Standard Landscape 10"×8"

- Large Landscape 13"×11"

- Large Square 12"×12"

The actual print size from Blurb is ¼ inch smaller than the option choices to account for the bleed edge. PDF and JPEG output will be the exact size as your chosen option.

Cover

There are three cover options for Blurb and four for PDF and JPEG:

✓ Premium Lustre
Premium Matte
ProLine Uncoated
ProLine Pearl Photo
Standard

- No Cover: This option is only available for the PDF and JPEG options.

- Hardcover Image Wrap: This prints the image directly onto the hard cover.

- Hardcover Dust Jacket: This is similar to the traditional linen hardback books with a printed paper jacket. With this option, you'll need to design the interior flaps of the jacket as well.

- Softcover: This is the card-cover option. The cover design is printed directly onto the soft cover.

Here are samples of the three Blurb-style covers:

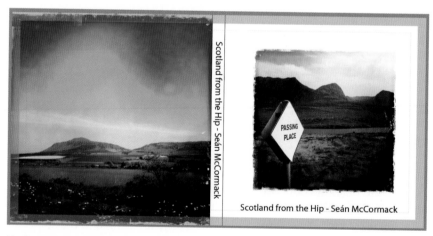

Hardcover Image Wrap

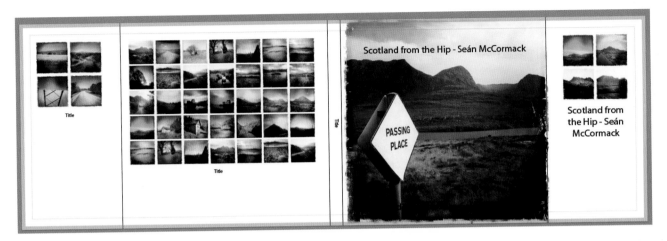

Hardcover Dust Jacket

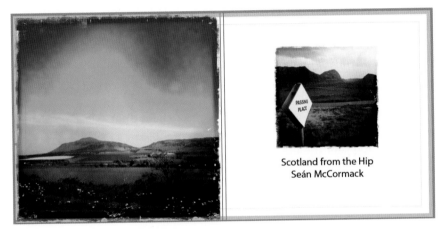

Softcover

Blurb Options: Paper Type, Logo, and Estimated Price
Blurb offers five paper types:

- Premium Lustre: Not quite in the same league as the ProLine Pearl photo paper, but this option offers a nice luster finish.

- Premium Matte: A higher-quality matte paper finish.

- ProLine Uncoated: Uncoated is completely matte, with no shine whatsoever. It's similar to fine art textured papers. Tones are muted. This particular book looks great on Uncoated, as do black-and-white photos.

- ProLine Pearl Photo: This paper looks and feels very similar to Epson's Premium Luster paper. This is my favorite of the shiny papers.

- Standard: The basic photo paper—perfect for proofing or for cheap books. Because the paper is thinner, you may occasionally see through to the photos on the other side of the page.

Blurb offers a swatch kit, and the cost is offset in your next book purchase.

The Logo Page is the final page in the book. It has the Blurb logo on it, which can be removed for an additional cost. I know some people just put their own logo on a sticker, and then affix the sticker over the Blurb logo.

Estimated Price comes from the Blurb server and will change as you alter the book, including adding pages, changing the cover, and switching paper types.

PDF and JPEG Options

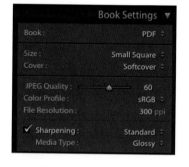

When you choose PDF or JPEG as the Book option, you'll see the following dialog:

JPEQ Quality sets the quality of the PDF and JPEG output. Higher quality is better, but will affect upload time and disk space.

Set the Color Profile according to the needs of the publisher you intend on using. When in doubt, leave it to sRGB.

File Resolution sets the pixels per inch of the output. Most publishers require 300ppi.

Sharpening sets the output sharpening. Just like the Export dialog, you have three amounts: Low, Standard, and High. There are also two paper types for sharpening: Matte and Glossy.

Publishing Your Book

Blurb

If you're creating a book for Blurb, click Send Book to Blurb at the bottom of the Right Panel.

This will open a login dialog.

At this point, the book will upload. Once uploaded, you can preview the book on the Blurb site. Be warned, it takes time!

By clicking the Export Book to PDF button at the bottom of the Left Panel, you can create a PDF copy of the Blurb book while you're waiting or prior to uploading it in order to proof it.

Once the book appears on Blurb, you'll be able to preview it and order it.

You can see the real version of the book demoed here: http://blur.by/1HhEoCT

PDF and JPEG
The button at the bottom of the Right Panel will change to reflect the chosen output.

That covers the main elements of the Book Module. There is still some customizing that can be done, though.

Creating Your Own Auto Layout

We began our book creation using an Auto Layout. There are two default Presets: Left Blank, Right One Photo; and One Photo Per Page. These names describe the layouts perfectly—something to consider when naming your own layouts.

Both of these presets have a small issue; they zoom the images to fill the photo cells in the layout. This is fine for square images in a square box (did you notice that I did that?), but for non-square images, it means you're cropping into the center of the photo.

To create your own layout, select Edit Auto Layout Preset from the Preset menu.

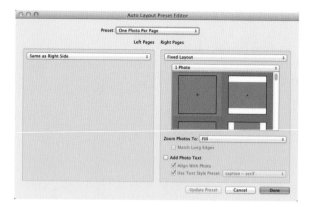

The Auto Layout Preset Editor will appear with settings based on the currently selected Preset. You can choose a different preset from the menu at the top.

The Left and Right Pages can have different layouts. Here the Left Page has been set to Same as Right Side, so the layout of the right and left pages will mirror each other. Let's create a different layout for the Left Page. Clicking the Same as Right menu, we get three other options: Blank, Fixed Layout, or Random from Favorites. The Random from Favorites option is great for a little variety in the pages, but you have to add layouts to the Favorites before this is useful. For this example, we'll choose Fixed Layout.

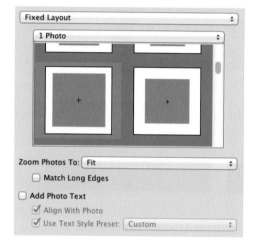

The layouts here are identical to those in the Page panel, or the options offered via the disclosure triangle at the bottom of a page's yellow border. Choose a layout. I've gone with a bordered square. Zoom Photos To allows a choice of Fit or Fill. Fit centers the whole image in the photo cell, while Fill zooms in the image to fill the whole cell. I want the whole photo in the cell in this layout, so we'll choose Fit. Match Long Edges is there to help balance two photos on a page. If one is horizontal and the other vertical, the horizontal image will look small. Clicking Match Long Edges will reduce the height of the vertical photo to match the length of the horizontal photo (the long edge on each).

You can opt to Add Photo Text. There are options to Align With Photo and to choose a specific Text Style Preset. I feel this would be more useable if you could choose a Text Template from here, that way text would automatically appear in the layout.

For the Right Page, change Fit to Fill in Zoom Photo To. At the top of the Auto Layout dialog, in Preset, the preset name now has the word "(edited)" appended to it to indicate it has been changed. Click this and select Save Current Settings as New Preset.

Give the Preset a name that lets you know what it does. After saving it, the new Preset will be available and selected in the Preset list.

Click Done to exit the editor. To apply the Preset, click Clear Layout, then Apply Layout.

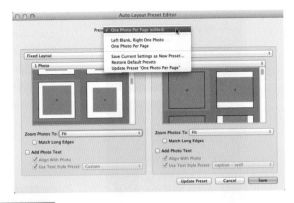

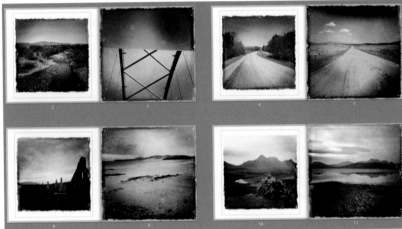

The new Auto Layout preset applied

Two-Page Spreads

We've covered Single and Multi Page views, but not the third viewing option for our pages: Spread View.

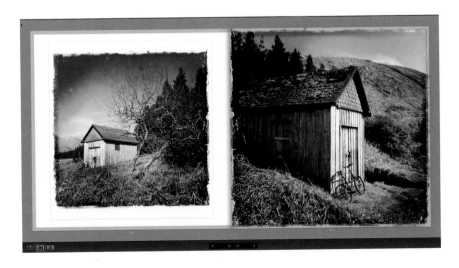

Spread View allows you to see how a two-page spread will balance together. There's an art to getting pages to balance well. The pages should complement each other. In magazine terms, this is a double-page spread, but Lightroom refers to it as a Two-Page Spread. To change to a Two-Page Spread, select that option from the Page Panel.

With Lightroom, placing a horizontal image across a double-page spread is easy. You just drag an image to the spread. Lightroom will work out all the cropping in the background so the spread will print correctly.

Page Numbers

You can add page numbers by checking the Page Numbers checkbox in the Page panel. Click the dropdown menu to select the location of the numbers. Choose from Top Corner, Bottom Corner, Top, Side, or Bottom. Top and Bottom numbers are centered. Side numbers are centered on the outside of the page.

With Page Numbers turned on, you get three more options in the Right-Click menu. These are Hide Page Number, Start Page Number, and Apply Page Number Style Globally.

Hide Page Number hides the number from the current page. In the process, the menu command is changed to Show Page Number, allowing you to bring it back. Start Page Number tells Lightroom to make this page number 1, and to count onward from this page. When you create page numbers, they will all have the same look. To change an individual page number style, first turn off Apply Page Number Style Globally. From the Type menu, choose a new style.

Reusing Your Layout

The Book Module doesn't have a way to save the whole book layout as a Preset or Template. You can only create a Saved Book, which includes the images. If you use small albums that have a fixed layout to make books, it can help to have something repeatable to drop images into. The only way to do this is save your book, then right-click on the Book Collection that appears in the Collections panel and choose Duplicate Book.

This will create an identical copy of the Saved Book. Go to Grid, then select and delete all images to remove them from the Saved Book. Next add the images you want in the new book to this duplicate Book Collection. Finally, drag the new images from the Filmstrip into the empty book.

Use Print for More Layouts

We'll discuss this in the Print Module section of the next chapter, but you can also create layouts using the Custom Package option in Print. These can be exported to JPEG and used with Auto Layout for even more spectacular results.

Creating Custom Page Templates

While there was talk of having an SDK (Software Development Kit) to create your own page sizes and layouts, none were ever brought to the public. Unfortunately, there's been no mention of it since Lightroom 5.

However that doesn't stop people from finding ways of creating custom page templates: a user has posted an unofficial method on the Adobe User Forums at: https://forums.adobe.com/thread/1254145

The post has been there since February 2015, so it should still be there now.

Final Thoughts on Book

While I do wish that there were more publishing options in Book, it's still a great, easy way to create photo books. The range of papers available from Blurb should suit most peoples' tastes and pocketbooks.

Commercial shooters can also make use of the PDF option for sending different portfolios to clients as required, with Auto Layout taking the sting out of the creation process.

Slideshow, Print, and Web

7

Slideshow, Print and Web were the three original output Modules for Lightroom. Slideshow is Lightroom's presentation module. It allows you to create slideshows in JPEG, PDF or video form. Print gives you fully customizable print layouts with text and color management, all of which can be saved for repeatable results. Finally, Web gives you a selection of web galleries. Third-party plugins will let you create full, exportable websites that are controlled from within Lightroom.

Slideshow

The Slideshow function in Lightroom 6 has a number of improvements from previous versions. Long-awaited functions like the Ken Burns effect and the ability to have slides change to the music beat are now included. Previous versions of Lightroom only allowed you to use one music track; now a new playlist with up to ten tracks is available. Tracks are played in order and can be moved about the list as needed.

Another new feature is Aspect Ratio preview, which allows you to see how the slideshow will look on output (e.g., HD video at 16×9 vs. SD video at 4×3). Finally, you can choose a lower quality setting for faster previews in playback. This doesn't affect export quality.

Getting Started in Slideshow

As with other modules, the best way to get familiar with Slideshow is to start building a presentation. Gather the images you want to present into a Collection—you can make a slideshow from a Folder, but since the Collections panel is available in Slideshow, you're better off starting with a Collection.

To make a Collection from a Folder, simply Select All in the Folder and use the shortcut Command + N on Mac or Control + N on PC. Give the Collection a suitable name and press Enter.

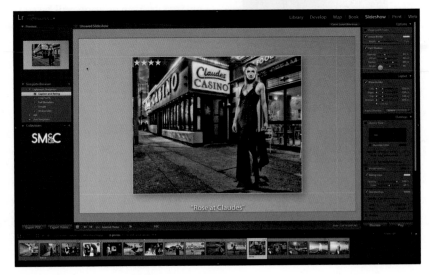

Now go to Slideshow by clicking on Slideshow in the Module Picker. You can also use the shortcut Command + Option + 5 on Mac, or Control + Alt + 5 on PC, or choose Slideshow from the Window menu. Without changing anything in the Module, you can press Play in the bottom of the Right Panel (or hit the return key) to start showing a slideshow. The layout will either be the default template or the settings last used in Slideshow. Pressing the Escape key will exit the Slideshow at any point.

Templates for Speedy Slideshows

Lightroom provides factory Templates that show some of the features of Slideshow. These can be selected in the Template Browser in the Left Panel of Slideshow. Hovering over the name of each Template will cause a thumbnail of a single slide to show in the Preview panel window.

Select a Template based on the Preview, and click Play or press Return to begin.

Customizing the Slideshow

The Right Panel holds all the settings for creating a slideshow. You don't need to use these in order, and for this look, we're not going to. First, select the Caption and Rating template from the Lightroom Templates folder in the Template Browser. This is just our starting point—we will make loads of changes from there.

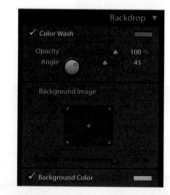

Backdrop

Our first setting change will be to the Backdrop. It's the fourth panel, right in the middle of the Right Panel. The shortcut is Command + 4 on Mac or Control + 4 on PC. Normally this shortcut style can be used for every panel, except for the Music panel, which is new. This panel has no shortcut. Even though it's the seventh panel, the Playback shortcut is Command + 6 (Mac) or Control + 6 (PC).

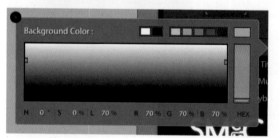

The Background Color is set from the last slider in the panel. Turning this off will give you a black background. Click the swatch to open the Lightroom color picker.

Initially this color picker shows only variations from black to white. You need to move the saturation slider over the HEX option to change from a grayscale view to a color view. Like with Book, you can select a color in the picker; you can also click the mouse and then drag the cursor to any place on the image

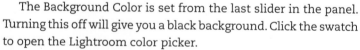

in the image preview area. Release when you're over the color you want to use from the image to select that color.

The Color Wash option is at the top of the Backdrop panel. This is on in your chosen template already, so click the swatch to bring up the color picker and set your preferred color. The blend between the Background Color and the Color Wash is set by the Opacity and Angle controls. At 100% Opacity, the Color Wash is at full color. Lower values make the color more and more transparent—at 0%, Color Wash

is effectively off. If you watch closely as you move the slider, you'll see that it controls how close the color wash runs to the edge. At lower values, it will be close to the edge. At higher values, it will be close to the center. Angle controls the position of the wash in relation to the background. At 0°, the wash is on the right; at 90°, it's on the top; and so on.

Clicking HEX allows you to see the color you're using as a 6-digit web value. The Color Wash here is #B06A4A, while the Background is #37241D.

The final option in Backdrop is Background Image. Simply drag and drop an image from the Filmstrip onto the cell to apply it as the background. You can also remove the image from the Filmstrip after this, if you don't want it to be part of the slideshow. Note that the Background Color and Color Wash get blended with the image. To prevent this, turn both options off.

You can't remove a background image once applied, but you can drop in another image instead, or simply turn off the option. Alternatively, use Command + Z (Mac) or Control + Z (PC) to undo, which will remove the image. The background image is applied to all slides.

Because Lightroom supports PNG files, you could do a special design as a Slideshow background, like a fake 50's TV or cinema drive-through cartoon background for your slides.

See Thru Me

To create a washed-out image effect with a background image applied, turn off Color Wash and set the Background color to white. Reduce the Opacity to about 25% to give a faded look to the background image.

Layout

To center the image in the Slideshow, go to Layout. Turn on Show Guides to see the boundaries of where the image will fit. With Link All turned on, either use the sliders in Layout (any of the four will work once they've been linked), or grab the guide lines and drag them to change the size of the image while keeping it centered. For an off-center look, turn off Link All, and move the sliders to suit your preferences.

Options

This is the first panel in the Right Panel of Slideshow. The first option is Zoom to Fill Frame. This zooms into the image until it fills the area defined by the guides from the Layout Panel.

Once zoomed, click and drag the image to reposition it within the guides. Notice that there's a faint outline showing where the original image is in relation to the guides (the red arrows are pointing at it).

The next option is Stroke Border. This adds a border around the image. This Stroke border stays within the Layout guides, so the image will shrink to fit as you increase the stroke width. Clicking on the swatch to choose a color will bring up the standard color picker that we've seen a few times already. If you uncheck the box, no stroke is applied.

The final option in this panel is Cast Shadow. This is a drop shadow control for the images on the backdrop. Personally, I think it adds depth to the look of the slide. Flat is in trend though, so you may want to leave this option off. If not, it's simple to use.

First check the Cast Shadow box. Use the Angle circle or slider to set the location where the shadow will fall. The dot sits in corresponding position in the circle. Opacity sets the strength of the shadow (100% is the darkest). Off-set controls how far from the image the shadow will appear. This gives the appearance of depth between the image and the backdrop. Finally, Radius controls the softness of the shadow. At zero pixels, the shadow is really hard; at 100 pixels, it's really soft. The default is 80 pixels.

Overlays

The Overlays panel allows you to add branding and information to each slide. This can be in the form of generic text on each image, or metadata, both EXIF and IPTC. Let's start by adding a logo with the Identity Plate.

Check the box to turn on the Identity Plate. The default Identity Plate will be used for this. To change to another Identity Plate or create a new one, click the triangle at the bottom right of the Identity Plate graphic window. This opens the Identity Plate editor, which we covered in Chapter 1. The Identity Plate appears on the top left of the slide. Click and drag it to move its position. An anchor appears as you drag, and will jump to the nearest edge center or corner. Move the Identity Plate to the top-center edge, where it should lock. You can scale the Identity Plate to fit better on the slide or reduce the opacity to fade it. If you've gone with a text-based Identity Plate, you can change the color of the text using the Override Color option. A final option for the Identity Plate is Render behind image. This places the Identity Plate below the image on the slide. If you move the Identity Plate behind the image, it will be hidden.

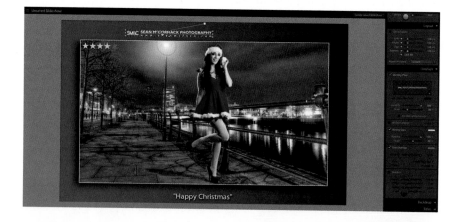

Overlays also feature a Watermarking option. This works in the same way as Watermarking in Export. Check the box to turn it on, choose a watermark preset from the list, or choose Edit Watermarks to create a new one.

There are two other Overlays already visible from the Template we chose: Ratings and Caption. Ratings shows the current star rating on an image. Normally I would only have this option turned on when using Slideshow for client selec-

tions. You can choose the color of the Ratings from the color swatch. You can set the transparency of the stars with Opacity, and the size of the stars with Scale. The stars can be dragged anywhere on the slide—they don't have to be on the image itself.

Caption is one of the options in Text Overlays. To activate it, check the Text Overlays box. Clicking the ABC icon in the Toolbar creates these overlays. Click on the Caption overlay on the slide and press the delete key to remove it. Now, click ABC in the Toolbar.

Custom Text will appear with an open text entry box. If you type directly into this box, any text entered will appear on all slides. To get different text on each slide, you have to make use of metadata.

Click on Custom Text to reveal other options. You can click Edit to open the Text Template Editor to create your own text from tokens. We've seen how this works in chapter 6 in the Book

Module. You can create as many text overlays as you like. Select Exposure, then select Edit... Press the spacebar to add a space, then choose ISO Speed Rating from the EXIF tokens list, followed by another space, then Focal Length (also in the EXIF tokens list). Choose Save Current Settings as New Preset from the menu. Call this preset "Camera Settings" and press Return.

Drag the text to the center bottom to balance the Identity Plate at the top. Note that because we have a Text Overlay selected, all the options in the Text Overlay section can now be set.

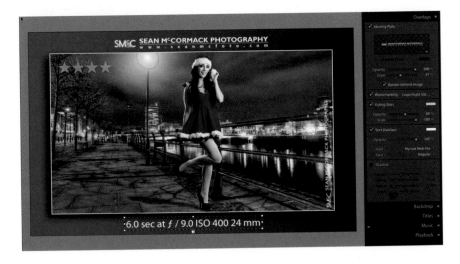

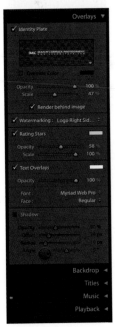

To change text color, use the color swatch. This opens the standard color picker. To fade the text, use the Opacity slider. Choose a font from the Font list. For the Font Face, choose from Regular, Italic, Bold, Condensed, or Condensed Italic. Some fonts may offer different Face options.

There's no Size slider, so set the size by dragging one of the eight markers on the text's bounding box. Move out to enlarge, or move in to reduce.

The Text Overlay options become available when a text box is selected, as does the Shadow option. It functions identically to the Cast Shadow option in the Options panel.

Titles

As well as the main photo slides, you can also create optional Intro Screen and Ending Screen slides. The controls for both slides are identical in function. First check the box to turn the slide on. Next choose a color for the background. This will be blank until you turn on the Add Identity Plate option. You may want an Identity Plate on the Intro Screen, but I usually create text with the slideshow title for this screen. There's no real formatting in the Identity Plate, so you may prefer to create PNG files in Photoshop or another editor for this. On Mac, you can use Option + Enter to create a new line as you type in the Identity Plate Editor.

You can override the text color from the Identity Plate via the appropriate checkbox, and change the size of the text using the Scale slider. Changes to these slides flash by on the screen, so pay attention as you edit or you'll miss them.

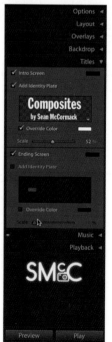

Those are the basics of customizing the slideshow. We'll look at video, music, and slide effects separately.

Creating Your Own Text Slides

While it's great having Intro and Ending Screens, sometimes you just want slides with your own text. Maybe you want your name on a different slide than the title slide, or you want to create a slide with text as a separator between sections of slides. Lightroom doesn't provide this capability directly, but we can cheat.

First create a blank slide. You can make one in Photoshop that is colored to match your slideshow; or even take a photo with your lens cap on to create a black image. Make as many virtual copies of this slide as you need for text slides. To create custom text for each text slide, choose a Metadata field that isn't used in the photos in the slideshow (something like Job Identifier or Instructions will usually work). Enter the text you want displayed on the slide in this field for each of the text slides.

Now press ABC in the Toolbar. Click Edit from the Custom Text menu and clear out the box. From the IPTC options, choose the Metadata field you chose for the text. Save this as a Text Template. Place the Text Overlay in the center of the screen. Change the font face, family, color, and opacity to suit your taste.

Place the slides into the slideshow where you want them. The text will show on these text slides, but not on the image slides.

Music

The Music options in Lightroom have always been in constant flux. Originally Lightroom could use iTunes playlists or MP3 files on PC. However, because the connection to iTunes would change with each new release of iTunes, the ability to sync to iTunes was abandoned in favor of using a single MP3 file. This was really limiting. Luckily it's quite easy to create a long MP3 file in Audacity, a free sound editor for Mac, PC, and Linux. I've covered it here: http://lightroom-blog.com/2011/02/14/slideshow-combine-multiple-mp3s-for-lightroom/. Still, this capability should really be part of Lightroom. Fortunately, Lightroom 6 finally fixed this problem, and now you can create a music playlist.

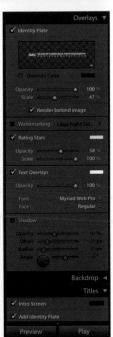

> **Music Copyright**
>
> Remember that owning music doesn't give you permission to distribute it. You need to license music if you're distributing your slideshows. Just as you want to get paid for your images, musicians deserve to get paid for their work. Sites like Audiojungle.com or Triplescoop-music.com have a huge range of tracks to choose from and license at reasonable rates. If you choose to use commercial music and get caught, music companies have no qualms against suing you for damages and bankrupting you with legal costs.

Go to the Music panel and click the switch in the panel header to turn music on.

Click "+" beside Duration to open to a file browser window. Choose an MP3 or M4A music file to add. Files in .aiff or .wav format are not supported by the player. Purchased songs from the iTunes store play back fine in testing. You can also choose more than one song at a time in the browser. The maximum number of songs in the list is 10.

Personally, I write little jingles in Garageband or Logic to avoid licensing issues. Even if you're not musically inclined, the loops are easy to put together into a short track.

To move tracks about, simply drag them to a new position. A blue line will appear where the track will go when the mouse is released. To remove a track, click on it to highlight it, then click the "–" beside Duration.

There are more options for music in the next panel: Playback.

Playback

The final panel in Slideshow is Playback. This panel contains controls for how the Slideshow runs and how long the slides will be displayed. It also has audio balance and pan and zoom controls.

Slideshow Mode

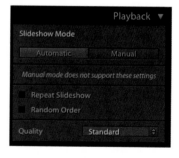

Slideshow can be Automatic or Manual. Manual mode needs user action to go from slide to slide, and all main options, including music, are turned off. It's rather blunt. In this mode, pressing play loads the first slide, but to change to the next slide, you must use the arrow keys or your presenter remote.

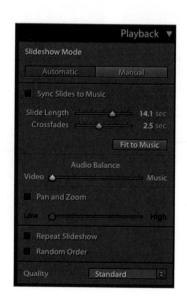

Music Controls

Automatic mode offers far more options. The first option is Sync Slides to Music. This detects the beat in the song and changes the slide with the beat. I've long requested the option for the timeline to do this manually. It does a great job, but there are no options. If you think the changes between slides are too fast, there's no way to slow down the transitions. Slideshow makers like Animoto also do automatic slideshows that change the image based on the accompanying music, but they allow the user to set the pace as required for the slideshow. Automatic mode doesn't play back video files, it merely shows the thumbnail image, as if it were a still image. Therefore, I don't recommend using Automatic Mode with video.

Manual Slide Times

For manual slide transitions and display times, we have the Crossfade and Slide Length sliders. These sliders set the time it takes to go between slides and the amount of time a slide is visible. They were formerly the Transition and Duration sliders in older versions of Lightroom. A slide will play for the Slide Length, and then both it and the next slide will transition for the Crossfade time. You can see the total length of the Slideshow on the right hand side of the Toolbar. Changing either slider will change this total.

Fit To Music

The Fit To Music button calculates the length of the playlist and divides it by the number of slides (accounting for video length if video is included). Both stills and videos are played as part of this mode.

Audio Balance

Speaking of video, the Audio Balance lets you control what happens to the audio from video files included in the slidehow. With the slider to the left, the music will fade out for the duration of the video, and only audio from the video will play. The music doesn't pause, just fades. With the slider to the right, the audio from the video is ignored and the music continues to play. Anywhere in between gives a balance of the music and the audio from video.

To refine a video in the slideshow, just use the editing tools we've seen from the video section in Library. To get a video into a slideshow, just drag it into the Collection you're using for the slideshow—exactly the same way you would a still image.

Pan and Zoom

This simple slider is a feature people have been begging for in Lightroom since Version 1. Also known as the "Ken Burns" effect, this feature allows you to pan and zoom across an image as the slideshow runs. (It's named for the filmmaker that invented the technique.)

When set to Low, the image only zooms in or out slightly and slowly pans. When set to High, the images are zoomed and panned more quickly. It helps keep the images in the slideshow more interesting. Start Low and then adjust to find the right balance for your slideshow. Video ignores this slider and playback is normal.

Final Playback Options

There are three remaining options.

- Repeat Slideshow: This option will replay the slideshow until it is stopped manually.

- Random Order: This shuffles the order in which the slides are played.

- Quality: This option sets the video preview quality in Lightroom. Choose from Draft, Standard, or High. This setting doesn't affect the output quality.

The Toolbar

We've seen some of the options in the Toolbar, so let's examine the remaining options.

1. The Stop button: Clicking this takes you back to the start of the slides, or stops the preview running inside the image preview area.

2. The Arrows: Clicking these arrows moves you back and forth through the slides.

3. The Use menu: This menu is where you choose what images in the current folder or collection will play. Choose from All, Selected, or Flagged. If Selected is chosen, but only one image is selected, all images will be used. These can also be chosen in the Play>Content menu.

4. The Play button: This button starts the preview playing in the image preview area. Once playback starts, the Play button becomes a pause button.

5. The Rotate Adornment buttons: These allow you to rotate Text Overlays, the Identity Plate, and Ratings.

6. The Text button: As we've seen, this is the button to use to create Text Overlays.

7. Slide Counter and Timer: This shows the current and total number of slides, as well as the slideshow duration.

Playing Back Your Slideshow

At the bottom of the Right Panel are two playback options. Preview will playback the slideshow in the image preview area. Play will play back the slideshow at full screen, hiding the entire interface.

When you begin, a Preparing Slideshow dialog will appear. This makes sure that all the slides are rendered and ready for playback, preventing a situation where pixilated images would appear. Slideshow relies on previews to run, so these previews have to be updated to render properly. Once the rendering is complete, playback will be more immediate.

If you have a second screen or projector attached to your computer, you'll have access to another part of the Playback panel, which will allow you to choose which screen the slideshow will play on. You can also choose to make the other screens blank.

Plug It In

Make sure the second monitor or projector is on and plugged into the computer before starting Lightroom.

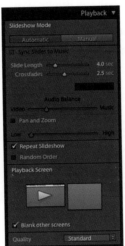

Templates

We started this chapter by choosing the Caption and Ratings Template. The remaining Templates all have interesting features that show off different aspects of the Slideshow.

Crop to Fill

This Template zooms the slideshow to fill the monitor, so the entire screen is used.

Exif Metadata

This is the Template to use when doing a talk with photographers. Using this template will show camera settings and other information about the image, so you don't get constant technical questions on the image displayed.

The Crop to Fill Template

The EXIF Metadata Template

Simple

Aptly named, this template puts a black frame around the image (the default Identity Plate will be on).

Widescreen

Sets the image to fit to a widescreen view.

The Simple Template

The Widescreen Template

Saving a Template

You can make changes to a Template, or start from scratch and make your own Templates. Simply click the "+" icon in the Template Browser panel header to start.

The New Template dialog appears. Name the Template. You can choose a folder for this template, or create a new folder from the Folder menu if required. The Template will be added to the folder when you create it.

Saving Your Slideshow

As well as saving a Template, you can make a Slideshow Collection. This saves both the images and the settings into a Module collection so the slideshow is ready to go at any time. Simply double-click on this collection to open it in Slideshow automatically.

The top of the image preview shows the current save status. In this case it's telling us the Slideshow needs to be saved. Click Create Saved Slideshow on the right or use the shortcut Command + S (Mac) or Control + S (PC).

The Create Slideshow dialog is similar to a Collection dialog. Enter a name and choose other options that are relevant to this slideshow (e.g., Set as Target Collection if you want to add more images). By default, our original Collection has been turned into a Collection Set and all the images have been moved to the Saved Slideshow within the set.

Exporting Your Slideshow

While previewing on your computer is great and using a laptop with projectors for seminars and talks works well, you may want to show your slideshow to a larger audience. You have three options: Export as PDF, JPEG, or video. The buttons for all three options are at the bottom of the Left Panel. Only two are visible at a time. You need to hold down the Option(Mac)/Alt(PC) key to convert Export PDF to Export JPEG. PDF stands for Portable Document Format, and is a common file type readable with the free Adobe Reader.

PDF

Click the Export PDF button. From the dialog, choose a name and the location for the PDF. Choose an image Quality setting (the default, 90, is excellent) and a preferred screen size from the list in Common sizes. Other allows you to enter a manual size. PDF slideshows play back at a fixed speed and don't contain music.

JPEG

Hold down the Option(Mac)/Alt(PC) key and click the Export JPEG button. This brings up a similar dialog as you saw with Export PDF. Enter your settings as required. You're saving a folder of images that will take on the name you enter here.

Video

The most recent addition to Slideshow Export is Video. Name the video and choose from the four video resolutions available: 480×270 for older phones, 640×480 for larger device screens, 720p for HD-ready devices, and 1080p for highest resolution. The files are H.264 Mpeg 4 files, with great quality with good files sizes. The frame rate on these is a fixed 29.97 frames per second.

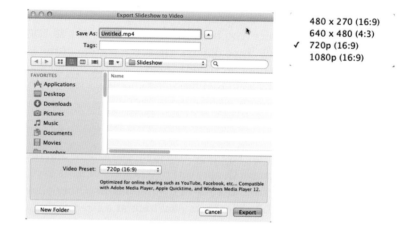

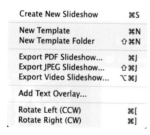

There are also shortcuts for creating these exports, visible in the Slideshow menu.

 Mac: Command + J for PDF, Shift + Command + J for JPEG, Option + Command + J for Video.

 PC: Control + J for PDF, Shift + Control + J for JPEG, Alt + Control + J for Video.

Timelapse

Timelapse is a type of video made from a sequence of still images, which are usually shot at fixed time intervals. My interest in these types of videos led to me find a way to make them quickly in Lightroom. Versions prior to Lightroom 5 had excellent support for creating timelapse videos, but Lightroom 5 doesn't have this ability. Fortunately, some of the basic functionality was returned in Lightroom 5.2.

I've created a special Template that creates a Timelapse Slideshow ready for video export. Note that you can't play a slideshow made with this template directly in Lightroom—the frame rate is simply too fast for the preview engine.

How to Get Timelapse in Lightroom

1. Get the Template for Slideshow (not for Develop) at: http://lightroom-blog.com/2013/09/17/timelapse-again-in-lightroom-5-2/

2. Unzip the Template.

3. In Slideshow, go to the Template Browser.

4. Right-click on User Templates.

5. Choose Import from the menu.

6. Create a collection of the timelapse photos in the Library.

7. Go to Slideshow.

8. Select the template from the Template Browser.

9. Click Export Video at the bottom of the Left Panel.

10. Choose what resolution you want: 720, 1080, etc., in Video Preset.

11. Choose a filename and path; then click Export.

12. That's it. Enjoy your timelapse!

Lr Timelapse

Jeffrey Friedl, the Lightroom timelapse plugin developer, created a script that allows me to create pans and zooms inside my timelapse videos. It's a bit complex, but someone built upon the concept to create a program called Lr Timelapse. It has evolved in leaps and bounds since its inception, and now includes options like pro video export, flicker removal, and all-RAW workflow. Check it out at: http://lrtimelapse.com/

If you're interested in the old script, you can find all the details at: http://regex.info/blog/2008-05-20/820

Print

The net is filled with warnings of how we're going to lose a whole generation of photos because people don't print them. For me, there's nothing like having a print in your hand or hanging on a wall. I regularly create prints for

pleasure and for sale. Whether you print from your own printer, or through a lab, a photo is only an image file until you print it.

Even now, many years after its introduction, the Print Module in Lightroom offers a superior printing experience over Photoshop's print options. Print layouts can be created and saved easily. Contact sheets can be printed from previews, so they print quickly compared to other programs. Custom layouts can be created for saving on paper costs, and for inclusion in the Book Module. All things can be saved for reuse, which makes life easier by saving time.

We'll look at the module controls first, and then examine some practical uses.

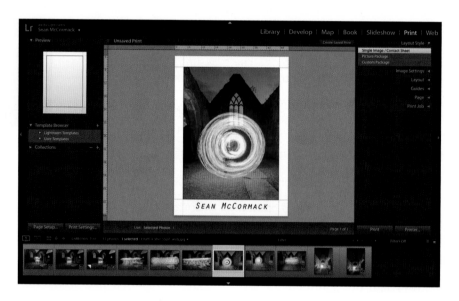

To enter the Print Module, click Print in the Module Picker, or use the shortcut Command + Option + 6 (Mac) or Control + Alt + 6 (PC). You can also choose Print from the Window menu. When you enter Print for the first time, Lightroom gives you a five-tip dialog tour of the module. You can stop these dialogs from appearing by checking the Turn Off Tips box.

The Left Panel

As with Slideshow, there are three panels in the Left Panel of Print: Preview, Template Browser, and Collections. They are similar in function to their Slideshow counterparts. At the bottom of the Panel are two buttons related to setting up pages and controlling settings for your print.

Preview

Preview shows an outline of the current layout. It updates automatically to reflect changes as you make them. Hovering over a Template with your cursor will preview the layout in the Preview window. Hovering your cursor over a Collection leaves the current Template visible and doesn't show the collection preview image.

The Template Browser

The Template Browser contains the default Lightroom Templates for Print, along with any Templates or folders for Templates you create. As mentioned, hover the cursor over a Template to preview the layout.

To make a new Template from your current settings, click the "+" in the Template Browser panel header. The New Template Dialog will appear. You can also use the shortcut Command + N (Mac) or Control + N (PC), or choose New Template from the Print menu.

Name the Template. Choose a name that reflects the contents of the layout. To put the Template in a custom folder, click the Folder menu and choose New Folder to make a new folder. The Template will appear in that folder in the browser.

The Template Browser initially contains just Lightroom Templates. These come from all three print Layout Styles. As well as being useful in their own right, these Templates serve as great starting points for your own custom layouts.

Collections

Again, Collections work identically to other Modules. Here you save Print Collections. These Print Collections will open the images in the Print Module when you double-click on them.

Page Setup

Clicking on Page Setup will open a dialog where you can select the settings for the type of paper you'll be using for the print. Select your Printer and the

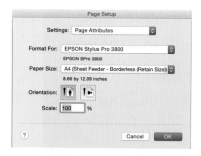

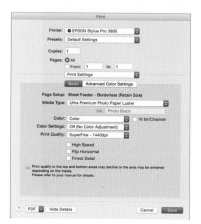

Paper. The size you choose will be what displays in Lightroom. Choose Orientation to suit your print. Lightroom will change the image preview area to match this selection. Set Scale to 100% to get as close a match to the image preview size onscreen when you print. Note that even when using this setting, some printers will still zoom in slightly for full-bleed prints.

The Fine Art Mat Template is set for vertical images. If you change this to a horizontal orientation, the gap at the bottom of the image will move to the side. You'll need to create a new template for horizontal images and to print them separately.

Print Settings

In Print Settings you go a step further than Page Setup—you choose the paper profile and color management options. We'll cover these in detail in the Print Job section.

The Right Panel and Layout Styles

As with all Modules, the settings are handled in the Right Panel. We've mentioned that Lightroom has three Layout Styles: Single Image/Contact Sheet, Picture Package, and

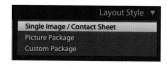

Custom Package. Single Image/Contact Sheet has a completely different set of controls than Picture and Custom Package, so we'll look at the two differing Right Panel control sets separately.

Layout Style: Single Image/Contact Sheet

This was Lightroom's original basic layout style. It's quite rigid, but really suits single-image layouts and grid-based layouts. In fact, it was once called Contact Sheet/Grid. You can create up to 15 columns and 15 rows for 225 images on a single sheet. These cells can consist of 225 different images, or one image repeated in each cell on the page. You can create grid layouts in Custom or Picture Package, but it's tedious. Single Image/Contact Sheet is perfect and speedy for these needs.

Image Settings

Image Settings contains controls that relate to how images are displayed in Single Image layout.

- Zoom to Fill: This enlarges the image to fill the image cell. It doesn't crop the image, and you can still click and drag the image to move it inside the cell.

- Rotate to Fit: This detects if the image has a different orientation to the cell. If necessary, it will turn the image in the cell so it fits better.

- Repeat One Photo Per Page: This fills all cells on a page with the same photo.

- Stroke Border: This allows you to create a border around each image. Click the swatch to bring up the color picker to choose the border color. Use the width slider to set the thickness of the stroke. The image will shrink as the width increases to contain the image and the border inside the image cell.

Layout

The Layout panel sets the design of the page. First choose your Ruler Units. The rest of the panel will update to reflect your choice. The ruler in the image preview area will also update automatically.

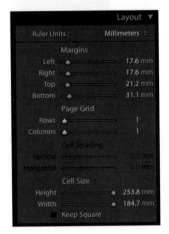

The Margins section is next. These margins set the size of the gap between the edge of the cells and the edge of the paper. Borderless prints will have their margins set to zero. This minimum setting is read from the print driver. In Guides, with Margins and Gutters turned on, you'll be able to see the margin lines on that page. These can be dragged to change the margin. As well as setting minimum margins for a borderless print, you can also set margins to create a digital matte around the photo. Leaving a larger margin at the bottom leaves room to add your Identity Plate to the layout.

Use the Page Grid sliders to set the number of rows and columns on the page—up to 15 of each. Cell Spacing sets the gap between cells, and is grayed out when there's only one cell.

Cell Size has Height and Width sliders that set the height and width of each cell. The Keep Square checkbox links the two sliders and forces the image into a square shape by cropping off the outside parts of the photo. You can still reposition the image in the cell to recenter as required.

Guides

Guides are visual aides to help you while previewing a print. Click Show Guides to turn them on. There are five Guides that can be used:

- Rulers: This turns on a rule on the left and top of the image preview area. The measurements in the ruler are set in the Layout panel.

- Page Bleed: This creates a gray border around the page showing where nothing will print. If you've set the paper to borderless, there won't be a visible page bleed.

- Margins and Gutters: This turns on lines for the page margins and cell gaps.

- Image Cells: This turns on a thin black line around the image cell. Don't confuse it with a stroke border.

- Dimensions: This displays the image cell dimensions in the top left of the cell.

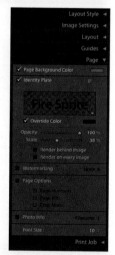

Page

Formerly the Overlays panel, this is where you modify settings that relate to the page itself rather than the layout.

Page Background Color

To apply a background color other than the default white (which is "paper white"—meaning it has no ink applied to it), check the Page Background Color box. The swatch will open the default color picker, which we've seen numerous times already. Choose your color from the color picker. This is the checkbox that ink manufacturers love. I really only use this for lab prints.

Identity Plate

Next is the Identity Plate. Click the checkbox to turn this on and then choose a rotation amount for the Identity Plate. The default is 0°, but you can choose Rotate Onscreen 90°, Rotate Onscreen 180° and Rotate Onscreen –90°.

In the Identity Plate window, click the triangle to choose an Identity Plate or create a new one. Use Override Color if you need to change the default text color to suit the image or background. Position the Identity Plate where you like. If you have Render behind image off, you can overlay the Identity Plate on top of the image. When Render behind image is on, any part of the photo can cover the Identity Plate.

To fade the text, use the Opacity slider. You can change the text size using the Scale slider, or by dragging the box makers around the Identity Plate when it is selected in the image preview area.

The final option for Identity Plate is Render on every image. This places the text in the center of every image cell.

Watermarking

As with Slideshow and Export, Watermarking places the watermark selected from the list onto each image in a print.

Page Info

There are three items that can be added to each page here: Page Numbers, Page Info, and Crop Marks.

Page Numbers places the current page number on the bottom right of the print. Page Info displays information from the Print Job panel on the bottom left of the print. This includes Sharpening amount, color profile, and the Printer information. Finally, Crop Marks prints guidelines on the page to make it easier to guillotine the page around the print.

Photo Info

Photo Info places text directly under the image cell on the page. It uses the standard Text Templates that we've seen in a few locations in Book and Slideshow. The text is included inside the Crop Marks and is considered part of the photo.

Font Size

This changes the size of the Photo Info, Page Info, and Page Number.

Print Job is next, but is shared by three layout styles, and will be covered in a dedicated section after Picture Package and Custom Package.

Layout Style: Picture Package

Print Package allows you to create custom layouts by drawing freeform cells, or by choosing individual cell sizes from the Cells panel. Picture Package was designed for pros looking to maximize the number of prints on a sheet of paper. Often clients order the same image in multiple sizes. School photography would be one example of this.

The key difference between Picture Package and Custom Package is that Picture Package can only have one photo on a page, no matter how many image cells there are. All cells will have that one photo in them, a little like Single Image with Repeat One Photo Per Page turned on. In fact, if that option were added to Custom Package, you probably could eliminate Picture Package.

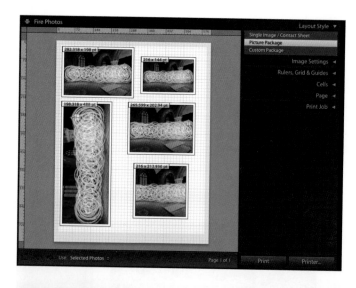

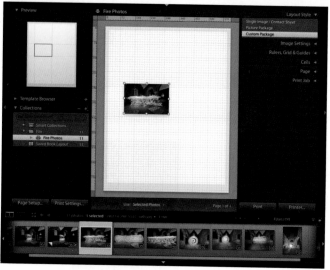

If you drag a different image onto the page to create a new cell, all the other cells will swap to the new photo. Because the panels in Picture Package and Custom Package are identical in function, we'll look at them in Custom Package since it is the more versatile of the two.

Layout Style: Custom Package

Custom Package allows you to create a layout with any amount of cells for any amount of images, in any position on the page. Obviously there's a limit from a visual point of view—you don't want the cells too small to be viewed. There are caveats to what can be done to the layout. You can't rotate a cell in an arbitrary way. There's no way to set a page bleed. Cast Shadow, a staple of other layout tools, is conspicuous in its absence. You can only have one background color on every page in the layout. Before jumping to the panels, let's look at how easy it is to start making a layout with Custom Package.

Create a Collection of images for print. To create a custom JPEG, enter Custom Package in Print. Drag an image from the Filmstrip to the page in the image preview area.

Click the cell on the page. The cell will become highlighted with eight draggable points. You can drag the cell into any rectangular shape from a long panorama to a square using these eight points. To resize the cell while retaining the current aspect ratio, hold down the Shift key as you drag a point. To change the size while keeping the center of the cell in the same location on the page, hold the Shift key and the Option(Mac) or Alt(PC) key while dragging a point. You can also fix the aspect ratio by turning on Lock to Photo Aspect Ratio in the Cells panel.

To move a cell, simply click on the cell and drag it. There are more options available by right-clicking on a cell, such as:

- Send to Back: This places the cell beneath any other cells on the page.

- Send Backwards: This sends the cell back one level. If there are three cells on a page, and you use this option on the most recently created cell, it will move it below the second most recent cell. If you think in

layers, imagine each cell has its own layer. Send Backwards would move the cell down one level.

- Send Forwards: Continuing with our layers analogy, this option moves the cell up one layer. With overlap, this would bring this image up over an overlapping cell that was created after this one.

- Send to Front: This makes the cell the topmost cell. With any overlapping, this image cell will be the one in front.

- Rotate Cell: Rotates the cell to the opposite orientation. It goes 90° counterclockwise from the original position. Doing it a second time returns it to the original position.

- Delete Cell: Deletes the cell from the page. The Delete key also does this with a selected cell, but will remove an image from the collection if no cell is selected.

- Match Photo Aspect Ratio: If you've been dragging the cell box around and have decided to you want to see the full photo, use this option to reset the cell to fit the image.

- Anchor Cell: This tells Lightroom to create this cell on all pages, with the same position, shape, and size. When on, this command toggles to Unanchor Cell. It's useful for repeating a logo or brand on each page.

To move a cell, just click it and drag it to another location on the page. To duplicate a cell, hold down Option (Mac) or Alt (PC), then click on a cell and drag the duplicate to a new location on the page. Once you've created a new cell, you can drag and drop an image from the Filmstrip to change it (in Picture Package, this would change the image in both cells). To reposition the image inside a cell, hold down Command (Mac) or Control (PC), and then click and drag the image.

Now that we've covered the basics of building a page, let's look at other panels in Custom/Picture Package.

Image Settings

While sharing a name with the Single Image/Contact Sheet panel, Image Settings here have a slightly different set of controls.

- Rotate to Fit: This detects if the image has a different orientation to the cell. It will turn the image within the cell so it fits better.

- Photo Border: This creates a white border around the image. The image will shrink as the border size increases to stay within the cell

dimensions. If you change the Page Background Color in the Page panel, the border will take on this color.

- Inner Stroke: This creates a line inside the Photo Border, with the width and color dependent on the slider and swatch settings. With Photo Border off, this can be used as a small border in the color of your choice.

Rulers, Grids, and Guides

Rulers, Grids, and Guides is similar to the Guides panel, but with different options.

Rulers Units sets the units used by the ruler and the grid. Choose from inches, centimeters, millimeters, points, or pica.

Grid Snap controls whether cells snap to the grid, to other cells (which helps line them up), or if they can be placed freely anywhere on the page.

Show Guides turns on all of the checked guides below it in the panel. These guides are:

- Rulers: These are the Rulers on the top and left of the layout.

- Page Bleed: This is the gray area around the page where no printing will happen. This is dictated by the print driver and paper you use.

- Page Grid: This shows a blue grid on the page to help with placing cells.

- Image Cells: This is a black line on the outside of a cell, visible when the cell is not selected.

- Dimensions: This shows the length and width of the cell in the top-left corner of the cell.

Guides show on the page onscreen, but are not printed.

Cells

We've seen quite a lot of Cell controls already, but there are more here. Add to Package starts with six cell sizes to choose from and place on the page with their named dimensions. If there isn't enough room on the current page, a new page is created automatically and the cells are placed there, instead. The sizes listed in these cells change with Ruler Units.

Click the triangle on the right of each Cell button to choose a different size for that button, or choose Edit to create your own custom size.

Enter the size you want and click the Add Button to make the change.

New Page creates another page in the layout. You can view up to six pages at a time. To remove all pages and cells, click Clear Layout to wipe everything and start from a fresh blank page.

While you can change the dimensions of a cell with freeform dragging of cell edges, you can also change the height and width of a selected cell using the sliders in the Cell panel. You can also click on the numbers and edit them to enter exact dimensions. If you hover the cursor over a number, the cursor changes to a finger with back and forward arrows. Click the number and drag left or right to change the dimension.

Rotate Cell will change the cell orientation, but leave the image inside unchanged.

Page

Page controls elements that are added to the layout. Page Background Color sets the color for all pages in the layout.

The Identity Plate controls are identical to those in Overlays in Single Image.

Watermarking applies a watermark preset and allows you to edit or create a new watermark.

Cut Guides lets you place lines or crop marks on the page to show where to cut the page. This is especially useful when printing several prints on one page.

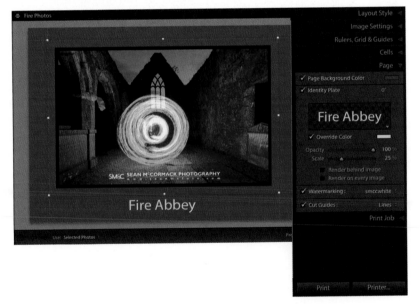

Print Job

Print Job is where you create a print or a JPEG of your layout. Both tasks have a different panel layout. Select either Printer or JPEG in the Print to: section at the top of the panel.

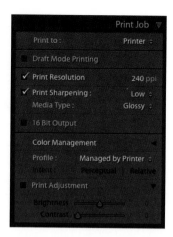

Print to Printer

The main aim of Print is creating a print. Print to Printer allows you to print to your own printer.

Draft Mode Print switches off all the other options in this panel. It makes use of the available previews instead of generating a fresh image for printing. This makes it incredibly fast, but at the expense of quality. You also lose the color management options in Print, so the colors won't be as accurate. It is good for a run of contact sheets, which would normally take a very long time to render for print. Note that the file must be available even for draft mode printing, unlike older versions of Lightroom. With Draft Mode Printing off, all the options become available.

Print Resolution sets the pixel density of the image being sent to print. Lightroom defaults to 240ppi, but print experts like Jeff Schewe recommend 360ppi for Epson, and 300ppi for HP or Canon. You can double that to the printer max of 720 for Epson and 600 for HP or Canon for optimal output. If the native resolution is lower, this may help your print, since Lightroom's method of enlarging the resolution (called upsampling) is excellent compared to that of the printer. Lightroom will automatically resample the image information to fit the resolution. How do you know what the native resolution of your print is? Divide the number of pixels of the long edge of the image by the length of the paper you're printing to (in inches). So a 6000-pixel long image printing out to 20 inches would be 300ppi (pixels per inch). If it were a 3000-pixel image going to the same 20-inch paper, this would be 150ppi, which is very low. Setting the Print Resolution to 300ppi would force Lightroom to upsample to make the image fit the 20-inch print. To use the native resolution, leave Print Resolution blank.

Print Sharpening sets the level of output sharpening for the print. Ink naturally seeps into the fibers of the paper, and blurs the image as you print. Lightroom's output sharpening automatically compensates for this, but the strength is dependent on the paper type and the amount of sharpening you prefer. The settings are based on the work of the late Bruce Fraser, a renowned color and sharpening expert (part of the Pixel Genius group with Jeff Schewe). Choose from Matte or Glossy paper. Note that Luster papers are Glossy. Choose from Low, Standard, or High for amount. If in doubt, try Standard first.

16-Bit Output is for printers that support it. Prints will take longer because the file Lightroom sends is larger, but you may see benefits in the graduated areas of your print.

Color Management is the key to getting great-looking prints. The Profile controls how the color is handled. The current Profile is set to Managed by Printer, which lets the printer do the work. There's a small disclosure triangle

that opens to reminds you to switch on the color management in the printer driver. Turn on Color Management in the printer driver, set the correct paper type, and print quality, and then hope that the printer does the right thing.

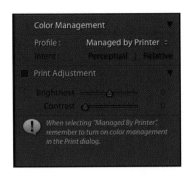

What you really need to do is let Lightroom manage the printing. Choose the correct Profile from the list to match your paper, or add it via the Other option. We've seen this before in Soft Proofing.

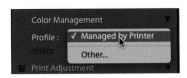

Check the profiles you want to appear in the Profile list.

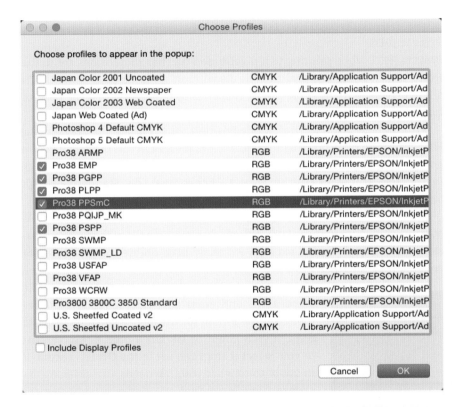

Select the Profile from the menu. Note that the warning now tells us to turn off color management in the print dialog. It also lets you know that Black Point Compensation has been switched on. This matches the black of the image to the black of the print, so it's as black as it can be (prints tend to be really dark gray rather than true black).

Like with Soft Proofing, you can change the render intent. Perceptual keeps the relationship between colors the same and generally works best for

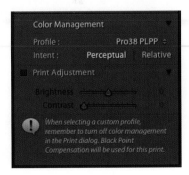

photographs. The printer will move colors until all colors fit into what it can reproduce. Relative keeps all the colors the printer can produce the same, but will change colors it can't reproduce into the nearest colors that it can.

Print Adjustment is a pair of arbitrary sliders that change the Brightness and Contrast of a print. You can't preview their effects; you simply need to print the image to find out how they look. Experiment to get the right values. In some ways, this is a dilution of the Color Management process, but if it saves time and prints, it's a function worth using.

From the bottom of the Right Panel, choose Print to make a print without seeing the Print Dialog, or press Printer... to open the Print Dialog. We'll look at the Print Dialog after Print to JPEG.

Print to JPEG

Print to JPEG, while printing to a pixel-based file, has dimensions set to the Ruler Units. Using this and the File Resolution gives us pixel dimensions should we need them. A file that is 12 inches by 8 inches with a File Resolution of 300ppi would make a 3600×2400-pixel file.

Print to JPEG also has Draft Mode Printing, which prints the Preview file. File Resolution does make a difference to the file size in this case, so if you're going to use the file for print, set the resolution to 300ppi. Print Sharpening is the same as it is for Print to: Printer. Choose from Low, Standard, or High amount, and from Matte or Glossy Paper.

JPEG Quality controls the size of the output file and the amount of JPEG compression. At maximum (100), this produces a large file with few compression artifacts. Smaller values (e.g., 90) show little difference, and are a lot smaller. For best quality, use 100.

To set a specific size on output, click Custom File Dimensions and enter that size. In Color Management, set the Profile for the device you'll be using to print. If your client or lab has a profile they've sent to you, select it from the list in the Other... option. If in doubt as to what your lab needs, use sRGB. Again, choose from Perceptual or Relative intents. Perceptual should generally be your first choice.

You can also use Print Adjustment here.

The buttons from Print to: Printer have changed to just one button: Print to File. Click this to name the folder where the files will go. The files will have this name also, in sequence.

A file created from Print to JPEG

Print Dialog

When using Print to: Printer, you have the two options at the bottom of the Right Panel: Print and Printer... As mentioned, Print will print using the last-used settings in the Print Dialog. Printer... opens the dialog to allow you to change the settings.

The main settings to change are in Print Settings. Lightroom manages color via your Profile selection, so Print Settings opens with Color Management off (as the figure shows). With Managed by Printer selected, these options are on, and you can choose one of the printer profiles.

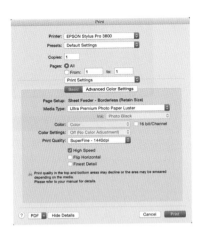

When you use a print profile in Lightroom, Color Settings are turned off automatically in the Print dialog

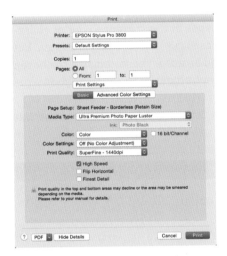

When using Managed by Printer, Color Settings are on

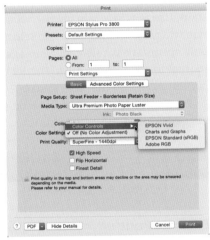

Choose a Color Settings option to suit your print when Managed by Printer

Save Your Prints

As well as using Templates to save your blank layouts, you can save layouts with the images in them.

At the top of the image preview area is the Print Header Bar. On the left we can see that this is an Unsaved Print. To save it, click the Create Print button on the right of the bar. This opens a Print collection dialog. Name the collection and place it in a Collection Set of your choice. Click Create to make the Print collection.

The new collection will appear in the Collection panel, with a small printer icon instead of the usual collection icon. Double-click on the collection to open it in Print.

The name on the Header Bar will also update automatically to match the name of the Print collection.

The Toolbar

The final piece of the Print puzzle is the Toolbar. First up is the Stop button. This returns you to the first image in the layout. The arrows let you move between pages or the six-page previews from Custom Package. As for Slideshow, Use is where you choose what images in the current folder or collection will play. Choose from All, Selected, or Flagged. If Selected is chosen, but only one image is selected, all images will be used. These can also be chosen in the Print>Content menu. Finally the right hand of the Toolbar shows the current page and the page total.

For Custom Package and the six-page layout, the Toolbar shows the six-page range and the page total.

Practical Print

This exploration of the Print panel has been reasonably practical, but it's hard to beat a few step-by-step guides to making your own layouts.

Contact Sheet

A contact sheet is a great way to show a lot of images in compact form—perfect for quick proofs and for sharing. There are four samples in the Template Browser, but we'll start from scratch.

1. Select Single Image/Contact Sheet from the Layout Styles panel.

2. Click Rotate to Fit, Zoom to Fill, and Stroke Border. Set the border to 0.2pt and Black.

3. In Layout, set both Rows and Columns to 4.

4. Set all the Margins and the Cell Spacing to 0.1 inch.

5. Use Command + N (Mac) or Control + N (PC) to make a new Template. Name it and click create. I called mine 4×4.

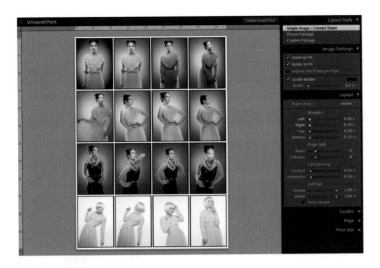

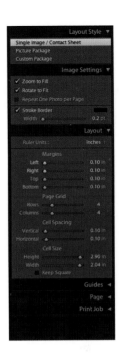

Single Image Mat

We do have a Template for this, but it doesn't hurt to make one from scratch. This template will be a horizontal one for Landscapes.

1. In Page Setup, choose Landscape orientation and your preferred page size.

2. In Layout Style, choose Single Image/Contact Sheet.

3. Click Rotate to Fit, Zoom to Fill, and Stroke Border. Set the border to 0.2 pt and Black, same as for the Contact Sheet.

4. In Layout, set the Rows and Columns to 1.

5. Set all the margins to 1 inch to start. If you have a printer that doesn't print borderless, this will overcome uneven margins, making for a nice even border.

6. Turn the Height and Width Sliders all the way up to maximize the print area. Click on the image in the cell and drag it to where it looks best.

7. This is your basic Mat, but let's go a step further. Move the Bottom Margin to 1.67 inch.

8. We can't do much in the way of text editing, but we can do a little with the Identity Plate. Open this in the Page panel. Edit the text and drag it beneath the image to fill the space created when we changed the bottom margin. Now for the cheat: scale this to 100%. Drag it to fill the width of the bottom. Now use the Scale to size it back—we've

secretly centered the text by doing this. Next, use the up and down arrows to make the text sit better in the blank space.

9. Use Command + N (Mac) or Control + N (PC) to make a new Template. Name it and click Create. I called mine Landscape Mat.

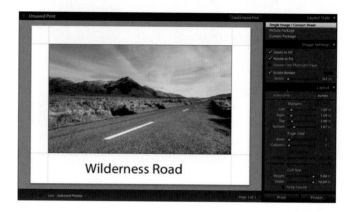

Three in One Print

Rather than stock a variety of paper sizes, often it's better to just print a series of small images on a larger sheet.

1. Select an A4 page in Page Setup—you have A4 paper, right?

2. Open Custom Package (so we can use different images on one page).

3. From the Cells panel, press the 4×6 option three times. The third image cell will appear on a new page.

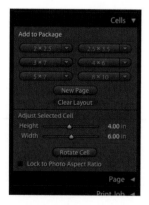

4. Right-click the cell and choose Rotate Cell. Drag the cell back to the first page. Delete the second page by clicking the "X" in the top right of the page.

5. It might seem like a good idea to leave the images on the edge of the paper, but because the pages can sometimes scale in the printer, often it's better to move the cells towards the center.

6. In Page, change the Cut Guides to Crop Marks. Save this as a template, ready for filling.

Custom Page for Book

While you can do a lot with Book, you don't have the versatility of Custom Package. The page sizes 8×10 and 10×8 are standard, but 7×7, 12×12, and 13×11 are not, so you'll need to make them as custom sizes.

1. In Page Setup, select Manage Custom Sizes from the bottom of the Paper Size List.

2. Click the "+" to add a new page size. Give it a name. Here I'm making pages for a 7×7 Book, so I call it 7×7 Book. Make the paper size 7×7, with a 0-inch Non Printable Area. We need this full bleed to suit the Book. You can also make the other two sizes if you wish.

3. Click OK to save the settings. The Paper Size will now be selected in Page Setup. Click OK again to open the page. Go to Custom package.

4. Click on a Cell triangle in the Cell panel and enter 3.5×3.5. Then click Add.

5. Press the button four times. This creates four cells on the page. Drag your photos into the cells.

6. There are two things you can do from here. One is to build your entire book layout here in Custom Print and fill the image cells, then save it as a Print. Next use Print to: JPEG to print the entire layout to JPEG. Finally, Import these images back into Lightroom, and use Auto Layout in the Book Module on a full bleed photo template to lay out the book in seconds. The other option is to make occasional designs that aren't in Book itself, but generally work in Book, where there are far better text options.

Bonus: Instagram

This square layout could also be used to create templates for Instagram. Use Print to JPEG to send the files into a Dropbox folder, where they will automatically upload to the net. On your phone, save them from that Dropbox folder into the phone's photo library and then load them into Instagram. Easy.

The Identity Plate Border

Back when Lightroom 1 came out, a few people from the Public Beta, including me and a man named Andres Noren, were asked to test out a private beta. Andreas came up with the idea that the Identity Plate doesn't have to be text. It could also be used to create borders. We tried it out and I put a border online. Next thing I know, I'm credited with its discovery! I'll take credit for first sharing presets, but not for inventing this Identity Plate concept. Anyway, it's a super cool idea, so here's how it works:

In Photoshop, open a transparent A4 page to match your print size. Make a border using one of the more exotic and messy paint brushes. Save it as a PNG. I've called this one Border1.png. Original, I know.

In the Identity Plate in Page, I choose Edit…, then select Border1.png in the Use a graphical identity section.

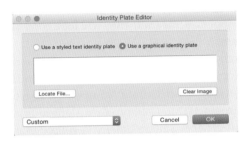

A warning will appear that the file is too big. Click Use Anyway.

Set the Identity Plate to 100% Scale. You now have a border. I confess this border is a little hasty, but you can scan old film borders and use them instead. Finally, use the Margins to move the photo around behind the border until you have it in your preferred position.

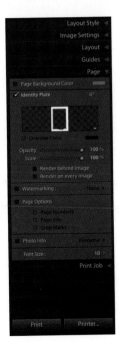

You can create loads of templates using the Print Module, so hopefully these have whetted your appetite for making more of your own. There are also many free templates online. A good selection of Print Templates for social media sharing, created by Jill Levenhagen, can be found at: http://www.flourishphotog.com/lightroom-template-index/

Web

The Web Module is where you can create galleries of your photos to put online. Even though Adobe owns Flash, Lightroom 6 has eliminated the Flash gallery in favor of HTML5 galleries, the most current web standard. Internally the preview engine has also been revised and updated to show HTML5

designs correctly. The new galleries are designed to be responsive, meaning they will look good on mobile devices.

Lightroom now ships with four different galleries, located in the Layout Styles panel on the right. These are Classic Gallery (an updated version of the Lightroom HTML Gallery), Grid Gallery (a new grid layout gallery), Square Gallery (a gallery that fills the page with square thumbnails), and Track Gallery (a version of the square gallery in which the images feature a normal crop). You can write your own plugins for Lightroom. Simply download the SDK (Software Development Kit) to learn how:

http://www.adobe.com/devnet/photoshoplightroom.html

All galleries, including third party plugins, have the same panel headers in the Right Panel. These are (in addition to Layout Style): Site Info, Color Palette, Appearance, Image Info, Output Settings, and Upload Settings. Upload Settings is separate from the galleries, and works in the same way for each plugin. We'll explore it once the galleries have been covered. Some of the galleries have matching controls in a panel—in this case, I'll describe the setting in only one panel and refer back to it from the others. I'll describe this setting in a slightly different format than the way I described the other Modules: we'll look at Web through the default galleries, upload photos, and finally, take a look at some third-party galleries, including some I've created. But first let's take a quick look at The Left Panel.

The Left Panel

A quick perusal of the Left Panel reveals a sight that is familiar by now. We have the Preview panel, which gives a preview of the gallery, or an icon for the gallery in the case of third-party galleries. It also previews a Template when you hover over one with your cursor. The Template Browser contains five folders: four for each of the Lightroom galleries, and a User Templates folder. The preview for each shows exactly how these Templates look, so it's

easier to just have a quick look than it would be for me to describe them in detail. Collections work the same way for all Modules. At the bottom of the Left Panel is the Preview in Browser button. This opens a preview copy of the gallery in your default browser (e.g., Chrome, Safari, Internet Explorer).

Classic Gallery

The Classic Gallery is the HTML5 update of the Lightroom HTML Gallery from Lightroom 1. The layout hasn't changed. To make life easier, run the panels in Solo mode using Option (Mac) or Alt (PC) + clicking on Site Info to show only that panel. All panels will remain in Solo Mode, and as you switch to different panels by clicking on their respective headers, the previous panel will close as the new one opens.

The Classic Gallery has two views—the initial grid and a larger single image view that appears when you click on a thumbnail. You can change the size of the large image, but not the thumbnails. The large image view is called the detail view.

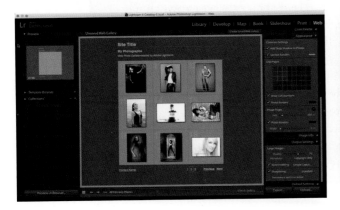
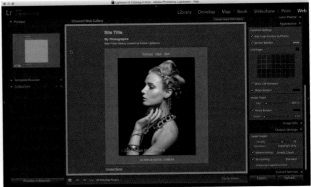

Site Info

Site Info contains the text elements for the page, and for the page header that you see in your web browser. Note that in this gallery most of the text on the page is editable directly in the image preview area. Simply click on the text and it becomes editable.

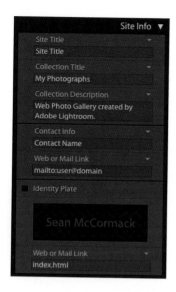

Site Title: The Site Title is the large text at the top of the gallery. It is the same text you'll see in the Page Header in the Web Browser.

Collection Title: Give the gallery a name to match the contents.

Collection Description: Write a few words about the content of the photos in the gallery.

Contact Info: This text is used for contact links. It looks a little odd if you just put in a name, so make it clear what the link is for. If it's for email, include "email" in the text; e.g., "Email Sean McCormack."

Web or Mail Link: By default, this is mailto:user@domain. The mailto: part is the email link, so replace the user@domain part with your email address. Clicking the link will open a blank email in your mail program, with the address entered automatically. For a web link, remove the mailto: part. For external websites, include the http:// part of the URL.

Identity Plate: You can add or edit the Identity Plate here. It appears on the top of the page, above the Site Info. You can have the Identity Plate link to either email or a web page from the field below it, exactly the same as with the Contact Web or Mail Link.

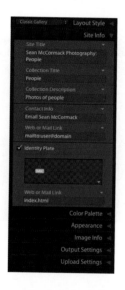

The figure above shows the entered settings. The logo looks funny on the gray, but we'll be changing the colors next! If you look at any of the text fields, notice that there's a little triangle beside them. Clicking this triangle will show previously entered text for the field.

Color Palette

The Color Palette is where you change the colors in the gallery.

Clicking on any swatch brings up the standard color picker. If you have specific web colors to enter from your designer, click the HEX button on the bottom right and enter them there.

Text: This changes the text color on the grid page, and the same text on the detail page.

Detail Text: This changes the text that appears with the image on the detail page; for example, the Previous, Index, and Next text. Click a thumbnail to view the detail page and see this change.

Background: This changes the color of the background.

Detail Matte: There is a block of color that surrounds the image on the detail page. This setting changes its color.

Cells: This changes the color of the border around a thumbnail image.

Rollover: When you hover the cursor over a thumbnail, it will temporarily change the color of the image border set in the Cells.

Grid Lines: This changes the lines around, above, and below the image cells.

Numbers: This changes the color of the numbers in each cells. You can turn the numbers off in the Appearance panel, but matching the color to the background effectively switches them off, as well.

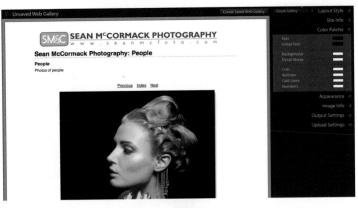

Here I've gone for a simple white background and black text view of the photos

Appearance

Appearance controls both the Grid Page and the Detail Page. The settings for each are only visible on that page. Lightroom warns you of this in the panel. When showing the grid, an exclamation mark in a circle appears beside the Image Pages section. When in the detail page, this warning icon is beside the grid icon in Grid Pages. I've highlighted it in red on Image Pages with the Grid Page active below.

Add Drop Shadows to Photos creates a fake shadow under both the thumbnails and the large images. Section Borders removes the lines over and under the image and thumbnails. It also changes the page size. You can change the color of these lines using the swatch.

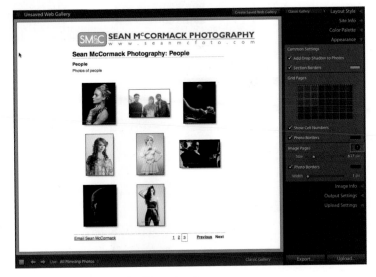

Most of the options are checkboxes here!

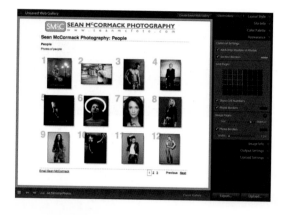

The Grid Pages grid controls the layout out of the thumbnails. You can go from three rows and columns to five rows and eight columns. The page will update when you click on the grid with a new setting. Just hover the cursor over the bottom-right tile that matches the number of rows and columns you'd prefer.

Show Cell Numbers is next. You can turn on or off the numbers from here. I've changed the color to gray in the Color Palette to show that this is working. Photo Borders places a stroke on the outside on the thumbnails. Change the border color using the swatch.

Image Pages have two options: Size and Photo Borders. Click on a thumbnail to view the changes. Change the size with the slider, and the Photo Border color and size using the swatch and slider.

Keeping with the simple black-on-white theme, I've turned off Cell Numbers, and gone for black Photo Borders.

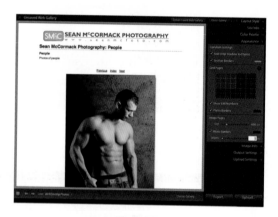

Image Info

Image Info places two sets of text on the image page for this gallery. The Title text is over the image, and the Caption is under the image. These aren't strictly the Title or Caption from the image metadata; they can be anything from the Text Template editor. Use a preset from the dropdown menu, or use Custom Text. Remember that Custom Text will appear on all images, so use metadata fields to get individual text on each image.

Output Settings

Output Settings control aspects of the image files that get exported as part of the gallery—specifically the Large Images in the gallery.

Quality sets the level of compression. The default (70) is a good balance of size and compression. If you want better quality, increase it. If you want the gallery to load faster, decrease it.

Metadata controls what gets added to the exported files. Choose between All or Copyright Only. Watermarking is the standard preset and edit option we've seen throughout the Modules. Finally, choose one of the three options (Low, Standard, and High) in Sharpening to set a level of output sharpening. This sharpening is not applied to the previews in Web.

Grid Gallery

Grid Gallery is a simpler and prettier gallery than the Classic Gallery. Rather than a detail page, it uses a popup Lightbox to show the large images. You can navigate the images using the arrows at the bottom, or click the "X" icon to return to the grid. As you click the arrow icons, the image fades out before the next one quickly fades in. Unlike Classic Gallery, you have to edit text in the panels.

Changing Gallery Warning

If you change to a different gallery in Layout Styles, all of your settings will be lost. Save the Gallery in the Header bar by pressing Create Saved Web Gallery (or Command + S for Mac, or Control + S for PC). Alternatively, make a Template in the Template Browser (or use shortcut Command + N for Mac, or Control + N for PC).

Site Info

There are three text fields in Site Info: Gallery Title, Gallery Author, and Gallery Author URL. Gallery Title text appears in bold in the gallery header. When you add a Gallery Author, the text displays as the name prefixed with "by" to take the form **Lightroom Gallery** by Gallery Author.

When you add a Gallery Author URL, the "by Gallery Author" text becomes a link to that URL.

Color Palette

The Color Palette is far more limited in this gallery. You can change the color of the Background, the Text, the Icons, and the Thumbnail Border. Again, this uses the standard color picker. The Icons are visible on the single images page.

Appearance

The Appearance panel controls aspects of the Thumbnails, the pagination, and the Header.

Thumbnail Size: This sets the size of each thumbnail. Choose from Small, Medium, and Large. The thumbnails will reflow to fit the page as you change their size.

Thumbnail Border Thickness: Choose the size of the thumbnail border. The scale goes from zero (no border) to five. Even at five, it's not a large border.

Thumbnail Shadows: Choose from None, Dark, or Light Shadows.

Pagination Style: This controls whether the thumbnails show on one page or on multiple pages. The next setting, Items Per Page, is active when Multiple Pages is selected. The pages can be navigated via the pagination icons in the header.

Items Per Page: With this, you can choose the number of images on a page with Multiple Pages selected. Choose from 5, 10, 15, 20, 25, or 30 images. If there are a lot of images, use more than one page to reduce the load time.

Show Header: This shows the header containing the text created in the Site Info panel.

Floating Header: The header can sit at the top of the page and move up when the page moves up, or it can stay at the top of the page with the images

scrolling under it as you page down. Floating Header mode is when it remains on top despite the scrolling of images.

Image Info

The Image Info panel is identical to that of the same panel in the Classic Gallery. The Title floats on the bottom of the image, and the Caption sits below it.

The Floating header with images scrolling underneath. Note the pagination icons in the header.

Output Settings

These are the same as those in the Classic Gallery.

Square Gallery

Square Gallery forces all thumbnail images into a square shape by cropping into the center of the photo. Vertical images will have the top and bottom cropped, while horizontal images have the sides cropped. Click on a thumbnail to open the main image. The main image will display in the same Lightbox as the Grid Gallery. The left and right arrow icons that appear when you hover over the left and right of the page are in a square compared to the circle of Grid, on this page.

387

Site Info

Site info is almost identical to that of the Grid Gallery, with one additional field: Extra Info. Fill in the Gallery Title, Gallery Author, and Gallery Author URL. In this case, the Gallery Author appears below the Gallery Title rather than beside it like it would in Grid. Extra Info appears on the right of the page.

Color Palette

The Color Palette is quite minimal. You can use it to change the Background and Text colors for all pages, as well as the color of the Icons that appear with the main image (the Arrows and the "X" to close the main page and return to the thumbnails).

Appearance

The Appearance panel in Square is smaller than the one in the Grid gallery. You can choose from Small, Medium, and Large thumbnails; and whether the thumbnails appear all at once, or as you scroll.

The two Header options, Show Header and Floating Header, are the same as they are in Grid.

Image Info

This is identical to that of the Classic and Grid galleries.

Output Settings

This is identical to that of the Classic and Grid galleries, though Quality is set to 75.

Track Gallery

This looks like a version of the Square gallery, but with the thumbnails not cropped.

Site Info

This is identical to the Site Info panel in the Grid gallery.

Color Palette

This is the same as the Color Palette in the Square Gallery.

Appearance

This is where you can set the height of the row in the track, from 100 to 400 pixels high. You can also set the size of the gap between rows. Choose from None, Small, Medium, and Large. Thumbnail Loading allows you to choose whether the thumbnails appear all at once, or as you scroll.

Finally, the Header options are the same as those in the Classic and Grid galleries.

Image Info

This is identical to that of the Classic, Grid, and Square galleries.

Output Settings

This is identical to that of the Classic, Grid, and Square galleries, though Quality is set to 80 by default.

Upload Settings

The Upload Settings Dialog is common to all plugins, both Lightroom and third-party. Here you can set up FTP to upload your files to your website. FTP stands for File Transfer Protocol, and is a common way to get files online. Before you start, you need to get the FTP settings from your host, or use your admin panel to set up an FTP account. This is different for different hosts, so not something that can be covered here.

When you have this information, go to FTP Server and choose Edit.

Fill in the information from your site. The server will be in the form ftp.yoursitename.com, with your FTP Username and Password next. You can choose to save the password in the preset, but remember that it's stored in plain text and people can find it if they know where to look.

Server Path is the the top-level folder where files go on the server. This could be a specific folder called www or public_html, for example. The Put in Subfolder field in the Upload Settings dialog will let you place files in folders below this, so you only need the main folder location. On my server, it's public_html. Set the Protocal next, choosing from FTP or SFTP, which is a more secure form of FTP. Your host will tell you which one. Next is Port. The default is 21—only change this if you've been told it's different. Finally choose the Passive mode your server needs. Passive is the most common, but mine happens to be Not Passive. The other option is Enhanced Passive.

When you've entered these settings, go back to the Preset menu and choose Save Current Settings as New Preset. Enter a suitable name and click Create.

This Preset will now be selected in the FTP Server list. When you click Upload, Lightroom will create a temporary copy of the gallery and use these FTP settings to upload the entire gallery before deleting the temporary copy. Remember to add the Subfolder if you need it. Below the Put In Subfolder section is the Full Path, which shows where the files will go.

Click Upload to get the files online. You'll see the Progress Bar in the Module Picker over the Identity Plate.

Finally you can create a version of the gallery on your computer. Use Export instead of Upload for this. You can also use Export if you want to use your own FTP program like Filezilla or Transmit.

The Toolbar

The Toolbar in Web is similar to the Toolbar in Slideshow or Print. First up is the Stop button. This reloads the current gallery. The arrows let you move images in the Filmstrip. Use allows you to choose what images in the current

folder or collection will play. Choose from All, Selected, or Flagged. If Selected is chosen, and only one image is selected, just this image will show. Images can also be chosen in the Web>Content menu. Finally, the right hand of the Toolbar shows the current Layout Style.

Third-Party Plugins

Besides the galleries that ship with Lightroom, there are many far more versatile verions of galleries from third parties (including me). I'll show two that I've created to make whole websites, and some others from direct competitors. The purpose of this information is to show you what's available—not simply for self-promotion.

LRB Portfolio

LRB is short for Lightroom Blog, which is my blog about Lightroom. I have a series of products available under the LRB banner. Chief among them is LRB Portfolio. LRB Portfolio is a complete website in a plugin. Generally Web plugins are placed manually in a folder in the Lightroom presets folder, but like many that are sold through Photographers-Toolbox.com, they run through the Plugin Manager in the File Menu. This means it can update automatically and can be installed and removed easily.

The plugin allows you to create a full website with up to seven galleries with a maximum of 5000 images. The galleries are side-scrolling galleries. This scrolling can be manual or controlled by hovering the mouse at the edges of the gallery.

You can also have a homepage, an about page, and a contact page. The homepage can be a gallery, a gallery link page, or a dedicated single image homepage. In addition, you can have two custom pages for information like pricing, etc. You can also embed an external page, like a blog, on one of these custom pages.

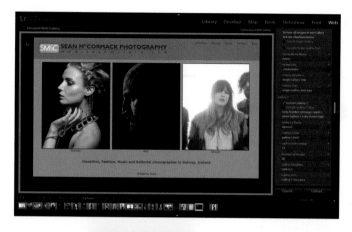

There's a huge amount of customization and plenty of free templates available from the website.

To get a trial of the plugin, go to: http://photographers-toolbox.com/products/smccormack/lrbportfolio/ (Or use the shortlink: http://bit.ly/LrbPort). There's a user guide available there, as well as promo and tutorial videos.

LRB Exhibition

This is another of my plugins that creates a full website. The features are similar to LRB Portfolio, but the galleries are all single-image views. As well as using arrows to slide to the next photo, you can turn on a slideshow feature that will automatically move from slide to slide continuously.

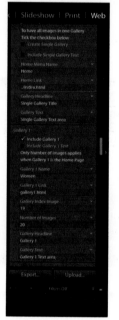

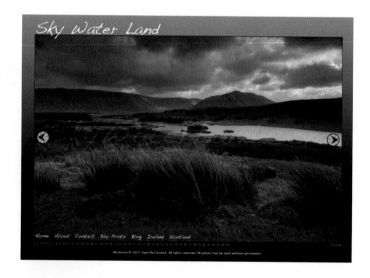

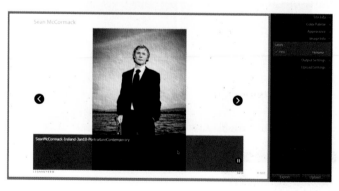

For the galleries, you can show numbers under the slides to allow you to more easily jump to any photo. You can also show the current image number out of the total number of slides under the photo (e.g., 27 of 45). You can also turn on a transparent text section that appears when you hover the cursor over a photo.

Again, there's a lot of customization available. The colors, arrows, and play/pause icons can all be changed.

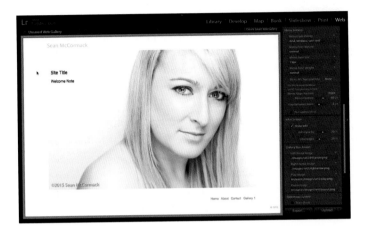

You can download a trial at:
http://photographers-toolbox.com/products/smccormack/lrbexhibition/

TTG Client Response Gallery

The Turning Gate is a site by my friend, Lightroom web expert Matthew Campagna. Matthew is based in Korea, but studied photography at the Brooks Institute. Even though technically we're competitors, we've often shared code and our frustrations of working within the Lightroom SDK framework. TTG has a whole series of building blocks using a Core Engine design, including a Client Response Gallery.

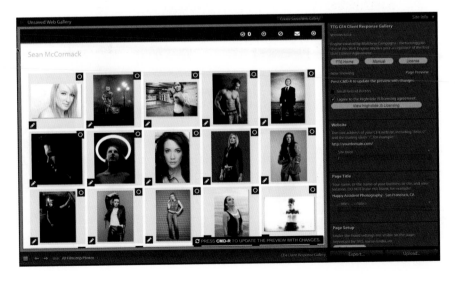

I've been using versions of this gallery since it began in a different form. This plugin allows the photographer to post a shoot online so the client can view the images and make selections and suggestions. This information is emailed back to the photographer via an online form. The filename list can be copied and pasted into the Text Filter Bar, or into a Smart Collection to gather the selections quickly, easily, and correctly.

See it online at:
http://shop.theturninggate.net/collections/ce4/products/crg

TTG Auto Index Gallery

This isn't really a gallery plugin per se; it's more of a gallery curator. All TTG plugins (and some other plugins, including some of mine) contain auto index information. Using this information, the Auto Index plugin will automatically populate a page with gallery links. This way, you only need to upload new galleries and the page will automatically update to show them. A nice bit of internet magic. This plugin is available at:
http://shop.theturninggate.net/collections/all/products/auto-index

Jigsawrus Gallery

Photographers-Toolbox.com was originally only for plugins from Timothy Armes. Tim has a whole range of metadata plugins, as well as some for web.

Jigsawrus uses javascript to automatically pull together images into a block layout. Images fit together like a jigsaw, and the layout will change as the page is made larger or smaller. Clicking on a thumbnail will expand a lightbox view of the image. It's compatible with the TTG Auto Index gallery plugin.

Lightroom Mobile, Web, and Creative Cloud

8

The future of computing is ever more mobile. With iPad and Android tablets taking the place of laptops in peoples' lives, it was inevitable that Adobe would introduce a version of Lightroom suited to these devices. Lightroom mobile debuted for the iPad in January 2015, followed swiftly by versions for the iPhone, then Android phones, and finally, Android tablets.

Lightroom mobile is specifically designed for these tablets. Barring the Surface 3 from Microsoft, no tablet is really capable of running the desktop version of Lightroom, so they require a dedicated tablet application. Even the original Lightroom beta was missing tools like Crop, so these mobile applications will definitely improve as more features get added.

So what is the purpose of Lightroom mobile? It's all about the couch. It's about getting things done in your down time, feet up at the TV; or on a plane; or even in the bath (use a waterproof case!). It's about play—using presets or sliders to give rough ideas of what our processing could be. It's about applying basic adjustments to let us know if an image might be worth keeping, even with a little exposure error on our part.

It's also about touch—using your fingers to make changes, set ratings or flags, or even just swiping to show off your images. It's about taking the feeling of being stuck at a computer out of your photographic process. For a first version, Lightroom mobile is surprisingly useful when you get past the current limitations.

Lightroom mobile has another online brother: Lightroom web. Any photos sent to Lightroom mobile show up here. You can choose to share some of these images with others, and even get likes and comments.

Lightroom CC (Creative Cloud) is what makes it all possible. Users with a Lightroom 6 Perpetual license get a 30-day trial of Lightroom mobile. Lightroom CC is part of the Photographers Bundle, which includes Photoshop CC for $9.99 a month. We'll talk more about Lightroom CC later. For now, let's take a closer look at Lightroom mobile.

Lightroom Mobile

Download Lightroom mobile from the App Store or the Google Play Store. It's free on both. On iPad or iPhone, you'll need iOS7, so the original iPad is out. You can use iPad 2 and newer, iPhone 4s and newer, and the 5th generation iPod Touch. For Android, the app is a little more exacting. It needs a device with a Quadcore 1.7Ghz ARMv7 with 1GB Ram and 8GB of storage. For the OS, you need at least 4.1.x, but newer is better. In terms of features, the iPad version currently has more, but additional features are becoming available on other devices with each update.

Before we begin, I'm going to be really clear about something: Lightroom mobile is a subscription product, so it's not subject to the restricted updates that Lightroom desktop has. It's in rapid development and will gain new features quickly. For this reason, the screenshots here will soon be dated. With this chapter, I'm aiming to get you up and running on Lightroom mobile, and new features that come out after this book is published will be an added bonus for you.

Getting Mobile

Before you play on your mobile device, you need to get set up on the desktop. (By desktop, I'm really referring to any machine running the full version of Lightroom, desktop or laptop).

Lightroom mobile can sync with one catalog at a time, and will delete all previous information each time it gets synced to a new catalog. Because of the time-consuming nature of sync, this translates to one thing: only use one main catalog with Lightroom mobile.

When you run Lightroom desktop for the first time, you'll see a dialog box asking if you want to turn on sync for all new collections. This dialog appears by default.

Personally, I'd turn this off. Syncing everything in every collection takes a lot of time to complete, and you do have limited space on your mobile device.

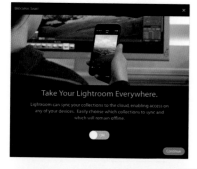

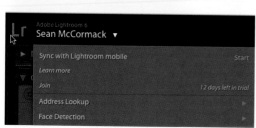

Once you're in Lightroom, the Lightroom mobile Identity Plate will be the default. Click on this to open the Activity Monitor. At the top of the Activity Monitor is the Sync with Lightroom mobile option. Press Start to begin. Because you sign in with an Adobe ID when you install Lightroom 6 and CC, Lightroom uses this ID to sign into Lightroom mobile automatically.

Lightroom mobile works from Collections. We've talked about Sync Collections already, but let's refresh your memory. Once

you're signed into Lightroom mobile, a small square becomes visible on the left of each Collection in the Collections panel.

Click this square to turn the Collection into a Sync Collection. The photos will start to sync to Lightroom mobile immediately.

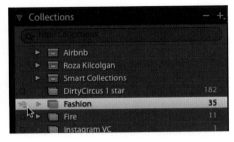

A bezel will flash letting you know that the Collection is syncing.

The Progress Bar will let you know how the sync is going, as will the Activity Monitor.

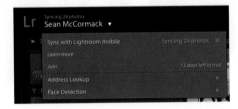

Smart Mobile With Smart Previews

Lightroom doesn't upload your original photo files; it loads Smart Preview versions of them. This gives full access to the controls and allows Lightroom to sync settings back to the desktop easily. Smart Previews also take up much less space, allowing you to have even more images on the device.

Signing In

Images will be loaded onto the server. Once there, they will sync to any devices you have connected. So, let's connect a device. The process is the same for all devices. The main difference between Lightroom mobile for each device is in the number of features. The iPad has the most features, and Android has the least, but both are constantly getting new features, so the Android version is never too far behind.

Not So Smart

You can't sync Smart Collections, but you can select all the photos currently in a Smart Collection and use them to create an ordinary collection. You might also have videos in a synced collection, but Lightroom mobile won't use them. They still count in the total number of files in a collection, however, so they can make Lightroom mobile look like it hasn't synced all the files when in fact it has.

Sync "Fashion" with Lightroom mobile

Start the Lightroom mobile app. You'll be greeted with the startup screen. The background image of this screen will change each time.

You'll be greeted by the sign-in window. Enter your details to begin.

Once signed in to Lightroom mobile, you'll see the Checking Collections pages. The amount of time this takes to load depends on the number of collections you have and your connection speed.

If you've signed in before syncing from Lightroom, you'll see a screen telling you there are no collections, and that you need to enable sync in Lightroom.

Otherwise, you'll see the collections you have synced. So far there's only been one collection synced, so this shows up at the top of the page.

Adding Photos

Initially, you'll also see a screen asking if you want to automatically add your camera roll photos to Lightroom mobile. Using this feature means that your photos automatically get backed up to Lightroom. It also means they take up twice as much room on the device.

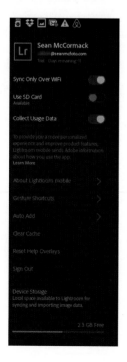

Preferences

Before we jump into the collection and start to play with the tools Lightroom mobile provides, let's look at some of the other features on the Android version. On the top left is the Lightroom icon. When tapped, this icon opens up the preferences menu.

Information about your account will be on top. If you're running the trial version, you'll see the number of days left in your trial. The first preference is Sync Only Over Wifi. If you have limited bandwidth on your data plan, or pay by the MB, I'd definitely leave this off. Coming home from a foreign vacation with $10,000 of Lightroom mobile sync costs is not what you want!

Next is an Android-only preference: Use SD Card. This allows you to move the app and the images to your SD card, so you can fit more images if necessary. Just remember that you'll

lose that capability when you remove the card from your device! Clicking this preference brings up a Change Storage Location dialog.

Using a 32GB card jumped my storage from 2.3GB to 26.3GB. Moving Lightroom mobile to the card rendered the shortcut on my main screen obsolete, so I had to create a new shortcut from the new version of the app from the Apps menu.

The next option, Collect Usage Data, allows Adobe to collect anonymous data about how you use Lightroom mobile to help improve it even more. Below the option name is text explaining what is being collected. Clicking Learn More will direct you to this page: http://www.adobe.com/products/lightroom-mobile/product-improvement-program.html.

About Lightroom mobile will open a list of credits for those who worked on the project. The top-left icon will be a left arrow. Click this to go back to preferences.

Next you'll see the Gesture Shortcuts, which explain how to use the software. Because the screenshot text is small, I'll go through them all in depth.

To toggle information overlays throughout the app, use a two-fingered tap. In Loupe (where you've zoomed into an image), swipe up for Pick, or down for Reject. For a Before/After view, do a three-fingered tap. Double-click on a tile or slider to reset them when making adjustments. To see a clipping mask, use two fingers to swipe a slider. In Crop, do a two-fingered tap to toggle between different overlays. Finally, to reset a crop, double tap the frame.

Auto Add is next. This sets the type of files Lightroom can add when you're importing from the device. There are two options: the first one is for JPEG, PNG, or BMP files; the second is for DNG files. Lightroom mobile can import DNG files if the device creates them. Both options are on by default.

Clear Cache empties the image cache to clear space on the device. This removes all the Smart Previews (except those downloaded for offline editing—we'll cover that shortly). Filling the cache is dependent on you being connected online.

Reset Help Overlays turns back on any help overlays you may have switched off as you browsed the app.

The last option is Sign Out, which logs you out of Lightroom mobile. Under Sign Out is a little bar letting you know how much space you have remaining on the device for images.

The iPad has some additional Preferences. The first one is Show Touch Gestures. This creates a red circle under your fingers when you tap the screen, letting you know the touch has been registered.

The second difference is the Share with Metadata option. Clicking this brings up the options page. With Share with Metadata turned off, all other options are grayed out. With it on, you can choose to include Caption, Camera & Camera Raw Info, and Location Info. Copyright info is always included.

Just to be awkward, the iPad's Touch Gestures have the same functions, but the locations are swapped: the gesture is first, and the action second, versus the Android app, which features the action first and the gesture second.

Mobile Collection Options

Now that we've looked at the Preferences and seen how to use the touch gestures, click the Lightroom icon to leave Preferences. With the single collection we have, take a look at the bottom of the collection cover photos. There is an icon there with three dots. Tap this icon. The cover photo will flip over to reveal a menu. Here are some details on each option in the menu:

Add from Camera Roll

This opens the camera roll on the device.

Simply tap each photo you want to add to the collection, and then tap the checkbox icon on the top-right of the screen to add them.

Tap Add from Camera at the top center of the screen to access more places from which to load images. The options depend on what apps are on the device.

Enable Auto Add

This opens a dialog box that allows you to add all new photos from the camera roll to this collection in Lightroom mobile. It contains a reminder that all photos are private until you share them. With all the security scandals in the news these days, I personally would only add images I definitely want online, and leave this option off. (Not that I shoot celebrity nudes!) This is the same option that you get the first time you run Lightroom mobile.

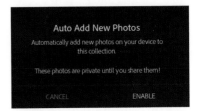

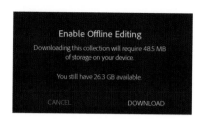

Enable Offline Editing

If you want to work on any photos in Lightroom mobile in a situation where you have no, or poor, internet access, you need to tap this option to download the images to Lightroom mobile while still in an area with good net access.

The dialog tells you how large the download is, and how much space you have left on the device. Once downloaded, the Collection cover photo will have a cloud icon with a down arrow, indicating it has offline editing enabled.

Share Collection

This opens the Share Collection dialog and offers further options. The dialog lets you know the collection is private until shared, and once shared, anyone with the link can access it.

Click Share to share the Collection. The Collection will now be listed as public. You can use Share Link to open an app page that lets you paste the link into a chosen App. Once shared, the Collection cover photo will have a globe icon in the top right.

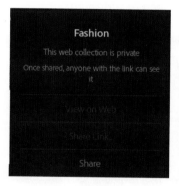
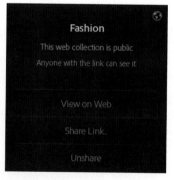

You can also View on Web, which will open the collection in a browser. We'll talk about Lightroom web shortly.

Rename

This opens a dialog allowing you to rename the Collection.

Remove

Remove opens a dialog that allows you to remove the Collection from your device, but not from Lightroom.

Present

This plays a slideshow of the images in the Collection. It's useful if you want to show photos to people, but don't want them accidentally changing your ratings or flags.

Fortunately the process of using Lightroom mobile is fairly straightforward. It's time to jump in deeper, by first looking at the Grid view and the tools associated with it, and then looking at Loupe view and the Lightroom mobile processing tools. But before that, I will quickly mention three last items in the Collections view. First, tapping the top center of the page will bring up a sort options menu. You can sort collections by Import Date, Title, Size (how much space the Collection takes on the device), and Status (whether they're available for offline editing or not). Next is the cloud icon. This lets you know the state of syncing. Generally it will be white and display Up to Date when tapped. It can also be orange, with a pause icon, letting you know there's an issue—for example, the device is almost full and can't be synced. Finally, tapping the "+" icon will let you create a new Collection.

Grid View

Tap in the center of a Collection cover photo to open the Grid view of the Collection. If the Help Overlays are on, you'll get a tip on using the two-finger tap to show information.

Tap anywhere on the screen to hide this tip. The main Grid view will be available.

Grid view shows a view akin to the Track gallery in Lightroom's Web Module. All images are equal height. At the top, you'll see the back arrow to go to Collections view. Tap the Collection name to bring up the Filter and Sort options. You can filter by Flag or Star Rating, or any combination of the two,

including more than one Flag setting; exactly the same as in Lightroom. Tapping All will return you to viewing the entire Collection. You can also sort by Capture Time, Modified Date, Filename, and Custom Order (from Lightroom). Tapping a sort option a second time reverses the sort order. This applies to the sort in Collections view also.

On iOS, you also get the choice between the normal Flat layout and a Segmented layout that sorts the collection into sets of photos by date.

Tap the number (+26 in this segment) to expand it.

The cloud icon for syncing, which we've discussed, is also at the top, as are the numerous Sharing options. Let's have a look at them. Tap the box with the up arrow to open the menu.

The Share options open a white version of the Grid, where you tap an image to select it. The process is the same for most options, so we'll just show it for the first one: Save to Gallery.

Save to Gallery

Save to Gallery opens a white-bordered version of Grid. Tap an image to include it in a selection. The total number of select photos will appear in parentheses beside the command title at the top center. For Save to Gallery, it's in the form: Save from Collection.

Tap the check mark on the top right of the window to save the images. The cloud icon will change to an icon with a series of flashing dots as the images download to a new folder in your phone's Gallery called "Adobe Lightroom."

Share

Share opens another selection Grid. Select your images and tap the checkbox at the top left. The images will download and an app selection window will open asking you to choose an app to complete the sharing action.

Web Collection Sharing

Web Collection Sharing opens up an identical dialog to the one we've already seen in the Share Collection section.

Add Photos...

This opens a similar dialog to Add from Camera Roll. It allows you to add photos from the device.

Copy To...

Copy to... opens a selection grid. Select the images and click the Next arrow on the top right to open a window of other collections. Create a new Collection if needed, or add to an existing Collection.

Move To...

The Move to... option is almost identical to the to... option. The difference is that with Move to..., the image will be removed from the current collection after being copied to the selected one.

Remove

Remove opens a selection Grid. Select images to remove, then click the trash-can on the top right to remove.

Slideshow

Just like Present, Slideshow plays a slideshow of images. You can move from image to image with a single finger swipe. A two-finger swipe will trigger the automatic image-to-image transition. To access transition options, tap the image area to have a floating header drop down. From this, choose your transition type from None, Crossfade, Wipe, and Flip. Choose the Slide Duration using the slider. The range goes from 2.0 seconds to 15.0 seconds in 0.1 second intervals.

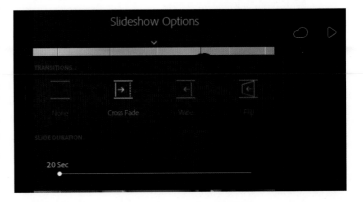

Tap Tap Tap

Doing a two-finger tap on the Grid will add information to the thumbnails. The first tap adds exposure information, the second changes to capture date, file dimensions, and file name. A third tap will turn off metadata info.

Loupe View

Tap an image in the Grid to go to Loupe view. Once in Loupe view, tapping the image will zoom it to fit the screen, hiding the interface. Tap again to see the controls over the image. You'll see the back arrow (to go back to Grid), the cloud icon (for sync information), and the sharing controls. These controls match their counterparts in Grid; there are just fewer of them. Slideshow is replaced with Play from Here, which starts a slideshow with the current image as the first image.

Double tapping will zoom in and out of the image. Two-finger tapping will cycle through the metadata overlays: Exif & Histogram, Exif only, and Histogram only.

The main tools for working with your photo are at the bottom of the image. We'll take a look at them in order of appearance from left to right.

Flagging

As with the desktop version of Lightroom, Flags have three possible states; Pick, Unflagged, or Reject. By default all images are Unflagged. First make sure Flags are highlighted. Swipe up on the image to make it a Pick, or swipe down to reject it. Swipe to the next image to leave it Unflagged. If the image is already a Pick, swipe down to change it to Unflagged or Reject. If it's a Reject and you want to change this, swipe up. Once changed, the Flag icon on the bottom will update to reflect the new status.

Star Ratings

Again, matching the desktop, you can have 0-5 stars on an image, with zero being the default. As with Flags, tap the Star Ratings icon to activate it (it's on Flags by default).

Swipe up to bump the rating upward, or down to change it downward.

Filmstrip

Tapping the Filmstrip icon will add the familiar row of images from the desktop version of Lightroom to the bottom of the mobile version. Swipe left or right on the filmstrip to see other images. Tap on an image to open it in Loupe.

Crop

Tap the Crop icon to start cropping an image. The Crop overlay showing the basic rule of thirds will appear. You can change this overlay to the Golden Ratio and the Grid overlay using a two-fingered tap. The preset Crop ratios are underneath the image. You can also choose a Free aspect ratio, and then swipe around the image to set the crop.

To show the options and the three overlays, see the following three screenshots:

The ratios available are 1×1, 4×5, 8.5×11, 5×7, 2×3, 3×4 and 9×16, as well as Free. Rotate lets you rotate the image 90°. Keep tapping until you get to the angle you need. Flip Hor gives a mirror-image flip, whereas Flip Ver gives the vertical swap, turning the image upside down. Centered fixes the Crop around the center of the image.

Presets

Next is the icon (three overlapping circles) for the built-in Presets. Note that as of now, you can't add your own presets in the mobile app. Tap the icon to

see a list of available Preset types under the image. They're split into different groups: Creative, Color, B&W, Detail, and Effect. You also have the option to use the Previous preset or Reset the image. The number with the name indicates the number of presets in the list.

Tapping on any of the names will bring up a menu with the name of each Preset and a preview of the effect. The best way to find out what each preset does is to try it on an image. Tap the Preset to apply it. Tap the group name to close the menu down.

Creative: Contains toning effects like Sepia Toning and Cross Processing.

Color: Has contrast and color temperature Presets.

B&W: Has a range of black-and-white Presets with varying contrast, and some Film emulations.

Detail: This has Clarity and Noise Reduction Presets.

Previous: Tap this to choose between copying the Basic Tones or everything from a previous image.

Reset: This lets you reset an image back to some set states, including when you opened the file in Lightroom mobile, when you imported the file, the Basic Tones, or everything. The first two of these options are not available until you apply settings to an image.

Tapping a Preset will overwrite a previous one.

Adjustments

Adjustments is the last of the four central icons, and it opens the equivalent of Develop in Lightroom mobile. Tap this to bring up some familiar tools from the desktop. For this section, I added an additional image to the Fashion Collection. The new image synced immediately.

Color Perfection

Tablets and phones do not have color calibration, so the color will never be as accurate as your desktop screen. This is a deal breaker for some people. Companies like X-Rite have products that can offer some calibration, but Lightroom mobile doesn't support them. Compare what you see on your device to the computer screen and make a decision on how much you can trust it.

White Balance: Tap this to bring up a selection of White Balance presets with preview icons.

As well as the presets, there's also a Selector tool to manually change white balance. Tap Selector to show this tool, which is circular with a checkmark on the top right. Move this tool around, aiming the tiny central circle at a gray area in the image. The image will update as you drag the tool to different locations on the image. To accept a value, tap the checkmark. To cancel, tap away from the selector.

Temperature: This brings up a slider for temperature. JPEGs will have a centered slider, while RAW files will have the current temperature as a starting point. Swipe along the slider to change the value; double-tap the slider to reset it.

Tint: This brings up a Tint slider. JPEGs will have a centered slider, while RAW files will have the current tint as a starting point.

Auto Tone: Tap this to toggle Auto Tone on or off. It's off by default unless it's been applied on the desktop.

Exposure: This brings up a slider to change the brightness of the image. JPEGs will have a centered slider, while RAW files will have the current exposure as a starting point. A two-fingered swipe will bring up the clipping overlay, making the image black. You don't need to have both fingers on the slider; one can be on the image, the other on the slider. First, tap and hold the slider. With a second finger, tap and hold down on the image. Finally, move the slider.

The slider action and overlay technique work in the same manner for Highlights, Shadows, Whites, and Blacks. The remaining sliders are Contrast, Clarity, Vibrance, and Saturation. The Previous and Reset options match those of the Presets.

Before and After

To see a Before view from the changes you've made, tap and hold the image with three fingers. The Before view will display as long as you keep pressing. The name on top will read "Before."

Undo/Redo

The final icon on the far right of the footer in Loupe is the Undo button. Tap this to undo a step. Once Undo has been tapped, a Redo button appears, allowing you to undo your undo. Lightroom mobile does not have a history like the desktop version, and will forget all steps you've made as soon as you go to another image. The settings you make on the device show as "From Lr mobile" in the History panel of the desktop version of Lightroom.

Force Sync

Normally changes will sync to the cloud automatically, but sometimes you need to force Lightroom mobile to sync. The cloud icon will change to include a "+." Tap this to bring up the Force Sync button, and then tap that button to initiate a sync.

The settings will be sent to Lightroom web and desktop.

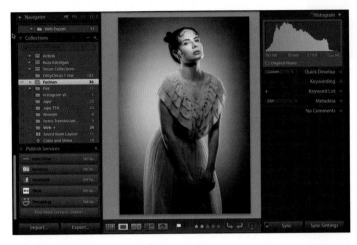

Copy/Paste

On iOS, while you can't save a Preset or even use Presets from Lightroom, you can use copy and paste to apply a preset in a roundabout way. First, in the desktop version of Lightroom, create a Collection called Presets. Create a Virtual Copy of a file and apply a preset to it. Click the Sync icon to the left of the collection name to send it to Lightroom mobile. Now, with the file in Lightroom mobile, do a long tap (tap and hold down) to open the Copy/Paste dialog. You can also set the photo as a cover photo from here. Select Copy Settings.

A dialog will open with the names of the panels from Develop. If you only want to copy a small amount of settings, tap Deselect All, and then tap individual items you want included.

There is an arrow to the right of Basic Tones. Tap this to select individual items from the Basic panel settings. Tap OK to copy the settings.

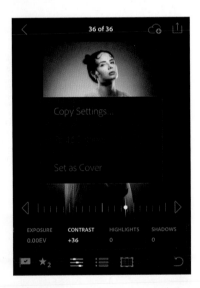

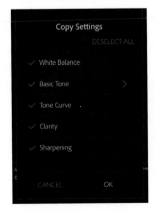

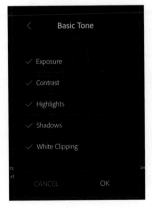

Long tap again. Paste Settings is now available. Use Paste Settings on other images to apply the settings. Batch paste is not available on Android devices yet, so you'll need to do this one image at a time.

As new versions are released, this feature will most likely appear on Android devices.

Zoom

Zooming is easy in Loupe: simply double-tap to zoom in and then out again. You can also use a two-fingered pinch in and out to zoom in and out.

Back at the Computer

The glorious thing about Lightroom mobile is that all the settings you change go right back to the desktop version. Occasionally you need to force a sync to make it happen, and make sure you use Enable Offline Editing when you will be away from a connection; otherwise, the process is pretty seamless.

When you open another catalog and are automatically logged in, you'll see the dialog on the left.

To keep the catalog that is currently on Lightroom mobile, click Don't Switch. Choosing the new catalog will delete all information from Lightroom mobile. The catalog is the boss, so everything starts with that catalog.

Now that Lightroom mobile on your device has been covered, let's look at the online version of Lightroom mobile, Lightroom web.

Lightroom Web

Once you start syncing files from Lightroom, they become available on the internet, even before they download to a device. You can always check to see which images have been synced to the web by looking for them online. To get to Lightroom web, simply go to http://lightroom.adobe.com and sign in. You need to use a modern web browser, preferably the most current version. Browsers on your device will also work.

Once you are logged in, the screen will look similar to that of

Lightroom mobile. Let's look at the entire layout before jumping in deeper. Clicking the Lightroom logo on the left will open a housekeeping menu with things like Change of Language, Terms of Use, Privacy & Cookies, Help & Support (which goes to https://helpx.adobe.com/lightroom.html), and finally Keyboard Shortcuts (just "n" for new collection and "?" for help).

We are currently in Collections view, but this can be changed to All Photos view, which shows all synced photos. We'll look at this view later.

Next is the Account section, where you can view details of your account and even manage your account. Click the "X" on the top right of the dialog to return to Lightroom web.

Finally, on the top right is an Adobe icon, which will take you to the main website.

Collections View

We begin in Collections View, where we see our list of Collections. Right now there's only one, but we can create a new one by clicking + Create Collection.

I've named this new one "Band." The new collection appears beside the first one, with a blank cover. We'll put some images in it shortly.

Before we look inside a Collection, let's look at the icons on the cover.

Sharing

First is the Share icon (a box with an up arrow). Click this to bring up the sharing options.

Like mobile, Collections remain private until you share them. Click Shared to access the sharing options.

Use the Filter options to restrict the images shown, and choose from Facebook, Twitter, Google Plus, or a direct link to share your photos. Click View to open the shared collection. This will let you see what others will see.

We'll come back to these Shared Collections shortly.

Add Images

The next icon is the "+" for adding images. Clicking on this will open the OS file browser, and you can add files from here. We'll do this for the Band collection. Navigate to the files you want to upload and press Enter. The files will upload to Lightroom web. A cloud icon with an up arrow will appear, with a counter showing the upload. There's no way to cancel this upload that I can find (I found this out by accidentally uploading to the wrong collection!).

Edit Collection

Clicking the three dots icon allows you to edit the Collection. You can choose a new Cover image, Delete, or Rename the Collection. Once finished, click the "X" to cancel or click the checkmark to accept your changes.

Into the Collection

Click on a Collection to view the contents. The main black header bar will be visible. Below this is the collection header. The title is on the left.

Beside this is a cog icon that will open the Collection Settings. You can edit the title or delete the collection from here.

Beside the cog icon is a play icon. Click this to start Presentation mode. Hover the cursor over an image to bring up the controls. Use the onscreen arrows, or the left and right arrows on the keyboard, to jump back and forth between images.

When you hover the cursor over an image, the controls that appear are part of the hover control panel, which has three settings: Pause/Play to run the slideshow; X to cancel; and a full screen icon to zoom out to full screen, which hides the browser. The current and total image counts show on the bottom left.

Below these settings are further commands, including Add Photos, which is identical to the "+" icon in Collections view; and Organize, which changes the Grid, allowing you to select images. Inside Organize, click on a photo to select it.

Once selected, you have two options: Remove or Delete. Remove takes the selected images out of the current collection.

Delete will remove the images from all collections and the device, but not from Lightroom.

Click the "X" on the right of the selected bar to exit Organize.

Next is the Shared icon. This is identical to the one in Collections View.

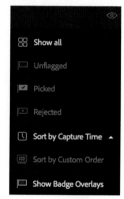

Finally, there's the eye icon on the right. This sets what you see in the Collection. You can sort by Flags (any combination of the three), by Capture Time (either most recent or oldest first), or Custom Order (the order must be made on the desktop). You can also show badges like the flag or rating status.

Shared Web Galleries

We had a brief preview of a shared web gallery earlier, but it's time for a deeper look. When you create such a gallery, Adobe creates a shortlink for you to share. Copy and paste this wherever you'd like. Only people with the link can see the gallery.

To the right of the border image is the options buttons. The first option, resembling a shuffle button, randomly toggles through borders. The next option lets you flip the border vertically, and the third option lets you flip the border horizontally. The last option lets you invert the colors of the border: white becomes black, and vice versa. Most of these option icons are also on Light Effect (except the invert button). All are on the Texture tool and operate in the same way. The final option is the Zoom slider, which lets you zoom out the border so it encroaches less on the image.

Light Effect includes the light leak we've seen in the Preset we've chosen. Click the light leak to see more presets. I'm going to use Side 8.

Side 8 is on the opposite side of the original light leak, so I use the flip vertical icon to swap it over. The orange strip of the light leak is a little too close to the image, so I use Zoom to bring it back to the edge. Finally, I use the Opacity slider to reduce the strength of the leak.

Import Overlays

All three of the Overlays selection boxes contain an Import button that you can use to import your own files. As you import, you can choose a blend mode (screen or multiply) to apply to these images.

Texture is the final overlay option. In addition to the already great textures in previous versions of Exposure, we now have custom textures from photographers like Lara Jade, Parker J Pfister, and Fundy. As with the other Overlays, click the image box to reveal the factory presets.

Choose the texture you prefer and position it using the tool options to the right of the texture selection box. Use Zoom and Opacity to change the view and strength of the texture.

Protect is located at the bottom of the panel. Use Protect Location to mark the center of an area you don't want affected by the Overlays. The Protect slider controls the radius of the protected area.

Focus

Focus gives controls for both Sharpening and Blur in the image. Sharpness is similar to the Unsharp Mask filter in Photoshop. Blur softens the image, but works in conjunction with Sharpening, so you can still blur areas of the photo without losing sharpness in areas of detail. Use the Sharpen Brightness Only checkbox to perform a luminance-based sharpening similar to Lightroom.

Grain

Grain adds fine texture to the image. We'll come back to this with black-and-white. Grain for Color has an additional slider: Color Variation. This allows color into the grain, and looks a lot like digital noise at high values. Perfect for emulating camera phones!

IR

IR controls the Halation or glow in the image based on the look from infrared film. Halation Opacity controls the glow amount, while Halation Spread controls the fogginess. Color Contrast boosts the color in the image as it increases. I've used IR to give a glow to the face of a subject by modifying a preset from the dropdown list.

Bokeh

Bokeh takes the Alien Skin plugin of the same name and adds it to Exposure. We'll look at it after working on a black-and-white image.

Save a Preset

Now that we've edited, it's time to save a Preset. Click the "+" icon in the Presets panel. Give the preset a name, and either choose an existing group or create a new one. Add a description to help in searching for the preset. Click OK.

Black-and-White

For a black-and-white preset, I choose Agfa APX 400-Dust and Scratches.

Color

The first difference with black-and-white is that in the Color panel, Color Sensitivity replaces Color Saturation. The sliders now control the brightness of the underlying color, rather than change the color, similar to the B&W panel in Lightroom.

Tone Curve

It's a minor change, but there's now a Gray channel curve to edit black-and-white photos, instead of the RGB channels curve available for color photos.

Grain

Now is a good time to talk about Grain. As with other panels, there's a preset drop-down menu for previews. I'll start with a huge helping of grain using the Rodinal Developer 100% preset.

It's super grainy, so I pull back the Overall Grain Strength Slider. You can also vary the Amounts separately with the Shadows, Midtones, and Highlights sliders. Type has two controls; Roughness controls how fine or rough the grains appear, and Push Processing increases the contrast and density of the grain.

Size bases the grain on actual film samples. Automatic sets it for you, but you can choose from three film types: 35mm (135), Medium Format 120, and 4x5 Larger Format. Relative size scales the grain from fine and small to large golfballs on the photo. I'm kidding, of course, but the grain can become unsightly when too large. As someone who used to shoot concerts in dark rooms with pushed Ilford Delta 3200, I can vouch for the fact that this feature does a good job of emulating that grain.

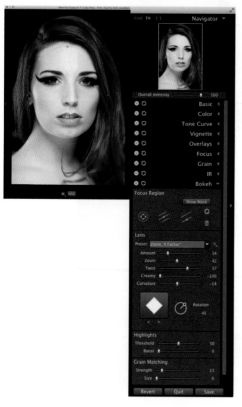

Bokeh

Bokeh is a plugin that simulates the Bokeh effect from a variety of lenses. It's fairly involved and we don't have a lot of space to discuss it, but let's dive right in. I've gone back to a basic preset for this: Fuji 160C.

Focus Region

Focus Region lets you choose what shape the blur will take. You have three options: Radial, Planer, and Half Planer. Radial and Half Planer are already familiar to Lightroom users. Radial matches Lightroom's Radial Filter. Half Planer is like the Graduated Filter. Planer is like two opposite Graduated Filters together with equal settings on both sides, with no effect in the middle. You can drag the outline points to change the shape and position of Radial, and change the angle and position of both Planer and Half Planer. The feather is controlled by the outside dotted circle or line, which can also be dragged into your ideal position.

Click Show Mask to temporarily see the mask in shades of black and white. Black is where the effect is. Imagine that the mask is for the image rather than the effect.

Lens

Lens starts with a Preset menu that contains a set of flyout menus for the presets, which emulate everything from toy lenses to pro sport lenses.

Amount controls the strength of the effect. Zoom creates a motion blur and looks similar to the bokeh of a Tilt Shift lens that is Tilted to limit focus. Twist enhances this effect further. Creamy runs from hollow bokeh (for instance, with the heart shape you'll see bokeh as a hollow heart) to creamy full bokeh. When using the Curvature slider, the shape will appear more star-like when the slider is moved to the left, and more circular when the slider is moved to the right. The box allows you to choose an aperture shape for the lens, with options from toy shapes like diamonds and hearts to multibladed aperture lens options. The Rotation tool lets you rotate this shape.

Highlights

Highlights allows you to boost the level of the lightest parts of the image, which emulates lens bloom. Threshold sets what parts of the image are affected. The higher the threshold is set, the more areas of the image are affected. Boost increases the light in these areas.

Grain Matching

Grain Matching has two sliders: Strength and Size. These let you add grain back to the blurred areas to match the non-blurred areas of the image to help it look more natural.

Overexposed

That's pretty much it for Exposure. I know we're barely touching the surface of the plugin, but hopefully it'll give you a feel for how much there is to explore.

Palette

Palette is a plugin for Lightroom, but it's the hardware kind. I was fortunate enough to be offered a chance to test a preproduction set of modules for this plugin, so I learned how it works.

Palette is very different from any hardware add-on I've seen for Lightroom. It's made of separate modules that lock together with magnets. Other than the power module, each module has three sides of seven copper connectors, and one side with six pins. The power module has three sides of pins, and one side has a micro USB–B connector (like most phones) and a power adaptor connector for low-powered USB situations.

Install the Palette App from http://palettegear.com/start to begin. This will install the Lightroom plugin as part of the process. Run PaletteApp to begin. You can start Lightroom, too. When the app opens, you'll see the range of devices that you can connect. Click Lightroom to create a new profile for Lightroom.

This new profile opens with an empty screen, with Profile Name at the top-left tab. Double-click this tab to give it a useful name. I'm calling it "Nightclub" because I'm working on the photos I process immediately after shooting in a local club.

Connect the power module with the supplied USB cable. It will also appear onscreen to match the physical connection. Neat? My son thinks so. The screen of the power module will show the Lightroom logo and the Profile Name (in our case, "Nightclub").

I'm going to connect two buttons, one fader, and two rotaries. The app updates to show these connections in real time. This setup forms the basis of controls I need for the job. After import, I apply a preset to the images, as per the club's request. The next part of the job is weeding out duds and fixing exposure and crop errors. For this I need a few specific tools to speed the process along.

I need a Reject button, and a Next Image button for selection. I need Exposure and Highlight controls. Often, brightening an image leaves the highlights too bright—hence the need for these tools. Finally, I need to change the crop angle.

To make these tools available to you, click on the module in the app and choose the function you want from the menu that appears. Some items, like Exposure and Highlights in the Basic Panel, are in submenus.

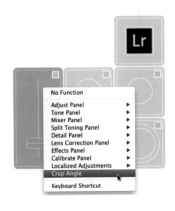

Not all menus in each Module use the same naming structure. I apply Crop Angle to the fader, and Exposure and Highlights to the rotaries. Reject is in the Flag menu, but there's no right-arrow function.

Finally, I choose "Keyboard Shortcut." This opens the Press Action dialog. I press my keyboard shortcut, but nothing happens. Why? As it turns out, you have to click the green button in the dialog first.

Now that the shortcut recorder is primed, I press the right arrow key to apply it. KEY Right appears in the dialog, so I press Done to accept it.

There's one more cool thing that my son loves about Palette, and you can see it in the first image above. You can change the surrounding color. The light blue is nice (you'll need to turn up the rotaries to see their color, first), but you have a range of colors available. See the tiny light blue square on each module? Click that to see the color selection.

Set up the color for each module. I've used red for Reject and green for Next.

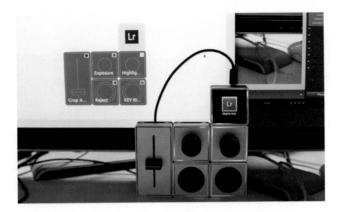

This app will be changing as the hardware develops, but the principles will remain the same.

Now that I'm ready to go, it's time to work through images. Faders, because of their fixed position, will cause settings to jump to the current location. For this reason, I prefer the rotaries. Having the Palette definitely makes the editing process of these photos much faster, and given the lateness of the hour that I edit them, I appreciate that it gets me to bed sooner.

More Than Photos

Palette came out of a Kickstarter project and is aimed at providing greater control in a handy package. Lightroom is just one of the applications that uses it, and many more are being added as time goes by. As well as Adobe apps, you can run midi hardware with it so it encompasses music, video, and design, as well as photos.

Help! Lightroom Ate My Homework!

Lightroom Q&A

Everyone has to start somewhere, and no one person knows absolutely everything about Lightroom. I learn new aspects of the program from gurus all the time, and they, in turn, learn from me. This chapter is a collection of frequently asked questions (and even a few I've made up) and their answers. I will start by giving you one bit of sage advice: with any problem, always restart Lightroom before you do anything else. Seriously. The program sometimes gets tired and needs a little nap from time to time. In fact, my friend and fellow Photographers-Toolbox.com plugin writer, Matt Dawson, once took pity on me and wrote a script that restarts Lightroom. I love it. I use it often. You can find out all about it here:

http://thephotogeek.com/lightroom-power-nap-restart-script/

With that said, here's some help!

I've Installed Lightroom CC, but it Crashes Immediately When I Open it. Help!

Open the Adobe Creative Cloud App. Click on the Cog icon in the top-right corner. Choose Preferences from the menu. In the General Tab, click Account. Click Sign out of Creative Cloud. Sign in again when prompted. This resets the account information and should cure your problem. There's a knowledgebase article on it here:

https://helpx.adobe.com/photoshop/kb/cc-applications-crash-immediately-launch.html

This issue was also fixed with version 6.0.1 of Lightroom.

How Do I Import from iPhoto or Aperture?

Lightroom ships with a plugin that allows this transfer. First back up your catalog by going to Catalog Settings and setting Backup (in the General tab) to When Lightroom Next Exits. Restart Lightroom. From the File menu, go to Plugin Extras and choose Import from Aperture Library or iPhoto Library.

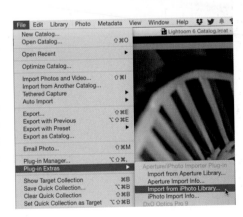

Lightroom will detect the library location, but you can specify a different one. You can also choose where the image files will be moved. The number of files, space required, and the space remaining are visible in the dialog. There's an Options button. Press this to open a dialog box where you can select to import Previews from iPhoto, Apply Keywords, and choose to Reference photos rather than creating new copies. Referencing photos saves space, but because the photos are still connected in iPhoto, this could lead to conflicts at a later time if you still use iPhoto. Click Import when you're done setting these options. For more information check out the official Adobe blog at:

http://blogs.adobe.com/lightroomjournal/2014/10/aperture-import-plugin-now-available.html

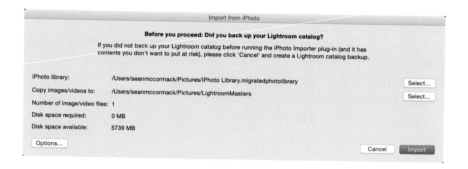

I Moved Files to Tidy My Drive and Now Lightroom Can't Find Them

Because Lightroom only references files, it doesn't follow them when they move. You have two choices. The first is to move the files back to their original location so Lightroom can see them, and then move them using the Folders panel in Lightroom. Alternatively, right-click on a missing folder and choose Find Missing Folder. Navigate to where you moved the folder and select it. Lightroom will update to recognize the new location.

Lightroom is Not Syncing Correctly With My iPad

Try deleting the Sync.lrdata file, which is located in a hidden directory. From Mac Finder, hold down the Option key and click on the Go menu. You will see an additional Library entry. Click this. From there, go to Caches/Adobe/Lightroom/Sync Data, where you will see the sync.lrdata file. Remove the

sync.lrdata file and restart Lightroom on the desktop. This should restart/refresh the sync.

On Windows, Sync.lrdata is located at: C:\Users\<user>\AppData\Local\Adobe\Lightroom\Caches\Sync Data\Sync.lrdata

AppData is a hidden folder. To view hidden files on Windows 8, use the shortcut Windows key + E. Click the View tab. Check File name extensions and Hidden items.

For Windows 7, right-click the Windows Logo button and choose Open Windows Explorer. Click Organize and choose Folder and Search Options. Click the View tab, and then select Show hidden files and folders. Clear the checkbox for Hide protected system operating files. Click Yes on the warning and then click OK. This should help the syncing process.

I Have No Idea Where Lightroom Put My Pictures. Where Can I Find Them?

To find any photo on the drive, use the shortcut Command + R on Mac, or Control + R on PC. You can also right-click on a file and choose Show in Finder (Mac) or Show in Explorer (PC) from the menu that appears. If you want to go back to the Folder in Lightroom from a Collection, right-click on the photo and choose Go to Folder in Library. Lightroom has placed these files based on your Import settings. If you use Add, Lightroom yet hasn't moved these files. If you used Copy or Move, the place Lightroom moved the files to is set in the Destination panel on the right of Import.

My Laptop is Full. How Do I Move My Images Safely off the Internal Drive?

To have Lightroom keep track of your photos, move them from within Lightroom. The easiest way to add a drive is to import a photo using Add. Then move your folders over to the new drive. The number of images you have dictates how long this process will take.

I've Updated Photoshop, but Lightroom Keeps Using the Old Version

The easiest solution to this issue is to reinstall Lightroom. Remember that both Mac and PC need to use the uninstaller to remove Lightroom. Lightroom doesn't delete your catalog when you uninstall. Sometimes on a PC you need to edit the windows registry to make it work. Go here: https://helpx.adobe.com/x-productkb/multi/edit-photoshop-command-missing-photoshop.html

Alternatively, search online using the terms "adobe knowledge base photoshop lightroom windows registry."

My Adjustment Brush Does Nothing

Check to make sure that Flow and Density are not set to zero, or at a very low value. Try setting them to 100 (the default value) to see if they work. Alternatively, you may be painting on white or light-toned areas with a white mask on. Press "O" to turn the mask on and off, or use the shortcut Shift + O to change the color of the mask.

I've Lost My Basic/Tone Curve (or Any Other) Panel!

It's easy to accidentally turn a panel off if you're not paying attention. Right-click on any visible panel and click on the name of your missing panel to turn it back on.

Can the Lightroom Backup File Really Fit All of My Images?

No, it can't. Lightroom backup only backs up the catalog file. Use a program like Chronosync (Mac) or Synctoy (PC) to make backups of your photos. Remember, with digital files you must have at least two copies of the photos. Three is better, with one copy in a different location than the other two. Backups are no good if they are all in the same place when the computer you're storing them on is stolen, lost, or destroyed.

When I Open Lighroom, I Immediately Get an Error Message That Says "Lightroom Encountered an Error When Reading From Its Preview Cache and Needs to Quit. Lightroom Will Attempt to Fix This Problem the Next Time it Launches." I Restart the Program, but Nothing is Resolved.

The preview cache is most likely beyond saving. You'll need to delete it. While this is painful from a time point of view because Lightroom will need to build all your previews again, it's not a critical error. Go to the folder with your catalog (Lightroom 6 Catalog is the default) and look for a file that ends in Previews.lrdata (but not Smart Previews.lrdata). On Windows it's actually a folder, whereas on Mac it's a file. Delete this file or folder and restart Lightroom.

Lightroom Won't Import the Files From My Brand New Camera

Lightroom releases support for newly released cameras at regular intervals, and will support your camera soon. For now, shoot JPEG and RAW so you can process right away but still have the RAW file for when Lightroom is updated to support those files. You could also convert the files from RAW to JPEG or TIFF in the software that came with the camera if you prefer not to wait for a Lightroom update that adds support for your camera.

Every File I Import Has Blue in the Shadows, or Shows Red Tones Instead of White. The Images Look Fine in-camera. How Do I Solve This?

You've turned on the shadow or highlight clipping indicator. To turn these indicators off, open the Histogram and click on the triangles at the top of the panel. You can also press "J" to turn on both the Shadow and Highlight clipping indicators, then press "J" a second time to turn them off. It's an easy mistake to make when you're not familiar with the program.

Lightroom is Running Slowly—is There Anything I Can Do to Help?

You can use the Optimize Catalog command in the File menu. This clears up any cruft that builds up in the catalog as time goes by. You could also try putting the catalog folder onto an SSD drive, and increasing the size of the Camera Raw Cache in the File Handling section of Preferences. On Mac, Preferences is in the Lightroom menu. On PC, it's in the Edit menu.

Another culprit that makes Lightroom run slowly is the Automatically write changes into XMP option in Catalog settings. Turn this off. You can always manually save XMP by selecting files and using the shortcut Command/Control + S.

 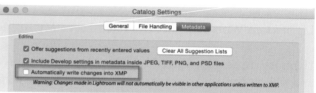

My Main Catalog is Corrupted. I've Tried All the Suggestions to Get it Going, but It's Hosed. How do I Use My Weekly Backups?

By default, Lightroom saves the backups into the same folder as the Catalog in a folder called Backups. These backups are named by date, so look for the most recent date. Lightroom zips these files, so unzip them. Rename the file to something sensible—perhaps even the original catalog name. Replace the corrupted catalog with the backup with the new name. If you don't know how long the corruption has been going on, you may need to use an older backup. Save XMP to store your settings externally to the catalog.

I've Been Using the Rating System on My Canon 5D Mark III, but It Doesn't Transfer into Lightroom

If you're using a Metadata Preset on Import (and you should be for the sake of copyright information, at least), check that you don't have the Rating option checked. If you do, uncheck the box and then update the Preset from the Preset menu.

I've Reattached My External Drive to Lightroom and It Still Says My Images are Missing (Windows)

When you attach different devices (even USB sticks), Windows assigns that drive a letter. If several devices have been attached since this drive was last plugged in, Windows may have assigned it a completely different letter. To change this you need to be logged in as an Administrator (and in Desktop Mode on Windows 8). Type diskmgmt.msc in the text search box and hit Enter. Right-click on the drive you want to reassign with a different letter (you want it to match the one in Lightroom), and choose Change Drive Letter and Paths. Click Change. If Assign the Following Drive letter is not selected, select it. Click the new drive letter you want and click OK. Click Yes to confirm the change.

I've Updated to Lightroom CC/Lightroom 6. Is It Safe to Delete Lightroom 5?

Lightroom CC/6 will update any old catalogs you have, so yes, it is safe to delete Lightroom 5. You should use the uninstaller for Windows, and you can simply delete it on Mac. Note that Lightroom CC needs an uninstaller for both Mac and PC. If you have changed from Lightroom 5 to CC and think you might want to get the perpetual version of Lightroom, keep the Lightroom 5 serial number in case you need it to get upgrade pricing.

When I'm Done Working in a Collection, I Delete the Photos I Don't Want. When I Go Back to Their Folders, the Photos Are Still There. What Can I do?

Okay. I'll give you the secret handshake, but you have to use it with care, because it's more of a claw than a handshake. On Mac, use Shift + Command + Option + Delete. On PC, use Shift + Control + Alt + Delete. This will delete

your files. There won't be the standard Remove/Delete dialog. The file will be gone from Lightroom and placed in Trash/The Recycle Bin. In other words, don't use it unless you're sure about it.

I Edited and Flagged Photos on My Laptop and Saved the Metadata. When I Import the Photos to My Desktop, the Edits Are There, but I Can't See My Flags. What Can I Do?

XMP will store your edits, metadata, ratings, and labels, but unfortunately it doesn't store flags. I've had to revise my process for making selects because of this. Next time, add a star or a label to the flagged images so you can find them after Importing them to a desktop computer.

I've Been Applying Names to Group Photos, but I Don't know Everyone in the Shots. Should I Just Delete the Face Regions?

Right now there's no way to force Lightroom to re-index a photo to detect faces, so only do this if you're really sure. Of course, the worst-case scenario is manually drawing a face region again. Rotating an image can force a rescan, but not if any of the face regions have been confirmed.

I Want to Upgrade to the Perpetual Version of Lightroom, Not the Cloud Version, but It Seems Impossible to Find

It is difficult to find. Adobe is keen to have people use the cloud. I think it's great value, but I totally understand why people want to have a version that feels like their own. Go here: https://www.adobe.com/products/catalog/software._sl_idcontentfilter_sl_catalog_sl_software_sl_mostpopular.html.

Click Buy, then change "I want to buy" from Full to Upgrade. In the next part, "I own," choose the version of Lightroom you're upgrading from.

I Want to Use a Catalog for Each Job, but I Still Want to Keep My Best Work Together Without Duplicating My Files. What Can I Do?

Keep the job catalog in the same folder as the images. Make the catalog files and bring the images into that folder. After you've made your selections and edits, create a collection of them. I suggest naming the collection to match the shoot. Select all in the collection and click on File > Export as Catalog. Call this catalog "Temp"—it'll create a folder called "Temp." At the bottom, make sure the number of images is correct, and that the box for Export negative files is not checked. This prevents duplicates. Press the Export Catalog button. The temporary catalog will be created.

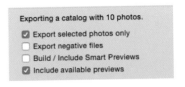

Now open your main catalog and click on File > Import from Another Catalog. Find the Temp.lrcat you just made and press return. Make sure you use Add new photos to catalog without moving in the small Import dialog that appears (this is the original Lightroom 1 Import dialog!). When the images are imported, delete the Temp folder.

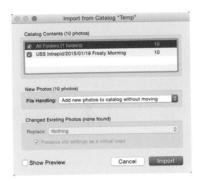

If you ever need to go back to the job catalog, find an image in the main catalog from the shoot and right-click on it. Choose Show in Finder/Explorer. This will open that job folder and you can open the job catalog by double-clicking on it within the folder.

Can I Put My Catalog and Previews in Dropbox So I Can Use Them on Two Different Computers?

Officially the answer is no. I do know an Adobe engineer that does this, but he has the knowledge to fix any problems if it goes wrong. I have tried it on test catalogs successfully, but there is one really, really, really, strict proviso: you must always close Lightroom every time you leave the computer you're working on. If you don't, Lightroom won't know which version of the catalog is correct, and it will create an additional, conflicted catalog (literally—it creates a catalog with "conflicted" in the name). Worse still, you might corrupt the catalog and lose everything. So here's the deal. Don't do it, and don't blame me if you do it and it goes horribly wrong.

Is There a Group or Forum You Recommend Where I Can Go to Ask Questions? I Want a Friendly Environment Where I Can Ask About Both Simple and Difficult Problems I'm Experiencing.

While I don't get there as much as I used to, I've always found Lightroom Forums to be great. It's generally full of friendly and helpful people. People who are helpful get promoted, so you always know if you can trust their information. http://lightroomforums.net

Well, folks, that takes us to the end of the book. I hope it's been of use to you. If you want to keep up with current Lightroom-related news and get new tutorials as I create them, be sure to check out http://lightroom-blog.com or follow @lightroomblog on twitter.

Index

Tiffen DFXv4.0

Tiffen is probably best known for its physical lens filters, but with DFX, it takes its experience with those filters and applies it to the creation of digital filters. These filters provide the basis of the Presets that form the heart of DFX v4.0. There are over 2000 simulations available in the program, making it the most preset-laden plugin that we're looking at. There's a huge range of film stock emulations, color gels, and gobo and lighting effects, for example. It's not all about Presets, though. Every Preset has access to a whole bank of parameters to make them even more versatile. DFX can be run as a stand-alone application, but once installed, you have access to it via the Edit in... menu. Once open, you'll notice it looks a lot like Lightroom.

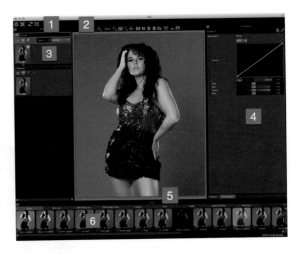

Layout

There are six main parts to the layout of DFX.

1. At the top left we have Save (the cog), Cancel (which returns us to Lightroom), Undo, and Add Mask.

2. The preview tools appear over the main image. These allow you to zoom in and out, see various before and after views of the image, and it offers the masks and histogram.

3. This shows the Layer Stack, where we can build up our effects and mask them as required.

4. This holds the Presets and Parameters, selectable from the bottom of the panel. Here we see a Parameters view of Curves. You can save new Presets by clicking on the page icon to the right of the Preset menu at the top of the panel. The new preset adds to the panel.

5. Here we have the Filters menu. From here you choose which of the Filter types you want to access. Choose from Film Lab, HFX Diffusion, HFX Grads/Tints, Image, Lens, Light, Special Effects, and Favorites. Color is new to DFX v4.0.

6. Once you've selected a Filter type, the individual Filters appear in a filmstrip preview. Clicking on a Filter will show the Presets in the right panel.

Curves

While Curves is new to DFXv4.0, we have seen them working in Lightroom. Click on Parameters at the bottom of the right panel if you're in Presets view. From the RGB dropdown, you can choose Red, Green, and Blue channels, as well as the RGB Channel. Add points to the curve by clicking and dragging up or down on the line. One main difference to Lightroom is the bank of sliders that lets you control the brightness of the four channels.

Previewing

Use the options above the image to preview. The first part of this panel is Zoom related. From left to right is Zoom in, Zoom Percentage, and Zoom out, Zoom to Fit (shortcut "F"), and Zoom (select this, then click and drag to zoom the selected area of the image).

Next are the preview options. First is the side-by-side comparison. The "before" shot is on the right, and the "after" shot is on the left (this is the opposite of Lightroom). Split the vertical preview, then split the horizontal preview. Next is the A/B comparison, which swaps the before and after views. Once pressed, an additional icon for undo view will appear to indicate you're previewing the "before" image.

Next is the Snapshot icon. Click this to create a snapshot of the current settings. A new icon will appear. Click this to swap settings to those of the snapshot. After this is the Show Mask icon, which gives a black-and-white view of the mask.

The final two icons here add panels to the layout. Histogram adds a histogram view on the bottom right, and Magnify adds a loupe under the Layer Stack. When you hover over the magnifier window, the cursor changes to a hand tool so you can drag the image around the viewer. Use the zoom options in the panel to change the magnification of the view.

Filters

There's probably a whole eBook of suggestions for what can be done with DFX, so to keep the process simple, let's work on this one image to completion.

First I want to add a gobo to the background, but not have it appear on our subject. I reset the Curves, and then from the Light filter type, I choose the Light filters. The individual presets now populate the Preset panel. I choose one of the Triangles gobos. Once selected, a circle appears over each corner of the image, along with the gobo. I zoom out and drag these circles out to change the size and shape of the gobo.

The gobo is covering our subject, so I'll have to mask it off. There are a few mask options available when you click the Add Mask icon on the top left. Gradient is like the Graduated Filter. Spot is more like the Radial Filter. Path lets you draw out the mask. Snap is like a magnetic lasso, snapping to edges as you draw. EZ Mask is what we'll use and cover in more detail. Selection gives you luminance and color controls to build up a mask based on the details of the image. Finally, Paint lets you manually paint a mask.

EZ Mask

Clicking EZ Mask opens a new icon bar at the top of DFX. We don't have space to cover everything on this bar, but we will look at the most important options. These are highlighted in red. Use Paint Foreground for parts of the image you want to keep from the filter (remember that foreground is not necessarily the subject). Paint Background is for objects you want removed. Paint Unknown is for situations when you're not sure of where edges are in instances when there's no separation between the subject and the background. Paint Missing tells EZ Mask you're missing things from the mask: wispy hair for example. Erase lets you remove the paint; fill lets you fill in the mask. The last icon at the end is Generate Mask. This will create a mask automatically based on where you've painted.

I'm using Paint Foreground outside the subject to select where I want the lighting effect. For the subject, I use Paint Background. I'm not being overly accurate with my painting.

With this done, I click Generate Mask. I'm happy with the results. If you need to refine, you can use Paint Missing, or simply paint more areas to give EZ Mask more information. I find it fantastic in general. Let's move on and give this image a film look.

Film Stocks

At the top on the Layer Stack is the New Layer icon (three lines with a "+"). Click this to make a new layer, then apply the next Filter to it. From the Film Lab Group, I'll use Beach Bypass 6 in the Presets Group. I need another layer now to add a Film Stock.

I go to Film Stocks and select Polaroid 600-Desaturated. There are hundreds of options, so it's a matter of choosing the one you like.

Borders

The final thing I'll do as an effect is to create a border for the photo. Again, I'll need to create a new layer so I don't accidentally undo the Film Stock I've applied. Borders are the first option in the Special Effects Filter group. There's a range of borders here, including inverted copies, which allows you to choose from black or white borders. I've gone for Border 4-Inverted.

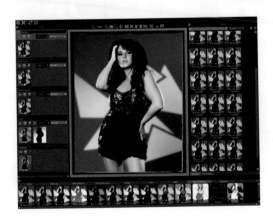

Color Correct

One last thing I need to do is desaturate the image a little more. I create a new layer and go to the Color group, where I select Color Correct. The parameters are vast, but the one I need is right near the top in Master section. I adjust the Saturation slider until I'm happy with the results.

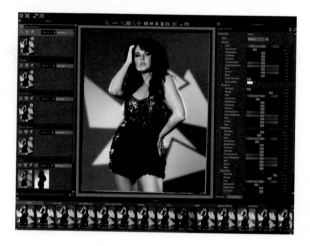

Back to Lightroom

To save the image, click the cog icon. This brings the edits back to Lightroom and stacks the edit with the original image, in the same folder.

Tonality Pro

Macphun (http://macphun.com) is a dedicated Apple Mac software team that produces high quality plugins for the OSX platform. Tonality Pro is their black-and-white plugin, which offers a complete workflow for grayscale conversion. There's also a non-pro version that's cheaper, but it doesn't offer Lightroom integration. Strictly speaking, Tonality does have color presets, but for the most part, it's focused on black-and-white.

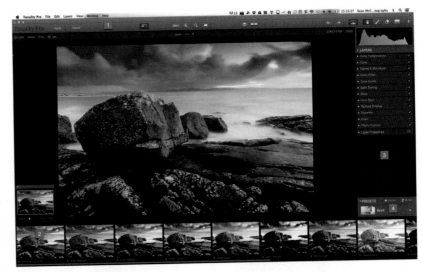

Layout

It'll be no surprise that the layout of this plugin looks familiar. Most current plugin designs are inspired by Lightroom's interface, and all tend to keep a reasonably similar feature set in order to compete with other products. Let's look at the five sections marked in the layout figure.

1. The header bar contains the Apply and Cancel buttons. Apply brings the edits back into Lightroom, and Cancel quits the plugin without saving. Next is the Navigator on/off button (see 5, below). Following this are the four zoom buttons: 100%, Zoom in, Zoom Out, and Fit to Screen. After this we have the Eye icon for Quick Preview, followed by the Before/After icon. Undo and Redo are next. The Histogram icon toggles the Histogram at the top of the right panel on and off. The final set of icons contains the Hand tool for moving the image around, the Brush tool for painting on a mask, the Erase tool to remove a mask, and the Gradient tool to create a graduated mask. Finally, the "?" is a help icon. You can find information about the image and a zoom percentage option below the header bar.

2. The Preset thumbnails appear in a filmstrip below the main image. Initially we see the Basic set. This can be changed in the Preset Panel (4). Click on a thumbnail to apply the look to the main image. Tonality Pro ships with over 150 Presets to get you started. You can hide or show the filmstrip from the View menu or by using the Tab key.

3. The Right Panel is where the work happens. We'll look at the settings shortly.

4. The Preset Panel lets you choose which group of Presets is visible below the main image. Click Basic to open up the panel. Choose a group that matches what you'd like. By going through the Presets and looking at the Right Panel settings, you'll see that each Preset will give you clues on how to get specific looks for your own presets. To create a preset from the current settings, click the Create button, name your preset, and click Add. To reset the current settings, click Reset.

5. This is the Navigator, toggled on in (1), above. You can also toggle it from the View menu, or with the shortcut "Z". Use the Zoom slider to Zoom in, and then move the white rectangle in the Navigator to move around the image.

Histogram

We've seen the toggle for the Histogram in (1). Hovering the cursor over the Histogram gives a representation of Ansel Adams's Zone System, for those inspired by the master. As you hover the cursor over each of the Zones, a crosshatch pattern will appear over areas of the image that represent that zone. There's also clipping indicators, which can be toggled on by clicking them or by pressing the "J" key.

Settings

This is the heart and soul of Tonality. We'll start from scratch by pressing Reset in the Preset panel. Let's look at the panels, while building up an edit in the process.

Layers

As you work in Tonality, you can build layers of the effects applied, mask them, or blend them to build up the look.

Color Temperature

The standard Temperature and Tint sliders allow you to change the underlying color of the image. They do have an affect on the conversion, so are always worth trying at any stage. Once you make a change in a panel, the header turns from white to yellow, letting you know edits have been made. Each panel's effect can be turned off from the checkbox, or reset from the icon that appears when you hover the cursor over the panel header.

Tone

The Tone panel resembles the Basic panel in Lightroom in some ways. Exposure is first and has two sliders: Standard and Adaptive. Standard acts like camera exposure—increasing or decreasing the effect is linear and can quickly lead to clipping. Adaptive is more like Lightroom's exposure, and will save highlights and shadows as much as possible. Contrast is next. Again there are two sliders: Standard and Smart. Standard does the normal job of flattening out the image tones and darkening the shadows when decreased, and lightening the highlights when increased. Smart affects certain tones more than others and stretches the relationship between highlights and shadows, resulting in a glow effect.

Next are Highlights, Midtones, and Shadows, which target the specific areas of the image they're named for. Highlights affect tones above the middle tone of the image with affecting Shadows. The reverse is true for Shadows. Midtone increases or decreases the midtone brightness without affecting the darkest or lightest parts of the image.

White and Blacks affect only the absolute lightest and darkest parts of the image.

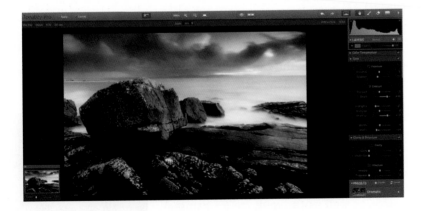

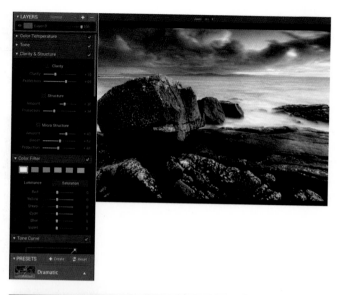

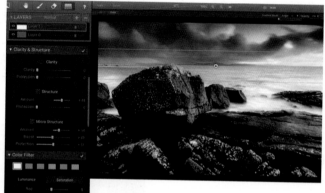

Clarity and Structure

Like with Lightroom, Clarity adds midtone contrast to give more "punch" to the image. Protection will prevent Clarity from affecting the brighter parts of the image. Structure adds apparent texture, but avoids the edges in the image. Again, Protection will prevent these features from working on the brighter parts of the image.

Micro Structure works on the details of the image. Boost brings this down to the pixel level. Protection prevents Micro Structure from affecting the brighter parts of the image. I like what's happening in the bottom of the image with Micro Structure, but it's damaging the sky.

To solve this, I'll only apply the Structure and Micro Structure on their own layer, and mask off everything else using a Gradient. I click "+" in the Layers panel, then add the new settings to this layer. Next I click Gradient to add a mask to the layer, and then move it into place. It's masking the wrong part of the image, so I use the Angle option and flip the orientation by setting it from 180° to 0°. Finally, I click the Apply button in the Gradient bar (not the one on the top left) to apply the mask. Remember that each Layer will have settings independent of other layers—the same as in Photoshop.

Color Filter

The 6 tiles represent glass filters used in traditional black-and-white photography. These change the Luminance and Saturation sliders below them, which you can also change manually. Luminance changes the brightness of the underlying color, while saturation brings the original color back to the image. To have it affect the whole image when using masked layers, the settings need to apply to all layers.

Tone Curve

The Tonality Tone Curve is a basic RGB Curve. Click to add points and drag them around to suit the image. At the bottom is a Levels control, where you can set the black and white points of the curve, as well as the midtone (or gamma) point.

Split Toning

Split Toning adds separate colors to the highlights and shadows in the image. You can choose one of the eight presets to start with, or create your own with the sliders. Tint controls the base color, while Saturation controls the strength of that color. Protection, as always, will prevent the settings from affecting the brightest parts of the image. Shadows have no highlights; hence, shadows has no Protection slider. Amount controls the strength of the toning. Balance controls which of the tones (shadows or highlights) takes precedence in the image.

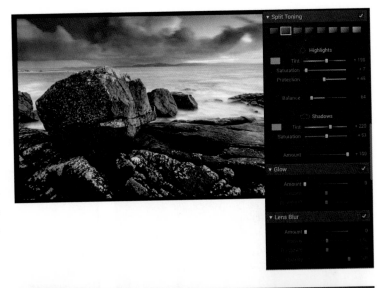

Glow

Glow literally adds a glow to the image. It resembles the halation seen with old infrared film, but it's useable as an effect in its own right. Amount controls the strength of the filter. Smooth will soften the effect when the slider is pushed to the right, or increase the contrast when the slider is pushed to the left. Finally, Threshold decides what tones are affected by the glow.

Lens Blur

Lens Blur adds a realistic, optic-style blur to the image. Amount controls the strength of the blur. Radius shows a circle, outside of which the effect is applied. Transition controls how fast the Radius edge goes from normal to blurred. Opacity fades the level of the effect. Place center allows you to choose any point on the image as the midpoint of the blur.

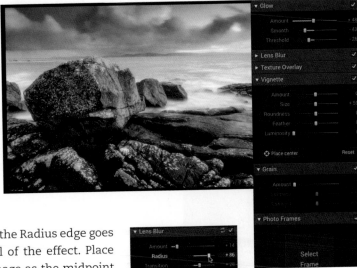

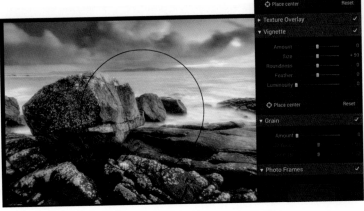

Texture Overlay

You can apply a texture to your image from this panel. Click Select Texture to choose from a range of built-in textures.

Choose from Paper, Metal, or Film, or even load your own. I'm a texture lover, so I use the factory textures frequently.

To control the strength of the texture, use the Amount slider. You can also blend the texture using the Blend menu. Choose from Normal, Multiply, Screen, Soft Light, or Overlay.

Vignette

Vignette allows you to lighten or darken the corners of the image. By default, this is based around the center of the image, but you can use the Place center button to change this. Amount controls how light or dark the corners will go. Size controls how far into the selected center the effect will go. Roundness varies the shape from circular to rectangular. Feather controls the hardness of the edge of the vignette. Larger values mean a softer transition. Luminosity will lighten the area at the center of the vignette to accentuate it. Finally, Reset will reset the vignette.

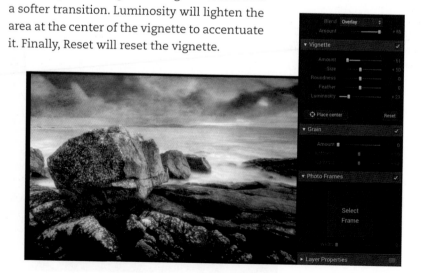

Grain

Grain adds realistic-looking film-style grain to your images. Amount controls the quantity of grain added. Softness blurs the grain and Contrast sharpens the grain.

Photo Frames

To add a border to the image, click on Select Frame from the Photo Frame panel.

Choose one of the 11 available frames.

Choose a width for the border, which increases or decreases how far the border encroaches on the image.

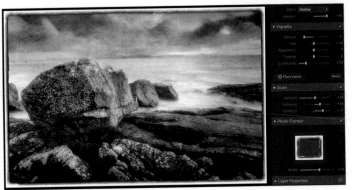

Layer Properties

Each layer can have separate properties. In Photoshop, these appear as part of the Layers panel, but in Tonality Pro, they have their own panel. Opacity controls the transparency of the currently selected layer. Blend uses one of

the blend modes to change how the image interacts with previous layers in the stack. Choose from Normal, Soft Light, Overlay, Multiply, Screen, Luminosity, or Color. You can also use the Original Image or the Previous Layer as the source for the current layer.

In addition to these options, further options are available by right-clicking on a layer in the Layers panel. These options involve layer or layer mask options for the current layer.

Back to Lightroom

Click Apply in the header bar to save the edits and bring them back into Lightroom. As with other external editors, the image will be saved to the same folder as the original, and be stacked with it.

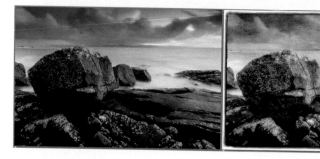

Topaz Impression

Impression from Topaz is a delightful plugin designed to bring out your inner artist. From sketches to oils on canvas to watercolors, it truly does let your photographs mimic classic painting techniques.

Impression works by taking your image and applying real brush strokes, scanned from thousands of works using oils, acrylics, inks, watercolors, pencils and pastels. Each stroke builds on other strokes quickly until the entire photo becomes a painting. It can create gorgeous results, and bring a whole new dimension to your work.

Once installed, Topaz Impression is available from the Edit In... menu. When the plugin initiates, it shows your selected image at almost screen size. Previews of painting presets from Featured presets are available to the right. For our photo, Topaz Impression defaults on the Charcoal 1 Preset.

Zoom and Preview

Before diving in, let's explore the interface. Starting at the top left, we have the preview tools. We've seen the default, which is the after view. You can also have a split before/after view in horizontal and vertical form, or as separate views—again, in horizontal or vertical forms.

Next is the Zoom tool. Click the magnifying glass icon to cycle through zoom presets. Use the slider to zoom, enter a number in the % box, or use the up/down arrows to go to a particular zoom level. Click Original to preview the original file.

Strength and Blend

The Strength Slider and Blend mode options are at the bottom. Use the slider or % box to reduce the opacity of the painting effect. Blend modes act as if the painting were on its own layer, like those in Photoshop.

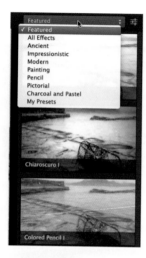

Presets

On the right of the preview are the Presets. These are grouped by style. Clicking Featured and then clicking the corresponding group name will select each group. It's a little beyond the scope of this plugin preview, but suffice it to say, the groups are well named. You can also save your Presets into the My Preset group. You can edit a preset by clicking the sliders icon to the right of Featured, or by clicking on the circular sliders icon that appears on a selected Preset.

Selective Parameters

To show these controls in action, we'll start by picking a preset, which we'll then edit. Down at the bottom of the Featured group is Watercolor IV. When we select it, a blue outline appears. The circular slider icon appears in the center of the Preset preview. Click this to open the Selective Parameters panel.

There are four panel headers for the Selective Parameters: Stroke, Color, Lighting, and Texture. To the right of the Watercolor IV header is the Reset All button. Click this if you want to start from the beginning. You'll still have a brush stroke applied, so it's not the same as starting from the original file. Let's look at the individual control panels after pressing Reset All.

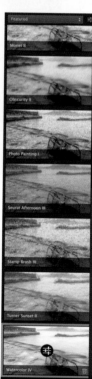

Stroke

Stroke controls how the paint or pencil emulation is applied. There is a wealth of options to change the brush type, coverage, spill, and volume, amongst others, available here.

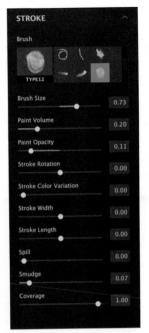

Choose from 17 different brush types, ranging from palette knives to stipple brushes. Each choice will have a different effect on the photo. Note that as each change is applied in real time, you see a purple line that runs on top of the preview, indicating progress as your changes are applied.

For this example we'll go with a TYPE01 brush. Brush Size is an intelligent slider: you're not selecting one fixed size, but a base size around which the brush size is based. That is, the brush size will vary up and down from the size you select to suit the content of the original photo. The sky will still have large strokes, but smaller details will have small strokes. Paint Volume controls the quantity of paint on the brush. Larger amounts put more paint on the canvas. Paint Opacity controls the lightness of the brush's touch. Higher amounts build strokes on top of each other; lower amounts show the underlying medium (the paper or canvas). Stroke Rotation and Rotation Variation change the angle of the brush and how often you change this angle. Imagine being a painter. Would you hit the canvas at the same angle every time? No, of course not. So using these settings helps the strokes look more human. Rotation Variation appears when Stroke Rotation is moved from zero.

Stroke Color Variation adds more than the base color from the original image. It can get quite psychedelic at high values.

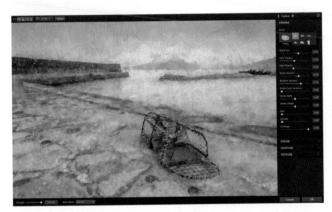

Stroke Rotation and Rotation Variation help make the paint strokes more human

Stroke Color Variation can lead to bizarre results at high settings

459

Stroke Width and Length control the size and the proportions of the stroke. Spill controls how much a stroke overlaps previous strokes. Smudge mashes the strokes together and reduces the definition of each stroke. At high values, the painting will appear to be made of wavy lines.

Coverage controls how much of the underlying medium is used. For most paintings, this would be full coverage, but watercolors and sketches often don't require this. When Coverage is changed from 1.00, two additional controls appear: Coverage Transition and Coverage Center. The screenshot below shows an exaggerated view of how they control the edge of the coverage, and where the center of the coverage is.

Smudge blends the strokes together

An exaggerated view of the Coverage control effects

Color

Color consists of nine swatch tiles that control the hue, saturation, and luminance of the overall image, and of the eight individual colors represented in the tile. Like with Lightroom's Color or HSL panel, Hue controls the color's shade and Saturation, as well as the strength and Luminance (or brightness) of the color.

While the overall tile has easy-to-see effects, the individual colors can be harder to spot. Topaz includes a tool to help: hovering the cursor over a tile will cause a crosshatch to appear over the areas of the picture that the tile affects.

Lighting

Lighting controls the quantity, quality, direction and falloff of the light on the picture. It's like having a movable lamp over the painting that dictates how we see it.

Brightness controls the highlights of the picture, and attempts to leave the darker colors the same. Higher values will affect the whole picture, though. Contrast will increase highlights and shadows when raised, and flatten out color when lowered. Vignette darkens the edges, bringing focus to the center of the picture. When changed from zero, you also get a Vignette Transition and Vignette control set that's similar to that of Coverage. Light Direction controls how the light falls on the picture. At the center it's flat and shadowless, but it changes how the brush stroke edges look away from the center.

Texture

We've mentioned the medium of painting already, and Texture is where you control that medium. It's not just paper or canvas; there is actually a wealth of other possibilities including brick walls and damaged asphalt. You could make your photo look like it's been made into graffiti.

Strength controls how much of the medium is visible through the paint. Size changes the dimension of the detail in the medium, for instance, the size of the bricks on the wall. Background Type can be original or solid. When solid, you can choose a color. This color appears as the background when you've changed coverage to show the background, but the color won't be seen otherwise.

Save Your Preset

The name of the current Preset is at the top of the Selected Parameters panel. If you've started from a Preset, you'll see the name of the preset with a "*" beside it, indicating it has been edited. If you've Reset All, it will say Custom. Beside this name is a "+" icon. Click this to open a dialog to save a new preset.

Give the Preset a name, and then select the categories you'd like it to appear in. Then click Save.

My Impression

Impression is a neat plugin offering a huge range of possible paintings or drawings. The fun element is definitely not to be discounted. I think it'll provide options to portrait photographers looking to offer different and unique products for their clients.

Back to Lightroom

When you're finished editing, simply click OK on the bottom right of Impression. The file will save back to the same folder as the original and stack with it.

Alien Skin Exposure 7

Exposure is Alien Skin's Film Emulation plugin. In truth, it does far more than just having film presets. It offers a whole range of image-finishing options. Photographers like Sue Bryce and Lara Jade heavily promote it, and that's appropriate, because it's really good at what it does. Alien Skin used to have a plugin called Bokeh for focus control: this is now part of Exposure, which makes the program even more valuable.

As seems to be the trend, Exposure, too, now has a standalone version. It has an image browser, RAW Converter, and its own Crop and Rotate tools. I mention these because they don't appear in the plugin version, so you may want to try the standalone version.

Getting Started With Exposure

As with the other plugins, Exposure 7 is accessed from the Photo > Edit In... Menu. This opens your image into the plugin.

There are three parts to the Exposure layout. In (1) on the left we have the Presets. Clicking on any of the groups will display thumbnail copies of the Presets they contain, using the image you're editing. As you make changes, the thumbnails update to reflect your edits. (2) shows the image you're edit-

ing. The Right Panel (or dock, as it's sometimes called), labeled (3), contains the Navigator for zooming in and out of the image. Both side panels can be hidden by clicking on the triangles on the center-left or center-right of the layout.

Presets

Exposure 7 ships with over 470 Presets to start with, and all of them can be previewed from the Presets panel. The viewing options are at the top of the panel. Open a group by clicking

on the triangle beside the group name. You can choose to view a large grid (fewer larger previews), a small grid (more smaller previews), or a list view of Presets. The fourth icon closes the group. The "-" icon to delete a Preset is currently grayed out. The final icon, "+", lets you add a Preset. We'll show saving a preset at the end of this section. There are four dots at the right side of the panel. Click and drag the panel edge at the fours dots to the right to expand the panel and see the thumbnails at an even larger size.

You can filter by Preset type, too. The default is All, but you can choose to show Color, B&W, Favorite, User, and Recent Presets. If you know a Preset name or want a particular ISO, use the Search icon (a magnifying glass) to find it.

B&W Presets offer slightly different Right Panel settings to Color Presets, so we'll look at two different Presets for editing. We'll start with a color look, then use B&W and to show how the options are different.

Color

A lot of my work is fairly straightforward, but I love light leaks, grain, vignettes, and film borders. If only competition judges liked them as much as I do!

For my Color Preset, I'm using Kodak Portra 400VC from the Lo-Fi group; specifically, the Light Leak version.

With the Preset selected, I close down the Presets panel from the center left triangle. From here, we'll start working in the panels available in the plugin.

Navigator

Directly under the Navigator is the Overall Intensity Slider. Adjust this slider to reduce the intensity of the effect from 100% down to 20%.

Basic

Mimicking the Basic Panel in Lightroom, Exposure offers a way to correct for deficiencies in shooting. The Exposure slider is like the older process versions in Lightroom, and will hard clip the image when pushed. The remaining tools are like their Lightroom counterparts.

Color

Color offers two control sections: Color Filter and Color Saturation. Color Filter lets you apply a color wash over the image as if you used that filter on the lens when taking the image. Open the Preset menu and move down over the presets. The main image updates to preview the chosen presets. I don't really like any of them, but you can see the effect of the Blue preset in the figure to the left.

Color Saturation allows you to saturate different tones and colors in the image separately. For tones, you can edit Shadows, Midtones, and Highlights. For colors, you have separate control over Reds, Yellows, Greens, Cyans, Blues, and Magentas. These color saturation sliders work like the Saturation sliders from the HSL panel in Lightroom. There are also Presets for Color Saturation—again, you'll see a preview of these presets as you run through the list of them. To the right of both Preset lists is a tiny icon with three lines and a down arrow. Click on this to create your own Preset and add it to the corresponding list.

Tone Curve

There are two parts to the Tone Curve panel: Tone and Split Toning. Tone has a standard RGB tone curve, along with separate red, green, and blue curves. There are Presets to try, also. You can save your own, as well as preview other Presets, just like with Color. In addition, you also have four sliders that modify the base curve. Contrast changes the underlying contrast of the curve. Shadows, Midtones, and Highlights work to change applicable areas of the image.

Split Toning is different than the Lightroom panel of the same name. The first tool is a gradient strip with two color pots. Clicking on a pot changes the controls so they apply to that pot. As you move the position of the pot along the color strip, it affects the range of tones the color will apply to the image. The pots can move to the opposite ends of the color strip from where they started, and they can move past each other in the settings so the colors can interact. Each Color has its own Strength slider, so remember to use both as you change colors.

Vignette

Vignette lightens or darkens the edges of the image, to draw attention to where you want the viewer to look. Start by using the Vignette Location to place the center of the Vignette. To see the Vignette properly before finalizing the softness, set Amount to 70, Size to -40, and Roundness to 100. The edge of the Vignette will be clearly visible. Now, use Random Seed to change the shape of the Vignette. Combine this with increased Distortion to make the shape of the vignette even more random.

Now, set Size to suit the subject. Next, change Roundness to place the edge around the subject. Use Softness to refine the feathering of the Vignette. Lastly, set Amount to suit the image. As Vignettes go, this tool is impressive. You can use Random Seeds, Lump Size, and Distortion to give more depth to the Vignette.

Overlays

Now we're on to the fun bit: Overlays. Here we get to choose our Borders, Light Effects, and Textures.

Borders is where you select the surrounding border for the photo. First, click the checkbox to activate the overlay. Next, click the border image to bring up a selection panel of borders. Click on the All group to see all of the available borders, or go to a specific group to view the matching borders. I've chosen a Damaged border.

To the right of the border image is the options buttons. The first option, resembling a shuffle button, randomly toggles through borders. The next option lets you flip the border vertically, and the third option lets you flip the border horizontally. The last option lets you invert the colors of the border: white becomes black, and vice versa. Most of these option icons are also on Light Effect (except the invert button). All are on the Texture tool and operate in the same way. The final option is the Zoom slider, which lets you zoom out the border so it encroaches less on the image.

Light Effect includes the light leak we've seen in the Preset we've chosen. Click the light leak to see more presets. I'm going to use Side 8.

Side 8 is on the opposite side of the original light leak, so I use the flip vertical icon to swap it over. The orange strip of the light leak is a little too close to the image, so I use Zoom to bring it back to the edge. Finally, I use the Opacity slider to reduce the strength of the leak.

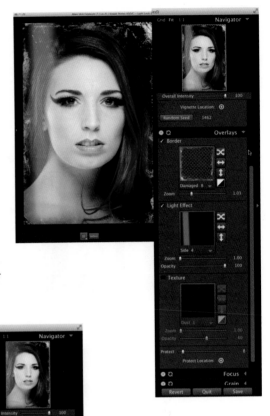

Import Overlays

All three of the Overlays selection boxes contain an Import button that you can use to import your own files. As you import, you can choose a blend mode (screen or multiply) to apply to these images.

Texture is the final overlay option. In addition to the already great textures in previous versions of Exposure, we now have custom textures from photographers like Lara Jade, Parker J Pfister, and Fundy. As with the other Overlays, click the image box to reveal the factory presets.

Choose the texture you prefer and position it using the tool options to the right of the texture selection box. Use Zoom and Opacity to change the view and strength of the texture.

Protect is located at the bottom of the panel. Use Protect Location to mark the center of an area you don't want affected by the Overlays. The Protect slider controls the radius of the protected area.

Focus

Focus gives controls for both Sharpening and Blur in the image. Sharpness is similar to the Unsharp Mask filter in Photoshop. Blur softens the image, but works in conjunction with Sharpening, so you can still blur areas of the photo without losing sharpness in areas of detail. Use the Sharpen Brightness Only checkbox to perform a luminance-based sharpening similar to Lightroom.

Grain

Grain adds fine texture to the image. We'll come back to this with black-and-white. Grain for Color has an additional slider: Color Variation. This allows color into the grain, and looks a lot like digital noise at high values. Perfect for emulating camera phones!

IR

IR controls the Halation or glow in the image based on the look from infrared film. Halation Opacity controls the glow amount, while Halation Spread controls the fogginess. Color Contrast boosts the color in the image as it increases. I've used IR to give a glow to the face of a subject by modifying a preset from the dropdown list.

Bokeh

Bokeh takes the Alien Skin plugin of the same name and adds it to Exposure. We'll look at it after working on a black-and-white image.

Save a Preset

Now that we've edited, it's time to save a Preset. Click the "+" icon in the Presets panel. Give the preset a name, and either choose an existing group or create a new one. Add a description to help in searching for the preset. Click OK.

Black-and-White

For a black-and-white preset, I choose Agfa APX 400-Dust and Scratches.

Color

The first difference with black-and-white is that in the Color panel, Color Sensitivity replaces Color Saturation. The sliders now control the brightness of the underlying color, rather than change the color, similar to the B&W panel in Lightroom.

Tone Curve

It's a minor change, but there's now a Gray channel curve to edit black-and-white photos, instead of the RGB channels curve available for color photos.

Grain

Now is a good time to talk about Grain. As with other panels, there's a preset drop-down menu for previews. I'll start with a huge helping of grain using the Rodinal Developer 100% preset.

It's super grainy, so I pull back the Overall Grain Strength Slider. You can also vary the Amounts separately with the Shadows, Midtones, and Highlights sliders. Type has two controls; Roughness controls how fine or rough the grains appear, and Push Processing increases the contrast and density of the grain.

Size bases the grain on actual film samples. Automatic sets it for you, but you can choose from three film types: 35mm (135), Medium Format 120, and 4x5 Larger Format. Relative size scales the grain from fine and small to large golfballs on the photo. I'm kidding, of course, but the grain can become unsightly when too large. As someone who used to shoot concerts in dark rooms with pushed Ilford Delta 3200, I can vouch for the fact that this feature does a good job of emulating that grain.

Bokeh

Bokeh is a plugin that simulates the Bokeh effect from a variety of lenses. It's fairly involved and we don't have a lot of space to discuss it, but let's dive right in. I've gone back to a basic preset for this: Fuji 160C.

Focus Region

Focus Region lets you choose what shape the blur will take. You have three options: Radial, Planer, and Half Planer. Radial and Half Planer are already familiar to Lightroom users. Radial matches Lightroom's Radial Filter. Half Planer is like the Graduated Filter. Planer is like two opposite Graduated Filters together with equal settings on both sides, with no effect in the middle. You can drag the outline points to change the shape and position of Radial, and change the angle and position of both Planer and Half Planer. The feather is controlled by the outside dotted circle or line, which can also be dragged into your ideal position.

Click Show Mask to temporarily see the mask in shades of black and white. Black is where the effect is. Imagine that the mask is for the image rather than the effect.

Lens

Lens starts with a Preset menu that contains a set of flyout menus for the presets, which emulate everything from toy lenses to pro sport lenses.

Amount controls the strength of the effect. Zoom creates a motion blur and looks similar to the bokeh of a Tilt Shift lens that is Tilted to limit focus. Twist enhances this effect further. Creamy runs from hollow bokeh (for instance, with the heart shape you'll see bokeh as a hollow heart) to creamy full bokeh. When using the Curvature slider, the shape will appear more star-like when the slider is moved to the left, and more circular when the slider is moved to the right. The box allows you to choose an aperture shape for the lens, with options from toy shapes like diamonds and hearts to multibladed aperture lens options. The Rotation tool lets you rotate this shape.

Highlights

Highlights allows you to boost the level of the lightest parts of the image, which emulates lens bloom. Threshold sets what parts of the image are affected. The higher the threshold is set, the more areas of the image are affected. Boost increases the light in these areas.

Grain Matching

Grain Matching has two sliders: Strength and Size. These let you add grain back to the blurred areas to match the non-blurred areas of the image to help it look more natural.

Overexposed

That's pretty much it for Exposure. I know we're barely touching the surface of the plugin, but hopefully it'll give you a feel for how much there is to explore.

Palette

Palette is a plugin for Lightroom, but it's the hardware kind. I was fortunate enough to be offered a chance to test a preproduction set of modules for this plugin, so I learned how it works.

Palette is very different from any hardware add-on I've seen for Lightroom. It's made of separate modules that lock together with magnets. Other than the power module, each module has three sides of seven copper connectors, and one side with six pins. The power module has three sides of pins, and one side has a micro USB–B connector (like most phones) and a power adaptor connector for low-powered USB situations.

Install the Palette App from http://palettegear.com/start to begin. This will install the Lightroom plugin as part of the process. Run PaletteApp to begin. You can start Lightroom, too. When the app opens, you'll see the range of devices that you can connect. Click Lightroom to create a new profile for Lightroom.

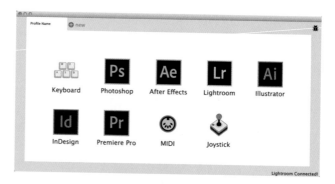

This new profile opens with an empty screen, with Profile Name at the top-left tab. Double-click this tab to give it a useful name. I'm calling it "Nightclub" because I'm working on the photos I process immediately after shooting in a local club.

Connect the power module with the supplied USB cable. It will also appear onscreen to match the physical connection. Neat? My son thinks so. The screen of the power module will show the Lightroom logo and the Profile Name (in our case, "Nightclub").

I'm going to connect two buttons, one fader, and two rotaries. The app updates to show these connections in real time. This setup forms the basis of controls I need for the job. After import, I apply a preset to the images, as per the club's request. The next part of the job is weeding out duds and fixing exposure and crop errors. For this I need a few specific tools to speed the process along.

I need a Reject button, and a Next Image button for selection. I need Exposure and Highlight controls. Often, brightening an image leaves the highlights too bright—hence the need for these tools. Finally, I need to change the crop angle.

To make these tools available to you, click on the module in the app and choose the function you want from the menu that appears. Some items, like Exposure and Highlights in the Basic Panel, are in submenus.

Not all menus in each Module use the same naming structure. I apply Crop Angle to the fader, and Exposure and Highlights to the rotaries. Reject is in the Flag menu, but there's no right-arrow function.

Finally, I choose "Keyboard Shortcut." This opens the Press Action dialog. I press my keyboard shortcut, but nothing happens. Why? As it turns out, you have to click the green button in the dialog first.

Now that the shortcut recorder is primed, I press the right arrow key to apply it. KEY Right appears in the dialog, so I press Done to accept it.

There's one more cool thing that my son loves about Palette, and you can see it in the first image above. You can change the surrounding color. The light blue is nice (you'll need to turn up the rotaries to see their color, first), but you have a range of colors available. See the tiny light blue square on each module? Click that to see the color selection.

Set up the color for each module. I've used red for Reject and green for Next.

This app will be changing as the hardware develops, but the principles will remain the same.

Now that I'm ready to go, it's time to work through images. Faders, because of their fixed position, will cause settings to jump to the current location. For this reason, I prefer the rotaries. Having the Palette definitely makes the editing process of these photos much faster, and given the lateness of the hour that I edit them, I appreciate that it gets me to bed sooner.

More Than Photos

Palette came out of a Kickstarter project and is aimed at providing greater control in a handy package. Lightroom is just one of the applications that uses it, and many more are being added as time goes by. As well as Adobe apps, you can run midi hardware with it so it encompasses music, video, and design, as well as photos.

Help! Lightroom Ate My Homework!

Lightroom Q&A

Everyone has to start somewhere, and no one person knows absolutely everything about Lightroom. I learn new aspects of the program from gurus all the time, and they, in turn, learn from me. This chapter is a collection of frequently asked questions (and even a few I've made up) and their answers. I will start by giving you one bit of sage advice: with any problem, always restart Lightroom before you do anything else. Seriously. The program sometimes gets tired and needs a little nap from time to time. In fact, my friend and fellow Photographers-Toolbox.com plugin writer, Matt Dawson, once took pity on me and wrote a script that restarts Lightroom. I love it. I use it often. You can find out all about it here:

http://thephotogeek.com/lightroom-power-nap-restart-script/

 With that said, here's some help!

I've Installed Lightroom CC, but it Crashes Immediately When I Open it. Help!

Open the Adobe Creative Cloud App. Click on the Cog icon in the top-right corner. Choose Preferences from the menu. In the General Tab, click Account. Click Sign out of Creative Cloud. Sign in again when prompted. This resets the account information and should cure your problem. There's a knowledgebase article on it here:

https://helpx.adobe.com/photoshop/kb/cc-applications-crash-immediately-launch.html

 This issue was also fixed with version 6.0.1 of Lightroom.

How Do I Import from iPhoto or Aperture?

Lightroom ships with a plugin that allows this transfer. First back up your catalog by going to Catalog Settings and setting Backup (in the General tab) to When Lightroom Next Exits. Restart Lightroom. From the File menu, go to Plugin Extras and choose Import from Aperture Library or iPhoto Library.

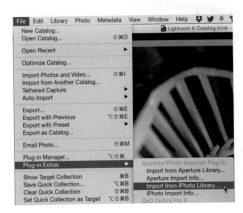

Lightroom will detect the library location, but you can specify a different one. You can also choose where the image files will be moved. The number of files, space required, and the space remaining are visible in the dialog. There's an Options button. Press this to open a dialog box where you can select to import Previews from iPhoto, Apply Keywords, and choose to Reference photos rather than creating new copies. Referencing photos saves space, but because the photos are still connected in iPhoto, this could lead to conflicts at a later time if you still use iPhoto. Click Import when you're done setting these options. For more information check out the official Adobe blog at:

http://blogs.adobe.com/lightroomjournal/2014/10/aperture-import-plugin-now-available.html

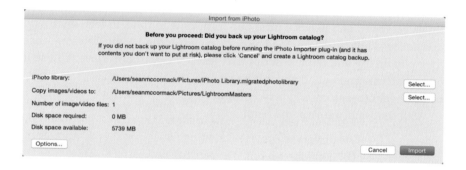

I Moved Files to Tidy My Drive and Now Lightroom Can't Find Them

Because Lightroom only references files, it doesn't follow them when they move. You have two choices. The first is to move the files back to their original location so Lightroom can see them, and then move them using the Folders panel in Lightroom. Alternatively, right-click on a missing folder and choose Find Missing Folder. Navigate to where you moved the folder and select it. Lightroom will update to recognize the new location.

Lightroom is Not Syncing Correctly With My iPad

Try deleting the Sync.lrdata file, which is located in a hidden directory. From Mac Finder, hold down the Option key and click on the Go menu. You will see an additional Library entry. Click this. From there, go to Caches/Adobe/Lightroom/Sync Data, where you will see the sync.lrdata file. Remove the

sync.lrdata file and restart Lightroom on the desktop. This should restart/
refresh the sync.

On Windows, Sync.lrdata is located at: C:\Users\<user>\AppData\Local\
Adobe\Lightroom\Caches\Sync Data\Sync.lrdata

AppData is a hidden folder. To view hidden files on Windows 8, use the
shortcut Windows key + E. Click the View tab. Check File name extensions
and Hidden items.

For Windows 7, right-click the Windows Logo button and choose Open
Windows Explorer. Click Organize and choose Folder and Search Options.
Click the View tab, and then select Show hidden files and folders. Clear the
checkbox for Hide protected system operating files. Click Yes on the warning
and then click OK. This should help the syncing process.

I Have No Idea Where Lightroom Put My Pictures. Where Can I Find Them?

To find any photo on the drive, use the shortcut Command + R on Mac, or
Control + R on PC. You can also right-click on a file and choose Show in Finder
(Mac) or Show in Explorer (PC) from the menu that appears. If you want to go
back to the Folder in Lightroom from a Collection, right-click on the photo
and choose Go to Folder in Library. Lightroom has placed these files based
on your Import settings. If you use Add, Lightroom yet hasn't moved these
files. If you used Copy or Move, the place Lightroom moved the files to is set
in the Destination panel on the right of Import.

My Laptop is Full. How Do I Move My Images Safely off the Internal Drive?

To have Lightroom keep track of your photos, move them from within Light-
room. The easiest way to add a drive is to import a photo using Add. Then
move your folders over to the new drive. The number of images you have
dictates how long this process will take.

I've Updated Photoshop, but Lightroom Keeps Using the Old Version

The easiest solution to this issue is to reinstall Lightroom. Remember that both Mac and PC need to use the uninstaller to remove Lightroom. Lightroom doesn't delete your catalog when you uninstall. Sometimes on a PC you need to edit the windows registry to make it work. Go here: https://helpx.adobe.com/x-productkb/multi/edit-photoshop-command-missing-photoshop.html

Alternatively, search online using the terms "adobe knowledge base photoshop lightroom windows registry."

My Adjustment Brush Does Nothing

Check to make sure that Flow and Density are not set to zero, or at a very low value. Try setting them to 100 (the default value) to see if they work. Alternatively, you may be painting on white or light-toned areas with a white mask on. Press "O" to turn the mask on and off, or use the shortcut Shift + O to change the color of the mask.

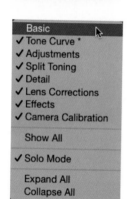

I've Lost My Basic/Tone Curve (or Any Other) Panel!

It's easy to accidentally turn a panel off if you're not paying attention. Right-click on any visible panel and click on the name of your missing panel to turn it back on.

Can the Lightroom Backup File Really Fit All of My Images?

No, it can't. Lightroom backup only backs up the catalog file. Use a program like Chronosync (Mac) or Synctoy (PC) to make backups of your photos. Remember, with digital files you must have at least two copies of the photos. Three is better, with one copy in a different location than the other two. Backups are no good if they are all in the same place when the computer you're storing them on is stolen, lost, or destroyed.

When I Open Lighroom, I Immediately Get an Error Message That Says "Lightroom Encountered an Error When Reading From Its Preview Cache and Needs to Quit. Lightroom Will Attempt to Fix This Problem the Next Time it Launches." I Restart the Program, but Nothing is Resolved.

The preview cache is most likely beyond saving. You'll need to delete it. While this is painful from a time point of view because Lightroom will need to build all your previews again, it's not a critical error. Go to the folder with your catalog (Lightroom 6 Catalog is the default) and look for a file that ends in Previews.lrdata (but not Smart Previews.lrdata). On Windows it's actually a folder, whereas on Mac it's a file. Delete this file or folder and restart Lightroom.

Lightroom Won't Import the Files From My Brand New Camera

Lightroom releases support for newly released cameras at regular intervals, and will support your camera soon. For now, shoot JPEG and RAW so you can process right away but still have the RAW file for when Lightroom is updated to support those files. You could also convert the files from RAW to JPEG or TIFF in the software that came with the camera if you prefer not to wait for a Lightroom update that adds support for your camera.

Every File I Import Has Blue in the Shadows, or Shows Red Tones Instead of White. The Images Look Fine in-camera. How Do I Solve This?

You've turned on the shadow or highlight clipping indicator. To turn these indicators off, open the Histogram and click on the triangles at the top of the panel. You can also press "J" to turn on both the Shadow and Highlight clipping indicators, then press "J" a second time to turn them off. It's an easy mistake to make when you're not familiar with the program.

Lightroom is Running Slowly—is There Anything I Can Do to Help?

You can use the Optimize Catalog command in the File menu. This clears up any cruft that builds up in the catalog as time goes by. You could also try putting the catalog folder onto an SSD drive, and increasing the size of the Camera Raw Cache in the File Handling section of Preferences. On Mac, Preferences is in the Lightroom menu. On PC, it's in the Edit menu.

Another culprit that makes Lightroom run slowly is the Automatically write changes into XMP option in Catalog settings. Turn this off. You can always manually save XMP by selecting files and using the shortcut Command/Control + S.

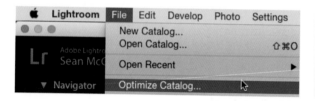 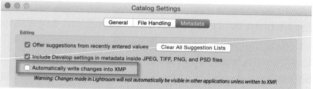

My Main Catalog is Corrupted. I've Tried All the Suggestions to Get it Going, but It's Hosed. How do I Use My Weekly Backups?

By default, Lightroom saves the backups into the same folder as the Catalog in a folder called Backups. These backups are named by date, so look for the most recent date. Lightroom zips these files, so unzip them. Rename the file to something sensible—perhaps even the original catalog name. Replace the corrupted catalog with the backup with the new name. If you don't know how long the corruption has been going on, you may need to use an older backup. Save XMP to store your settings externally to the catalog.

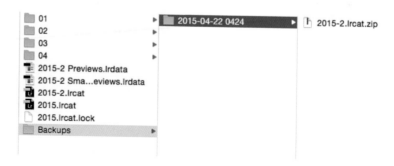

I've Been Using the Rating System on My Canon 5D Mark III, but It Doesn't Transfer into Lightroom

If you're using a Metadata Preset on Import (and you should be for the sake of copyright information, at least), check that you don't have the Rating option checked. If you do, uncheck the box and then update the Preset from the Preset menu.

I've Reattached My External Drive to Lightroom and It Still Says My Images are Missing (Windows)

When you attach different devices (even USB sticks), Windows assigns that drive a letter. If several devices have been attached since this drive was last plugged in, Windows may have assigned it a completely different letter. To change this you need to be logged in as an Administrator (and in Desktop Mode on Windows 8). Type diskmgmt.msc in the text search box and hit Enter. Right-click on the drive you want to reassign with a different letter (you want it to match the one in Lightroom), and choose Change Drive Letter and Paths. Click Change. If Assign the Following Drive letter is not selected, select it. Click the new drive letter you want and click OK. Click Yes to confirm the change.

I've Updated to Lightroom CC/Lightroom 6. Is It Safe to Delete Lightroom 5?

Lightroom CC/6 will update any old catalogs you have, so yes, it is safe to delete Lightroom 5. You should use the uninstaller for Windows, and you can simply delete it on Mac. Note that Lightroom CC needs an uninstaller for both Mac and PC. If you have changed from Lightroom 5 to CC and think you might want to get the perpetual version of Lightroom, keep the Lightroom 5 serial number in case you need it to get upgrade pricing.

When I'm Done Working in a Collection, I Delete the Photos I Don't Want. When I Go Back to Their Folders, the Photos Are Still There. What Can I do?

Okay. I'll give you the secret handshake, but you have to use it with care, because it's more of a claw than a handshake. On Mac, use Shift + Command + Option + Delete. On PC, use Shift + Control + Alt + Delete. This will delete

your files. There won't be the standard Remove/Delete dialog. The file will be gone from Lightroom and placed in Trash/The Recycle Bin. In other words, don't use it unless you're sure about it.

I Edited and Flagged Photos on My Laptop and Saved the Metadata. When I Import the Photos to My Desktop, the Edits Are There, but I Can't See My Flags. What Can I Do?

XMP will store your edits, metadata, ratings, and labels, but unfortunately it doesn't store flags. I've had to revise my process for making selects because of this. Next time, add a star or a label to the flagged images so you can find them after Importing them to a desktop computer.

I've Been Applying Names to Group Photos, but I Don't know Everyone in the Shots. Should I Just Delete the Face Regions?

Right now there's no way to force Lightroom to re-index a photo to detect faces, so only do this if you're really sure. Of course, the worst-case scenario is manually drawing a face region again. Rotating an image can force a rescan, but not if any of the face regions have been confirmed.

I Want to Upgrade to the Perpetual Version of Lightroom, Not the Cloud Version, but It Seems Impossible to Find

It is difficult to find. Adobe is keen to have people use the cloud. I think it's great value, but I totally understand why people want to have a version that feels like their own. Go here: https://www.adobe.com/products/catalog/software._sl_idcontentfilter_sl_catalog_sl_software_sl_mostpopular.html.

Click Buy, then change "I want to buy" from Full to Upgrade. In the next part, "I own," choose the version of Lightroom you're upgrading from.

I Want to Use a Catalog for Each Job, but I Still Want to Keep My Best Work Together Without Duplicating My Files. What Can I Do?

Keep the job catalog in the same folder as the images. Make the catalog files and bring the images into that folder. After you've made your selections and edits, create a collection of them. I suggest naming the collection to match the shoot. Select all in the collection and click on File > Export as Catalog. Call this catalog "Temp"—it'll create a folder called "Temp." At the bottom, make sure the number of images is correct, and that the box for Export negative files is not checked. This prevents duplicates. Press the Export Catalog button. The temporary catalog will be created.

Now open your main catalog and click on File > Import from Another Catalog. Find the Temp.lrcat you just made and press return. Make sure you use Add new photos to catalog without moving in the small Import dialog that appears (this is the original Lightroom 1 Import dialog!). When the images are imported, delete the Temp folder.

If you ever need to go back to the job catalog, find an image in the main catalog from the shoot and right-click on it. Choose Show in Finder/Explorer. This will open that job folder and you can open the job catalog by double-clicking on it within the folder.

Can I Put My Catalog and Previews in Dropbox So I Can Use Them on Two Different Computers?

Officially the answer is no. I do know an Adobe engineer that does this, but he has the knowledge to fix any problems if it goes wrong. I have tried it on test catalogs successfully, but there is one really, really, really, strict proviso: you must always close Lightroom every time you leave the computer you're working on. If you don't, Lightroom won't know which version of the catalog is correct, and it will create an additional, conflicted catalog (literally—it creates a catalog with "conflicted" in the name). Worse still, you might corrupt the catalog and lose everything. So here's the deal. Don't do it, and don't blame me if you do it and it goes horribly wrong.

Is There a Group or Forum You Recommend Where I Can Go to Ask Questions? I Want a Friendly Environment Where I Can Ask About Both Simple and Difficult Problems I'm Experiencing.

While I don't get there as much as I used to, I've always found Lightroom Forums to be great. It's generally full of friendly and helpful people. People who are helpful get promoted, so you always know if you can trust their information. http://lightroomforums.net

Well, folks, that takes us to the end of the book. I hope it's been of use to you. If you want to keep up with current Lightroom-related news and get new tutorials as I create them, be sure to check out http://lightroom-blog.com or follow @lightroomblog on twitter.

Index